From Beasts to Souls

D1331198

From

BEASTS

to

SOULS

GENDER AND EMBODIMENT
IN MEDIEVAL EUROPE

edited by

E. JANE BURNS *and* PEGGY MCCRACKEN

University of Notre Dame Press

Notre Dame, Indiana

Copyright © 2013 by University of Notre Dame
Notre Dame, Indiana 46556
www.undpress.nd.edu
All Rights Reserved

Manufactured in the United States of America

Library of Congress Cataloging-in-Publication Data

From beasts to souls : gender and embodiment in Medieval Europe /
edited by E. Jane Burns and Peggy McCracken.
pages cm
Includes bibliographical references and index.
ISBN 978-0-268-02232-7 (pbk. : alk. paper) — ISBN 0-268-02232-1 (pbk. : alk. paper)
1. Literature, Medieval—History and criticism. 2. Animals in literature. 3. Sex role
in literature. 4. Soul in literature. I. Burns, E. Jane, 1948– editor of compilation.
II. McCracken, Peggy, editor of compilation.
PN682.A57F76 2013
809'.02—dc23
2013000463

Contents

———

Figures

Introduction

Gendered Bodies in Unexpected Places

In 1992, Marjorie Garber published a compelling analysis of J. M. Barrie's *Peter Pan*, explaining why Peter Pan had (almost) always been played by a woman. Suggesting first that Peter was a cross-dressed version of Wendy, who in turn represented a version of Barrie himself, Garber went further to suggest that Peter was "suffering from a kind of species dysphoria, caught between being a bird and being a human child."[1] As the wise old bird Solomon Caw explains to Peter in Barrie's 1902 stage play *The Little White Bird,* Peter is "a Betwixt-and-Between":

> "Then I sha'n't be exactly a human?" Peter asked.
> "No."
> "Nor exactly a bird?"
> "No."
> "What shall I be?"
> "You will be a Betwixt-and-Between," Solomon said, and certainly he was a wise old fellow, for that is exactly how it turned out.[2]

For Garber, the character of Peter Pan offers a "split vision" of an adult woman who is also a little boy,[3] a "third sex" enabling Barrie to break

1

open the Victorian dichotomies of man/woman, father/mother, man/boy. He does so, in this instance, specifically by displacing those predictable dyads onto a division of species: human/bird. For Peter Pan, then, gender crossings enacted by his human body are doubled by a facile movement between boys and birds: his human body can fly.

Peter Pan is not based on a medieval source, though in its representation of a species- and gender-crossing protagonist, it stages issues played out in a wide range of medieval cultural artifacts. Indeed, the Middle Ages provides a particularly rich trove of hybrid creatures, semi-human beings, and composite bodies. We need only think of the many differently bodied creatures that adorn manuscript pages or decorate stone capitals and carvings on Romanesque churches: human heads with tails but no body, leaf masks and faces without obvious gender, disembodied breasts, an ungendered face exposing female genitalia, a man's face with a swan neck, bird wings, lion feet, and a snake tail, or sirens with a woman's head and a bird's body.[4] Showcasing the fullest possible spectrum of imagined species crossings, these figures incorporate both human and animal elements within a decorative vegetal matrix that allows facile movement between, and even confusion of, components from each realm. As human bodies are curved and twisted into stemlike shapes, animal tails often end in plantlike tendrils. The newly discovered ceiling at Metz shows that fish bodies can be combined with almost any animal torso.[5] On Romanesque capitals generally, humans appear with the head of a dog or an ass, but more frequently animals are shown bearing human heads or exhibiting the human behavior of musicians, acrobats, dancers, or jugglers.[6] And yet, however fanciful and elaborate these cross-species hybrids become, binary gender assignments seem to remain unchallenged. Gender is clearly marked, for example, by the bearded faces of centaurs and other men with animal or fish bodies, and by the pronounced breasts and long hair of mermaids. Different from the example provided by Peter Pan, the species crossings in these medieval images seem to occur without any apparent effect on the gender of the changed bodies that result.

A number of medieval literary texts stage a similar process, describing seemingly effortless cross-species transformations of people into wolves and wolves into people or the existence of women-serpents or

birdmen with no significant disruption of embodied gender. In the French tradition, for example, we never question the gender of the bird-lover in Marie de France's *Yonec* or that of the werewolf in *Bisclavret*. Even medieval accounts of fairies tend to focus on bodily change while leaving gender intact. All fairies are not shape-shifters, and all characters that demonstrate the ability to change form are not called fairies, but the fairy figure drawn from folklore is the most prominent form for the representation of nondivine and nondemonic supernatural beings in medieval texts, as Laurence Harf-Lancner has argued.[7] Often, however, the human body of the shape-shifting protagonist is firmly grounded in the most exemplary forms of courtly gender—the expression "as beautiful as a fairy" (belle comme une fée) underwrites the conventional norm of appreciation for female courtly beauty. Male fairies are perhaps less common but no less securely gendered. Auberon, king of the fairies, is a dwarf who has lived for more than one hundred years, and even if he does not have the physique of a great knight, he is securely grounded in attributes of his gender, as defined in medieval narratives: he is a paragon of masculine beauty and he leads a great army.[8]

Monsters offer another example of beings that expand or distort the limits of the body. The figure of Mélusine may be exemplary of the disputed boundary between the two—is she a fairy or is she a monster?[9]—and as in the case of Mélusine, debates about monsters seem often to focus on the implications of embodiment for gender.[10] Monstrous medieval bodies, whether monstrous female reproductive bodies or impotent male bodies, can also serve as a repository for specific cultural fears about human sexuality and embodied identity.[11] Might it be possible and productive, however, to rethink the larger gendered implications of hybrid or transformative medieval bodies beyond their reflection of or relation to the human?

The current volume seeks to raise the issues of species and gender in tandem, asking readers to consider more fully what happens to gender in medieval representations of nonhuman embodiment. We ask when and how the nonhuman or species-changing body might in fact become differently gendered or degendered, and to what extent it might occupy a new position in a spectrum of gendered possibilities. Under what circumstances do medieval literary texts, historical accounts, and

visual images connect species identity with gender identity? And what are the gendered values assigned in medieval works to nonhuman or cross-species embodiment?

To be sure, medieval literature offers many examples of gender mutability, but not usually within stories about shape-shifting protagonists or cross-species transformation. Narratives of cross-dressing and representations of androgynous identity populate texts ranging from saints' lives and Arthurian romance to Christine de Pisan's *Mutacion de fortune*.[12] Cross-dressing is associated even with the canonical figures of Lancelot and Guenevere, and particularly striking examples are provided by the *Roman de Silence, Tristan de Nanteuil,* or *Floris et Lyriope,* where gender ambiguity or disguise may suggest queer sexuality.[13] While the gender crossings represented in narratives about cross-dressing protagonists are often temporary, cast as the product of practical disguise or facilitated by borrowed clothing, they raise nonetheless the issue of the arbitrariness of gender categories by blatantly transgressing them. Often at stake in these scenarios of gender-bending are cultural patterns and power dynamics rather than physical alterations of embodied beings. Yet they attest to a fascination with the fragility of the boundary between categories of masculine and feminine and an interest in exploring ways to breach, displace, question, or reconfigure it.

Medieval sexuality studies has long been a crucial area of inquiry into gender and embodiment, and scholars have described the various ways in which desire not only escapes the different-sex alignments prescribed and policed by social and religious institutions but reconceives bodies in terms of desire.[14] In some romance narratives, for example, desirable bodies are represented less in terms of gendered characteristics than in terms of their exemplary courtly attributes.[15] Heterosexual hegemony is revealed as contested and fragile, and even as same-sex desire is roundly condemned in some religious, legal, and literary discourses, it is represented without censure and even sanctioned in others.[16] The human/nonhuman divide may be a site in which differently embodied forms of being suggest differently imagined forms of desire, and gender is an important category of analysis for thinking about both bodies and sexuality.[17] To what extent might explorations of medieval sexuality and gender dynamics change if they addressed non-

human bodies along with the human, or if they addressed the joining of human and nonhuman or not entirely human bodies?

Our claim is—from the perspective of medieval studies, but with a theoretical urgency that addresses the fields of posthumanist and feminist studies in general—that inquiries into nonhuman and differently embodied being call out strongly for a new and careful assessment of gender.

We might consider at this point the character of Tinkerbell, who, even more than Peter Pan, carries us beyond the physical body and beyond the human. In Barrie's play *Peter and Wendy,* where the roles of both Peter Pan and the Lost Boys were typically played by actresses, the character of Tinkerbell was not enacted by an embodied human at all but represented only by a "flame of light not much larger than a human finger [that] flashes about the room."[18] If Barrie's own definition of Tinkerbell places her "Betwixt-and-Between" genders—at once a fairy and a "tinker," that is, a tinsmith like the actual historical male tinkers who mended pots and kettles—the stage production further locates her between animate and inanimate worlds. Her seemingly human but incomprehensible "dialogue" is conveyed only by the sounds of tinkling bells, as intangible as the darting light that alone makes her "visible." To be sure, Barrie does not cultivate this potential cross-gender/species/inanimate ambiguity to its fullest. By referring to Tinkerbell as a "she" who engages in a jealous battle with Wendy for Peter's affections, Barrie undercuts the full force of a disembodied character who can fly and also communicate through nonhuman sounds. Thus does Barrie himself, in a sense, pave the way for Disney's later uncompromising reduction of Tinkerbell to the category of the feminine, a creature, however supernatural, bearing an incontrovertibly female body.

And yet one wonders about the theoretical potential of that darting light representing a character who behaves like an engaged and active subject without possessing a human or animal form. While Peter flies like a human on fairy dust, Tinkerbell flits around the room, moving in and out of drawers because she has no "body" of a fixed or determined size. And yet she is not disembodied, invisible, or wholly intangible. Tinkerbell is embodied in light and sound, both inanimate forces that can move but cannot be contained, outlined, or restrained. Their

essence is to be changeable. In Barrie's play, this "woman's" gender re-
sults from a pronoun alone. In a number of interesting ways, then,
Tinkerbell raises the possibility of exploring what happens to gender
when we move beyond the physical body and, even further, beyond the
human.

The contributors to this volume take up that challenge, showing
that medieval cultural artifacts, whether literary, historical, or visual, do
not limit questions of gender to predictable forms of human or semi-
human embodiment. They also reflect on the gender of stones and of
the soul, of worms and dragons. By expanding what counts as "the
body" in medieval cultural studies, the essays to follow expand our un-
derstanding of gendered embodiment—articulating new perspectives
on its range, functions, and effects.

Whereas feminist critics have long interrogated the many and var-
ied gender formations that are both constructed through and some-
times obscured by conventional forms of human embodiment in
medieval texts, those studies typically limit their understanding of "the
body" to the *human* body.[19] Following the lead of feminist theorists
from Simone de Beauvoir to Judith Butler, feminist scholars of the
Middle Ages have sought to understand the varied roles that human
bodies played in constructing gendered subjectivity.[20] Whether analyz-
ing religious or secular bodies, historical women, literary characters, or
visual representations of female bodies, feminist medievalists have
tended to focus their efforts on understanding relational dynamics of
women's bodies in the social sphere, explaining the relations between
female bodies and the cultural formations that created, surveyed, con-
trolled, or fostered them. Apart from recent studies on monsters and,
to some extent, on fairies, less emphasis has been placed on under-
standing the gendered implications of nonhuman bodies.

More recently, medievalists have begun to explore relationships be-
tween human and nonhuman embodiment and to question what repre-
sentations of nonhuman bodies may offer to our understanding of the
human. Joyce Salisbury's *The Beast Within* was a pathbreaking contribu-
tion to medieval animal studies, revealing, along with other studies, the
extent to which inquiries into human-animal relations pervade medieval
textual traditions from fables to allegory and from didactic and moral
treatises to scholastic, encyclopedic, and legal works.[21] Other inquiries

have focused on the practical relationships between humans and animals as scripted in hunting, the merging of man and horse in the figure of the knight, and the humanlike qualities of animals.[22] Medievalists have examined both the symbolic uses of animals in bestiaries and the material use of animals in medieval textuality, and they have identified the human subjugation of animals as an essential grounding for the medieval concept of the human.[23] Drawing on theoretical work from posthumanism, medievalists have demonstrated the extent to which medieval authors use nonhuman embodiment to think about the human, about sovereignty, and about social and political relations.[24] Although much of this scholarship is informed by or sympathetic to feminist theory and criticism, there has not yet been any sustained attention to the ways medieval explorations of the boundaries of the human might redefine or challenge our contemporary concepts of gender.

This is one potentially rich and important contribution that posthumanism can make to feminism: spurring us to move beyond the feminist challenge of thinking through the all-too-human body and to imagine bodies that include the animal, vegetal, and even inanimate aspects of embodiment, all the while keeping gender at the forefront of our analysis. The goal of *From Beasts to Souls* is to ask how medieval cultural representations of nonhuman or partially human creatures, whether literary, visual, religious, or theological, give us new ways to think about gender and embodiment on a broader theoretical spectrum. The contributors to this volume explore that question in a range of medieval contexts extending from learned debates to everyday objects of popular culture. Their essays ask: To what extent can we draw on depictions of differently bodied creatures in the Middle Ages to dislodge and reconfigure the long-standing constraints imposed by an understanding of the body as always human and of the human body as merely male and female?

While the essays collected here take medieval Europe as a point of departure, their analyses of gender and embodiment carry us across a number of cultural contexts and academic disciplines: moving from French and English literature to objects of Germanic and Netherlandish material culture, from theological debates to literary concerns with the soul. They engage with issues of gender and embodiment located in

stones, skeletons, and snake tails, swan-knights, werewolves, and wandering genitalia, along with a host of other unexpected places. They ask us to consider the gendered embodiment of the dead, the amorous attraction between humans and minerals, the political implications of magical bodies, and the social function of bodies reduced to gendered parts. Although these topics and others addressed in this volume derive from medieval literary, theological, and cultural artifacts from northern Europe, they have potential implications for a broader cultural and geographic expanse. These essays are not intended to represent every area of medieval Europe; rather, they offer models for thinking about gendered embodiment that might provoke work in other areas, intersecting productively, we would hope, with studies of race and contact among Jews, Muslims, and Christians, particularly in Iberia, as well as work from Mediterranean studies that identifies the connections and exchanges among Europe, the East, and Africa.

We have grouped the essays into sections that reflect specific ways they address gendered embodiment beyond the human in the Middle Ages: Part I, "Intimate Connections"; Part II, "Embodied Souls"; and Part III, "Institutional Effects." The first group of essays engages with some of the more private and personal functions of medieval bodies: desire, intimacy, and love. The second group examines the theological implications of embodiment, specifically the bodies of souls. The third group of essays addresses more public functions of gendered bodies as they relate to social institutions of feudal loyalty and marriage, inheritance, and gendered labor. To be sure, the distinction between public and private functions of embodiment is porous. Cultural and feminist historians from Peter Brown to Caroline Bynum have shown that throughout the Middle Ages the human body was understood to occupy a tenuous position between two key spheres of existence, being at one and the same time intimately personal, private, and individualized while also performing in highly visible, public, and communal capacities.[25] The essays that follow showcase a range of differently bodied, nonhuman, or species-changing creatures that participate in both public and private spheres, challenging as they do so our conceptions of human/animal embodiment and gendered social space.

Essays in the first section, "Intimate Connections," allow us to see the extent to which already in the early Middle Ages we find configurations of desire beyond the biological, intimacy beyond the purely human, and love and friendship beyond what courtliness would normally allow. Jeffrey J. Cohen's "The Sex Life of Stone" provocatively opens up the categories of the human, animal, vegetable, and mineral to reveal medieval configurations of desire untethered to the biological. Moving beyond animal studies to the consideration of "inorganic others," such as rocks, Cohen's analysis shows what an embodied posthuman stone might do. Drawing on classical and medieval stone lore along with John Mandeville's account of diamonds, Cohen discusses medieval views of stones as erotic, gendered, and lively creatures.

Peggy McCracken's essay "Nursing Animals and Cross-Species Intimacy" identifies patterns of intimacy that extend beyond the purely human in a comparative study of representations of cross-species nursing. McCracken examines medieval swan-knights in the Old French Crusade Cycle, a human mother's relationship with suckling fawns in *Decameron* 2.6, a maternal deer in Ibn Tufayl's Andalusian tale *Hayy ibn Yaqzan,* and a scene in which adulterous women nurse puppies, and argues that intimate configurations of maternity and animality persist in noble genealogies.

In chapter 3, "The Lady and the Dragon in Chrétien's *Chevalier au lion,*" Matilda Tomaryn Bruckner suggests that reading through gendered animals can provide a new perspective on heterosexual love in the Middle Ages. To fully understand the relation between Yvain and the lady Laudine in this romance, we are encouraged to shift our focus from the lion to the lady and to the clear outlines of a dragon lurking behind her. In this tale, which so insistently calls our attention to beasts, the anomaly of a female-gendered dragon in the role of the knight's lady significantly alters the expected paradigm of courtly love.

The essays in the second section, "Embodied Souls," broaden our understanding of the relation between souls and bodies in the Middle Ages by considering the physically recognizable bodies of dead people and by expanding the soul-body debate with the addition of an unexpected third term: worms. In "Rubber Soul: Theology, Hagiography, and the Spirit World of the High Middle Ages," Dyan Elliott asks

whether the soul can have a body of its own and, if so, whether this body is gendered. Examining Beguine hagiography, she shows that a postmortem identity has important consequences for gender. Although the soul, once separated from the body, is supposed to be devoid of sex, Beguine hagiography describes an embodied and sexed afterlife in which the body gradually drains into the soul.

Turning to a literary representation of a female soul in "Kissing the Worm: Sex and Gender in the Afterlife and the Poetic Posthuman in the Late Middle English 'A Disputacion betwyx the Body and Wormes,'" Elizabeth Robertson argues that the poem represents nonhuman but still gendered entities—a corpse, a soul that allows the corpse to speak, and a speaking worm. Their debate about embodiment and decay stages the dilemma of a female soul/corpse attempting to escape her bodily desires at the same time that she displays them in her active embrace of the sexualized worms.

Section 3, "Institutional Effects," includes essays that demonstrate ways in which nonconforming bodies can challenge institutionalized categories of power. In chapter 6, "Hybridity, Ethics, and Gender in Two Old French Werewolf Tales," Noah Guynn argues that Marie de France's *Bisclavret* and the anonymous lay *Melion* call into question medieval institutions of feudal loyalty among men and female subservience in marriage by exploiting ambiguities of characterization and narration. Depictions of gender difference and incongruous, compound forms of being are used in these texts to challenge the moral and social institutions that underwrite gender asymmetry and misogyny.

Chapter 7 shows how a shape-shifting, hybrid female body is used in the fourteenth-century *Roman de Mélusine* to advance the fictive political ancestry of the duc de Berry as a putative descendant of the Lusignan family line. In "A Snake-Tailed Woman: Hybridity and Dynasty in the *Roman de Mélusine*," E. Jane Burns reads the half-snake, half-dragon courtly woman Mélusine against established clerical views of her as the Eden serpent, arguing instead that the romance rewrites the Eden myth for an expansionist political purpose.

To close, Ann Marie Rasmussen carries us beyond questions of feudal loyalty and dynastic lineage to focus on visual expressions of female symbolic power associated with domains of women's work. Her

analysis of the mobile vulvas and wandering penises depicted on medieval sexual badges in chapter 8, "Moving beyond Sexuality in Medieval Sexual Badges," argues that these highly sexed images of hybrid creatures have little to do with heterosexual or homosexual desire. She reads them instead as advancing a kind of female masculinity based in spheres of social and economic life managed and dominated by women.

Taken together, these varied explorations of gender and embodiment attest to a diverse range of differently bodied and differently gendered beings in medieval culture. These early textual and visual materials demonstrate that once we attempt to think beyond the limitations of the human body, many new possibilities for understanding gender emerge. In fact, these medieval models suggest that it is by moving beyond the human and beyond predictable configurations of human bodies that we can begin to imagine new configurations of gender, whether in the form of gendered bodies, desires, and intimate practices, as gendered souls, or in terms of gendered spaces, institutions, and the social behaviors within them.

NOTES

1. Marjorie Garber, *Vested Interests: Cross-Dressing and Cultural Anxiety* (New York: Routledge, 1992), 174.

2. J. M. Barrie, *The Little White Bird* [1902], in *The Works of J. M. Barrie* (New York: Charles Scribner's Sons, 1930), 134.

3. Garber, *Vested Interests,* 175.

4. See, for example, Marie-Thérèse Camus, *La sculpture romane du Poitou: Les grands chantiers du XIe siècle* (Paris: Picard, 1992); Pierre Ripert, *Le bestiaire des cathedrales: Imagerie de la statuaire médiéval symbolique des monstres, gargouilles et autres chimères* (Paris: Éditions De Vecchi, 2010). On religious and secular manuscript illumination, see, among many others, Michael Camille, *Image on the Edge: The Margins of Medieval Art* (Cambridge, MA: Harvard University Press, 1992), and Marie-Hélène Tesnière, *Bestiaire médiéval: Enlumineures* (Paris: BNF, 2005).

5. Jerome Fronty, *L'étrange bestiaire médiéval du Musée de Metz* (Metz: Éditions Serpentoise, 2007). For a discussion of other representations of fish-animals and fish-knights, see Karl Steel and Peggy McCracken, "Into the Sea with the Fish-Knights of *Perceforest,*" *postmedieval: a journal of medieval cultural studies* 2, no. 1 (2011): 88–100.

6. Camus, *Sculpture romane*, 302.

7. Laurence Harf-Lancner, *Les fées au Moyen Âge: Morgane et Mélusine, La naissance des fées* (Geneva: Slatkine, 1984), 8. Harf-Lancner locates the claim specifically in the twelfth century for French literature.

8. *Huon de Bordeaux*, ed. William Kibler and François Suard (Paris: Champion, 2003), lines 3150–56.

9. See Burns, "A Snake-Tailed Woman," chapter 7 of this volume.

10. For a foundational study, see Jeffrey Jerome Cohen, *Of Giants: Sex, Monsters, and the Middle Ages* (Minneapolis: University of Minnesota Press, 1999).

11. Dana M. Oswald, *Monsters, Gender and Sexuality in Medieval English Literature* (Rochester, NY: D. S. Brewer, 2010).

12. Valerie R. Hotchkiss, *Clothes Make the Man: Female Cross Dressing in Medieval Europe* (New York: Garland, 2003).

13. E. Jane Burns, "Refashioning Courtly Love: Lancelot as Ladies' Man or Lady/Man?" in *Constructing Medieval Sexuality*, ed. Karma Lochrie, Peggy McCracken, and James A. Schultz (Minneapolis: University of Minnesota Press, 1997), 111–34; Robert L. A. Clark, "Queering Gender and Naturalizing Class in the *Roman de Silence*," *Arthuriana* 12, no. 1 (2002): 50–63; Kathleen M. Blumreich, "Lesbian Desire in the Old French *Roman de Silence*," *Arthuriana* 7, no. 2 (1997): 47–62; Francesca Canadé Sautman, "What Can They Possibly Do Together? Queer Epic Performances in *Tristan de Nanteuil*," in *Same Sex Love and Desire among Women in the Middle Ages*, ed. Francesca Canadé Sautman and Pamela Sheingorn (New York: Palgrave, 2001), 199–232; Jane Gilbert, "Boys Will Be . . . What? Gender, Sexuality, and Childhood in *Floire et Blancheflor* and *Floris et Lyriope*," *Exemplaria* 9, no. 1 (1997): 39–61.

14. Ruth Mazo Karras, *Sexuality in Medieval Europe: Doing unto Others* (New York: Routledge, 2005).

15. James A. Schultz, *Courtly Love, the Love of Courtliness, and the History of Sexuality* (Chicago: University of Chicago Press, 2006).

16. Karma Lochrie, *Heterosyncrasies: Female Sexuality When Normal Wasn't* (Minneapolis: University of Minnesota Press, 2005); Sahar Amer, *Crossing Borders: Love between Women in Medieval French and Arabic Literatures* (Philadelphia: University of Pennsylvania Press, 2008); Carolyn Dinshaw, *Getting Medieval: Sexualities and Communities, Pre- and Post-Modern* (Durham: Duke University Press, 1999).

17. See especially Noreen Giffney and Myra J. Hird, eds., *Queering the Non/Human* (Aldershot: Ashgate, 2008); and on the knight who does not love women and the androgynously gendered deer in Marie de France's *Guigemar*, see William Burgwinkle, *Sodomy, Masculinity and Law in Medieval Literature: France and England, 1050–1230* (Cambridge: Cambridge University Press, 2004).

18. Bruce K. Hanson, *Peter Pan on Stage and Screen, 1904–2010* (London: MacFarland, 2011), 39 and 33. See also the 1928 version of the play entitled *Peter Pan or the Boy Who Would Not Grow Up* (New York: Charles Scribner and Sons, 1928), in which "TINK flashes hither and thither" (27).

19. A prime example is provided by the biologist and feminist historian of science Anne Fausto-Sterling in *Sexing the Body: Gender Politics and the Construction of Sexuality* (New York: Basic Books, 2000). An obvious exception is found in primatologist and feminist theorist Donna Haraway's work on cyborgs, which opened a path for considering gender beyond the human that few other feminists pursued. See for example, *Simians, Cyborgs and Women: The Reinvention of Nature* (New York: Routledge, 1991). For a classic work on feminist animal studies that addresses sexism and speciesism as interlocking oppressions, see Carol J. Adams and Josephine Donovan, eds., *Animals and Women: Feminist Theoretical Explorations* (Durham: Duke University Press, 1995).

20. Following Simone de Beauvoir's *The Second Sex,* trans. H. M. Parshley (New York: Knopf, 1952), key studies include Jane Gallop, *Thinking through the Body* (New York: Columbia University Press, 1988); Elizabeth Grosz, *Volatile Bodies: Toward a Corporeal Feminism* (Bloomington: Indiana University Press, 1994); Judith Butler, *Bodies That Matter: On the Discursive Limits of Sex* (New York: Routledge, 1993); and of course the iconic works of Luce Irigaray and Hélène Cixous on "writing the body." For the latter, see Toril Moi, *Sexual/ Textual Politics: Feminist Literary Theory* (London: Routledge, 2002). Select studies by medievalists include Linda Lomperis and Sarah Stanbury, *Feminist Approaches to the Body in Medieval Literature* (Philadelphia: University of Pennsylvania Press, 1993); E. Jane Burns, *Bodytalk: When Women Speak in Old French Literature* (Philadelphia: University of Pennsylvania Press, 1993); Sarah Kay and Miri Rubin, eds., *Framing Medieval Bodies* (Manchester: Manchester University Press, 1994); Judith M. Bennett, *History Matters: Patriarchy and the Challenge of Feminism* (Philadelphia: University of Pennsylvania Press, 2006).

21. Joyce E. Salisbury, *The Beast Within: Animals in the Middle Ages* (New York: Routledge, 1994). Another early contribution to medieval animal studies was Dorothy Yamamoto's *The Boundaries of the Human in Medieval English Literature* (Oxford: Oxford University Press, 2000). See also Jacques Voisenet, *Bestiaire chrétien: L'imagerie animale des auteurs du Haut Moyen Age (Ve–XIe s.)* (Toulouse: Presses Universitaires du Mirail, 1994); Jacques Berlioz and Marie Anne Polo de Beaulieu, *L'animal exemplaire au Moyen Age (Ve–XVe siècle)* (Rennes: Presses Universitaires de Rennes, 1999).

22. Susan Crane, "For the Birds," *Studies in the Age of Chaucer* 29 (2007): 23–41, and "Chivalry and the Pre/Postmodern," *postmedieval: a journal of medieval cultural studies* 2, no. 1 (2011): 69–87; Jeffrey Jerome Cohen, "Chevalerie,"

in *Medieval Identity Machines* (Minneapolis: University of Minnesota Press, 2003), 35–77; Steel and McCracken, "Into the Sea."

23. Debra Hassig, *Medieval Bestiaries: Text, Image, Ideology* (Cambridge: Cambridge University Press, 1995); Sarah Kay, "Legible Skins: Animals and the Ethics of Medieval Reading," *postmedieval: a journal of medieval cultural studies* 2, no. 1 (2011): 13–32; Bruce Holsinger, "Of Pigs and Parchment: Medieval Studies and the Coming of the Animal," *PMLA* 124, no. 2 (2009): 616–23; Karl Steel, *How to Make a Human: Animals and Violence in the Middle Ages* (Columbus: Ohio State University Press, 2011).

24. See in particular the essays in Karl Steel and Peggy McCracken, eds., "The Animal Turn in Medieval Studies," special issue, *postmedieval: a journal of medieval cultural studies* 2, no. 1 (2011).

25. See, for example, Peter Brown, *The Body and Society: Men, Women, and Sexual Renunciation in Early Christianity* (New York: Columbia University Press, 1988); Caroline Walker Bynum, *Fragmentation and Redemption: Essays on Gender and the Human Body in Medieval Religion* (New York: Zone Books, 1991).

I

Intimate Connections

Chapter 1

———

The Sex Life of Stone

JEFFREY J. COHEN

CRITICAL ANIMAL STUDIES HAS INSISTED THAT NONHUMAN ORGANISMS be considered outside their dependencies upon human definition, making the field one of our most promising modes for practicing posthumanism.[1] Inspired by the nomadic ethology of Gilles Deleuze and Félix Guattari, Rosi Braidotti has argued that the animal is to be "taken in its radical immanence as a body that can do a great deal, as a field of forces, a quantity of speed and intensity, and a cluster of capabilities," opening the way to a "bioegalitarian ethics."[2] What happens, though, if we substitute for *animal* what Braidotti calls "inorganic others"? Can we still attain her "posthuman bodily materialism," one in which the forces, intensities, and potentialities belong to a nonbiological body, belong to, say, a rock? What would this embodied, posthuman stone *do?* Would it possess those attributes we associate with biological bodies: motility, mutability, sexual difference, worldedness *(Umwelt),* desire? Could such a stone be gendered? Would it reproduce? Or would this lithic organism offer something stranger still?

In his manifesto for what he calls a queer ecological studies, Timothy Morton has urged scholars to research "the ways in which queerness, in its variegated forms, is installed in biological substance as

17

such."[3] What about nonbiological substance? What about materiality "as such"? Mattering is an active, ethical process. It ought to be as capacious as possible. Instead of Braidotti's bioegalitarian ethics, what of a zōē-egalitarian ethics, where *zōē* indicates not just bare or animal existence but a life force that vivifies all materiality, even when not made of biotic carbon, endowed with organs, or possessed of DNA? Through what queer alliances can we dream, instead of a disciplinary biopolitics, a vibrant zōēpolitics that widens what constitutes a life?

Jane Bennett contends that the "quarantines of matter and life encourage us to ignore the vitality *of* matter and the lively powers *of* material formations."[4] Matter, Bennett insists, possesses aesthetic, affective, and practical agencies. The world unfolds through our alliances with a lively materialism, where we are one actant among many within a turbulent identity network.[5] In Bennett's account ethics is relational in ways that exceed the merely human, constituting a "complex set of relays between moral contents, aesthetic-affective styles, and public moods" lived out within a "landscape of affect." Life becomes a "restless activeness, a destructive-creative force-presence that does not fully coincide with any specific body."[6] *Affect* denotes a nonsubjective yet ebullient materialism—the living stuff of which we are made and by which we are surrounded, itself also alive.[7] This vibrant materiality is made evident through vivid, performative writing. Bennett is a poet of the world's detritus, an urban Thoreau, discovering in refuse that glimmers on a storm drain and in cold, hard metals an invitation to a more enchanted and capacious view of what it means to be alive. This "impersonal life" can speak only in borrowed words, perhaps, but a cognizance that matter possesses agency, story, a biography or maybe a zōēgraphy is essential to our leading of a more just existence.[8]

We who study texts that survive from the distant past have inherited as part of our scholarly formation an ethics of recovery that stresses remembrance, preservation, and custodianship. Along with this ethics, though, we might also embrace an ethos built upon the practice of wonder. Such wonder would be a collaborative praxis, by which I mean *inhumanly* collaborative: a promiscuously desiring alliance with places, objects, texts, forces of nature along with humans living and dead. Provoked by Bennett's rethinking of matter's agency, encouraged by phi-

losophers like Graham Harman and Bruno Latour and by queer ecologists like Timothy Morton and Robert Azzarello, we might wonder how far this vibrancy can extend: to animals? to objects? to materiality itself, the elemental substrate of molecules, fundamental matter?

To provide a possible answer to these questions, I will turn to stone, the first solid to have congealed on primal earth, the most inert, mute, intractable, and lifeless of materials.

STORY AND STONE

What we know of the earliest humans we have learned through lithic intimacy: axes and arrowheads endure long after the cultures that shaped them vanish; body become stone constitutes the fossil record; windbreaks for fires are among the earliest human architectures to endure. Rock communicates story across the linguistically insurmountable gap that separates prehistory from us, even if much of what it communicates is poetic, felt more than grasped.[9] Stone inhabits a temporality alien to us, one in which the flow of years may as well be an outpouring of nanoseconds, one in which *Homo sapiens* is yet another parvenu species on an earth that perpetually spawns ephemeral new forms of life.[10] Because of its inhuman endurance stone insinuates itself into human yearnings for immortality (we convince ourselves that lithic architectures will last forever); for a world larger than our mortal realm (the tablets engraved with divine commands Moses brought from Sinai were stone); for the preservation of collective history and personal memory (commemorative monuments and grave markers are typically fashioned of rock); for the survival, beyond the horizon of our own bodily impermanence, of the stories that we tell.

An Irish legend about the biblical Flood beautifully collects these various desires for stone as a material capable of transport across nonhuman spans of time. The deluge narrated in Genesis 6 was typically understood as marking an absolute rupture: when waters swirl fifteen cubits above mountaintops, all terrestrial things are necessarily obliterated. Yet some medieval writers imagined that the postdiluvian break was not absolute. According to the twelfth-century writer Gerald of

Wales, for example, the Irish held that the biblical patriarch Noah had a granddaughter named Caesura.[11] When she realized that she was not going to receive an invitation to board the family ark, she navigated with a fleet of ships to Ireland. Her hope was that the distant island might be spared the coming deluge, since no sin had been committed upon its unpeopled shores. Most of her companions drowned when their vessels foundered. Although she arrived in Ireland, Caesura did indeed perish, apparently just before God unleashed the torrent that submerged the isle: "In spite of her cleverness, and, for a woman, commendable astuteness in seeking to avoid evil, she did not succeed in putting off the general, not to say universal, disaster."[12] Gerald notes that her tomb survives to this day. He is puzzled, however, about how her story could likewise endure. Invoking a medieval legend of music surviving the Deluge through inscription upon metal, he suggests that her story may also have been incised, and thereby protected from the obliterating rush: "A narrative of these things had been inscribed on some material, stone or tile, which was later found and preserved."[13]

A quiet and implicitly feminist protest against divine injustice, the Caesura narrative is poignant, with its desire for endurance beyond supernal catastrophe, for a self-directed life capable of surviving that cataclysm which is history. That Gerald's translation of Irish *Cessair* into Latin *Caesura* makes her name mean "*a cutting, felling, hewing, pause*" only adds to the poetic intensity of this story carved in rock, underscoring another human desire that stone elicits and amplifies: the yearning for beauty. The allure of stone—call it the lithic sublime—is primal. It's impossible to visit Stonehenge and not be struck by the grandeur of its trilithons and menhirs. The megalithic circle is a marvel of human architecture, a seeming triumph of industry over landscape. Yet the standing stones did not gain their power to entrance simply through incorporation into a human composition. The Neolithic structure seems to have been inspired by naturally occurring rock formations in the Preseli Hills, the origin of the bluestones now on Salisbury Plain. Another entry into understanding that never-finished, ever-changing lithic wheel is to ask: How did the bluestones of the Preseli Mountains convince prehistoric humans to carry them hundreds of miles and erect them on a grassy plain?[14] What did generation upon succeeding generation dis-

cover in this stone that persuaded them to amplify the structure, to create new stories about its rocks, to keep the monument alive? Stonehenge is a collaboration between two artists, humans and rocks. Its splendor is literally non/human, in/organic.

DESIRING STONE

Petrified and petrographic human longings are probably universal. Stone is historic, supplying the very substance of temporality itself, but can it also be something less recalcitrant and more energetic? We desire stone for the transport into the future it offers, for its ability to connect us to the past. But can desire for stone take less abstract, more sensual and embodied forms?

Rock, earth, and metal have long been molded through art to reflect and incite human sexual desire of many kinds. You'd have to be averting your eyes in Pompeii not to come across a bronze or clay phallus, a statue of Priapus with a giant penis. Charles III, a fourteenth-century king of Naples, was scandalized when he picnicked with his court at Herculaneum to watch the excavation of what promised to be a remarkable statue, a time capsule sent from the ancients. The emerging marble heads promised two lovers, but the fully unearthed piece depicted Pan having enthusiastic intercourse with a goat. Another classical statue of Pan, carved in Greece and owned by Charles's mother, depicted the demigod making love to Daphnis, a shepherd boy from Sicily.[15] Then there's Pygmalion. This sculptor fell desperately in love with his own creation, a statue he had carved of an ideal woman. According to Ovid, Pygmalion caressed the perfect and immobile figure, spoke ardent words to uncomprehending ears, purchased gifts. He clothed and unclothed the unyielding flesh. He even slept with the statue in his bed. Venus took pity upon the lovelorn artist and animated the object of his desire.

Yet none of these stories are exactly about stone. Take Pygmalion— and not just because in many versions Galatea is sculpted from ivory, an organic (if just as insensate) substance. The Pygmalion narrative overwrites lithic blankness with fully mobile male heterosexuality. In Ovid's

Metamorphoses, Pygmalion is a lonely bachelor. Having seen the Propoetides become prostitutes, he forswears the company of women. Pygmalion is, in a word, a misogynist: he loves a petrifying, masculine fantasy of what a woman should be and disparages actual, lived femininity. The figure that his artist's hands fashion is a remedy for feminine faults, a lifeless paragon that renders embodied and earthly women inadequate. After Venus vivifies his creation so that he can consummate his passion, he quickly impregnates Galatea with a child. Their son Paphos has nothing of stone about him. The story is an escape from lapidary constriction, from inorganic lifelessness. At the narrative's conclusion Galatea is fully human, while the Propoetides who spurred Pygmalion's art find themselves petrified.

Pygmalion's idolatrous love is almost tiresome in its heteronormativity. Interestingly, though, agalmatophilia (the erotic love of statues) is a recognized sexual attraction with a history of being labeled deviant.[16] Agalmatophiliacs seem to exist mainly in classical sources, and this scarcity of contemporary practitioners has been explained as the natural result of a "burgeoning plastics industry" rendering "the pathological interest in stone statues *per se*" obsolete.[17] Yet Richard von Krafft-Ebbing in his *Psychopathia Sexualis* includes a section on "the violation of statues," where he reports the case of "a gardener who fell in love with a statue of the Venus de Milo, and was discovered attempting coitus with it."[18] Perhaps, though, what we behold in agalmatophilia is a love of art gone too far rather than desiring stone. Queer potential inheres in any non-normative eroticism, of course, but desire for statues typically replicates male heterosexuality at its most narcissistic, with woman reduced to utter passivity, to inert and desubjectified matter. Despite a zeal for combinatory experimentation, agalmatophilia is hopelessly anthropocentric: love of statues is a longing for human form in stone's immobile substance, not an itinerant desire that could be called stone love.[19]

GEM LOVE

Stone is entwined intimately with human sensuality, especially in the form of precious gems. Surely there is a story to tell here that is about something more than anthropocentric desires, a story that might fea-

ture stone as animate, as agent. Take, for example, the diamond engagement ring. As a pledge of love, rings carry an ancient history, especially as matrimonial tokens. Yet the nuptial diamond holds a special place in modern culture.[20] To become so precious the jewel's material origins must be erased: no dwelling on the labor conditions under which the gem was excavated, no contemplation of the civil wars or terrorism its purchase may have financed. "A diamond is forever" means that the stone arrives not just from nowhere but from nowhen: the diamond dwells in an impossible, eternal, changeless temporality, in the hope that matrimony might, too. Not to be contemplated is the fact that the diamond will long outlive its giver and its bearer. The ring is the sanctifier of the connubial couple, the guarantor of the superlativeness and immunity from time that love within licit marriage is supposed to possess. The diamond engagement ring is heteronormativity in crystal form. But is it also the catalyst to a public sexual identity, the instigator of a story that culminates in a bedroom.

Despite being so revered, the jewel is not an investment. Although expensive to purchase, the stone maintains negligible resale value.[21] Although formerly scarce, diamonds are now relatively ubiquitous. New mines are constantly discovered. Good gems can be created by machines. Nearly immune to decay, the millions already purchased endure, a glut of worthless love tokens. If the diamond is such a sterile and useless chunk of earth, why would anyone desire the stone so ardently? Three possible answers arise to that question: because we are genetically programmed to overesteem useless gifts (the answer from evolutionary biology); because we are easily duped by the culture into which we are born (the answer from ideological analysis); or because stones have agency, and diamonds have found a way to insinuate themselves into our desires, our pleasures, our erotics (a queer ecological materialism).

First, evolutionary biology. In an article published in *Psychology Today*, Satoshi Kanazawa answers the perennial question "Why are diamonds a girl's best friend?" by turning to humanity's animal past, fashioning an eternal narrative that resembles a Jane Austen novel:

Given that women can have only so many children in their lifetimes and that they must invest much more in each child, the reproductive consequences faced by a woman for failing to discriminate

between dads and cads are very large. . . . A good way to screen for men who are simultaneously able and willing to invest is to demand an expensive gift . . . known as *courtship gifts* or *nuptial gifts* in evolutionary biology. . . . Diamonds make excellent courtship gifts . . . because they are simultaneously very expensive and lack intrinsic value. No man (or woman) can be inherently interested in diamonds; you cannot drive them, you cannot live in them, you cannot do *anything* with them. . . . Their beauty lies in their inherent uselessness.[22]

For Kanazawa diamonds possess no utility, harbor no worth; because they are valueless, they have no story to tell about themselves, they are empty props in a human drama. These crystals do not effectively exist until placed within a human system of exchange predicated on the securing of conjugal union. Their passive role in this performance enables diamonds or any other inutile gift to be invested with ardor and rendered attractive. The goal of evolution in the tale Kanazawa tells seems to be traditional marriages built upon good economic principles. Thus diamonds sort the dads from the cads, the good housewives from the mere gold diggers.

What such an approach cannot account for is a world in which so much that comes into being, endures, even flourishes, has little or no use value. Evolution and sexual selection are neither rational nor precise, but they are relentlessly productive. Much of what is engendered is superfluous, exorbitant, inexpediently beautiful. Through a careful reexamination of the work of Charles Darwin, Elizabeth Grosz has detailed how evolution is more than survival-driven morphological and behavioral specialization. Through the interaction of organisms and environments over long periods of time—when viewed from the temporality of rocks rather than of individual carbon-based forms—evolution fosters unstable intensifications of body and world, an unpredictable and indeterminate "becoming-artistic" that invariably "exceed[s] the bare requirements of existence."[23] Grosz argues that the origins of this surplus that is art (as a producer of sensations, affects, and intensities) can be traced to Darwin's idea of sexual selection, "the becoming-other that seduction entails . . . a fundamentally dynamic, awkward, mal-

adaption that enables the production of the frivolous, the unnecessary, the pleasing, the sensory for its own sake" (7).[24] In animals sexual selection engenders the ravishing superfluity that is birdsong, ostentatious plumage, deep-water incandescence, dance. In humans the same processes render us congenital artists. Our hymns and paintings are born of impulses we share with birds and fish. They are just as unnecessary, just as vital. Perhaps this is why we polish the dull stones we find into the radiance of gems.

Unexplained, however, is why quartz, agates, marble should effloresce with unnecessary colors, whorls, tufts, spines, curves, patterns: why such "spontaneous beauty," why "these works executed by no one"?[25] Why, more specifically, have sexual narratives and social norms effloresced around diamonds and not emeralds, rubies, or amethysts—just as luminous, just as susceptible to artistic transformation? Diamonds do possess traits that set them apart. They are more vitreous, translucent, durable, and impervious than other gems. They seem impossibly to be of two elements at once, earth (they are minerals) and water (yet they seem immutable ice). Thus the medieval travel narrative known as the *Book of John Mandeville* describes diamonds as the becoming-rock of cold water: "For gret forst [frost] the water wexith into crystal, and uppon that wexeth the good dyamounde."[26] Natives of exotic lands, difficult to mine and beautiful to behold, diamonds have exerted a gravitational pull upon the human imagination since the classical era. Perhaps then it is no surprise to find them atop engagement rings.

Of course, emeralds and rubies also did not have the De Beers company as their champion. Anxious over a decline in sales in the United States, this South African corporation hired a New York advertising agency to create a multimedia campaign that included the strategic placement of diamond jewelry in films and the dissemination of images of celebrities sporting diamond engagement rings.[27] Three years later American diamond sales had risen 55 percent. According to Barry B. Kaplan, "Ayer's success inspired the agency to pursue a new goal—to reinforce the 'psychological necessity' of diamonds. An estimated 70 million people over the age of fifteen would be targeted with future marketing campaigns."[28] This necessity was inculcated through a new slogan, "A diamond is forever." A copywriter named Frances

Gerety coined the phrase in 1947, but the motto—the most successful ever formulated in modern advertising—now seems as timeless as the diamond itself.

This account of the diamond's modern desirability leaves the stone itself inert. The only reason diamonds are so valued, it seems, is that they possessed a powerful international corporation as their advocate. Pity the neglected amethyst and the unloved topaz, doomed to the lower shelves of the jewelry store because the De Beers company did not represent their interests. Yet this version of the diamond story omits the gem's long history. Nuptial gifts and transnational corporations are clearly part of the diamond's biography, but still open to query is how the diamond per se insinuated itself into human erotics. Maybe diamonds are part of contemporary love stories because they have been infiltrating our desires for a long time. What account can the diamond itself provide? Might the rock in this adamantine narrative be a protagonist rather than an ancillary object, a mere prop? What does the diamond want? As the medieval lapidary tradition knew well, gemstones radiate power. They enable, intensify, transform, and incite. Stones possess potentialities that are theirs alone, regardless of human actions. Medieval writers called these abilities *vertu,* a remarkably capacious term that can be glossed as "power, force, energy, vigor, vitality, life, efficacy, magic, grace, divinity, endurance, might, chivalric valor, dominion."[29] *Vertu* is a kind of *wille* that may be possessed by things, rendering them volitional. Like *wille,* a noun that applies almost exclusively to humans and the divine, the impulses *vertu* enfolds include "a disposition, an inclination, an urge," and "a natural tendency," as well as what might be called "carnal desire or craving."[30] Yet *vertu* is exerted by, among many other objects of the world, cold and lifeless stones.

ADAMANTINE *VERTU*

The diamond is the hardest of substances. The diamond resists. But the diamond also desires; the diamond attracts; and the diamond endures. *Diamond* can be written in a variety of ways: *adamas* in Latin; in Old French *aimand, aimant, amand, adamant;* in Middle English *diamaund, dea-*

mond, adamaunt. Diamond (the attractive gem) and *adamant* (the invincible substance of Satan's chains, an unbreakable metal) are etymologically the same noun, so that each inevitably possesses qualities of the other.[31] As a resistant compound, *adamant* comes from the Greek verb *adamao,* "I tame, I subdue," and the related adjective, meaning "indomitable." But medieval writers also recognized the Latin verb *to love* in *adamant,* taking the words to mean "loving deeply" *(ad-amant).* Medieval writers saw in diamond/adamant these possibilities (to quote the translations offered by the *Middle English Dictionary*): "a kind of precious stone" and "something indestructible and enduring, something impenetrable." *Adamant* as desire-stone could also signify the substance known as lode-stone, shipman's stone, or magnet, a rock with inbuilt gravitational force. To cite one gloss given by the *Anglo-Norman Dictionary,* "Amand est une piere preciouse qe trest a lui le fer."[32] According to the *Book of John Mandeville,* this traherence can be so strong that when ships glide over submarinal adamant they are pulled to the sea's bottom by the nails in their planks.[33] As we will see, though, it is not just iron that adamant can draw.

Although *diamond* and *adamant* ultimately become separate terms, different substances, each is forever haunted by its etymological doppelganger. Thus the modern English adjective *adamantine* means "unyielding, unbreakable" and "diamond-like; pertaining to diamonds." Most versions of the *Book of John Mandeville* offer a test for good diamonds that involves placing "dyamaunde" next to "adamaund." If the diamond is "goode and vertuous," a needle will no longer be drawn toward the "þe schipman stoon." The *Book* also declares that diamonds the size of hazelnuts often grow upon "þe roche of þe adamaunde in þe see and vpon hillis."[34] Not surprisingly, as that which resists and that which attracts, that which will not be decomposed and that which draws, that which is indomitable and that which desires, the diamond was a complicated actor in medieval texts.

The term *geographesis* can usefully designate two interdependent impulsions: the recurring human desire to inscribe stories on lithic surfaces and the ability of stone to catalyze and intensify narrative. Stories of stone are always told not only *through* but also *by* the lithic. In its most intense forms geographesis evinces a kind of geoerotics. This lithic

desire may well be indifferent to the humans in whose narratives its magnetism is enmeshed: allure or desire or *vertu* will entangle stone with human love stories, but its inorganic motility, its residence within an alien temporal frame (Chaucer called it "athamant eterne" in the *Knight's Tale*), can also push the stone to go its queer way. A diamond is a normalizing cultural device, but its radiance also constitutes motile, vibrant matter. As an agential and inhuman substance, the gem poses a recalcitrant challenge to our anthropocentrism—or, as Marguerite Yourcenar writes in her introduction to Roger Caillois's *The Writing of Stones,* invites us to "an inverted anthropomorphism in which man, instead of attributing his own emotions, sometimes condescendingly, to all other living beings, shares humbly, and yet perhaps with pride, in everything contained or innate in all three realms, animal, vegetable, and mineral."[35] Roger Caillois, the foremost theorist of mineral power, knew well that such a perspective shift requires a "kind of indifference toward what is human." Once the world's possibilities are enlarged to allow for inorganic agency, we can better comprehend the "mine of prodigality" and "feast of superfluity" that is nature.[36] Caillois insisted that this last term designates a collectivity that is in no way separate from what is human: nature does not know where the biological ends and the inorganic begins.

That gems might be something more than inert substances or passive signs within a closed circuit of exchange—might be actants within a network that brings together human and nonhuman elements in a relation of mutual intensification and even transformation—is amply evident in classical and medieval stone lore. Lapidaries are encyclopedic collections of stories about rocks, minerals, and metals. Originating in ancient Greece, these lithic biographies teem with unexpected narratives in which stone plays an agential role. The gems whose virtues the lapidaries detail are provocations to changes in the weather, granters of eloquence or health, objects of desire that resist the grasp of those seeking their powers, companions for world travelers, confederates of human and animal schemes, the heroes of small epics. Thus Albertus Magnus writes of a stone called *alecterius:* "Alecterius is a gem also called 'cockstone,' and it is shining white, like a dull rock crystal. It is extracted from the crop of a cock after more than four years. . . . The stone has

the power to arouse sexual desire, to make one pleasing and constant, victorious and distinguished; it confers the gift of oratory, and makes friends agree. And held under the tongue it quenches or mitigates thirst. This last is a matter of experience."[37] The organic/mineral hybridity of alecterius is not unusual. Nor is its therapeutic utility. Medicinal uses dominate the lapidaries. When "powdered and mixed with honey and taken by women," *crystallus* will fill the breasts with milk (2.2.3). Such employment might suggest that stones become agents only when humans employ them as tools. Yet many stones make strange demands of those who enter into relations with them. Here is Albertus on a black rock called *gerachidem:* "The genuineness of the stone may be tested in this way: while wearing the stone [a man] smears his whole body with honey and exposes [himself] to flies and wasps, and if they do not touch him, the stone is genuine; and if he lays aside the stone, at once flies and wasps fall upon the honey and suck it up. And they say that if the stone is held in the mouth it confers [the ability] to judge opinions and thoughts. And it is reported that the wearer is made agreeable and pleasing" (2.2.7). Stones exert forces that in cooperation with human bodies change what is possible (flies and wasps avoid the honey they crave because the smeared flesh is warded by *gerachidem*); they are also frequent incitements to transformation (*gerachidem* in the mouth renders its bearer a different kind of person). Diamonds can trigger a becoming-stone. Most lapidaries attest to the fact that to possess *adamas* is to become diamondlike: "Adamant is a ston of his name, at þat no man may be ouercome when a man bereþ it vpon him."[38] The *Book of John Mandeville* describes "þe vertu of þe dyamaund" as encompassing the powers of persuasion and of triumph in just war; protection from strife, enchantment, and assault by "wilde beest"; and proof against venom. Like many stones the diamond does not act alone but forms an alliance with its bearer. If the virtue within the human body wanes, the power of the diamond likewise weakens.[39] The stones of the lapidaries are, in other words, radiant matter, infective matter, networked matter, matter that moves to form connection, matter that wants to connect with non-lapidary worlds, wants to touch the organic and to change it. A stone's resplendence is therefore its lure.

In *Chaos, Territory, Art,* Elizabeth Grosz argues that "art is of the animal," coming from "something excessive, unpredictable, lowly" (63). Following Deleuze and Guattari, she maintains that artwork does not represent but *monumentalizes* sensation via sensual production, intensification, and transmittal. Art, in other words, emits a vibratory resonance that arouses the body and connects flesh and work (71, 62). In this account the nonbiological can, in the form of a painting or architecture, hold and catalyze sensation, but the inorganic cannot itself create.[40] "Art," Grosz writes, "enables matter to become expressive, to not just satisfy but also to intensify—to resonate and become more than itself" (4). Matter is not of itself vibrant; transformation by biological agents brings that vitality into being. This organic bias comes from Darwin, who like Grosz sees the thrilling exorbitance that is art primarily in the intensification of biological bodies over time. Matter can be the receptacle for this vibrancy but cannot innovate such expressiveness or intensifying possibilities on its own. The "excessive expenditures" (65) that are the bodily origin of art are, in this account, engendered by sexual selection: a "calling to attention, this making of one's own body into a spectacle" (66). Of course such a conceptualization of art precludes stone from the agential production of surplus, of beauty—a little surprising, because in some of her earlier scholarship Grosz worked closely with the essays of Roger Caillois. Grosz found inspirational Caillois's insistence that animal mimicry is a superfluity inimical to survival value, so that mimicry constitutes animal art. This rather neglected French theorist later argued something very different from Grosz's pronouncement that "art is of the animal." In his beautifully illustrated book *L'écriture des pierres* (1970, translated in 1985 as *The Writing of Stones*), Caillois discovered within the lithic an "intrinsic, infallible, immediate beauty, answerable to no one."[41] He found this same aesthetic impulse in butterflies, praying mantises, and humans: a universal surfeit that is art.

Grosz argues that sexual difference is the primal catalyst to bodily intensification, thereby rendering biological organisms the only artists. Yet is the elemental yearning toward sexual difference, or just toward embrace? What if combination and heterogeneity, connection and assemblage, are fundamental? What if sexual difference merely acceler-

ates a preexisting and underlying phenomenon, an immanent inclination toward innovation and generation? What if this impulse toward assemblage making and intensification is already erotic? For Grosz the dividing line of life and the precondition for art is sexual difference, which in turn presupposes that life will be organic, will possess a carbon-based, potentially reproductive body. Yet if life is "catastrophic, monstrous, nonholistic, and dislocated, not organic, coherent, or authoritative"—*zoē* or life force rather than *bios* and organic biology—then even diamonds can possess a sexuality, and maybe even sexual difference.[42]

And indeed they do, at least according to the medieval travel writer known as John Mandeville. Diamonds are found in India, Mandeville writes, where they are as exotic and as lively as any fabulous creature: the Amazons, Ethiopians, and Sciopods who precede them, the nudists and idol worshippers who follow.[43] These extraordinary stones possess a gender, male or female.[44] They seem to be heterosexual in their mating habits, if rather unchaste in their constant mingling, coming together to create ever more glistening rocks: "They groweth togodres, the maule and the femaule. And they beth noryshed with the dew of hevene, and they engendreth comunely and bryngeth forth other smale dyamaundes, that multeplieth and groweth all yeres."[45] Though gendered, these stones are hardly heteronormative. Possessed of a lithic promiscuity, these lively diamonds are intimately connected to the soon-to-be-encountered nudist communist cannibals of Lamoria, the ultimate test of Mandeville's tolerance: the Lamorians, like these Indian stones, procreate "comunely," do not know their own offspring, yet continue in their mating and their multiplication unperturbed.[46] They form a community deeply challenging to the norms of those who created, translated, disseminated, and read the *Book of John Mandeville*. His diamonds grow as if they are biological organisms, nourished by dew. "Et croissent ensemble madle et femelle" declares a French version of the *Book*, making the diamonds seem as if they are following God's injunction to Adam and Eve, "Crescite et multiplicamini."[47] In this text the small diamonds they engender are even called *petitz filz*. If kept moist after harvesting, their bearer can enable them to continue to grow, as if they were mineral pets ("qe multiplient et engroisent touz les aunz"; "ils croissent touz les aunz visiblement, et ly petitz deviegnent bien grantz").

Like living creatures, they have the powers and affects of the lapidary diamonds: they can vanquish poison, prevent nightmares, foster peace. Diamonds also heal lunacy . . . and Englishmen, Mandeville states, are born under the influence of the moon, rendering them congenital wanderers.

The lunar pull that tugs at diamond and Englishman alike is not accidental, recalling the closeness of diamonds to adamant. Mandeville, remember, writes of distant seas in the depths of which magnetic stones lurk ("roch of the adamaund," "roches de aymant"), drawing to watery oblivion any vessel that glides above, the victim of the iron nails that bind its planks.[48] The moon is like adamant, according to the encyclopedist John of Trevissa: as iron follows "the stone adamaunt," so the sea follows the moon, so the planets exert their pull on sublunary life.[49] This earth, its elements, its inhabitants are ever in motion because of the *adamas*-like gravity of the planets and moon above. As an earlier encyclopedist, Isidore of Seville, declared: "The universe consists of the heavens and the earth, the sea and all the stars. It is called the universe *[mundus]* because it is always in motion *[motu]* for no rest is given to its elements."[50]

Diamonds are vibrant matter incarnate, an inorganic form of life. They are impermeable, yet they attract. They can be mined from the earth, but only by a commingling with the organic. Pliny relates, and Albertus Magnus repeats, that *adamas* "is destroyed and softened by the blood or flesh of a goat, especially if the goat has for a considerable time beforehand drunk wine with wild parsley or eaten mountain fenugreek" (*Book of Minerals* 2.2.1). Diamonds activate human desires for endurance, for art, for something that can both resist our ardency *and* love in return, for a world more capacious than the small one we too often think we inhabit. The human and the nonhuman both possess aesthetic surplus, both possess a vibrancy that escapes category and constraint, both possess what Deleuze and Bennett describe as *une vie,* a life.[51] We humans might enjoy something the inorganic does not, or at least does not to the same degree: language, and therefore linguistic narrative. Though genetic coding, for example, is language, humans hold an intensity of narrative that is special, perhaps even unprecedented and unparalleled. But the inorganic holds something that can

never be ours: a temporality alien to our short years, an epochalness that we can glimpse if we extend our imaginations and our narratives and our creativity to the limit, but a duration we also cannot inhabit, cannot make our own. Stone demands the abandonment of human history, demands to be understood within an eonic time frame. It's not that stones are, as Heidegger said, worldless *(weltlos)* or incapable of world-forming *(Weltbildung)*. They are not even poor in world *(weltarm)* or devoid of *Umwelt (*worldedness*)*. Stones are rich in worlds not ours, while we are poor in the time-space they possess. We have therefore a terrible problem communicating with each other.

Within this impossibly *longue durée* stone vigorously manifests the movements, desires, connections, and transformations that are life. Within this temporality stone can be seen as having invaded our bodies, as having given us the calcium-based spines we need to hold our forms, the frames that allow us to wander.[52] Into stone our forms dissolve at death. Is it at any wonder that this intimate companion, here upon this earth so much longer than we, should be the beauty we wear as rings and pendants, the adornment of our graves? Stone is the stuff out of which we fashion as fellow artists architectures that we trust to be conveyed into futures we cannot imagine, futures for which we nonetheless yearn. We desire stone, and if we can allow stone its proper temporality, we can see that stone is promiscuous enough to desire us as well.

Surely, then, there opens between us and stone some nonanthropo-centric interspace, some enchanted location never known in advance, a *Mitwelt* or "with-world," a place of being-together. In this middle without terminus, the human and the nonhuman, the organic and inorganic, queerly touch.

NOTES

1. Although the literature on critical animal studies is vast, an excellent starting point for premodernists would be Karl Steel, *How to Make a Human: Animals and Violence in the Middle Ages* (Columbus: Ohio State University Press, 2011); and Karl Steel and Peggy McCracken, eds., "The Animal Turn," special issue, *postmedieval: a journal of medieval cultural studies* 2, no. 1 (2011).

2. Rosi Braidotti, "Animals, Anomalies, and Inorganic Others," *PMLA* 124, no. 2 (2009): 528. Braidotti likewise insists that we rethink the "old hierarchy that privileged *bios* (discursive, intelligent, social life) over *zōē* (brutal 'animal' life)," arguing for *zōē* as "generative vitality . . . a major transversal force that cuts across and connects previously segregated domains" (530). On these two kinds of life being "irreducibly indistinct," see Karl Steel, "Briefly, on the Animal Sacer," *In the Middle,* July 29, 2010, www.inthemedievalmiddle .com/2010/07/briefly-on-animal-sacer-curse-anyone.html; and Jacques Derrida, *The Beast and the Sovereign,* trans. Geoffrey Bennington (Chicago: University of Chicago Press, 2009), 315–17, 324–33.

3. Timothy Morton, "Guest Column: Queer Ecology," *PMLA* 125, no. 2 (2010): 273–74. See also Morton's bracing work in *Ecology without Nature: Rethinking Environmental Aesthetics* (Cambridge, MA: Harvard University Press, 2007) and *The Ecological Thought* (Cambridge, MA: Harvard University Press, 2010).

4. Jane Bennett, *Vibrant Matter: A Political Ecology of Things* (Durham: Duke University Press, 2010), vii.

5. *Actant* is a term borrowed from the philosopher of science Bruno Latour, who employs the word to emphasize that nonhuman objects and collectives may possess agency. For a comprehensive introduction to actor network theory, see his *Reassembling the Social* (Oxford: Oxford University Press, 2005).

6. Bennett, *Vibrant Matter,* 54. Bennett is following Deleuze and Guattari here in glossing the "great Alive" as a "pure immanence," as matter-movement, a "vitality proper not to any individual" (54). See Gilles Deleuze and Felix Guattari, *A Thousand Plateaus: Capitalism and Schizophrenia,* trans. Brian Massumi (Minneapolis: University of Minnesota Press, 1987), 407.

7. Bennett, *Vibrant Matter,* xii–xiii. On affect as impersonal and potentially inorganic, see also 61, where affect is described as "not specific to humans, organisms, or even to bodies: the affect of technologies, winds, vegetables, minerals."

8. Ibid., 18, 54.

9. See especially Gustaf Sobin, *Luminous Debris: Reflecting on Vestige in Provence and Languedoc* (Berkeley: University of California Press, 1999). For a less poetic, more technical view of stone remains and human culture, see Nick Kardulias and Richard W. Yerkes, eds., *Written in Stone: The Multiple Dimensions of Lithic Analysis* ed. (Lanham, MD: Lexington Books, 2003), and for work that combines the affective and the archaeological, see Christopher Tilley, *The Materiality of Stone: Explorations in Landscape Phenomenology* (Oxford: Berg, 2004).

10. I explore the temporality of stone at greater length in "Stories of Stone," in *postmedieval: a journal of medieval cultural studies* 1 (2010): 56–63, and

"Time Out of Memory," in *The Post-Historical Middle Ages,* ed. Sylvia Federico and Elizabeth Scala (New York: Palgrave Macmillan, 2009), 37–61.

11. Gerald of Wales, *The History and Topography of Ireland,* trans. John J. O'Meara (London: Penguin Books, 1982), 93–94. Gerald seems to be taking this story from the Lebor Gabála Érenn, where the granddaughter is named Cessair (and does not write her history in stone). I am grateful to Liza Blake for sharing her work on Gerald's narrative and its indigenous context with me. My thoughts on Caesura/Cessair were further catalyzed by Aisling Byrne's paper "The Archipelagic Otherworld: Geography and Identity in Medieval Ireland and Britain," presented at the New Chaucer Society Congress, Siena, 2010.

12. Gerald of Wales, *History and Topography,* 93.

13. Josephus tells a similar story about how the virtuous children of Seth bequeath to the world after the Flood a knowledge of astrology by inscribing their wisdom on a pillar of stone: *Antiquitates* 1.2.2–3. Andy Orchard lists Irish traditions of the descendents of Cain inscribing their history upon pillars of stone and lime to survive their deaths in the Flood ("Poem of Fifty Questions"). According to Cassian, Cham realizes that he cannot bring books of dark knowledge onto the ark and so inscribes his profane secrets on sheets of metal and the hardest rocks ("durissimis lapidibus"). For both references, see Andy Orchard, *Pride and Prodigies: Studies in the Monsters of the Beowulf Manuscript* (Cambridge: D. S. Brewer, 1995), 67–68.

14. See, for example, Maev Kennedy, "The Magic of Stonehenge: New Dig Finds Clues to Power of Bluestones," *Guardian,* September 22, 2008.

15. Villa of the Papyri, recounted well by Judith Harris, "Erotic Art of Ancient Pompeii," *California Literary Review,* February 14, 2009, http://calit review.com/313. See also Alastair J. L. Blanshard, *Sex: Vice and Love from Antiquity to Modernity* (Chichester: Wiley-Blackwell, 2010), 31–32.

16. Blanshard, *Sex,* 28–30.

17. A. Scobie and A. J. W. Taylor, "I. Agalmatophilia, the Statue Syndrome," *Journal of the History of the Behavioral Sciences* 11 (1975): 49. See also Murray J. White, "The Statue Syndrome: Perversion? Fantasy? Anecdote?," *Journal of Sex Research* 14, no. 4 (1978): 246–49.

18. Richard von Krafft-Ebbing, *Psychopathia Sexualis, with Especial Reference to the Antipathic Sexual Instinct: A Medico-Forensic Study,* 12th German ed., trans. F. J. Rebman (New York: Medical Art Agency, 1922), 525.

19. Some of my thinking here is inspired by the work of Judith Jack Halberstam in *Female Masculinity* (Durham: Duke University Press, 1998), especially his work on the stone butch (111–39).

20. See Diana Scarisbrick, "The Diamond Love and Marriage Ring," in *The Nature of Diamonds,* ed. George E. Harlow (Cambridge: Cambridge University Press, 1998), 163–70, who points out that Augustine of Hippo asked that

priests allow marriages even when those who wanted to be married could not afford rings (163).

21. Nikki van der Gaag, *Diamonds* (Oxford: New Internationalist, 2006), 89–93.

22. Satoshi Kanazawa, "Why Are Diamonds a Girl's Best Friend?" *Psychology Today,* May 29, 2008.

23. Elizabeth Grosz, *Chaos, Territory, Art: Deleuze and the Framing of the Earth* (New York: Columbia University Press, 2008), 6. Her n. 6 contains a condemnation of sociobiology for its inability to embrace indeterminacy. Subsequent citations to this work are given parenthetically in the text.

24. Grosz argues that hers is a "nonaesthetic philosophy for art," but following Roger Caillois, I believe that this non-survival-driven surplus (often glossed as "the emergence of innovation and invention," 2) *is* aesthetic.

25. Roger Caillois, *The Writing of Stones,* trans. Barbara Bray, intro. Marguerite Yourcenar (Charlottesville: University Press of Virginia, 1985), 2, 13.

26. John Mandeville, *The Book of John Mandeville,* ed. Tamarah Kohanski and C. David Benson (Kalamazoo, MI: Medieval Institute Publications, 2007), 61.

27. Van der Gaag, *Diamonds,* 76. See also George E. Harlow, "Diamonds in the Twentieth Century," in Harlow, *Nature of Diamonds,* 208–13, and Barry B. Kaplan's excellent account, "Forever Diamonds," n.d., 1, *Gemnation,* www .gemnation.com/base?processor=getPage&pageName=forever_diamonds_1.

28. Kaplan, "Forever Diamonds," 2.

29. *Middle English Dictionary,* "vertu," http://quod.lib.umich.edu/m/ med/.

30. *Middle English Dictionary,* "wille" (n.), defs. 2(a), (b), and (c), http:// quod.lib.umich.edu/m/med/.

31. See the overview of diamond words in George E. Harlow, "Following the History of Diamonds," in Harlow, *Nature of Diamonds,* 116. Harlow points out that *adamas* in many Greek and Roman texts is likely corundum, "the next hardest mineral."

32. See *Anglo-Norman Dictionary,* "adamant," www.anglo-norman.net.

33. The *Book of John Mandeville,* or *Mandeville's Travels,* has been aptly described as a medieval "multitext." No authoritative version exists, so that the *Book* can be regarded not as a "a single, invariant work, but as a multinodal network, a kind of rhizome." Iain Higgins, "Defining the Earth's Center in a Medieval 'Multi-Text': Jerusalem in the *Book of John Mandeville,*" in *Text and Territory: Geographical Imagination in the European Middle Ages,* ed. Sylvia Tomasch and Sealy Gilles (Philadelphia: University of Pennsylvania Press, 1998), 32–33. I therefore range among the Middle English and French examples. Here I quote from the edition of the "Defective Version" found in Queen's College, Oxford, MS

383, published as *The Defective Version of Mandeville's Travels,* ed. M. C. Seymour, EETS (Oxford: Oxford University Press, 2002), 72. The passage describes why the naked men and women of an island off the Indian coast have ships made without iron. As is typical of Mandeville, the provocative juxtaposition of "naked" shipmaking and the natural state of the bodies described is made without comment.

 34. Quotations again from Mandeville, *Defective Version,* 70–71.

 35. Marguerite Yourcenar, introduction to Caillois, *Writing of Stones,* xii.

 36. Ibid., xiii.

 37. This is from the late thirteenth-century *Book of Minerals* 2.2, a tractate entitled "Precious Stone and Their Powers," constituting an alphabetical lapidary. The material derives mainly from Marbod, Arnold of Saxony, Bartholomew of England, and Thomas of Cantimpré. I quote from the translation of Dorothy Wyckoff (Oxford: Clarendon Press, 1967). Subsequent citations to this work are given parenthetically in the text.

 38. *Peterborough Lapidary* 66, cited in the *Middle English Dictionary,* "adama(u)nt," def. 1(a), http://quod.lib.umich.edu/m/med/.

 39. Mandeville, *Defective Version,* 70–71.

 40. Thus for Grosz artistic production "eternalizes or monumentalizes sensation" (*Chaos, Territory, Art,* 4).

 41. Caillois, *Writing of Stones,* 2.

 42. Quotation from Morton, "Queer Ecology," 273.

 43. India was in fact the sole source of diamonds in the West until their discovery in Brazil in 1730. See Alfred A. Levinson, "Diamond Sources and Their Discovery," in Harlow, *Nature of Diamonds,* 73.

 44. The idea that stones might possess genders does not originate with Mandeville but goes at least as far back as Theophrastus (ca. 315 BC). Theophrastus does not mention diamonds per se but offers that *lyngurium,* a magnetic stone produced by the lynx, takes on the gender of its creator and that sard and *cyanus* naturally come in two colors that signify whether they are male or female. See *De lapidibus,* ed. and trans. D. E. Eichholz (Oxford: Clarendon Press, 1965), 67–69.

 45. Mandeville, *Defective Version,* 62. Like much of the information on diamonds in Mandeville, this account is amplified from the *Speculum naturale* of Vincent of Beauvais (8.40). Mandeville, however, was the popular conduit through which amorous diamonds passed into widespread medieval knowledge.

 46. Ibid., 65.

 47. John Mandeville, *Le livre des merveilles du monde,* ed. Christiane Deluz (Paris: CNRS Editions, 2000), 306. The Latin commandment from Genesis will be quoted on the island of Lamory (332).

48. Mandeville, *Defective Version,* 62; Mandeville, *Livre des merveilles du monde,* 314.

49. John of Trevissa, cited in *Middle English Dictionary,* "adama(u)nt," def. 2, http://quod.lib.umich.edu/m/med/.

50. Isidore of Seville, *Etymologiae* 3.29, ed. W. M. Lindsay, 2 vols. (Oxford: Clarendon Press, 1911). Robert Bartlett quotes and translates the passage to illustrate the medieval idea that the four constituent elements of the cosmos (earth, air, fire, water) are always in motion, a restless *machina mundi.* See Robert Bartlett, *The Natural and the Supernatural in the Middle Ages* (Cambridge: Cambridge University Press, 2008), 38.

51. Gilles Deleuze, "Immanence: A Life . . . ," *Theory, Culture and Society* 14, no. 2 (1997): 3–7; and Bennett, in the inspirational chapter "A Life of Metal," in *Vibrant Matter,* 52–61. Bennett writes: "As the indefinite article suggests, this is an indeterminate vitality. . . . A life thus names a restless activity, a destructive-creative force that does not coincide fully with any specific body. A life tears the fabric of the actual without ever coming fully 'out' in a person, place or thing. . . . A life is a-subjective" (53–54).

52. Manuel De Landa provocatively calls this process the "the *mineralization* of life," in *A Thousand Years of Nonlinear History* (New York: Serve Editions, 2000), 26.

Chapter 2

Nursing Animals and Cross-Species Intimacy

PEGGY MCCRACKEN

MEDIEVAL NARRATIVES REPRESENT HUMAN-ANIMAL RELATIONSHIPS in a variety of ways, as many of the essays in this volume demonstrate, but stories about cross-species nursing describe an intimacy with animal bodies rarely found in other accounts of human-nonhuman interaction. Often part of a story about animals that rescue abandoned human babies and nurture them until they can be reintegrated into human society, cross-species nursing is usually motivated by need. The maternal animal rescues a human child from starvation, providing nurturance in the familiar way that animals provide for human needs, particularly for food, in most cultures. However, a number of medieval narratives put into question or modify the representation of cross-species nursing as merely expedient and temporary. They suggest that the nursing animal body transmits an animality that persists even after human protagonists are reintegrated into human society.

This essay uses representations of cross-species nursing as sites in which to investigate a particular representation of gendered becoming-animal. I examine nursing animals from a variety of perspectives, and I

move among different periods, languages, and genres: the twelfth- and thirteenth-century Old French Crusade Cycle, Boccaccio's *Decameron,* Ibn Tufayl's *Hayy Ibn Yaqzan,* and a sixteenth-century altar painting from Krakow. My goal is not to make a claim for continuity of representation or even to put these representations into dialogue with each other, but rather to ask how they might speak collectively across time and what they might say together about a particular kind of human-animal intimacy. I dwell the longest on the first text because it elucidates so well the values of mother's milk. I then examine the different (though complementary) representations in the other texts, including the altar-piece. Using the critical concept of becoming-animal, as elaborated by Deleuze and Guattari, I suggest that these texts raise questions not only about the boundary between the human and the animal but also about the "nature" of maternal intimacy, and even about what a mother is.

THE SWAN KNIGHT

The Old French Crusade Cycle is a compilation of narratives whose first books recount the curious genealogy of Godefroy de Bouillon, one of the leaders of the First Crusade. Godefroy is described as belonging to the lineage of the Swan Knight, *li lignage del cisne,* and the first part of the cycle recounts the story of his animal ancestor.[1] The elaboration of a story about an illustrious lineage that includes both animals and humans raises questions about generation and embodiment—what kind of engendering introduces animality into a genealogy? It also raises questions about gender and about what a mother brings to a lineage, since although Godefroy's famous ancestor is a swan-knight, the story of his ancestry associates animality with maternity—first with a mother who gives birth to swan-children, and then with a deer that nurses the children when they are taken away from their mother and abandoned in a forest. The Crusade Cycle describes Godefroy's swan lineage as a prestigious attribute, but his ancestor's relationship to the deer that nursed him is lost to view in narratives about the crusader's exploits. Nonetheless, the story suggests a lingering intimacy with animality in the relation to a maternal body.

La naissance du Chevalier au cygne (The Birth of the Swan Knight) re-
counts King Oriant's marriage to Beatrix, a woman of unknown ances-
try.[2] Beatrix becomes pregnant, and when she gives birth only the king's
mother, Matabrune, attends her. As a daughter and six sons are born,
fairies appear and place silver chains around their necks. The chains,
we subsequently learn, are instruments of fairy magic. They protect the
children from death and guarantee their human form. The children
take them off and become swans, they put them back on to resume
human form. If they ever lose the chains, they will remain swans for-
ever (338–50).[3]

The scene of birth is a pivotal moment in the story. The evil Mata-
brune thinks Beatrix is unworthy of her son and seeks her demise. She
takes the newly born children, sends them away to be drowned, and
substitutes a litter of puppies in their place. She then tells her son that
his wife has given birth to this monstrous progeny.[4] The implication is
that Beatrix has coupled with dogs, and later in the story her husband
says exactly that: "She lay carnally with dogs, body to body, and then she
gave birth to seven dogs" [ele giut as ciens cors a cors carnelment / Et
si en ot .VII. ciens] (923–24). The link between multiple births and
multiple sexual partners was already introduced in this story when the
childless Queen Beatrix claimed that a mother of twins must have slept
with two men, and the seven offspring could suggest that Beatrix her-
self had seven (canine) lovers.[5] But the mother-in-law's accusation of
bestiality introduces something more than adultery into the story. Well
before the children are transformed into swans, the text associates them
with animality when the puppies are put in their place. While the seven
siblings are never called a litter, the substitution of the puppies for the
children suggests the association—the multiple births are somehow
animal-like.

Animality characterizes Beatrix's children in Matabrune's substitu-
tion of puppies for the babies, in her false accusation that they are the
offspring of dogs, and in the ability they later demonstrate to transform
into swans. Yet the children share yet another relationship to animality,
which is occluded in the resolution of their story when all but one of
the swan-children are restored to full humanity. Soon after the new-
born babies are abandoned in the woods by Matabrune's servant, the

children are saved by a parenting couple. A hermit finds the abandoned children and then a doe comes out of the woods to nurse them:

> When the children feel that the beast nurses them, each one takes hold of a teat and pulls on it. The six boys and the girl are well satisfied. The hermit sees what God sends him, and his heart is full of wonder and joy. . . . He goes directly to his hermitage and the beast follows closely after him. The beast nurses the children and the hermit prays daily to God that he will set them in the right path. The hermit and the beast raised the children in a great wood. . . . The beast and the hermit willingly raised the children for more than ten full years.

<hr />

> Quant li enfant sentirent le beste kes alaite,
> Cascuns a sa mamiele sacie et a lui traite.
> Bien s'en sunt li .VI. fil et la fille refaite.
> Quant li hermites voit cou que Dex li envoie
> En son cuer s'esmervelle et si en ot grant joie
>
>
>
> A son ostel s'en va toute la droite voie
> Et la bieste de prés tout adés le convoie
> Desi a l'ermitage, la u Dex les avoie.
> La beste les alaite et li hermites proie
> Dameldieu cescun jor kes mette a boune voie.
> Les enfans ont noris, ne soit nus ki nel croie,
> Entre lui et la beste dedens la grant arbroie;
>
>
>
> Les enfans ont noris de gré et volentiers
> La beste et li hermites plus de .X. ans entiers.
> (372–91)

The hungry babies eagerly suckle from the doe, and the text describes the hermit and the deer raising the children together, even after the deer apparently no longer nurses them. Like other stories about cross-species nursing, the story about the swan-children and the doe is a story of rescue. It posits maternal instinct as somehow so "natural" that it transcends species: a mother responds to infant need, whether or not the infant is her own or of her own kind.

Animals that suckle abandoned human children are found in many medieval and antique legends, including perhaps most famously the story of Romulus and Remus, who were fed by a wolf. Narratives like these may insist on the animal characteristics that the human foundlings absorb. The nursing wolf or bear or lion passes to the child its fierceness and courage, for example. Less often, such stories suggest that the child may also absorb the bodily characteristics of the animal that nurses him, as in *Valentin et Orson,* where the child nursed by a bear "became as hairy as a wild beast because of the she-bear's milk" (Si fut l'enfant pour cause de la nutrition de l'ourse tant velu ainsi comme une beste sauvage).[6] These stories suggest a mixing—of person and animal, of the human and the bestial—as a result of contact and learning, but that mixing may also be passed through mother's milk.

Such understandings of what mother's milk may pass on to a child reflect medieval understandings of maternal nursing. Mother's milk, considered a form of mother's blood, conveys a woman's virtues or faults to the child she nurses. According to Alfonso el Sabio's *Siete Partidas* the best wet nurses are "well-mannered and healthy, and beautiful, and come from a good family."[7] Bernardino of Siena warns that an unworthy wet nurse can contaminate the child she nurses: "The child acquires certain of the customs of the one who suckles him. If the one who cares for him has evil customs or is of base condition, he will receive the impress of those customs because of having sucked her polluted blood."[8] The story of the children nurtured by a doe in *La naissance du Chevalier au cygne* does not explicitly state that the children receive deerlike features from the animal that suckles them, and in fact the doe is lost to view in the subsequent developments that allow all but one of the swan-children to leave animal embodiment behind. But the importance of mothers in the story of the Swan Knight's lineage draws attention to the nursing deer that appears so briefly in the story.

WHAT IS A MOTHER?

After the hermit and the deer have cared for the abandoned swanchildren for ten years, Matabrune discovers that the children are still alive, and she sends one of her men to steal their silver chains. This

servant goes to the forest and finds six of the children in the hermitage; the seventh has gone into the woods with the hermit. Matabrune's man takes the six chains from the children, who then change into swans and fly to a lake near their father's castle. Matabrune believes that she has dispatched the children and thinks that if only their mother could be burned for the crime of adultery she would have everything she has wished for ["Bien [sui] de cou delivre, alé sunt li enfant; / S'ore estoit la mere arse ne me fauroit nïent"] (605–6). Pressured by his mother finally to enact justice against the imprisoned Beatrix, King Oriant calls his nobles to an assembly where he will pass judgment on his wife. If God does not defend her, he declares, Queen Beatrix will be burned.

God does indeed come to the aid of this good and pious woman ["Preudefame est et sainte de grant [relegïon],"] (659), through the agency of a son she has not seen since his birth.[9] An angel appears to the hermit and reveals to him the abandoned children's parentage, Matabrune's treachery, and Beatrix's impending execution. The condemned mother will be saved by her son, the angel announces—the one sibling who was not transformed into a swan. He has been raised by the hermit as something of an ignorant wild child,[10] and when an angel announces the battle he must undertake to save his mother, the hermit protests that the boy cannot undertake a judicial battle since he does not even know what arms are ["Il ne vit onques arme ne lance ne escu"] (686).[11] More crucially, perhaps, this boy doesn't know what a mother is. When the hermit tells him that he must go to defend his mother, the boy has to ask for an explanation:

> "Sire," the boy asks, "what is a mother? Is it something you eat? Is it like a bird or a beast?" "Son," the hermit replies, "a mother is a woman who carried you in her womb."

> "Sire," fait il, "qu'est mere? Et s'on le mangera?
> Samble oisiel u beste? Nel me celés vous ja."
> "Fius, ains est une fame qu'en ses flans te porta."
>
> (747–49)

The hermit answers the ignorant boy's question in general terms, because of course he cannot be more specific—he does not know who

the boy's mother is (though given the fate of his siblings, it would not be so far-fetched to think that their mother was indeed a bird).

The hermit accurately describes pregnancy and not nursing when he defines what a mother is, and he describes maternity in exclusively human terms ("ains est une fame"). But if the hermit had defined maternity in terms of nurture rather than birth, the son's question would have had a different answer. His mother would then indeed have been a beast, the doe that suckled him (a mother *is* something you eat, in this sense) and that partnered with the hermit to raise him.

The boy goes to court to defend his mother. Before the battle, he is baptized and christened with the name Elias, and with God's help he defeats the queen's champion and saves his mother. He reveals Matabrune's treachery to the king, and the swans in the king's pond are identified as his siblings. Five of the six swans are able to resume human form when the silver chains stolen by Matabrune's servant are recovered and returned to them. The sixth swan cannot become human because his chain has been destroyed, and this swan pulls his brother's boat, gives his brother the "Swan Knight" name, and becomes something like an attribute or a heraldic animal. The swan is a reminder of a past way of being, perhaps, but he no longer represents the possibility of becoming animal for his human brother. He is domesticated to his brother's use, a companion animal more than a companion.[12] For the Swan Knight, a former swan, animal embodiment is preserved as an emblematic, even heraldic identity; the animality of becoming-swan, or even of becoming-deer, is suppressed in the heroic adventures that follow Elias's defense of his mother and restoration of his siblings to human form and noble status.

For many medieval thinkers, difference from the animal is taken as one of the most fundamental definitions of what it means to be human, and evidence of this difference ranges from the human ability to reason, to the human ability to walk upright, to the refinement of human touch.[13] The fragility of this founding distinction may be recognized in the many medieval narratives that explore the boundaries of the human—stories about werewolves, about people who change into birds and birds that change into people, about animals that talk, and about savage boys who don't know what a mother is. The Old French Crusade Cycle seems both to explore and to resist the idea of permeable

boundaries between the animal and the human: that is, it imagines a shared human-animal being only to contain it in the restoration of five of the swan-children to full humanity and their brother to a fully animal being.

Yet in the text's description of the animality that inheres in the lineage of Godefroy de Bouillon, and particularly in its suggestion of the occluded intimate relationship with the nursing doe, it imagines a relation analogous to what Deleuze and Guattari have called "becoming-animal." I find this concept useful because it posits not transformation but contamination, not metamorphosis but relationality. Becoming-animal is not about what one becomes, but the process of becoming; becoming is about relationships rather than systems or structures. It is anomalous, it changes dimensions, it deterritorializes: "Becoming produces nothing other than itself. . . . What is real is the becoming itself, the block of becoming, not the supposedly fixed terms through which that which becomes passes. Becoming can and should be qualified as becoming-animal even in the absence of a term that would be the animal become."[14] Medievalists have used this critical concept to think about both fantastic and ordinary bodies—the becoming-wolf and becoming-human of the werewolf; the becoming-animal that characterizes the assemblage that unites the horse and rider in the figure of the knight.[15] In the Old French Crusade Cycle, the relation described in "becoming-animal" also makes visible the ways in which this medieval text denies a relationship between the animal and the human, even while acknowledging and even embracing it. For example, the resolution of the Swan Knight's story locates the protagonist securely in human embodiment while maintaining what is defined as the prestigious lineage of the swan ("li lignage del cisne") but denying any animality that may have been shared in the intimate relationship with the deer.

Deleuze and Guattari insist that becoming-animal works by alliance, not descent. It is, they tell us, described better by contagion than by genealogy.[16] In *La naissance du Chevalier au cygne,* the reinstatement of the swan-children into a social structure defined by genealogy substitutes a human mother's care for the swan-children's decade-long intimacy with the nursing deer. Once they leave their swan form behind,

the children are baptized and named, and they join the king and his re-instated queen in a royal household. The text notes the sorrow of the one swan who remains unchanged, but it then seems to preclude any possible becoming-human for this animal.[17]

Most importantly, the nursing doe is lost to view, left behind in the forest where the boy lived before he knew what a mother was, before, that is, he understood genealogy. Yet this early episode of cross-species nursing seems to linger in the text, recalled in the text's emphasis on maternal nursing in the story of the Swan Knight's descendants. The ancestors of Godefroy de Bouillon include a succession of human, Christian mothers who nurse their own children, protecting them from the contagion of strange milk and strange blood, so that they may grow into holy conquerors, into crusaders and rulers.

MOTHER'S MILK

The narrative about the Swan Knight posits the extraordinary destiny of Godefroy de Bouillon as resulting from his extraordinary lineage. Although Godefroy is known for his descent from the Swan Knight, "li lignage del cisne," the virtue and renown of his lineage are guaranteed, not by the ancestor born as a swan-child, but by a succession of saintly mothers who appear in *Le Chevalier au cygne* (The Swan Knight) and *Les enfances de Godefroi* (The Childhood of Godefroy), the narratives that follow *La naissance du Chevalier au cygne* in the Old French Crusade Cycle. These mothers ensure the nobility of the lineage through their blood— their bloodlines and their milk. Such a valorization of the maternal is not unusual for epic narratives, as Finn Sinclair has shown. In the genealogical matrix of *chansons de geste,* Sinclair claims, "the female/maternal character is figured as the genealogical ideal, possessor of all positive qualities."[18] In the Old French Crusade Cycle, an insistence on the importance of maternal nursing and the qualities it carries implicitly suggests that the forgotten doe may have left a lingering influence on the children she nurtured.

When Elias the Swan Knight marries and his wife conceives a child, an angel appears in an annunciation-like scene to prophesy the birth of

a daughter who will in turn be the mother and grandmother of three illustrious sons: one will be a king (this is Godefroy), another a duke, and the third a count. The angel impresses on the mother the importance of guaranteeing the well-being of the daughter she bears:

> Blessed be the body that will carry such sons! Take good care of the girl as soon as she is born. When your ladies will have swaddled her, have her baptized before she is given any food. And after that, feed her with your own breasts, for God wishes her to be of good character and that her nature not be corrupted by a servant's milk.

———

> Beneois soit li cors qui fera tel portee!
> Gardés bien la pucele si tost con ele ert nee.
> Quant les dames l'aront tres bien emmaillolee,
> Ains qu'il ait en son cors nule viande entree,
> Commandés qu'ele soit baptisie et levee,
> Aprés, de vostre pis alaitie et gardee,
> Car Damedex le velt qu'el soit bone eüree,
> Que de lait de soignant ne soit desnaturee.[19]

The angel's instructions identify maternal nursing as key to preserving the "nature" of the child, who would be "denatured" by a servant's milk. As in the cautions about unworthy wet nurses cited above, this text identifies mother's milk as influencing a child's character. Lineage and the virtues of lineage are aligned with nature, and mother's milk guarantees the "nature" of her child, Yde.

Just as Yde must be nursed only by her own mother, she too must nurse her own sons. When her first child is born, *Les enfances de Godefroi* tells us, "They sought a wet nurse to take care of him, but Countess Yde did not permit him to be denatured [*desnaturer*] by nursing from another. He never had any other nurse but her, she nursed him until he could be weaned."

> L'enfant ont quis norriches por son cors governer.
> Mais ains la contesse Yde ne le pot endurer,
> Qu'il en alaitast l'une por lui desnaturer:

Ainc n'ot autre norriche que lui al doctriner;
Tant le norri la dame qu'il se pot consevrer.[20]

Yde nurses all three of her sons, we are told, and the narrator sug-
gests that this is seen as somewhat unusual: "The lady fed them all, as
far as I know," he says, "and never did any of them nurse from a matron
or a servant. Ladies and townspeople and servants all spoke about it
often and [her husband] marveled greatly at it."

En .II. ans et demi furent né li enfant,
Dont jo vos conterai des ichi en avant.
Tos les norri la dame, par le mien esciant,
Ainc nus d'ax n'alaita ne moillier ne soignant.
Moult emparloient dames et borjois et serjant;
Et li bons quens Witasses s'en vait moult merveillant.
(638–43)

This so-called "marvelous" exclusivity is emphasized again in the repe-
tition typical of epic narratives: "The children were well taken care of
and nourished. Never did Countess Yde allow any of them to be nursed
by any woman besides herself. She fed them with her own body at her
breast."

Moult furent li enfant bien gardé et norri.
Onques le contesse Yde nus d'ax ne consenti
Qu'alaitiés fust de feme fors solement de li;
El meïsmes ses cors a son pis les norri.
(656–59)

And in yet a further elaboration on the countess's zeal in guaranteeing
that her sons are not "denatured" by the milk of a wet nurse, the nar-
rator comments: "Never did the countess—who was so noble and
beautiful—allow a single one of her three sons to be nursed by another
woman or a servant. She nursed them herself at her breast."

Onques la contesse Yde qui tant fu prox et bele,
Uns seus de ses trois fiex, par nisune querele,

Ne laissa alaitier a feme n'a ancele,
Ains les norri la dame tos trois a sa mamele.

(686–89)

Then he tells us that one day when the countess was at mass, one of
her sons woke and cried from hunger. The servants sent for a wet nurse,
who calmed the boy. When Yde returned from mass and learned that
her son had been fed by another woman, she ran to the child to expel
the tainted milk.

She laid the child on a big table covered in rich cloth and took the
child and rolled him on it and took him by his shoulder and forced
the milk he had drunk out of him. But later his deeds and reputa-
tion were less than they might have been.

――――――

Desore une grant table a fait l'enfant estendre
Une ceulte porprine, et puis fist l'enfant prendre,
Seure l'a fait roller, puis par l'espaulle prendre,
Son lait c'ot alaitié li ot fait moult tost rendre;
Puis en fu a tos jors ses fais et ses nons menre.

(710–14)

Yde's maternal zeal was justified, the text emphasizes, in an endorse-
ment of the "natural" virtues of the mother's milk: this son's accom-
plishments are not as great as they might have been because he was
corrupted by the milk of the nurse who substituted for his mother.

In the story of Yde, the saintly mother of Godefroy de Bouillon,
the mother's body, her milk, and her blood guarantee her sons' "na-
ture," and they seem also to guarantee the sons' destiny, just as Yde's
destiny was safeguarded by her own mother's milk. The vital force of
the maternal lineage mitigates the possibility of corruption, of conta-
gion, and ultimately, of animality. But although these narratives seem to
insist that purity in the lineage is grounded in maternal nursing, Gode-
froy's lineage also encompasses an animal nature—not just the swan
embodiment preserved in the ancestral claim to be descended from "li
lignage del cisne" but also whatever animality the Swan Knight received
from the doe that nursed him as a child.

The Crusade Cycle imagines an intimacy with animality in the mutating bodies of the swan-children but also in their relationship to the deer that not only saves the infants but along with the hermit raises them for ten years. These stories imagine two forms of becoming-animal: a becoming-swan and a more intimate becoming-deer, suggested in the emphasis on the importance of mother's milk in the preservation of a child's nature. Although the story of the rescue of Beatrix's abandoned children by the hermit and the deer does not explicitly suggest that the doe's milk transmits her characteristics to the nursing children, the persistent emphasis on maternal nursing and on the importance of mother's milk in the narratives about Godefroy de Bouillon's ancestry suggests retrospectively the potential animality that nursing may transmit. The Old French Crusade Cycle offers the example of an animal-human mixing that remains both acknowledged and hidden, a cross-species intimacy that promotes legendary prestige as it disavows any bodily legacy.

NURSING ANIMALS

Cross-species nursing is imagined in the Old French Crusade Cycle, as in a number of other narratives, as a story about rescue and need. The doe comes out of the woods to save the abandoned children by suckling them. Human need also motivates cross-species nursing in *Decameron* 2.6. Here too the story of becoming animal is described only to be repressed in the restoration of the human protagonist to a noble lineage. Here, too, animality persists, though not in the emblem of a prestigious animal-knight ancestor or in the recall of a nurturing maternal deer. The story of Madonna Beritola's companionship with a doe and her fawns describes maternal nursing and becoming-animal in terms of a contagion analogous to the plague that the storytellers of the *Decameron* flee.

Indeed, the narrator describes the virulence of this plague, not just in accounts of human infection, but also in the spread of the disease from human to animal, as Eleonora Stoppino has noted.[21] The narrator explains:

What I am about to say is incredible to hear, and if I and others had not witnessed it with our own eyes, I should not dare believe it (let alone write about it), no matter how trustworthy a person I might have heard it from. Let me say, then, that the plague described here was of such virulence in spreading from one person to another that not only did it pass from one man to the next, but, what's more, it was often transmitted from the garments of a sick or dead man to animals that not only became contaminated by the disease but also died within a brief period of time.

––––––

Maravigliosa cosa è a udire quello che io debbo dire: il che, se dagli occhi di molti e da'miei non fosse stato veduto, appena che io ardissi di crederlo, non che di scriverlo, quantunque da fededegna persona udito l'avessi. Dico che di tanto efficacia fu la qualità della pestilenzia narrata nello appiccarsi da uno ad altro, che non solamente l'uomo all'uomo, ma questo, che è molto più, assai volte visibilmente fece, cioè che la cosa dell'uomo infermo stato, or morto di tale infermità, tocca da un altro animale fuori della spezie dell'uomo, non solamente della infermità il contaminasse, ma quello infra brevissimo spazio uccidessi.[22]

The narrator marvels that the disease is capable of moving from human to animal, and the context of a species-crossing contagion lends particular resonance to the story of Madonna Beritola, as Stoppino has also argued.

Emilia is the narrator of *Decameron* 2.6. She announces that her story will recount a grievous shift of fortune, and she begins to speak of Madonna Beritola. When this lady's husband is imprisoned by Charles I of Anjou, she flees Sicily for Naples with her two sons, one of them a newborn. Their boat is blown off course and shelters in the bay of an island to wait for calmer weather. The passengers debark, and every day Beritola leaves them to go to a remote and solitary place to lament the fate of her imprisoned husband. One day while she is away, a pirate ship arrives, everyone else is taken captive, and the ship departs. Madonna Beritola is the only person left on the island. As she is gathering berries and herbs to eat, she sees a roe deer enter a cave and then leave it. She

herself goes into the cave and finds two newborn fawns, "which seemed to her the sweetest and most charming sight in all the world" (le parevano la più dolce cosa del mondo e la più vezzosa).[23] She still has milk in her breasts from her own baby, and she tenderly picks up the two little deer and holds them to her breasts:

> They did not refuse her kindness, and so she suckled them just as their own mother might have done, and from that moment on they made no distinction between her and their mother. Thus the gentle lady felt that she had found some company in that deserted place, and then having become as familiar with the doe and with her two offspring, she resolved to spend the rest of her life there.

> Non essendolesi ancora del nuovo parto rasciutto il latte del petto, quegli teneramente prese e al petto gli si pose. Li quali, non rifiutando il servigio, così lei poppavano come la madre avrebber fatto; e d'allora innanzi dalla madre a lei niuna distinzion fecero. Per che, parendo alla gentil donna avere nel diserto luogo alcuna compagnia trovata. . . . Quivi e a vivere e a morire s'era disposta, non meno dimestica della cavriuola divenuta che de' figliuoli.[24]

If Beritola acts out of need here, it is her own. The deer fill her need for companionship, they compensate her longing for the family she has lost, and Beritola comes to love the young deer as if they were her children.

After Beritola has dwelt with her deer for some time, another boat is blown into the bay. Madonna Beritola is found but refuses to leave the island, where she has resolved to make her life with her animals. Finally she is persuaded to depart, but she will not leave the deer behind and takes them on board with her. Many of those on the rescue ship do not know Beritola's name, and they call her "Cavriuola," after her companions, the doe *(la cavriuola)* and her two young *cavriuoli*. The newly christened Cavriuola is taken back to human society by the nobleman and his wife who have rescued her, and she lives in their house modestly, like a servant, dressed in widow's weeds, affectionately looking after her deer.

The rest of the story includes more hidden and mistaken identities, and then a series of recognitions. Cavriuola is first reunited with her eldest son, who has seen her many times but failed to know her. She suddenly recognizes him and leaps into his arms:

> Some secret force stirred within her, causing her to recall the boyish features of her son's face, and without further proof she threw her arms around his neck. . . . [Her son] was greatly surprised, for he could recall having seen her many times before in that castle without ever recognizing her; nevertheless, now he instinctively recognized his mother's smell, and reproaching himself for his former insensitivity, in tears he received her into his arms, kissing her tenderly.

> Da occulta vertù desta in lei alcuna rammemorazione de' puerili lineamenti del viso del suo figliuolo, senza aspettare altro dimostramento, colle braccia aperte gli corse al collo. . . . Il quale, quantunque molto si maravigliasse, ricordandosi d'averla molte volte avanti in quel castello medesimo veduta e mai non reconosciutola, pur nondimeno conobbe incontanente l'odor materno, e se medesimo della sua preterita trascutaggine biasimando, lei nelle braccia ricevuta lagrimando teneramente basciò.[25]

The lady also finds her other son and her husband, who has been restored to his earlier status by the defeat of Charles of Anjou, presumably in the Sicilian Vespers, and they all return to Sicily. Apparently the deer and the nickname are left behind.

Madonna Beritola's relationship with her deer is treated as a symptom of her exile and isolation. When she is restored to human company, she brings the deer with her as an attribute of her exile—they remain her intimate companions, and she is known by their name, "Cavriuola." We do not find any suggestion that the deer gain human qualities from her attentions—the text does not describe them as becoming human through intimacy with the nursing human mother. Rather, as the nickname "Cavriuola" suggests, the relationship between the lady and the deer seems to be a privileged moment of becoming-

animal, one that is lost when Beritola is rescued from exile and reunited with her family, and when she reassumes her noble identity, now enhanced by her sons' advantageous marriages, and gives up "Cavriuola" in exchange for her family name. But animality does persist—and here is where contagion resurfaces—when Beritola touches her long-lost son. This son recognizes his mother by her smell, "l'odor materno." This is an oddly intimate thing to recognize, it is a way that animals recognize each other. It is as if the mother had imparted an animality to her son, through her embrace, her touch, briefly, only momentarily, but significantly. That is, if we may read the son's recognition of his mother by her smell as somehow animal-like, this seems to be an animality passed from mother to son, through contagion, rather than through blood or milk.

Both *Decameron* 6.2 and *La naissance du Chevalier au cygne* deploy genealogy to contain the contagion of animality. The moment of recognition through smell—described as briefly as it is experienced—does not reappear as the mother leaves her deer family for a securely human lineage. Like the story of the swan-children suckled by a deer, but with a reversal of the animal-human roles, the story of Madonna Beritola suggests an animality shared in the intimacy of nursing, an animality imagined as passing through the intimate maternal touch. Here animality is contained by the reintegration into an illustrious human lineage but lingers still—in the memory of a maternal deer, in the recognition of a maternal odor.

KNOWING MOTHERS

In *Decameron* 6.2 and in *La naissance du Chevalier au cygne,* intimacy is a contagion; it passes something—recognition, knowledge, becoming—from mother to son and, perhaps, from the suckling fawn to the nursing mother. The recognition, knowing, and becoming shared in intimacy with the animal are explored more pointedly in Ibn Tufayl's *Hayy Ibn Yaqzan,* a philosophical tale composed in Arabic in twelfth-century Andalusia. *Hayy Ibn Yaqzan* recounts the story of a child who grows up alone on a deserted island from the time he is an infant. This exile is not

unlike those recounted in the stories of the swan-children abandoned in the forest or the noblewoman left alone on an island. A doe nurses the child, Hayy, in his infancy, and nature is the teacher from whom the young boy learns to live. He observes animals' feathers and coats and learns to make clothing to cover his nakedness; he confronts the superior strength of other animals and learns to make weapons. When the doe that nursed him, taught him to eat, and protected him begins to grow old, he cares for her. When the doe dies, Hayy tries to resuscitate her and through his knowledge of the maternal deer's body learns about the spirit that animates living beings and deduces the existence of the soul.

This brief account does not do justice to the philosophical or poetic content of the text, nor does it describe its engagement with other philosophical texts and with debates about education, religion, truth, and discovery.[26] I focus here on only one part of the story, the text's description of Hayy's relationship with the deer. The deer's dual role as a mother who nurtures the boy and a maternal body that ultimately offers him knowledge of the spiritual world beyond the body casts the animal as both a protagonist in the story and a subject of knowledge.

In *Hayy Ibn Yaqzan* the child raised by a deer in isolation from human society acquires animal-like traits: "Thus the child lived among the deer, imitating their calls so well that eventually his voice and theirs could hardly be distinguished. In the same way he imitated all the bird calls and animal cries he heard with amazing accuracy, but most often he would mimic the calls of the deer for alarm, courtship, summons or defense—for animals have different cries for these different contingencies. The animals were used to him and he was used to them, so they were not afraid of each other" (109–10). The text describes becoming animal not as a magical transformation but as imitation, as learned behavior. Hayy mimics the animals, and his being with them is not just an imitation but a becoming, a joining—he becomes part of a population, what Deleuze and Guattari might call a pack.[27]

The text also describes this joining in affective terms. The narrator tells us that the child grew so fond of the doe that he would cry if she were late returning to him, and she would come rushing back (109).

When the doe grows old, Hayy cares for her, and when she dies, he grieves for her:

> When she grew old and weak he would lead her to rich pastures and gather sweet fruits to feed her. Even so, weakness and emaciation gradually tightened their hold, and finally death overtook her. All her movements and bodily functions came to a standstill. When the boy saw her in such a state, he was beside himself with grief. His soul seemed to overflow with sorrow. He tried to call her with the call she always answered, shouted as loud as he could, but saw not the faintest flicker of life. He peered into her eyes and ears, but no damage was apparent. In the same way he examined all her parts but could find nothing wrong with any of them. He hoped to discover the place where she was hurt so he could take away the hurt and allow her to recover—but he could not even make a start; he was powerless. (110)

As Karl Steel has argued, one way in which animal-human difference is established and maintained in medieval texts is through the definition of the animal as not grievable. Human death solicits grief, but for the most part animal deaths are seen as useful or animals are seen as dying in service to human needs.[28] The poignant display of affection and grief in *Hayy Ibn Yaqzan* is unusual. *La naissance du Chevalier au cygne* does not recount the death of the doe that nursed the swan-children, but even so, the child who remains in the forest after his siblings are transformed into swans is not shown to display any affection for her or any remorse at losing her (or the hermit) when he leaves the forest. Beritola's affection for her deer is clear in *Decameron* 2.6, but she shows no hesitation about abandoning them when she is reunited with her human family. By showing the child's grief at the loss of the deer that nursed and raised him, Ibn Tufayl's story emphasizes Hayy's isolation from human society and human genealogy, and from the animal-human difference defined through human social structures. The boy's fondness for the deer and his grief at her death are described as reciprocal affective ties; such a representation depends on the boy's isolation from the

human social networks within which his affection for the deer might be contested by the structures of lineage and genealogy.

Hayy's grief leads him to knowledge of the soul. When he cannot find a wound that might have caused the doe's death, he decides that there must be some internal obstruction in her body. He cuts the deer open, examines her organs, and deduces that her death was caused not by a physical obstruction but by the departure of some animating force. Isolated from any religious instruction and taught only by nature, Hayy discovers the soul and its mover; he discovers God. "He soon dropped the body and thought no more of it, knowing that the mother who had nursed him and showed him so much kindness could only be that being which had departed. From that—and not from this lifeless body—all those actions had issued. The whole body was simply a tool of this being, like the stick with which he fought the animals. His affection was transferred now from the body to the being that was its master and mover. All his love was directed toward that" (115). Here embodiment is a puzzle to be solved and the beloved mother is revealed to be not a body but some animating force that inhabited the body. *Hayy Ibn Yaq-zan* describes the boy's affection for the nursing animal body only to subordinate the body to the soul, and the soul to its master, God. Love for the mother teaches a love for God.

Hayy Ibn Yaqzan does not describe the protagonist becoming animal as the result of maternal nursing any more than *La naissance du Chevalier au cygne* does. But Hayy's affective relationship with the doe recognizes the intimacy of their connection and enables the boy's understanding and imitation of the animals in the forest. The maternal deer's death marks the point at which Hayy begins to become human. He separates from the pack and understands himself as a unique being. He moves from becoming animal to studying animals, and through his interrogation of animal physiology he discovers the soul. If the absence of human society, and particularly of a human mother, makes possible the affective relationship with the nursing deer, the revelation of divine order in nature occludes the nursing animal's body—first an object of affection, then an object of study. Once it has offered its lessons, it is (literally) dropped and forgotten. And yet the intimacy with the animal

remains the motivation for Hayy's discovery. Figured as a becoming-animal, a belonging to a pack, Hayy's relation with animality leads to an understanding of God.

NURSING ANIMALS

If representations of nursing are a site where medieval texts imagine the possibility of an intimate relationship with animals and animality, that possibility is often tied to extreme situations—abandoned infants are rescued by nurturing animals, abandoned mothers are comforted by caring for young animals. In other words, intimacy with nursing animals seems to require isolation from human society. To incorporate that intimacy into human social structures and institutions would be perverse, or at least that is what is suggested by *The Punishment of the Unfaithful Wives,* an altarpiece from Krakaw produced around 1505 and discussed in a recent study by Diane Wolfthal. The altar is dedicated to St. Stanislaus, whose thirteenth-century *vita* is the source for the scene portrayed on the altarpiece.[29] Women who committed adultery and became pregnant while their husbands were away at war are punished by King Boleslaw, who forces them to nurse puppies while their own children suckle dogs. The punishment, the *vita* explains, is a cruel judgment of the women's betrayal of human nature through their failure to remain chaste in their husbands' absence. "[The king] milked the women, to whom their pitying husbands had shown mercy, in a manner of unparalleled cruelty: for, after having thrown aside their servile offspring, he applied puppies to their breasts, leaving it to these animals to punish the women for their servile disgraces. He claimed to show by this action that these women were unworthy to suckle human offspring but that they, who had forgotten human nature and preferred illicit sexual relations over the lawful kind, had preferred the canine sort."[30] Adulterous women betray their human nature, according to the cruel king; like dogs in their lust, they are accordingly forced to suckle puppies instead of their own illegitimate children in what is taken as an appropriate punishment for their crimes. The king's punishment is found to be too

harsh, however. St. Stanislaus intercedes for the women, and the punishment is rescinded.

Wolfthal's insightful analysis offers a rich reading of the visual representation of the unfaithful wives in the context of other medieval scenes of nursing. She argues that the representation functions as an inversion of the image of the sacred and popular theme of the *Virgo lactans*. She also argues that it emphasizes the importance of maternal fidelity in guaranteeing succession and inheritance, and she suggests that it probably refers to the belief that a mother's milk shapes the character of the infant she nurses: "Not only does it depict the danger of immorality passing from mother to child through her milk and the confusion of lineage lines, but it also suggests the blurring of the boundary between human and animal." Wolfthal notes that dogs are often associated with lust in visual images, and we can see that textual narratives too make such a link. Recall Matabrune's claim, repeated by her son, that Beatrix "lay carnally with dogs, body to body, and then she gave birth to seven dogs."[31] The painting's nursing dogs are very different from nursing deer in the narrative texts I have discussed above, in part because of their likely connotations of indiscriminate lustfulness; in part because their suckling is a punishment, not a necessity or a choice; and in part because of the domesticity of the scene. These nursing animals are not isolated on some desert island, and cross-species nursing is not a response to isolation or need. The puppies and the human babies suckle in the street, and as Wolfthal argues, the public visibility of the intimate act makes public the women's adultery and its consequent abasement of lineage.

Unlike rescue narratives that cast maternal instinct as so natural as to cross species boundaries, the altarpiece, like the episode from the saint's *vita* that it illustrates, posits human-animal suckling as unnatural. Apparently the punishment is perceived as so unnatural that the saint intervenes to stop it. But if the animal-human relationship defined by nursing is somehow unnatural, the danger of the cross-species contagion it suggests is surely located in the intimacy of the relationship: the women might grow to love the dogs to the exclusion of their own children—after all, these adulterous wives have already shifted loyalties once.

NATURE AND NURTURE

The medieval narratives about nursing animals discussed above define human "nature" as intimately—and sometimes precariously—transmitted through mother's milk. Lactation is a bodily characteristic that human mothers share with other mammals. All of the narratives examined above articulate a relationship with animality through the figure of a lactating mother, and they implicitly suggest that animality may be transmitted through the intimate proximity of suckling. Even though animality is contained or occluded when characters are integrated into human society or into the truth of the divine order, a becoming-animal persists as an attribute, an odor, or even a lesson that lingers after animal companions are left behind. These narratives imagine a vulnerable humanity that is corrupted or confirmed by maternal nurture, and they represent the process of becoming as a contagion that may cross species through intimate contact with the maternal body. In their representation of a gendered access to becoming animal, narratives about nursing animals point to the intimate configurations of maternity and animality that persist in noble genealogies.

NOTES

Many thanks for critical readings, conversations, and inspiration to Alison Cornish, Artemis Leontis, Laurence De Looze, Megan Holmes, Karla Mallette, Yopie Prins, Catherine Sanok, Eleonora Stoppino, Valerie Traub, and Elizabeth Wingrove.

1. *Les enfances Godefroi,* ed. Emanuel J. Mickel, vol. 3 of *The Old French Crusade Cycle,* gen. ed. Jan A. Nelson and E. J. Mickel (Tuscaloosa: University of Alabama Press, 1999), line 2302.

2. *La naissance du Chevalier au cygne,* ed. Emanuel J. Mickel and Jean A. Nelson, vol. 1 of *The Old French Crusade Cycle* (Tuscaloosa: University of Alabama Press, 1977). This text has also been known under the title *Enfants-Cygnes.* There are four versions of the narrative. Three are known by the names given to the mother in each: *Elioxe, Beatrix,* and *Isomberte.* The fourth is a composite that combines *Elioxe* and *Beatrix.* All the narratives are probably from the early thirteenth century. I focus on *Beatrix,* which is longer and gives a more detailed

account of the Swan Knight's birth and childhood. Subsequent line citations to *La naissance* are to the *Beatrix* version of this edition and are given parenthetically in the text.

3. The story of children who can change into swans probably circulated as a folklore motif; its first written record is in Johannes de Alta Silva's *Dolopathos*, composed around 1190. The Crusade Cycle borrows this story, either from the *Dolopathos* or from some other source, to explain the origins of the Swan Knight who is Godefroy's ancestor. See discussion in *La naissance*, lxxxxi–lxxxxix.

4. For other accounts of monstrous progeny associated with mother's blood, see my "Menstruation and Monstrous Birth," in *The Curse of Eve, the Wound of the Hero: Blood, Gender, and Medieval Literature* (Philadelphia: University of Pennsylvania Press, 2003), 61–76.

5. This motif is also found in Marie de France's *Le Fraisne*.

6. *Valentin et Orson: An Edition and Translation of the Fifteenth-Century Romance Epic,* ed. and trans. Shira Schwam Baird (Tempe: Arizona Center for Medieval and Renaissance Studies, 2011), 46. See also the account of "wild Peter," a boy found in northern Germany in 1724, and whose body was covered by thick hair—a consequence, it was thought, of the animality he imbibed from the bear that nursed him. Londa Schiebinger, *Nature's Body: Gender in the Making of Modern Science* (Boston: Beacon Press, 1993), 56.

7. Quoted in translation in Carolyn A. Nadeau, "Blood Mother/Milk Mother: Breastfeeding, the Family, and the State in Antonio de Guevara's *Relox de Príncipes (Dial of Princes)*," *Hispanic Review* 69, no. 2 (2001): 155–56.

8. Quoted in translation in Clarissa Atkinson, *The Oldest Vocation: Christian Motherhood in the Middle Ages* (Ithaca: Cornell University Press, 1991), 60. See also Christiane Klapish-Zuber, *Women, Family and Ritual in Renaissance Italy,* trans. Lydia Cochrane (Chicago: University of Chicago Press, 1985), 161–62.

9. The *Beatrix* version of the story significantly Christianizes the story. Even the faeric transformation of the children is described as coming from God: "Or sunt cil .VI. oisiel si con dire m'oés / Quar ensi les avoit nostre Sire faés" (493–94).

10. Joan B. Williamson notes that he is also animal-like. "Elias as a 'Wild-Man' in *Li estoire del Chevalier au cisne,*" in *Essays in Honor of Louis Francis Solano,* ed. Raymond J. Cormier and Urban T. Holmes (Chapel Hill: University of North Carolina Press, 1970), 196.

11. He is very much like the young Perceval in Chrétien de Troyes's *Conte du graal.* When he arrives at court and the king asks his name, he replies that he is called "Biaus Fius" (910).

12. On domestication and animal-human difference, see Karl Steel, *How to Make a Human: Animals and Violence in the Middle Ages* (Columbus: Ohio State University Press, 2011).

13. Joyce Salisbury, *The Beast Within: Animals in the Middle Ages* (New York: Routledge, 1994); Steel, *How to Make a Human;* Fernando Salmón, "A Medieval Territory for Touch," *Studies in Medieval and Renaissance History,* ser. 3, 2 (2005): 59–81.

14. Gilles Deleuze and Félix Guattari, *A Thousand Plateaus: Capitalism and Schizophrenia,* trans. Brian Massumi (Minneapolis: University of Minnesota Press, 1987), 238.

15. See in particular Jeffrey Jerome Cohen, "Chevalerie," in *Medieval Identity Machines* (Minneapolis: University of Minnesota Press, 2003), 35–77.

16. Deleuze and Guattari, *Thousand Plateaus,* 238, 241.

17. Later in the cycle this swan too is restored to human form. *La fin d'Elias,* lines 704–8 in *Le Chevalier au cygne and La fin d'Elias,* ed. Jan A. Nelson, vol. 2 of *The Old French Crusade Cycle* (Tuscaloosa: University of Alabama Press, 1985).

18. Finn E. Sinclair, *Blood and Milk: Gender and Genealogy in the "Chanson de Geste"* (Bern: Peter Lang, 2003), 66. Sinclair discusses the *Elioxe* version of *La naissance du Chevalier au cygne,* where—as she points out—the mother's death in childbirth may be read as a sacrifice of the ideal mother to the masculine lineage (71–77). See also Sinclair's discussion of the displacement of the Swan Knight's wife by his daughter as the privileged maternal ancestor of Godefroy de Bouillon in *Le Chevalier au cygne* (90–95). On debates about ways in which romance narratives debate what a mother's blood brings to noble lineage, see my *Curse of Eve,* 61–91.

19. *Le Chevalier au cygne,* in *Le Chevalier au cygne and La fin d'Elias,* 1410–17.

20. *Les enfances de Godefroi,* in *Les enfances de Godefroi and Le retour de Cornumarant,* ed. Emanuel J. Mickel, vol. 3 of *The Old French Crusade Cycle* (Tuscaloosa: University of Alabama Press, 1999), lines 588–92. Subsequent citations to this work are to this edition and are given parenthetically in the text by line number.

21. Eleonora Stoppino, "Animality and Prophylaxis in Medieval Italian Literature," paper presented at the "Geographies of Risk" conference, University of Illinois, Urbana-Champaign, September 23–25, 2010. Stoppino has pointed to the difference of this model (human-to-animal contagion) from modern notions of contagion that locate the origin of disease in animals (bird flu, swine flu, even AIDS). My reading of becoming-animal in relation to contagion is inspired by Stoppino's work on Boccaccio.

22. Translation from Giovanni Boccaccio, *The Decameron,* trans. Mark Musa and Peter Bondanella (New York: Norton, 1977), 7 (occasionally modified slightly to give a more literal reading). Original from Giovanni Boccaccio, *Decameron,* ed. Vittore Branca, 2 vols. (Florence: Le Monnier, 1951), 1:15–16.

23. *Decameron,* trans. 99, original 1:197.

24. *Decameron,* trans. 99, original 1:197–98.

25. *Decameron,* trans. 105–6, original 1:210–11.

26. For an overview, see *Ibn Tufayl's Hayy Ibn Yaqzan: A Philosophical Tale,* trans. Lenn Evan Goodman (Chicago: University of Chicago Press, 2009), 3–91. Subsequent page citations from this work are to this edition and are given parenthetically in the text.

27. Deleuze and Guattari, *Thousand Plateaus,* 241.

28. Chloë Taylor, "The Precarious Lives of Animals: Butler, Coetzee, and Animal Ethics," *Philosophy Today* 52 (2008): 60–72. For an exploration of medieval texts that imagine affective ties between animals and humans, including mourning, see Steel, *How to Make a Human,* 221–45. On the "logic of the pet," see Cary Wolfe, *Animal Rites: American Culture, the Discourse of Species, and Posthumanist Theory* (Chicago: University of Chicago Press, 2003), 104.

29. Diane Wolfthal, *In and Out of the Marital Bed: Seeing Sex in Renaissance Europe* (New Haven: Yale University Press, 2010). The wing of the altarpiece is reproduced on 157; discussion is on 156–66. I know the altarpiece only through Wolfthal's compelling study.

30. G. Henschenius and D. Papenbroeck, eds., *Acta sanctorum maii* (Venice, 1738), 221, quoted in Wolfthal, *In and Out,* 157–58.

31. "Ele giut as ciens cors a cors carnelment / Et si en ot .VII. ciens" (*La naissance du Chevalier au cygne,* 923–24).

—————

The Lady and the Dragon in Chrétien's
Chevalier au lion

MATILDA TOMARYN BRUCKNER

Man is the animal that must recognize itself as human to be human.
 Giorgio Agamben, *The Open: Man and Animal*

Une autre lecture est certainement possible qui mettrait l'accent sur
les rencontres avec les personnages féminins.
 Jacques Le Goff and Pierre Vidal-Naquet,
 "Lévi-Strauss en Brocéliande"

A FIRE-BREATHING DRAGON HOLDS A LION BY THE TAIL. AN ANGUISHED
cry of pain attracts a knight who cuts off the dragon's head, then chops
the felonious beast to pieces. Though freedom has cost him the tip of
his tail, the grateful lion demonstrates through gestures that he places
himself now and forever in the knight's service. Such is the signature
image of Chrétien de Troyes's *Chevalier au lion,* as uniquely recognizable
as Lancelot crossing the Sword Bridge in the *Chevalier de la charrette,* the
companion romance threaded through *Yvain*'s plot, just as the compan-
ionship of lion and knight is woven through to rival those best of

friends, Gauvain and Yvain. A buddy tale about a tail that links man and beast; a chivalric tale of masculine identity formation, encapsulated by the romance's titular image and belatedly bestowed title.[1] But that interpretive paradigm, like the hero's furious dicing, makes the dragon disappear. *Yvain*'s emblematic figure requires a more complete reading to understand what is at stake in the puzzle of combat between two fabulous animals, presented as real yet invested with a dazzling variety of cultural and literary traditions that play across the entire scope of Chrétien's romance to complicate their role and import, their positive and negative valences. We need to discern behind obvious connections overtly signaled in the narrative more hidden associations tying Yvain's lady, beloved enemy and betrayed wife, to the fire-breathing dragon who holds a lion by its tail. Beyond her evident links to the natural and supernatural world, a fiery Laudine challenges the buddy tale and restores complexity to a heroine who may seem at first glance almost absent and one-dimensional. But her draconian fire-power, channeled through her link to the magic fountain, will play as central a role in this analysis as it does in the *Chevalier au lion*. Enter the dragon; take blazing hold of the tale.

The hero's leonine reconstruction is equally at stake in this claim for identifying Laudine with the dragon. Indeed, explicating more fully what ties together dragon and lion, lady and knight, entails questions about the nature of the human animal, caught up in the intricate relations between animal and human, male and female, nature and culture. In a romance that insistently calls our attention to beasts, whether as characters in the narrative or comparisons in the description, the crisscrossing elements that form identity along the spectrum of human and animal interactions demonstrate that the boundaries between them remain permeable, displaceable, overlapping. By following (through allusion, association, repetition, and displacement) a series of concentric circles that move out from and back to the central image of lion and dragon locked in combat, this essay aims to explore how those borders between the animal and the human, or more properly in the plural, between male and female humans and a bestiary of running, stamping, trotting, and flying animals, shift, thicken, and complexify, creating in-between spaces, identities that resist simple division and definitive cate-

gorization.[2] In this romance world, oppositions are reconfigured along a graduated series or hierarchy; continuities across differences set up a continuum linking opposite poles. And as we shall see, the sexual and social unit formed by Yvain and the Lady of Landuc, illuminated by the animal/human nexus, reveals equally problematized limits within the male-female couple whose conjunction, so difficult to effect and maintain, constitutes the romance's end (as well as end point) just as significantly as the hero's reconstruction of identity around the figure of the lion.

Though we humans typically locate the animal outside in the natural world, in biblical as well as philosophical traditions the same inside/outside division appears disconcertingly within human nature, part animal, part man. This doubling of "caesuras," in Giorgio Agamben's terminology, necessitates man's efforts to define himself in relation to the animal, a necessity noted by Thomas Aquinas in his gloss on Adam naming the animals: though beasts are not needed in the Garden of Eden for any practical purpose, their presence is nevertheless vital "in order to draw from their nature an experimental knowledge."[3] Cleavages inside and out produce uncertain boundaries and lead to shifting definitions that, by including the excluded or excluding the included, open an intermediate space between "human and non-human, man and non-man, speaking being and living being."[4] In the *Chevalier au lion* that space will be densely populated by intermediary figures linked to and illuminating the central couple, each one separately as male or female, both together in their shared human nature.[5] Even as the romance accepts "man" as the measure of the human, it problematizes that abstraction by exploring male and female differences lodged in their common human nature.

To track shifting borders and problematic definitions, this exploration begins with a preliminary overview of how animals are deployed in the romance, which will lead into specific associations tied to Yvain and Laudine, including those that cross over between them, whether at the level of imagery, vocabulary, action, or character. The issue of language will remain crucial throughout, not only because language has traditionally been seen as differentiating the rational animal from all others, but also because Chrétien's romance continually signals how the narrator's

language, as well as the characters' speech, forms and transforms what we and they perceive as animal or human characteristics, properties, and behavior. While the viewpoints privileged are primarily those of the hero and the putatively male narrator, the texture and *conjointure* of the romance reframe those perspectives with their implicit commentary. My analyses strive to make explicit how *Yvain* constructs and reconstructs categories of the natural, the human, female and male, animal and not animal, in relation to the traditions and received ideas put on stage.

For those familiar with all five of Chrétien's romances, the concentration on animals in *Yvain* is striking. While horses, dogs, deer, and birds appear everywhere in his romance world, as in the daily life of aristocratic reader/listeners, none of the other romances turns its focus so persistently on beasts, domestic and wild, familiar and fantastic, noble and ignoble. None features them so prominently in numerous similes and metaphors that sometimes approach the extended elaboration of antique epic tradition. Only the *Chevalier au lion* brings animals on stage to play a major role as characters whose potential meanings are critical to understanding what the romance is about. Both lion and dragon appear as real as the humans who encounter them, but their fabulous character emerges as the product of multiple literary, moral, and theological traditions—the Bible, fables, bestiaries, lyric, *lais,* romance—which lend a "thick potential" (borrowing from Clifford Geertz) for the romancer's complex, often ironic reinventions. Part of the reader's task then is to determine in what sense these fantastic beasts are real, even if that task remains as uncertain and open-ended as irony itself, the trope that says one thing yet means another. How many *other* readings, *re-*readings, might be turned when a dragon catches a lion by the tail?

Just as Yvain's animal companion overshadows the vanquished dragon, the figure of the lion—associated with gods, lords, and heroes, represented as emblem of defense and justice, symbol of the sun, Christ and Antichrist, courageous or bloodthirsty—dominates medieval animal imagery.[6] In the *Chevalier au lion,* the lion appears first in

simile and metaphor: Esclados, the fountain lady's first husband and defender, has a lion's fierce appearance as he attacks Calogrenant (486), just as Yvain's attack in defending the Lady of Noroison resembles that of a lion among deer tormented and chased by hunger (3203–4).[7] After the period of madness triggered by his failure to return as promised to his wife, Yvain is ready to meet his animal double, who duly materializes in the next episode: literal lion and figurative lions will now interact through narrative development.

Significantly, the encounter of knight and lion marks a change in the romance's use of animal comparisons. Two-thirds (twenty out of thirty) occur before the combat between lion and dragon. The romance's first part offers a whole bestiary to give the measure of human traits against a variety of animals whose characteristics move them closer or farther away from the human:[8] from horsefly and wasp used to describe Keu's figurative bite and sting (116–17) to the birds and beasts who stalk their prey, when Yvain pursues Esclados as a falcon does a crane (880). Once Yvain has reemerged into sanity after living like an animal (without clothes, speech, memory), his rehumanization is energized by the parallel humanization of a lion companion whose animal spirits conversely recharge the knight's valor. From this midpoint, figurative animals must compete with animal-like figures—the giant Harpin de la Montagne armed with club and bearskin, two "sons of devils" hideous and black—who act in the narrative in order to act out the in-between spaces connecting animal and human. These marvelous and diabolical dimensions of the not-human, below and beyond the natural, line up with earlier liminal figures—Calogrenant's peasant *(vilain)* and Yvain's wild-man self—to interrogate the lion-knight complex and confound the borders of the human by questioning what is inside or out.

The uneven distribution of beastly analogues is mirrored in the tendency to concentrate animal comparisons on Esclados (three), Yvain (sixteen), the *vilain* (six)—and the lion, who merits four. Thinking his companion dead, the lion tries to kill himself by running onto Yvain's sword like "a wild pig out of his mind" (3520).[9] Lying next to his master "comme unz agniax fesist" [as would a lamb] (4008), a picture of Isaiah's messianic future, the lion enhances Yvain's value for the family threatened by the giant. That unexpected docility first appears to Yvain

when the lion performs the gestures of fealty, crying for mercy, offering service—actions described by the narrator in such a way as to change the lion into a rational animal, without speech perhaps, but effective in communicating meaning. In these moments, the lion becomes a faithful vassal, a pet dog who hunts for his master (3438–39), ready to turn back into a ferocious and courageous beast (like a good knight) whenever Yvain needs defending.[10] These animal comparisons confer on a grateful lion the full range of feeling and behavior that should characterize the knight relaunched on a career of service. After the combat between Yvain and Gauvain, fighting incognito as champions for two sisters, the fourth comparison describes how the lion, catching up with his companion, expresses great joy "comme beste mue" (6487). All his best qualities absorbed and demonstrated by the Knight of the Lion, the lion can now return to himself as the "mute beast" whose presence soon vouches for his namesake when Yvain too experiences the joy of reunion with Laudine.

Of course, the titular hero is the main figure who accumulates animal imagery. He is explicitly or implicitly compared with thirteen different animals: horse, lion, cat, dog, stag, falcon, rat, bird, squirrel, "chisemus" (1116), partridge, quail, dove. Most of the comparisons place him in the position of hunter or hunted, but two examples in particular step outside that frame. Taking leave, Yvain wishes he could be a dove every time he wants to be at his wife's side (2582–84). A winged version of the lion's lamb, that peaceful bird is the very picture of a docile lover/husband; in retrospect, it ironically anticipates Yvain's failure to even think of returning until well past the deadline given. The second image arises when Yvain returns to defend Lunete against treason. At the sight of Laudine, Yvain's heart must be held back, like a horse pulling ["le cheval tirant"] (4345) against its bridle, restrained only with great difficulty. The horse as a figure of passion has a long history; here it suitably joins Yvain's frustrated love for the Lady of Landuc with his identity as *chevalier,* a man quintessentially *à cheval.* The yearning and repentant knight-husband, whose heart takes the image of impetuosity put to the test of restraint (4342), takes for himself a new name to conceal the real but discredited one. His identity still in the process of reconstruction, Yvain takes a turn through metonomy as the "Chevalier au lion," a knight defined by his horse and his lion.[11]

Passions that move bodies, common to man and animal, are shared by that other member of the human species, woman. And while it is often difficult to know exactly what the lady wants, as demonstrated by the testy negotiations with Lunete on the subject of marrying her husband's killer, it is surely significant that the single animal comparison for Laudine made explicit in the romance highlights the successful culmination of that process of persuasion when the Lady of Landuc feigns modest deference to her barons' pleas to marry Yvain.

> And their prayers don't grieve her at all, rather they raise and lift up her heart to do what it desires: the horse who isn't moving slowly makes a greater effort when spurred along.

> Et les proieres riens n'i grievent,
> Ainz li essaucent et soulievent
> Le cuer a fere son talent:
> Le cheval qui ne va pas lent
> S'esforce quant on l'esperonne.
> (2145–49)

At a different point along the trajectory of their love, the lady's desire, like Yvain's, finds its chevaline analogue, but hers is unrestrained. An eager horse moving fast on its own steam, Laudine rides her love in the exercise of power. She may be no knight, but she is no less the *châtelaine* who commands her domain.[12]

The heart as a horse rushing forward in the direction of desire, a metaphorical representation that equates sexuality and animality, also establishes a textual equivalence between Yvain and Laudine. The same correspondence is inscribed in words that subtly animalize them by locating them in the topos of love as a hunt in which each plays the hunter and the hunted. Consider the scenes that prepare Yvain's presentation as a suitable choice for marriage. First, Yvain watches Esclados's funeral cortege to catch another glimpse of the widow he fell in love with at first sight: "Through that window my lord Yvain is on the lookout for the beautiful lady" [Par chele fenestrë agaite / Mesire Yvains la bele dame] (1286–87). The verb *agaitier* suggests the watchful hunter spying upon his prey, as the wild man does in the forest (2824—cf. 1363); the

same verb stalks its way repeatedly through the narrator's tale. When Lunete argues the logic of loving the winner rather than the loser of knightly combat, her mistress suspects that "you are watching for me and want to trap me with words" [tu m'aguaites, / Si me veuz a parole prendre] (1700–1701). Indeed, this scene and its key phrase serve as dress rehearsal for the dénouement, when Lunete "captures" Laudine's pardon for Yvain (6624, 6751—cf. 3684, 5039–42, 6388). Both literal and figurative trapping are constantly interwoven in the romance. When his horse triggers the portcullis "like a crossbow that lies in wait for the rat until he makes a mistake" [come arbaleste qui aguete / le rat tant qu'il vient au forfet] (912–13), Yvain remains trapped inside the castle. But the hesitant lover, first so tame ["si dontez"] (2016), allows himself, once married, to be persuaded to leave with Gauvain and guilefully obtains a rash boon from his lady, "who's not watching out for a leave" [qui du congié pas ne se gaite] (2548). Male or female, humans, like animals, prey upon each other.

One more example most pertinently establishes the female capacity for aggression even as the wording itself denies it. When finally led into Laudine's presence, the abashed lover hangs back until Lunete teasingly encourages him: "Don't be afraid that my lady will bite you" [poour n'aiez / De ma dame qu'elle vous morde] (1968–69). But that is precisely what she has done, bitten him with love, like the dragon whose bite holds a lion by the tail. The verbal link avoids exact repetition but is no less compelling: the dragon held ["tenoit"] (3349) the lion's tail and burned his back ["si li ardoit / Toutes les rains de flambe ardent"] (3350–51)—with flames pouring from a mouth wider than a large pot (3368). The erotic potential here is obvious, especially when the tip of the tail cut off suggests a symbolic taming (castration for psychoanalytically inclined readers, circumcision for medieval readers informed by biblical usage). The interplay between aggression and love, taming and flaming, triggered by a linguistic transformation that makes the dragon and Laudine figures for each other, incites us to reread the central scene. Why would a dragon hold a lion by the tail? Was he trying to get away?[13] The apparent gratuity of their configuration generates perplexities that demand interpretation.

Consider how Yvain decodes the contest. Confronted by such an extraordinary "merveille" (3553), he hesitates a moment (cf. Lancelot's

two steps before climbing into the cart). In romance, the dolorous cry he heard typically signifies a damsel in distress, but here the knight finds himself facing a dilemma: Which animal is the victim? The narrator places us inside Yvain's mind, as he reasons according to traditional associations that establish a positive-negative opposition and hierarchy between the two beasts (3352–75). Pity summons him to defend the noble lion ["La beste gentil et franche"] (3375) against the "treacherous serpent" ["felon serpent"] (3377).[14] Most of Yvain's thoughts empha-size the evil character of the dragon: venomous ([Roques] 3353, 3355), "felon" and filled with "felonnie" (3357, 3361), it merits only evil ["mal"] (3358) in return. Just as Yvain's image of a noble lion evokes the king of the beasts in fables or the figure for Christ in bestiaries, his insistence on the dragon's evil connects it to the biblical serpent in the Garden of Eden and Revelation's dragon at the end of time. But competing inter-texts and their ironic reinvention will undercut Yvain's allegorical model of interpretation.[15] The entangled bodies of dragon and lion, locked together in combat, elicit further search for figurative meaning(s).

Recalling Agamben's doubling of caesuras, we might read Yvain's intervention as the moment when he shifts the border within his animal/human nature by exorcising his own dragonlike tendency to-ward evil, excluding from the human what will be pushed outside into the natural world. From the viewpoint of Eden, he makes the choice for good by internalizing the lion's strengths: great courage and prow-ess, nobility yet ferocity in service, humility, gratitude, and generosity. Thus Jacques Le Goff and Pierre Vidal-Naquet argue in "Levi-Strauss en Brocéliande" that the ambiguities between nature and culture, savage and human, are resolved after Yvain's crisis of madness: in their view, the diabolical, now clearly externalized, can be defeated in the adven-tures that follow.[16] On one level, the argument is persuasive: Yvain's performance in the second half of the romance clearly aims to redeem his fault and transform him into an ideal knight in the service of others, especially others of the feminine sex. But that cue brings us back to Laudine, the dragon, and another level of reading that follows how am-biguities resolved may simply relocate in those uncertain, intermediary spaces stretching between animalized humans and humanized animals.

Let us start again from the dragon. To what extent does the ro-mance validate Yvain's negative associations and link them to the Lady

of Landuc? Tying the *serpent* to the feminine has a venerable history, with Eve as the first female link in the human chain of bad choices, Adam's seducer seduced by the snake. Laudine's literary models— Petronius's Widow of Ephesus seduced at her husband's grave (a story retold in Marie de France's fable 25), the capricious lady of troubadour lyric—offer feminist critics plenty of grist for the misogynist mill.[17] In the romance, misogyny speaks directly, if ironically, through the narrator's voice when he labels Laudine's refusal to listen to Lunete's good advice as the typical folly of women who refuse what they want (1640– 44)—Lunete seconds the view (1650–52). Men deservedly take their fair share of abuse in the romance, but given the importance of perception in shaping interpretation, the relative distance taken by the narrator in relation to his hero and heroine is not without consequence. Measured by her limited time onstage and the limited access to her thoughts and feelings, Laudine is located at a greater distance from a narratorial point of view more closely aligned with the hero.

Narrative order actively reinforces the link between the Lady of Landuc and the dragon, both located within a sequence of animalistic, diabolically evil forces aligned against the defender of the good, human, and rational. Every episode in the second half of the romance shows Yvain defeating opponents on the wrong side of justice and humanity: Count Alier (the Lady of Noroison's unwanted suitor), the dragon, Harpin (threatening to rape and prostitute Gauvain's niece), three knights fighting as one (to prove faithful Lunete a traitor), two demon sons (maintaining the evil custom at Pesme-Aventure), Gauvain (representing the older sister disinheriting the younger), and finally Laudine. In all but the last two contests, the lion's presence at Yvain's side reinforces literally and figuratively the necessary ferocity that evil deserves, but when the Knight of the Lion opposes his best friend and his wife, the lion's role necessarily changes, and a number of displacements, mixing negative and positive, human and inhuman, need to be disentangled.

In this series, the most obviously threatening forms of evil assume monstrous male shapes, but evil also wears a female face and speaks as the elder sister of Noire Espine, who unjustly refuses to share their inheritance with her younger sibling: "May evil fire and evil flame burn me if I ever give you anything better to live on!" [Max fus et male flambe

m'arde / Se ja t'en doing dont miex te vives!] (5974–75). Only when
Gauvain and Yvain have fought to a draw, and each wants to concede
victory to his best friend, does Arthur intervene by asking for the dam-
sel who has disinherited her sister by force and "evil mercy" [male
merci] (16377). Language tricks the bad sister to recognize her malfea-
sance and, thanks to the fiery repetitions of her curse, forges a link with
the diabolical character of a fire-breathing dragon.[18] And the Lady of
Landuc? Does the central image figure how an abandoned wife burned
Yvain with the flames of her love turned to hate, as promised? The
public accusation at Arthur's court, when her messenger proclaims
Yvain to be a lying deceiver, surely burns and bites.[19] Love, like anger,
is an aggression, a struggle for power: Who's the prey, who the preda-
tor? As the romance proceeds, we can see how their positions reverse,
slip, and double, as Yvain deserts Laudine, who unmasks Yvain, who
storms Laudine. In this episode, Yvain flees into madness, hoping to
disappear "en abisme" (2789)—the phrase conjures up hell's flames
licking his back.

As one of the elements that distinguishes human culture from
animal nature, fire plays its role in the *Chevalier au lion*. The cooked meat
of civilization, prepared by Yvain from the lion's kill, contrasts with the
raw meat eaten by the wild man. The laudable ardor of chivalric perfor-
mance fires up the fountain defender's anger "more burning than coals"
[plus ardans que brese] (810). As the lion demonstrates, fiery violence
has its appropriate place in human affairs. In a more negative vein,
flames of desire literalize in aggressive acts of devastation when the
giant burns everything around the castle in his rampage to possess the
castellan's daughter. A familiar topos in the Ovidian twelfth century,
love as fire also figures the nascent feelings that the Lady of Landuc
lights in herself, "just like the log that smokes until it catches fire" [Aus-
int com la buche qui fume, / Tant que la flame s'i est mise] (1778–79).
Gauvain uses the same rhetoric to persuade Yvain to leave his bride:

> Love's joy delayed resembles the green log that burns within with
> greater heat and stays more vigorous, the longer it takes to catch
> fire.

Joie d'amor qui vient a tart
Sanle la vert busche qui art,
Et dedans rent plus grant calor,
Et plus se tient en valour,
Com plus se tient dë alumer.
(2519–23)

Passion is shown again to be an arena that engages both male and female, although the most negative aspects of love's fire seem more particularly associated with Laudine's draconian character.[20] Paradoxically, the lady overtly linked to water is also a figure of fire: the water in the fountain is cold but boiling (378–79); poured out, it unleashes torrential rains punctuated with thunder and lightening.[21] Laudine's fountain ties her to fairies found bathing in solitary places, representing both risk and opportunity, the intervention of the marvelous into nature's landscape.[22] The daughter of Duke Landudet ("about whom a *lai* is sung" [2155]) seems strictly human, but the fountain that marks her realm lends Laudine a supernatural aura: she gives the impression of being "more beautiful than any goddess" (2367). While the peripatetic knight is appropriately figured by his lion, the Lady of Landuc is rooted in a place by her equally emblematic fountain. In feudal terms, she symbolizes the land any unfiefed knight would eagerly take possession of through marriage (cf. the Lady of Noroison and the daughter-heir at Pesme-Aventure).

Laudine's connections with three of nature's four basic elements, fire, water, earth, invite a Bachelardian analysis, but my dragon theme leads to another path. In researching antecedents for Melusine, fairy, lady, dragon, Le Goff and Emmanuel Leroy Ladurie examine a number of stories, circulating from the twelfth century in folkloric as well as Latin sources, concerning marvelous and diabolical women who turn into dragons and disappear when discovered.[23] Though animal-human transformations in *Yvain* are strictly figurative, such stories nevertheless furnish a useful background for Laudine, especially since some of the suspect wives were sighted in dragon form while taking their bath, a watery sign that also plays an important role in Venantius Fortunatus's *vita* of Saint Marcel, the fifth-century bishop of Paris represented spear-

ing a dragon on Notre-Dame Cathedral. In analyzing that sixth-century account, Le Goff traces a variety of associations from the fifth to the late twelfth and early thirteenth centuries, which yield two different attitudes toward dragons. Clerical culture's unequivocal distinction between good and evil, like Yvain's allegory, imposes a totally negative view of the dragon as the symbol of Satan. But folkloric culture, more ambivalent, links dragons with powerful natural forces that may be beneficial or destructive and must therefore be propitiated through primitive rituals to remain inoffensive or positive in their effects. Le Goff suggests that the twelfth century's development of an aristocratic lay culture with its own set of values made possible the breakthrough of this ancient view of dragons, despite clerical efforts to eliminate their ambiguity.[24]

Chrétien's romances are a prime site for constructing that aristocratic worldview, and I would argue that *Yvain* offers a glimpse of folkloric dragons associated with natural forces bringing both benefits and destruction.[25] Such forces may incarnate a particular place and are particularly associated with watery places, like the marshes of Paris for the dragon vanquished by Saint Marcel,[26] like the fountain that functions as synecdoche for the Lady of Landuc. However wondrous its mechanism, her fountain operates as an irreducible feature in the natural environment, linked to violent as well as beautiful forces: the storm unleashed by pouring water crashes down trees and shakes walls but ends with brilliant sunshine and joyous birdsong (echoes of lyric springtime and love). When the fountain's defender attacks, this natural sequence is layered in chivalric custom: the homology between nature and human nature hinges on parallel acts of violence, which may lead paradoxically to love and marriage.

And just as the borders of nature constantly shift in contrast to what lies above, beyond, or below it, so, when we try to define her, the lady of the fountain refuses to be contained within the boundaries of place or human genealogy. Laudine's identity shades off into problematic realms, natural, marvelous, possibly diabolical; she is a force connected to love and joy but also to violence and destruction. The last of many repetitions of the storm's violence—"when it seemed as if the entire forest must sink into the abyss" (6528–29)—provokes her barons

to curse the founder who first placed the castle on such vulnerable land. Thus summoned, the *châtelaine* must defend "*sa* fontaine" (1737), hers yet containing forces beyond her control.[27] She needs a man to defend it, but in the final episode it is precisely her husband Yvain who makes war on the fountain he claims as *his* (6508–9). The romance seems to question whose power, natural or human, can really possess and tame the fountain's dangerous gifts.

Natural forces encapsulated by the fountain "outside" read "inside" as the elemental drives of human emotion, a mirror of Yvain and Laudine's psychological storms and passions played out in the complex project of joining them, across the differences and similarities of men and women. In the couple, the minimal unit of human society, nature and sex furnish the building blocks of culture. Yvain is irresistibly drawn to the fountain, first by the mediation of Calogrenant's account of his misadventure, then by accident ["aventure"] (3486) just after matching up with the lion, again in defense of Lunete, and finally by choice in the last episode. What propitiatory acts can gain the favor of the fountain, the lady, the life-giving, socially enhancing riches of water and land? How does one avoid the serpent's bite while winning love, goodwill, power? As Fortunatus tells it, Saint Marcel defeated the dragon to claim a place for civilization not by killing but by banishing it: ordered to stay hidden in the water or the wilderness, the dragon disappeared without a trace.[28] The bishop's verbal command eludes the cycle of violence tied to weapons of war; the wondrous and threatening force of nature expressed in this watery place retires, not destroyed but tamed and hidden away by the power of the miraculous. In Chrétien's romance no miracle occurs, but we may speculate that, when words rather than arms effect the reconciliation between Yvain and the lady, we encounter the same recognition that dragons, inside and outside human nature, can be restrained but do not cease to operate at some level in nature's hidden places, in the psyche and the body, as in the fountain.[29]

We have seen that the clever manipulation of words is one way to trap and tame. In the final episode, Lunete catches her mistress with an oath to prevent retaliation and secure a pardon for the Knight of the Lion, who, unbeknownst to them, is the one making war on an undefended fountain. "Prise" by Lunete's words (6751), Laudine is made to forgive the one who prizes her so little ["riens ne me prise"] (6752) and

to love him in spite of herself, since she would otherwise never have accepted reconciliation, "peace" in feudal terms:

> That which I do not want to take up again nor do I care to remember, since I must be accorded with him, would have always simmered in my heart, just as fire smolders under ashes.

> Tous jours mais el cuer me couvast
> Si com li fus cueve en la chendre,
> Che dont je ne veul or reprendre
> Ne ne me chaut du recorder,
> Puis qu'a li m'estuet acorder.
> (6762–66)

This is a new twist on the dragon's angry fire and the flames that earlier heated up in parallel descriptions of love, the burn more intense the more impeded. Here the lady actively suppresses and hides away her inner fire, constrained if not yet propitiated by the binding force of her word.

To fully appreciate the consequences of this verbal surrender, still sizzling with draconian firepower, we need finally to explore the inner and outer borders of Laudine's heart *(cuer, recorder, acorder)* and the fountain as threshold to it. In joining the couple, the play of language speaks to the rational animal, human and social, but the sexuality of bodies, associated here with the animal realm, requires something more than words to catch fire and keep hold. If, as we have seen, the boundaries of human identity can shift inside and out in relation to animals who represent different aspects of the human, so too the body itself can be dismembered or re-membered in the exploration of the self, broken into movable pieces as the reconstructable self finds its parts redistributed within and without. That is one way to understand the extensive attention paid to body parts that wander through the actions, emotions, and verbal texture of the romance. The lover's yearning heart that separates from the body and joins the beloved is a well-known topos of troubadour lyric frequently exploited by Chrétien—we saw it combined with animal images as the lovers' hearts pull like horses toward the beloved. Indeed, Yvain was first tamed by the force of his heart holding

fast to Laudine (2017–18). In medieval psychology, the heart does heavy duty as the site of memory, love, courage, will.

These examples tend to efface the outside border of difference to bring two bodies together into one. But the narrator's long rhetorical riff on Yvain's and Gauvain's contradictory emotions as adversaries looks within the body to find the separate parts it contains. Like a lodging, the body has different rooms (6029; cf. 1382–1409): with love enclosed in a hidden chamber, hate charges forward, spurred on like a horse (6038) whose passion this time is martial. Elsewhere pieces of the body animalized become extensions of the self: the angry dog with raised fur that Yvain imagines for himself (645) materializes in the lion's menace, fur and crest erect (4213, 5527). These descriptions move from the lover's heart to the heart of the knight, intent on more literal dismemberment. Just as the animals hunted by Yvain and the lion became chunks of meat, so pieces torn off the giant are treated by the narrator's figurative language as food: Harpin's blood flows like sauce (4196); a piece of his cheek cut off is meat skewered for grilling (4209); he is larded (4231) with two blows of Yvain's sword. Reduced to subhuman pieces of flesh, the superhuman giant falls dead, destroyed by the lion-knight, whose animal ardor fires the narrator's graphic descriptions. Animal and human bodies thus intermingle as the integrity of the body undergoes ennobling enhancement by joining with another or degrading reduction into consumable flesh.

Following the body's movable bits and pieces appears to lead away from Laudine's heart, yet each of these images plots a necessary stage in Yvain's return to her good graces. To prepare the final image of reluctant but obligatory forgiveness, Lunete's trap masterfully choreographs words and gestures. Under pressure to find a new defender, the lady of the fountain must agree to swear that she will do all she can to reconcile the Knight of the Lion with his lady. Lunete first states the oath: Laudine must work until he has his "lady's good heart/will" [le boen cuer sa dame] ([Roques] 6638). Following medieval procedure, her mistress restates it—

My heart will never weaken as I do all I can to return to him the love and grace he used to have from his lady.

ja mes cuers ne sera fains
Que je tout mon pooir n'en faiche.
L'amor li rendrai et la grace
Quë il seut a sa dame avoir.

<div align="center">(6644–47)</div>

—and falls neatly into the verbal trap. But what is the precise mechanism of this deceitful game in terms of bodies and pieces, male and female identity? Laudine's heart is here doubled: inside her body, as the will to obtain a knight's pardon with his lady in exchange for his service; outside, in a putative other body she does not perceive to be her own but that of an unknown lady who, like a dragon, has the lion-knight by the tail. The phantom lady is located between two men's names, one hidden by the other, two bodies that are in fact one: the errant Yvain, whose anger against himself, experienced at the moment of falling into madness, has now been turned outside against his lady's fountain, his fountain, his lady; the knight-errant whose good service for women and against evil in a variety of human, animal, and monstrous forms has been expressed in the literal hacking of bodies to pieces, as in the figurative exchange of human heart with lion heart, earning him the right to call himself the Knight of the Lion and defend the fountain against himself. Two male bodies are reunited as one, united not with the shadowy phantom but with the real lady, as in the final image in B.N. fr. 1433, where Yvain and his beloved are pictured embracing in a bed decorated with a lion.[30] Once the heart is given, the rest must follow.

The heart will follow, that is, if you have the necessary key. Two guardians take their stand at the inner and outer precincts of Laudine's heart. Lunete plays the inside role twice, mediating between Yvain and the Lady of Landuc. As their names alliterate in the liquidity of l's, she appears in some sense as Laudine's better angel, as opposed to her dragon face:[31] her good twin, or rather the feminine face of her Moon, the traditional sign of woman, lit by the figure of her companion and masculine counterpart, the radiating Sun that turns away from Gauvain, failed solar hero, to shine on the ardent heroism of the lion-knight.[32] Outside the castle lies the fountain, with its mysterious tie to the lady and the land: unless you attack it, you cannot enter and defend it. But the path to that adventure appears to be guarded by a marvel as curious

as the magical fountain: the *vilain,* described by Calogrenant as seven-
teen feet tall, with a long horse head, elephant ears, cat's eyes, a wolf
mouth, and boar's teeth, dressed in two hides, who guards wild bulls in
the forest and tames them by physical force.[33] Passage to the lady and
her fountain is oddly routed through an encounter with a being who at
first glance is not human, monstrous in size, animal in shape, or rather
not a single animal but a hybrid of the domestic and wild, the exotic and
familiar, all predators of one sort or another.[34] Another intermediate
figure between animal and human, his excessive form mirrors that of
the giant Harpin who also carries a club and wears an animal skin. He
anticipates the wild man that Yvain will turn into when he loses his
human self and becomes a speechless animal living in the forest, hunt-
ing with uncourtly bow and arrow. Though Calogrenant first thinks this
vilain without reason and incapable of speech, he speaks eloquently.
Queried as to what he is, a good thing or not, he replies, "I am a man"
[Je sui uns hom] (328). "What kind?" "Such as you see me, never other-
wise" (329–30). Like those intermingled human and animal forms that
decorate *Yvain*'s opening letter in B.N. fr. 12603, this rustic giant is a
human hybrid of animals, as well as a hybrid of all those intermediary
forms scattered throughout the romance.[35] A proleptic *mise en abyme* of
Yvain reflected through multiple animal comparisons, the *vilain*'s unset-
tling identity elicits questions about the good and its opposite, the na-
ture of the human in relation to animals, the use of natural force, reason,
and speech in human activity, the role of change over time. Any knight
seeking the adventure of Laudine's fountain must first meet an un-
knightly figure who poses the conundrum of his human and animal
selves.

You need animals to know the human, male and female; you need a
dragon as well as a lion to know something about Yvain and Laudine as
they change and stay the same in the course of unexpected events and
meetings that reconfigure their identities, the good and the bad, the
parts and the wholes, the shifting animal-human combinations. Reread-
ing the central image one last time, through the romance's final scenes,
we can see how the dragon still has the lion by the tail, as Laudine holds
Yvain through his love for her, through the mutual fire of their sexu-
ality. His tail smarts with the bite of love and anger, but this time the

lion is definitely not trying to get away. He has learned to accept the risk of wrestling with dragons, and he too has a hold on Laudine. Last time, the dragon was chopped into pieces (now visible as a figure for Yvain's desertion turning love into hatred). This time, like Saint Marcel's dragon, the lady is tamed by words, summoned to hide her destructive power in the fountain's watery domain, her fire banked under ash, a dragon propitiated by binding words, so that she can supply the benefits of love and wealth, so that he can defend the fountain. In a mutual pact of aggression and nonaggression, in which both are victim and aggressor, each is tamed by the other to form a *conjointure,* like the romance itself, of violence and love, animal and human. Just as the sun outshines the moon, Yvain's friendship with the noble lion almost obscures the more indirect, ambivalent hybrid formed by Laudine and the dragon. But readers should not be fooled by the play of light and shade: human nature, whatever the sex, shows its dark and bright sides here. And the romance implies that ladies, creatures of a changeable moon, turn the tides of man and men no less powerfully than the more spectacular exploits of a lion-knight. Human animals, male and female, so hard to join and hold together across their sexual and social differences, share the ambiguities of human identity, fractured, shifting, recomposable, and persistently explored through animal others, the many in-betweens that link the human and inhuman, the animal and not-animal, whether inside or out. Hiding away Laudine's dragon in the obscurities of romance may be read finally and paradoxically as a form of authorial respect: both a bid to propitiate her natural force and a word trap triggered by a clever romancer, eager to catch the power of her hidden fire to light his own literary flame.

NOTES

The chapter epigraphs are taken from, respectively, Giorgio Agamben, *The Open: Man and Animal* (Stanford: Stanford University Press, 2004), 26, and Jacques Le Goff and Pierre Vidal-Naquet, "Lévi-Strauss en Brocéliande," in *Claude Lévi-Strauss: Textes de et sur Claude Lévi-Strauss,* ed. Raymond Bellour and Catherine Clément (Paris: Gallimard, 1979), 316 n. 1.

 1. *Le Chevalier au lion* is named only in the epilogue.

2. On the abusive generalization of opposing the human to "l'animal" in the singular, see Jacques Derrida, *L'animal que donc je suis,* ed. Marie-Louise Mallet (Paris: Galilée, 2006), 53–73.

3. Quoted in Agamben, *Open,* 22. On "caesuras," see 15–16, 79. As in the tradition they both critique, universal "man" (with little or no regard to gender) remains the focus of philosophical discussion in Derrida, *Animal,* and Agamben, *Open.*

4. Ibid., 38.

5. The romance's difficulties in discerning the human resemble medieval clerical authors' "fluid, potentially contradictory" definitions of the natural and the supernatural; Robert Bartlett, *The Natural and the Supernatural in the Middle Ages* (Cambridge: Cambridge University Press, 2008), 26.

6. Michel Stanesco, *"D'armes et d'amours": Études de littérature arthurienne* (Orléans: Paradigme, 2002), 102. On grateful lions, see 94–109.

7. All citations to this work are to line numbers and are taken from David F. Hult's edition in Chrétien de Troyes, *Romans* (Paris: Livre de poche, 1994), unless designated by "Roques," meaning Mario Roques's edition, *Yvain, ou Le Chevalier au lion,* Classiques Français du Moyen Âge 89 (Paris: Champion, 1970), occasionally resorted to for Guiot's version. My translations are as literal as possible.

8. Cf. Lancelot's role as "the one who will give the measure."

9. "Enraged boar" also translates *pors forsenés,* but the choice of *pors* rather than *sengler* (302) suggests the comic change in register in this parody of *Pyramus and Thisbe,* which adds overtones associated with male-female couples to the lion-knight companionship.

10. See Bartlett on dogs versus dog-headed creatures (*Natural and the Supernatural,* 94–110) and "the fascination medieval observers felt for any animal activity that seemed to mimic rationality" (91).

11. Cf. Jeffrey J. Cohen's notion of the "knight-horse" in *Medieval Identity Machines* (Minneapolis: University of Minnesota Press, 2003), 46–47.

12. Comparisons bringing together horses, women, and sexual desire are available to the medieval public in a variety of tones, from the exalted love of the Song of Songs, where the male voice compares his beloved to a mare among Pharoah's chariots (1:8, translated by the Vulgate as cavalry, *equitatui meo*), to the first troubadour's boasting claim to have two horses for his saddle, Lady Agnes and Lady Arsen (Guilhem IX, *Companho, farai un vers tot covinen*). On sexual desire mediated by chivalric excellence, see René Girard, "Love and Hate in *Yvain,*" in *Modernité au Moyen Âge: Le défi du passé,* ed. Brigitte Cazelles and Charles Méla (Geneva: Droz, 1990), 249–62.

13. Cf. the miniatures: in B.N. fr. 1433, fol. 85, the lion faces off to the left, with the dragon behind and entwined, as if pursuing him; in Garrett 125,

fol. 37, the dragon faces right toward the lion, whose body also moves right, while his head turns back to see the dragon's hold on his tail. *The Manuscripts of Chrétien de Troyes,* ed. Keith Busby, Terry Nixon, Alison Stones, and Lori Walters, 2 vols. (Amsterdam: Rodopi, 1993), figs. 240 and 315.

14. Anticipating a possible attack, Yvain also acknowledges the lion's negative association with excessive ferocity.

15. Peter Haidu, *Lion-Queue-Coupée: L'écart symbolique chez Chrétien de Troyes* (Geneva: Droz, 1972).

16. Le Goff and Vidal-Naquet, "Levi-Strauss en Brocéliande."

17. Marie-Noëlle Lefay-Toury, "Roman breton et mythes courtois: L'évolution du personnage féminin dans les romans de Chrétien de Troyes," *Cahiers de civilisation médiévale* 15 (1972): 193–204 and 283–93; E. Jane Burns, "The Man behind the Lady in Troubadour Lyric," *Romance Notes* 25 (1985): 254–70; Roberta L. Krueger, "The Question of Women in *Yvain* and *Le Chevalier de la charrete,*" in *Women Readers and the Ideology of Gender in Old French Verse Romance* (Cambridge: Cambridge University Press, 1993).

18. By turning black (5934) when she sees her sister arrive at court, this "evil [male] creature" (6189) associates herself with the two demon sons (5508). Though women often suffer from male violence in this romance, here both victim and aggressor are female, just as Laudine herself plays both roles. Echoing the fraught link between the Lady of Landuc and Lunete, the sister theme also puts into relief Gauvain's questionable service as brother-in-arms here and elsewhere (cf. references to his performance in *Lancelot*).

19. Frederic L. Cheyette and Howell Chickering, "Love, Anger, and Peace: Social Practice and Poetic Play in the Ending of *Yvain,*" *Speculum* 80 (2005): 75–117, argue that Yvain's attack against the fountain, motivated by anger against Laudine for his public humiliation, constitutes a strategy to negotiate peace and end their conflict, according to standard feudal practice.

20. According to the twelfth-century liturgist John Beleth, the smoke of bone-fires lit on midsummer night kept away dragons (Bartlett, *Natural and the Supernatural,* 71–72). With Arthur's arrival at Laudine's fountain and the limit of Yvain's leave both linked to St. John's Day, we might wonder if Chrétien and his readers knew the custom.

21. Laudine's oxymoronic association with fire and water may serve as a figure for her contradictory nature as dragon (see below).

22. Cf. the *lais Graelent* and *Guingamor.* See Laurence Harf-Lancner, *Les fées au Moyen Âge: Morgane et Mélusine, La naissance des fées* (Geneva: Slatkine, 1984).

23. Jacques Le Goff and Emmanuel Leroy Ladurie, "Mélusine maternelle et défricheuse," *Annales: Economies, sociétés, civilisations* 26 (1971): 587–90.

24. Jacques Le Goff, "Culture ecclésiastique et culture folklorique au Moyen Âge: Saint Marcel de Paris et le dragon," in *Un autre Moyen Âge* (Paris:

Gallimard, 1999), 256–65. The reemergence of this folkloric dragon can be glimpsed in the custom of parading a dragon figure in Rogation processions: in Paris, people threw cakes and fruits into a wicker dragon's open mouth (possibly as large as a pot!).

25. Marie de France's fables 52 and 72 also associate men with dragons whose riches can be won or lost. In fable 72, dragon and betrayal are feminized when the wife incites her husband to deceive *une serpente.*

26. Le Goff, "Culture," 237 n. 25, 244–45.

27. Cf. Aristotelian and Galenic views of female sexuality. See Vern L. Bullough, "Medieval Medical and Scientific Views of Women," *Viator* 4 (1973): 485–501.

28. Le Goff, "Culture," 268.

29. Wace famously complained that he couldn't find the fountain of Broceliande.

30. Fol. 118r shown in Busby, *Manuscripts,* fig. 318 (507).

31. Regarding the alliteration, cf. the alliterating la**d**y of *Lan*d**uc, daughter of **D**uke *Lan*d**udet, whose repeated syllables conjure up **Lan**val and **Lan**celot. Given this play with naming, the absence and presence of Laudine's proper name, appearing in only three out of ten manuscripts, suggests the sort of trick associated with Yvain's incognito and multiple identities.

32. Despite his cosmic gloss as the sun of chivalry in relation to Lunete's moon (2398–415), Gauvain is eclipsed by the lion as solar hero: Yvain must go back to nature, back to the animal, to recalibrate the appropriate human measure.

33. The *vilain*'s domination of his bulls offers a reductive vision of Yvain's companionship with the lion. Cf. Donald Maddox, *The Arthurian Romances of Chrétien de Troyes* (Cambridge: Cambridge University Press, 1991), 54–81.

34. Chrétien uses the same technique in describing the Hideous Damsel in *Perceval.*

35. Human-faced animals, some with dragon bodies, and other assorted creatures, fill the letter A as six dragons climb up and down its sides. Busby, *Manuscripts,* pl. IIId (346) and fig. 299 (495).

II

Embodied Souls

———

Rubber Soul

Theology, Hagiography, and the Spirit World of the High Middle Ages

DYAN ELLIOTT

"Who are you?"

"Ask me who I *was*."

Charles Dickens, *A Christmas Carol*

ONE SUMMER NIGHT IN THE LATE ELEVENTH CENTURY, GUIBERT OF Nogent's widowed mother was just dropping off to sleep when "her soul seemed to leave her body without her losing her senses." Suddenly, she was standing at the edge of a pit filled with terrifying specters, among which she recognized her husband, Evrard, as he had appeared when still a young man. But when she asked the specter if he was, in fact, Evrard, he denied it. Guibert attempts to explain: "Now it is no wonder that a spirit should refuse to be called by the name which he had as a man, for spirit should give no reply to a spirit which is inconsistent with its spiritual nature. Moreover, that spirits should recognize each other by their names is too absurd to be believed; otherwise in the next world it would be rare to know anyone except for those close to us.

89

Clearly it is not necessary for spirits to have names, since all their vision, or rather their knowledge of vision, is internal."[1] Guibert's reasons may strike one as somewhat specious: Wouldn't it be easier for spirits to get to know other spirits if they did have names? And if the spirits' vision was entirely internal—which I am taking to mean a spiritual sense turned inward—how would they manage to meet other spirits anyway? Equally unsatisfactory is the implication that names are somehow inconsistent with the nature of spirits. For one thing, why didn't the spirit of Guibert's mother know about this inconsistency? Was her sojourn in the spirit world too fleeting? The real conundrum, however, is that the spirits of the dead seem to have been dissociated from their names, and presumably the identities that went with them, yet they maintain the same appearance that they bore when they were in the body. How could that be? Is the implication that the soul has a body of its own and that this body is gendered?

These are, as we shall see, questions that were still very much up in the air at the time that Guibert was writing. By the thirteenth century, however, answers necessarily began to emerge in the course of the ever increasing traffic between this world and the next. The present study examines how the implicit doctrine that developed in the course of Beguine hagiography provided a permanent bridge between living and dead, confirming both the continuity of identity of the deceased and Christianity's theological commitment to the integral nature of body and soul. At the same time, however, the solidification of a postmortem identity had important consequences for gender: for although the soul was supposed to be devoid of sex, hagiography created a supernatural landscape in which body gradually drained into soul.

BODY, SOUL, AND GENDER

What do we call a human *[homo]?* Do we mean body and soul, just like a team of horses or a centaur? Or is it just a body which is being used by the soul that rules it, like a lantern, which is not the flame and the container together, but only the container, although we call it a lantern because of the flame? Or do we say that a human is

nothing other than the soul, but on account of the body it rules—just as we call a rider not for the person and horses together but for the person alone? But is it only when that person is attending to governing the horse?

Augustine, *On the Customs of the Catholic Church*

As problematical as the relationship between body and soul might be, Christian theology regarded both components as integral to the human condition—in this life as well as the next. This is to be expected in a religion that was built around the resurrection of the body. To show the interdependence of body and soul, Tertullian (d. ca. 220), the first true theological voice in the West, even posited their simultaneous creation by the same act of insemination, an act that would also determine gender.[2] "The soul, being sown in the womb at the same time as the body, receives likewise along with it its sex; and this indeed so simultaneously, that neither of the two substances can be alone regarded as the cause of the sex. . . . The insemination of the two substances are inseparable in point of time, and their effusion is also one and the same, in consequence of which a community of gender is secured to them."[3] For Tertullian, the incarnation of Christ provided winning proof that both body and soul were essential to human nature and hence that the two were equally destined for salvation. "Both natures has He [Christ] already united in His own self: He has fitted them together as bride and bridegroom in the reciprocal bond of wedded life. Now, if any should insist on making the soul the bride, then the flesh will follow the soul as her dowry. The soul shall never be an outcast, to be had home by the bridegroom bare and naked."[4] Tertullian would eventually insist that resurrected humanity retained not only their bodies but their sexed bodies—an anomalous position in view of his acknowledgment that procreation would cease in the afterlife.

Although Tertullian's position on the seminal soul was ultimately rejected, Western theologians nevertheless sustained his strong impetus in favor of an embodied and sexed afterlife. This predilection presented distinct challenges for women, whose bodies were construed as markers of subordination. This was decidedly true in the classical medical and philosophical tradition in which women were famously perceived

as failed men.[5] But female deficiency was seconded by what would become mainstream interpretations of the two moments of creation described in Genesis. Initially we are told, "And he [God] said let us create man to our image and likeness *[ad imaginem et similitudinem nostram]*. . . . And God created man *[homo]* to his own image: to the image of God he created him: male and female he created them" (Gen. 1:26–27). Although *homo* is better understood as "humankind" versus the gendered designation "man," nevertheless some commentators found these passages sufficiently opaque as to provide warrant for arguing that only Adam had inherited the true image of God. This view would be corroborated by the later description of the creation of Eve from Adam's side (Gen. 2:22), rendering her something of an afterthought, albeit it a divine one. But for many early Christians, the priority of creation and gender alike were lesser considerations. Much of the allure of early Christianity resided in the possibility of an equality based on the abolition of biological sex and gender roles altogether. Christ's comments on the afterlife, where there would be no marriage and humankind would live like angels (Matt. 22:30), was often interpreted as supporting this optimistic androgynous strain. The impetus to move beyond sex was probably best expressed in Paul's statement that in Christ there was no male or female, but that all were one in Christ Jesus (Gal. 3:28). Even so, Paul himself was divided on this score, undermining the case for a genderless future by requiring women to cover their heads, rationalizing that only man was made in the image and glory of God (cf. Gen. 1). He drove this point home with a reminder of Eve's secondary creation (1 Cor. 11:7–8).

How was one to reconcile these apparent contradictions? The patristic solution was to compartmentalize. It was the body and the body alone that designated sexual differentiation and hence female inferiority. In contrast, the soul as a spiritual substance was necessarily sexless. But not all parts of the soul were equal. Generally the soul was regarded as having three divisions: vegetative, animal, and rational. While other life forms partook of the two first categories, the rational soul was invested in humankind alone. The rational soul itself was also subject to division, however. Augustine had distinguished between the lower rational soul, which negotiated the outer world via the senses and

the imagination, and the higher rational soul, which alone bore the image of God. It was in the context of the higher rational soul that the promise of Galatians was fulfilled and that men and women could become truly equal. And yet the priority of Adam's creation and the devaluation of the female body still left open the question of whether women partook of God's image equally with men.[6]

But let us linger for a moment on the road not taken. What if the West had chosen *not* to retain the body in the hereafter? At the time that Tertullian was writing, a number of Gnostic sects believed that the essence of humanity was spiritual and that the body was detritus to be left behind in the afterlife, where sexual distinction would likewise vanish.[7] Somewhat ironically, the idiom in which they expressed this richly anticipated terminus was often reliant on the sexist metaphor of women being turned into men in preparation for the ultimate ritual of the bridal chamber. However unfortunate the image, this ritual placed men and women on an equal footing for their eventual disembodied union with the divine. It is also possible for this image to be inverted. According to Tertullian's satirical characterization of the Valentinian Gnostics, at the end of time the truly worthy men would be stripped of their sex and united as brides to their angelic grooms. Of course, Tertullian could not resist the opportunity of taking a swipe at the prospect of such wizened, bewhiskered brides.[8] Still, the Gnostic perspective on humanity exerted a wide appeal. The great, but ultimately heretical, Alexandrian theologian Origen (d. 232) likewise saw human history as a devolution of spirit into matter. Thus he argued that the "tunics of skin" *(tunicas pellicias)* that God gave the postlapsarian Adam and Eve were, in fact, their bodies (Gen. 3:21).[9] Even Tertullian's open scorn for the Valentinians should not be mistaken for total indifference to the appeal of Gnosticism. In an earlier treatise on female dress one can feel the Gnostic undertow in his exhortation: "The same angelic nature is promised to you, women, the selfsame sex is promised to you as to men."[10] Likewise, lurking behind Augustine's parallel disparagement of the dualist Manichaees and their fanciful cosmology was his history as an auditor in the sect.[11]

By the end of the patristic period, speculation on the contingency of gender in the afterlife ceased, even as the war against Gnosticism

and its dualist tendencies appeared to have been won. There were exceptions. For example, the eccentric Carolingian theologian John Scotus Erigena (d. ca. 877) was deeply influenced by Origen. Erigena would thus argue that Christ had risen from the dead in an androgynous spiritual (versus corporeal) body.[12] But it was not until the High Middle Ages that we can again see the rise of some interesting speculation on the relationship of body to soul—questions in many ways germane to the kind of identity problems that we saw Guibert of Nogent grappling with. There was even the revived possibility of a Gnostic-inflected androgyny.

Orthodox theologians tended to uphold the party line, which advanced the permanence of gender and the body, though differing on the extent to which both sexes inherited the image of God. Rupert of Deutz (d. 1129), for example, understood the *image* of God in terms of reason and *likeness* in terms of justice. After the fall, humanity lost justice but retained reason. Initially it is unclear whether Rupert's assessment accommodated woman. The fact that he later maintains that Eve was already corrupted in three ways before she gave her answer to the serpent might inspire doubt on this score. Yet Rupert eventually comes out on what we might consider the more enlightened side, arguing that Eve was, in fact, created in God's image, since both sexes shared reason equally.[13] This affirmation required that Rupert carefully skirt around Paul's requirements regarding female veiling, in which the apostle avers that man is the glory of God and woman the glory of man. But instead of succumbing to this apostolic reasoning, Rupert tackles the Pauline distinction full on, commenting that Paul never said that woman was "the glory *and image* of man." In contrast, Peter Abelard (d. 1142) would argue on the basis of the same text that man alone bore the image of God, while woman bore only God's likeness *(similitudinem)*. He did grant, however, that women were possessed of reason and immortality, hence emulating God in these essential ways. But man possessed these qualities in greater abundance, which was why he was not seduced by the serpent.[14]

The question of whether woman was made in God's image would have a negligible impact in the temporal realm, however. The image of God was tucked away in the upper reaches of the rational soul, and no

one doubted the inferiority of the female body and its deleterious ef-
fects on the lower, more mundane, part of the rational soul. But would
the same conditions pertain when a person was separated from his or
her body? Mystical rapture was believed to be such a state. Paul had
spoken about a man (presumably himself) raptured to the third heaven
who knew not whether he was in body or out of body (2 Cor. 12:3). But
let us put this spiritually rarefied experience to one side for the moment
in favor of the one instance of disembodiment that was common to all:
when the soul separated from the body in death. The general consensus
was that only after the Last Judgment would an individual be reunited
with his or her body, albeit a refurbished and in most cases rejuvenated
one.[15] But there was that indefinite interval between dying and resurrec-
tion when a soul had no body. And if there was no body, wouldn't that
mean that there would be no need for the lower rational soul? Wouldn't
all that remained be the image of God, which, from a patristic perspec-
tive, had no sex or gender?

If this were the case, the period spanning death and resurrection
might constitute a brief taste of what Erigena had imagined eternity to
be. Yet for most religious authorities this interim state emphasized the
necessity of a body. Bernard of Clairvaux (d. 1153), for example, viewed
the disembodied soul as a "glorious church, without spot." Its only lim-
itation was a kind of reflexive longing for the body, which Bernard him-
self found incomprehensible.[16] Peter Lombard (d. 1160), citing Augus-
tine, addresses this question directly: "Someone may ask what use it is
for spirits of the dead to receive their bodies at the resurrection, since
the highest blessedness can be offered them without their bodies. This
is a difficult question, nor can it be completely settled by us. And yet it
is not in doubt that the mind of man, once taken away from the senses
of a flesh which has been set aside in death, is not able to see the un-
changeable substance as the holy angels see it. This may be so for some
hidden cause, or because there is in the mind some natural desire to rule
the body, and it is held back by this desire from tending with all its
might to that highest heaven, until that desire comes to rest."[17] Bewil-
dering as it may be, the body exerted a powerful gravitational pull even
in its absence.

There was at least one author, however, who explored both sides of the equation at different points in his life. Around the year 1100, relatively early in his career, Honorius Augustodunensis wrote the *Elucidarium*—a theological commentary that seemed determined to explore the interim period of bodilessness between death and resurrection. The *Elucidarium* presents an image of the afterlife that more or less corroborates the vision experienced by Guibert's mother. As seemed to be the case with the spirit that Guibert's mother recognized as her husband, Honorius argued that the souls of the dead bore the same appearance they bore in life "in a human body out of air."[18] The degree of corporeality in Honorius's afterlife is rather murky, however. On the one hand, he tells us that the blessed deceased are destined for a spiritual mansion, though this is not a physical place "because spirits do not inhabit physical spots." Yet the more modest elect, who have worked out their salvation through quotidian paths like marriage, are admitted to an "earthly paradise" with the caveat that "spirits should not be believed to live in corporeal spots."[19] The souls also inhabit aerial bodies that can feel pain: Honorius compares the aerial bodies of those in purgatory to the bodies of demons, which were fashioned specifically with painful torments in mind.[20] The inhabitants of purgatory are helped by the alms, vigils, and other supplications of the living. But they can also enjoy fleeting appearances from angels and saints, who occasionally send them a fresh breeze or a special fragrance for relief.[21]

The people who are eternally damned are much worse off. They are subjected to nine different types of punishments engineered to afflict the spiritual senses (such as fiery torments, palpable shadows, and unbearable stench), all the while uncomfortably arranged back to back and upside down with their feet in the air. Yet this unpropitious posture does not inhibit their view of the relatively happier souls above them in purgatory (which is an annex attached to the upper level of hell). Moreover, the purgatorial souls seem so well off comparatively that the less fortunate souls in the lower hell believe they are looking at the refreshment of the saints. This is as high as they are permitted to look, however.[22]

Meanwhile, the blessed can see everyone living and dead. Not only do they recognize one another with full awareness of all the merits and

demerits of the other souls, whether saved or damned, but they can also see and recognize their loved ones, know them by name, and pray for the ones either on earth or in purgatory who can still benefit from prayers. The damned are past help. Furthermore, the elect have no sympathy for them and would not think of praying for them.[23] In addition to different levels of vision, spiritual merit is reflected in a given soul's mobility. The elect are extremely mobile—they can appear whenever, wherever, and to whomever they want; the souls in purgatory can appear on earth only with angelic approval; but the denizens of hell are destined to stay where they are. If they do seem to appear, it is usually demons masquerading in their form. The one exception to this rule is the rare occasion when one of the damned is permitted to appear before a saint.[24]

Although dependent on Augustine for many particulars, Honorius's version of the afterlife is still characterized by an idiosyncratic and bizarre sense of precision. Yet as extensive as Honorius's knowledge of supernatural climes might have been, he was not alone in attempting to access this privileged information. The much more mainstream Peter Lombard likewise raised questions concerning the purgation of those who had departed this life: how bodies could be burned without being consumed; and how incorporeal spirits could be burned by a material fire. Such questions speak to a parallel perception of a spirit world that was heavily laden with physicality.[25]

Honorius's attitude to materiality underwent a complete reversal some twenty years later, however, when he fell under the influence of Erigena.[26] Sometime in the 1120s, Honorius wrote the *Clavis physicae,* a condensed and slightly simplified version of Erigena's *De divisione naturae.*[27] Following in Erigena's footsteps, Honorius describes prelapsarian humanity as a spiritual body infused with reason, which is the image of God.[28] "If the first human *[homo]* had not sinned, there would be no division of the sexes. Rather, he would have remained immutably in the primordial faculties of reason *[primordialibus suis rationibus]* in which the image of God was constructed." These pristine entities would have multiplied in the same way angels did through a replication of intelligences. But humanity turned its back on this divine form of multiplication, instead following the corruptible way of animals. Offspring were

accordingly afflicted by a diversity of forms.[29] Later Honorius describes humanity's animalistic means of reproduction as a punishment rather than a choice,[30] even as emotions like fear, hate, and desire, though natural enough for animals, are unnatural for humans.[31] From this perspective, the categories of male and female are not a part of nature.[32] Moreover, the corruptible material body, made "from the slime of the earth" (Gen. 2:7), was assumed only after sin when newly divided humanity was expelled from paradise into dwellings of mud or tunics of flesh—that is, the body—in which the spiritual body still lurks.[33] The reunification of humanity begins with Christ, in whom there is no male and female (Gal. 6:3).[34] Humanity will be called back to its pristine glory as a "light spirit" *(levis spiritus):* free of corporeal gravity, it will ascend to the heavens.[35]

So radically negative a perspective on matter had portentous ramifications for the Incarnation. In a little-known set of questions Honorius denies that Christ physically descended into hell, concluding: "This reasoning compels us to confess that hell is spiritual, as transmitted by the authority of the highest fathers. For if the kingdom of heaven is spiritual, in which the highest of just souls rejoice, it is necessary that its opposite, i.e., hell, be spiritual, in which the souls of reprobates are tortured."[36] More provocative still is his denial of Christ's physical ascension into heaven, by the reasoning that "rising from death, the mortal body changes into spiritual, but spiritual thus changes into divinity just as light into air, retaining its own substance."[37]

Honorius was writing at a time when the church was not particularly concerned about dualism. Indeed, some theologians seemed in danger of forgetting the threat altogether. Thus Rupert of Deutz tries to explain why any reasonable person would associate the tunics of skin in which Adam and Eve were wrapped with the body, positing that some people were just unwilling to accept that the Creator of the world, who had stretched the vast canvas of the sky and placed the celestial bodies, should subsequently busy himself with stitching the skins of small animals. He nevertheless reviles this error, pointing to the priority of the body in Creation.[38] By the end of the century, however, what must have seemed an arcane theological premise was suddenly reanimated as a horrific possibility by heretics who came to be referred to

by their critics as the Cathars, a name derived from the Greek word for pure.[39]

The Cathar faith was a dualist movement that had a number of different regional sects with disparate beliefs.[40] In general, however, they were believed to be united by the conviction that the cosmos was divided up between a spiritual realm, which was good, and a material one, which was evil. A popular explanation for this polarized state of affairs was that the material world had come about as a result of a kind of revolt in the heavens, in which a number of celestial inhabitants (designated either as angels or as souls) were tempted to leave by Satan—often depicted as a rogue angel. Satan (a.k.a. Jehovah) created the material world in crass imitation of the spiritual realm. He made crude bodies out of flesh (tunics of skin) and lured angels inside to animate them. The misery of the human condition, moreover, was prolonged beyond a mortal life span, since the Cathars believed in reincarnation.[41] The only way to escape the mortal coil was to receive the *consolamentum*—a sacrament administered usually by the laying on of hands by a member of the Cathar priesthood (the Perfect). In short, life was literally hell, and the body was the prison in which the soul was incarcerated.[42]

GENDERED SOULS: THE BEGUINES AND THE SPIRIT WORLD

The mind is the eye of the soul; pure from every blot of the body; reason is the gaze of the mind; understanding is the vision. . . .

Just as it is often said, the soul is incorporeal, nevertheless it is able to have a body—not a corporeal body, but a body similar and with all the same bodily members from the one it left.

Thomas of Cantimpré

Contemporary dualists threw orthodoxy for a loop. Not surprisingly, the works of Erigena and Honorius were obscured by a pall of suspicion.[43] Suddenly certain orthodox turns of phrase seemed suspect. For instance, venerable authorities like Archbishop Hincmar of Reims

(d. 882) were wont to make gloomy pronouncements like "The body, by which the soul is clothed, is polluted by carnal works."[44] In a similar vein, the English cardinal Robert Pullus (d. 1150) described the soul as "dressed in flesh and skin," while hypothetically raising the question of why God would put a soul, made in his own image, into a sordid body in the first place.[45] Honorius too referred to the body as the clothing of the soul.[46] Both Honorius and Peter Lombard had compared the way in which angels and demons could transform themselves with the way in which a person could change his or her clothes.[47]

If the body, human or angelic, was understood as a mere garment that was easily assumed or shed, then all that separated the human and angelic races was an accident of fashion.[48] This perspective was corroborated by venerable attempts to align humanity with the angels. Robert Pullus alleged that "[God] united the soul of Adam and all angelic nature in heaven."[49] Likewise, the popular *Summa sententiarum* gives an account of Creation that could very well be mistaken for a dualist tract. It describes how God, wishing to share his state of beatitude, created rational creatures. Some of these creatures were destined to remain in their pristine (i.e., angelic) purity; others would be placed in mortal bodies. In addition to implying that humans were angels in mortal bodies, the assumption that all the souls were created at the same time, long before their designated bodies, also has a distinct dualist tonality.[50]

But these uncomfortable resonances did not cause orthodox theologians to question their commitment to the efficacy of the body or the immutability of gender. Their solution, as we shall see, was to reinvest in the body and gender alike. And from a prowoman perspective, this should probably be regarded as a good thing. Thus far I have been emphasizing the Gnostic, and by the same token Cathar, tendency to dismiss gender and body alike as transient, which was arguably conducive to equality between the sexes. The fact that the Cathar movement did initially permit female perfects may suggest an element of egalitarianism—at least in its early days. We can still catch a glimmer of this possibility in the imagery used as late as the fourteenth century in the Fournier register. In the course of retelling a popular dualist vision, one Cathar sympathizer propounded that there was no difference between man and woman except the flesh—the work of Satan, which would

eventually disappear. The image of woman being transformed into a man was also part of the heretical imagistic lexicon.[51]

But Catharism clearly went the other way, affected more by the difference between women and men on earth than by the anticipation of its abolition. Peter Biller has stressed the strong antifemale tendencies in Catharism, in both theory and practice, and has further challenged its purported appeal to the "material woman." On the basis of the remaining sources, it would seem that Catharism in practice was especially hard on woman's reproductive function: a pregnant woman was shunned and could not receive the *consolamentum* since she was considered to have a devil in her belly.[52]

The Beguine movement countered the antimaterial/antifemale tendencies associated with the Cathars. The earliest and most famous sponsor of the Beguines was James of Vitry (d. 1240)—theologian and eventually cardinal bishop of Tusculum in the Holy Land. Celebrated as a preacher, James had preached the Albigensian Crusade against the Cathars. His famous life of Mary of Oignies (d. 1213), the first biography of a mystic, continued this antiheretical initiative. The work was dedicated to Fulk, bishop of Toulouse, "who was exiled from his own city by heretics and had come . . . to beg help against the enemies of the faith"—an exodus from Egypt to the Promised Land, as James put it.[53] Apparently, Mary's life was written at the request of Fulk, who believed that the example of women such as her would be a powerful tool for preachers against heresy.[54]

The Beguines were at the forefront of the kind of embodied female spirituality that was characterized by Caroline Walker Bynum as follows: "Women were more apt to somatize religious experience and to write in intense bodily metaphors; women mystics were more likely than men to receive graphically physical visions of God; both men and women were inclined to attribute to women and encourage in them intense asceticisms and ecstasies. Moreover, the most bizarre bodily occurrences [were] associated with women (e.g., stigmata, incorruptibility of the cadaver in death, mystical lactations and pregnancies, catatonic trances, ecstatic nosebleeds, miraculous anorexia, eating and drinking pus, visions of bleeding hosts)."[55] James's *vita* emphasized extreme

asceticism and ecstasies—relatively moderate phenomena in an inventory of mystical affects that, as the above list would suggest, would become increasingly flamboyant. As I have argued elsewhere, James and his follower Thomas of Cantimpré (d. 1272) attempted to offset the example of heretical "martyrdom" through excessive asceticism that was displayed by the Beguine saints, who literally became living martyrs in their own bodies.[56] Their asceticism was a tacit rebuttal to the dualist vision of the disposable body: as opposed to acting as the soul's prison, the Beguine body effected its salvation. But it is especially significant that the hagiographical vehicle for achieving grace was not just any body but the female body. That the face of embodied holiness as unmistakably female served as a stern rebuttal of Cathar misogyny.

The second feature, ecstasies (or raptures), hold a peculiar place in the litany of female somatism insofar as the woman's enrapt and immovable physical body was the symbol of the soul's out-of-body, and out-of-gender, experience.[57] In the context of Paul's rapture, the *Glossa ordinaria* describes the third heaven as "a spiritual firmament where angels and the holy souls enjoy the contemplation of God."[58] Peter Lombard concurs. But he also aligns the three heavens with Augustine's three types of vision. The first type is corporeal, which perceives external objects; the second is spiritual, which regards mental images; but the third and most excellent vision is intellectual, where bodies and images are absent and the mind only gleans incorporeal substances fashioned for it by God. Or, better still, the first concerns knowledge of corporeal bodies, the second of celestial bodies, but the third of the realm of angels and of God himself.[59] In short, mystical ecstasy would seem to be one of those rarefied states during which the soul temporarily would be separated from the body, and hence from sex and gender.

Yet as the example of ecstasy suggests, a body was necessary to demonstrate a bodiless state. By the same token, it was one thing to describe ecstasy in theological terms, but in the realm of imagery and metaphor it was clearly another matter. And from this perspective it was difficult to keep the genderless soul in sight. For Gnosticism was not alone in describing union with God in terms of nuptial metaphors. Union with the divine had traditionally been described as a marriage between the soul as bride and Christ as celestial bridegroom. Origen

had long ago associated the soul's marriage with God with the potent lyricism of the Song of Songs.[60] This traditional symbolism was given a new lease on life in the wake of Bernard of Clairvaux's influential sermon cycle on the Song of Songs, which required that his audience (the immediate audience being his Cistercian brethren at Clairvaux) identify with the bride in her quest for union with God.[61] The Beguine movement, which was deeply indebted to Cistercian spirituality, was in the vanguard of what came to be known as bridal mysticism. Moreover, James of Vitry's prologue carefully weaves Beguine spirituality into the skein of the Song of Songs.

> Women were wasting away with such an intimate and wondrous state of love in God that they were faint with desire and . . . for many years could only rarely rise from their beds. There was no other cause for their sickness except him, since their souls melted with desire (cf. Sg 5.6) for him. . . . They cried aloud in their heart[s]. . . . "Stay me with flowers, compass me about with apples, for I languish with love" (Sg 2.5).
>
> Others were so rapt outside themselves with such a spirit of inebriation, that they rested in that holy silence throughout almost an entire day, "while the King was on his couch" (Sg 1.12); they neither spoke nor were sensible of anything external to them.[62]

The imagery was also applied to the Beguines' famous Eucharistic devotion: "Some of them ran with such desire after the fragrance (Cf. Sg 1.3) of such a great sacrament [the Eucharist] that in no way could they endure to be deprived of it; and unless their souls were frequently invigorated by the delights of this meal, they obtained no consolation or rest but utterly wasted away in languor."[63] Each was Christ's bride, who, like the bride of the Canticles, was sick with love.

When it comes to Mary's spirituality, there is no doubt that James believed Mary to have been privy to moments of pure intellectual vision, which he describes in precise theological terms: "Purged from the cloud of all corporeal images and every fantasy and imagining, she received in her soul simple and divine forms as if in a mirror."[64] This

brief acknowledgment of the intellectual nature of the vision tends to be overwhelmed by the careful adornment of Mary in her bridal best, however. In praise of her humility, James exhorts: "Why do you not show your Christ to the world? . . . When 'the King led you into the wine cellar' (Sg 1.3), is it not possible that you sometimes cried out in inebriation, O, Lord why are you hiding yourself? . . . For if the world knew you, it would sin no more but would immediately 'run after the fragrance of your ointment' (Sg 1.3)."[65] In prayer she enters "the bridal bed of divine counsel."[66] "With the savour of this wisdom" she "'lean[s] upon her Beloved' (Sg 8.5) . . . [eating] milk and honey from the lips of the Bridegroom' (cf. Sg 4.11)."[67] Toward the end of her life, Mary will move away from her relatives to be "more sweetly 'under the shadow of him whom she desired'" (Sg 2.3). As her foretold death approached "[she] now could not contain herself . . . impatient that there be any delay before she was able to embrace the Lord." "While she was being tortured with such violent desire and rapt outside herself, her entire body almost seemed to burst from the fullness of her heart." "She was inebriated and could not be silent." God revealed to her, "'There is not much time left to you,' and she heard the voice of the Lord calling her, 'Come my friend, my turtle dove! You shall be crowned.'"[68] The day of her death is presented as her wedding day. In anticipation of this great event, "The voice of the turtle was heard in our land" (Sg 2.12), as Mary sang her own Canticles—a song lasting two days and three nights.[69]

But mystical union was only one venue in which a disembodied soul might appear in the Beguine hagiographical corpus. A number of the Beguines were imbued with a special kind of prophesy that could discern the condition of souls of not just the living but even, and perhaps especially, the dead. Thus these women have been described as apostles or ambassadresses of purgatory, expediting the sentence of those imprisoned there and running messages between the dead and the living—a role that was already anticipated by Guibert's mother.[70] James of Vitry unabashedly stakes these claims for the Beguines. The prologue to the life of Mary makes brief reference to a woman whom those familiar with Thomas of Cantimpré's work would immediately recognize as Christina of St.-Trond (a.k.a. Mirabilis). This woman had died and was destined for paradise, but she chose to return to earth to

do penance for those in purgatory.[71] In a scene evocative of Polanski's *Repulsion,* Mary herself is terrified to see arms reaching out to her from she knows not where. Upon learning that these are the souls in purgatory, however, she begins to pray for them fervently.[72]

These souls, pathetically represented by arms alone, remain anonymous in their desperation. But the other two references to souls in purgatory in the *vita* are pointedly gendered. In one instance, Mary stands surety for a woman who is on her deathbed, and she is later shown an image of the woman in purgatory. Another occasion concerns a good widow formerly married to a merchant who, "in the manner of merchants, had acquired some goods by fraud." Mary warns the family that their mother is destined to spend some time in purgatory, and their impeccable response is fervent prayers and restitution for ill-gotten goods. Their efforts are soon rewarded: "Not long afterwards, the soul of the widow appeared to the handmaid of Christ, more transparent than glass, whiter than snow, and brighter than the sun."[73] She has considerately stopped by en route to heaven to thank her benefactress.

James is relatively discreet about the sins of others. He does mention that the woman in question was mother to the devout virgin Margaret of Willambroux, however, perhaps venturing this disclosure because the outcome was so favorable. But all such discretion is thrown to the winds by Thomas of Cantimpré, a fervent admirer of both James and the Beguine movement, whose representations of the departed retain their names, their foibles, and, of course, the forms of their bodies. This is already apparent in the supplement he wrote to James of Vitry's life of Mary of Oignies—his first of a number of writings on female saints.[74] Thomas does not shy away from mentioning that one of Mary's relics cured Hugolino, a close friend of James and the future Gregory IX, of the spirit of blasphemy.[75] Nor does he spare Mary's mother, who makes one of those rare visitations from hell that, according to Honorius, are occasionally witnessed by saints. The mother reveals that she has been damned for living off the fruits of usury wittingly. Mary's doctrinally correct response is not to weep any more for her mother: "The intellectual reason of her soul, which only the Almighty created, was in harmony with God, the judge of all."[76] Thomas also reveals the deceased Mary's displeasure over James's decision to set off for Rome

to congratulate Hugolino for his elevation to the papacy—aware that he will not return. She appears not only to James to state her objection but also before Giles, the prior of the monastery at Oignies. Giles shares this revelation with James, an exchange that Thomas records as follows: "Be stunned, reader! Gaze on a miracle! The bishop was not impressed by these words. He laughingly rejoined to the prior, 'Lady Mary said the same thing to me. I am not moved by such things.'"[77] But the posthumous relationship between Mary and James is not invariably contentious: upon being invoked, Mary appears before her errant disciple when he is in danger of being shipwrecked and saves his life.[78]

Thomas's *Supplementum* in no way resembles the linear narrative of a traditional saint's life insofar as it moves constantly between the living and the dead. Nor does it read like a typical collection of miracles, which likewise would distinguish between miracles performed in life and after death. For instance, two of the miracles involve a clump of Mary's hair that has healing power while she is still living; after Mary's demise, Hugolino is cured by a finger that James carries around as a relic; there are several prophecies Mary makes in her lifetime that are fulfilled only after her death.[79] Moreover, all of the people mentioned seem to be interconnected and in constant communication: a chatty group of friends whose relationships continue beyond the grave.[80] Significantly, all of the dead are recognizable and gendered. The one exception is Mary's mother, who is described as "a dark spirit" that strikes horror in Mary when she discerns it at her side during Mass. It would seem that only the damned are deprived of their gender and personhood. Mary's intellectual reason is mentioned in this context but not in an androgynous transcendent way—only insofar as that faculty permits her to accept God's judgment unquestioningly.

Thomas's subsequent hagiographies will continue many of James of Vitry's initiatives, particularly the fostering of communication between the living and the dead.[81] As augured in the prologue of Mary's *vita,* Thomas's life of Christina Mirabilis quite literally turns on a dead woman coming back to life to do penance for the dead.[82] Christina herself seems to have one foot in the spirit world by virtue of her extraordinary penances (which include entering tombs). Physically, moreover, Christina is already something of a specter: "Her body was so subtle

and light that she walked on dizzy heights and, like a sparrow, hung suspended from the most slender of branches."[83]

Christina's penitential mission was too idiosyncratic to fit into any recognizable tradition. She was clearly no bride of Christ; nor did Thomas attempt to make her into one. But in Thomas's last two hagiographical endeavors—the lives of Margaret of Ypres and Lutgard of Aywières—both saints were very consciously styled as brides of Christ in ways that resonate with one another. This is in spite of the immense differences in the lives and spirituality of the women themselves. As in the case of Christina of St. Trond, Thomas did not know Margaret personally, but only through the report of her confessor, Friar Zeger. In contrast, Thomas had a strong personal relationship with Lutgard, adopting her as a kind of spiritual mother.[84] Lutgard developed a mature, independent, but stable spirituality within a Cistercian community: she was in her sixties when she died. Margaret's spirituality, however, seems unstable and somewhat immature, to the extent that her piety has fittingly been compared to teenage rebellion. She lived at home and died in her early twenties.[85] Far from acting as spiritual director to anyone, she had an extreme and even questionable dependence on her confessor, Friar Zeger.

And yet Thomas manages to draw some very striking parallels between the two women. For instance, both women seem to have experienced extremely heteronormative conversions. Margaret was called away from her carpenter-beau by Friar Zeger: "When he called her and admonished her to reject secular things, like Saul she said without reluctance, 'Lord, what do you want me to do?' Without delay she was as changed from her former state as heaven is distant from earth."[86] Her conversion was soon seconded by a vision of Christ, who offered her a crown.[87] In Lutgard's case, she was actually speaking with her suitor when Christ showed up in human form and revealed the wound in his side, saying: "Do not seek any longer the caresses of an unseemly love. . . . Here I pledge *[spondeo]* that you shall attain the delights of total purity."[88]

The similarities of these two very embodied calls to the religious life are corroborated by other parallel imagery. After her death, Margaret appeared in "a transparent crystalline body and a rosy colour in her

breast," speaking with the words of the virgin martyr Agnes—the very words that were incorporated into the rite for consecration of a virgin as bride of Christ: "Behold, what I have desired, I now see; what I hoped for, I now possess. I am united in heaven with him whom I loved with total devotion on earth."[89] Margaret had suffered a very early and tragic death from massive hemorrhaging, which Thomas may have construed as a martyrdom of sorts, hence the association with Agnes. In Lutgard's case, the same images are redeployed. Just after Lutgard's pivotal vision of Christ, a noble matron spontaneously compared her with Agnes. Lutgard responded with the words of the saint: "Depart from me, fodder of death, nourishment of villainy, for I have been overtaken by another lover." (She was clearly thinking of her suitor, not the noble matron.) Later, when Lutgard was actually wishing that she could experience martyrdom like Agnes, she was covered with blood by a sudden hemorrhage in her breast. The visionary Christ explained that this bleeding was in fulfillment of her wish for martyrdom.[90] Paralleling Margaret's postmortem experience, Lutgard also appeared to a fellow nun almost immediately after her death, revealing that she was not required to spend any time in purgatory. When she was passing over that spiritual penal colony, however, her compassion managed to spring a few souls free, so that she arrived in heaven with a kind of entourage.[91]

Clearly Thomas excels at depicting spectral visitations that augment the glory of his mystical contemplatives. His efforts to portray the contemplative life itself are, however, mixed. Considering that the *Liber de natura rerum*, his foray into the natural sciences, contains a lengthy discussion of the soul, no one would seem better qualified to write about its different capacities. And yet, as the two epigraphs at the start of this section would indicate, there was a distinct tension between the types of received wisdom he imbibed: on the one hand, the mind is the eye of the soul entirely without blemish; on the other hand, the disembodied soul retains the form of the body. Lutgard's mystical experiences were vivid revelations enlisting spiritual vision, utilizing images that were easy enough to convey. On two occasions, when Thomas attempted to describe visions that partook of the higher intellectual vision, however, the results were, understandably, mixed. The first occurred on Pentecost. When the nuns were chanting the *Veni Creator,*

Lutgard was suspended two cubits in the air. Considering how difficult it is to express the depth of a contentless mystical experience, Thomas's solution, describing it from outside as it were, is quite effective. It tells us nothing about the soul, however, only how the body behaves in its absence. In the other instance, Thomas attempts to tackle the highest level of contemplation head on.

> The three beds in the Song of Songs distinguish three states of the soul. . . . The first bed is compared to the bed of penance, which is that of beginners; the second to the state of battle, which is for those who are progressing; the third is the contemplative life, the state of the perfect. In the first, the soul lies wounded; in the second, wearied; and in the third, delighted. . . . In the third bed, that of rest, Lutgard sought the Beloved perfectly when she did not lean on the angels or the saints, but rested sweetly in contemplation on the couch of the Bridegroom alone.[92]

Thomas's solution is eloquent, instructive, but inescapably gendered.

Thomas was working with a much more limited spiritual dossier when it came to Margaret's life. Her mystical experiences seem primarily dependent on spiritual vision, with the exception of one incident. It concerns a seemingly miraculous event that occurred when Friar Zeger was out town and Margaret was desperate for his presence. In response to her anxious prayers, she was permitted to see her confessor in Lille, which was miles away. Thomas puzzles over this marvel:

> What therefore shall I say? Would it be right to believe that so perfect a bride of Christ lied? By no means. For I do not believe that, even if her life were at stake, she would have deliberately and knowingly told a lie, especially not about this.
>
> What then shall I say? If, as *The Book of the Nature of Things* says, nature has given the lynx the ability to penetrate solid and opaque bodies with the light of its eyes (contrary to the normal condition of animals, yet without any miracle), why then couldn't Christ, who is said to be wonderful in his saints, have been willing and able to let

Margaret see for a while, to comfort her, the man in whose absence she could have no peace in her heart—and to see him even from a great distance? . . . According to the Philosopher, it is agreed that the eye is situated in the "wet" category. There are three properties in water: moisture, translucence, and transparency. Water shares the last of these properties with the celestial substance, and in the nature of the light, this is the ultimate stage of purification from matter. For these two reasons—because light is the most penetrating force in nature, and because it attains the ultimate stage of transparency in the body to which it is directed—let us then posit in the eye of the lynx a watery substance in its highest degree of purification with respect to transparency. It follows then that the light of the lynx's eye can penetrate a solid and opaque body.[93]

Thomas devotes more attention to this occurrence than to any other incident in Margaret's life. In fact, Margaret's vision of Friar Zeger absolutely dwarfs Thomas's treatment of her vision of Christ, which, as luck would have it, follows immediately after.[94] His perhaps injudicious prolixity is understandable. Thomas was fresh out of three years of study at the *studium generale* with Albert the Great as his teacher, no less.[95] Doubtless he was anxious to show off some of his new learning. Still, Thomas's devolution into corporeal vision is unfortunate, even in pursuit of a possible miracle. Spiritual vision, frequently the vehicle of mystical revelations, is already compromised by its dependence on images generated by the imagination—a direct conduit to the senses. Corporeal vision was purely sensual.

Moreover, comparing the corporeal eye, particularly the female eye, with that of any kind of animal is slippery turf, and it would be a true miracle if the turf caused a slip upward. It is much more likely that all sorts of other uncanny, but bodily, resonances associated with female vision or, worse still, between women and animals, would come to mind. And Thomas's *Liber de natura rerum* contains its fair share of both. One is reminded of how a menstruating woman can stain a mirror (and assorted metals) with her prolonged gaze.[96] When a woman becomes pregnant a certain darkness appears over her eyes within ten days.[97] Certain pregnant women are extremely impressionable and should not look

at ugly animals, especially monkeys, lest that visage appear on the child.[98] It is also natural for women to imprint the image of something they see or even think about on the fetus when they are aroused and conceiving, just like an animal.[99] Thomas cites with approval Pliny's comment that the eyes are the habitation of the soul: one can only wonder what kind of soul could possibly live in women's eyes.[100]

> He said that his soul was like a glassy spherical vessel, that it had
> eyes both before and behind, and that it was filled with knowledge,
> and nothing could escape its range of vision.
>
> Caesarius of Heisterbach

Caesarius of Heisterbach (d. ca. 1230) was recounting the experience of a monk who had died, only to return to life and subsequently report on the appearance of the soul. Apparently these monks were unaware that by the thirteenth century the disembodied soul had become securely associated with the familiar form of the deceased. This form should not be mistaken for a body, however, not even a body of air: Thomas Aquinas (d. 1272) had definitively argued that the soul had no materiality whatsoever.[101] So far from being represented by an androgynous sphere, the separated soul was an inexplicable simulacrum of the gendered body it longed for.

Could any other outcome ever have been possible? Claude Carozzi has argued that there were, in fact, two different camps contending over the nature of the soul: the one that was influenced by Erigena saw not only the soul as spiritual but also the punishments and rewards after death; the other camp saw the soul as a kind of body capable of experiencing the punishments or rewards of the afterlife.[102] If, in fact, there were two distinct sides, I doubt very much that the spiritual one ever had much of a chance. As an incarnational religion, Christianity was naturally inclined to materialize the spiritual. Moreover, as Bynum's recent work *Christian Materiality* suggests, this tendency reached an apex in the later Middle Ages.[103] But it was the result of a long process: since patristic times, the church had responded to dualism by stressing the symbiosis of body and soul—a relationship to be perfected in the

Resurrection. So the disembodied soul was forced into a prolonged holding pattern, during which time the law of gravity had a chance to assert itself. As the soul sank, the body reached out to grasp it, leaving an indelible imprint. The shadow corporeality of the soul was in orthodoxy's best interests. It meant that during that dangerous time of disembodiment, an individual was assured of the stability of identity and gender, staving off the threats of reincarnation or angelic assimilation. Hagiography played an important role in consolidating these interests both through vivid and familiar representations of the soul and by the creation of an irresistible continuity of identity that accommodated not just specific individuals but even their circle of friends. Who wouldn't want to be part of Thomas of Cantimpré's eternal Facebook?

Still, security came at a cost. God had made the androgynous rational soul in his own image; the sexed body remade the soul in its own. With the gradual gendering of the soul, the equality implicit in the rational soul retreated further into eternity's vanishing point. For the quasi-embodied soul was not just a placeholder for gender or identity: it was the gateway that permitted the entire temporal hierarchy to be superimposed on the afterlife and transformed into a celestial hierarchy of merit.

NOTES

The first heading's epigraph is from Augustine's *De moribus ecclesiae catholicae* 1.4.6, Patrologia Latina (hereafter PL), 217 vols., ed. J.-P. Migne (Paris: Garnier Fratres and J.-P. Migne, 1844–64), 32:1313 (translation mine). The second is from Thomas of Cantimpré's *Liber de natura rerum* 2.7 and 14, ed. Helmut Boese (Berlin: Walter de Gruyter, 1973), 87, 95. The third is from Caesarius of Heisterbach's *Dialogus miraculorum* 1.32, ed. Joseph Strange (Cologne: J. M. Heberle, 1851), 1:39, trans. H. Von E. Scott and C. C. Swinton Bland, *The Dialogue on Miracles* (London: Routledge, 1929), 1:42.

1. Guibert of Nogent, *Autobiographie* 1.18, ed. Edmond-René (Paris: Les Belles Lettres, 1981), p. 148; trans. John Benton, *Self and Society in Medieval France: The Memoirs of Abbot Guibert of Nogent* (Toronto: University of Toronto Press, 1984), 94. Jacques Le Goff sees this vision as precedential not only insofar as it stresses the links between the living and dead but also in that it makes clear that what will eventually be called purgatory is now a specific location and clearly a place of punishment. Jacques Le Goff, *The Birth of Purgatory,* trans. Arthur Goldhammer (Chicago: University of Chicago Press, 1981), 85–86.

2. See Tertullian, *De anima* 5.1–9.8, 27.1–4, in *Quinti Septimi Florentis Tertulliani opera,* Corpus Christianorum Series Latina (hereafter CCSL) 2 (Turnhout: Brepols, 1954), 2:786–94, 822–23; trans. in *The Ante-Nicene Fathers,* ed. Alexander Roberts and James Donaldson (1890; repr., Grand Rapids, MI: Eerdmans, 1994), 3:184–89, 208–9. (hereafter *ANF*); cf. *De resurrectione mortuorum* 53.8, in *Opera,* 2:999, trans. in *ANF,* 3:587. On the negative ramifications of Tertullian's emphasis on seminal identity and its role in establishing original sin, see Norman Powell Williams, *The Ideas of the Fall and of Original Sin* (London: Longmans, 1927), 233–38.

3. Tertullian, *De anima* 36.2, in *Opera,* 2:838, trans. in *ANF,* 3:217. For an analysis of Tertullian's theory of the soul, see Jonathan Barnes, *"Anima Christiana,"* in *Body and Soul in Ancient Philosophy,* ed. Dorothea Frede and Burkhard Reis (Berlin: Walter de Gruyter, 2009), 447–64.

4. Tertullian, *De resurrectione mortuorum* 63.1–3, in *Opera,* 2:1011, trans. in *ANF,* 3:593–94. A similar logic is present in the Pauline-inflected nature of his antidualist treatise *Against Marcion:* Christ's love for his bride, Ecclesia, is equated with the husband's love for his wife, and hence the flesh dignifies the created world in general and the body in particular (Tertullian, *Adversus Marcionem* 5.18.8–10, in *Opera,* 3:718–19, trans. in *ANF,* 3:468–69). See Jérome Alexandre, *Une chair pour la gloire: L'anthropologie réaliste et mystique de Tertullien* (Paris: Beauchesne, 2001), 279–328.

5. See the summary of these views in Joan Cadden, *The Meanings of Sex Difference in the Middle Ages: Medicine, Science, and Culture* (Cambridge: Cambridge University Press, 1993), ch. 1.

6. See Augustine, *On the Trinity* 12.7.10. Also see Richard McGowan, "Augustine's Spiritual Equality: The Allegory of Man and Woman with Regard to the Imago Dei," *Revue des études augustiniennes* 33 (1987): 255–64. McGowan points out that when Augustine says that man alone fulfills the image of God with regard to bodily sex, he is speaking metaphorically using man as a symbol of the higher soul and woman the lower (261–62). Cf. Lyndon Reynolds, "Bonaventure on Gender and Godlikeness," *Downside Review* 106/107 (1988–89): 176–79.

7. See David Brakke's book, *The Gnostics: Myth, Ritual, and Diversity in Early Christianity* (Cambridge, MA: Harvard University Press, 2011), which manages to make sense of this conflicted term.

8. Tertullian, *Adversus Valentinianos* 32.5, in *Opera,* 2:776, trans. in *ANF,* 3:519. See Einar Thomassen, "Valentinian Ideas about Salvation as Transformation," in *Metamorphoses: Resurrection, Body and Transformative Practices in Early Christianity,* ed. Turid Karlsen Seim and Jorunn Økland (Berlin: Walter de Gruyter, 2009), 176–86.

9. Origen propounds this view in his *Homilies on Genesis.* Augustine will refute this error in his *De Genesi contra Manicheos libri duo* 2.21.32, PL 34:212–13.

10. Tertullian, *De cultu feminarum* 1.2.5, in *Opera,* 3:346, trans. in *ANF,* 4:15.

11. See Peter Brown, *Augustine of Hippo: A Biography,* rev. ed. (Berkeley: University of California Press, 2000), 35–49.

12. Caroline Walker Bynum, *The Resurrection of the Body in Western Christianity, 200–1336* (New York: Columbia University Press, 1995), 143.

13. Rupert of Deutz, *De trinitate et operibus suis* 2.3, 3.5, 2.7, PL 167:249, 291, 252). Cf. Peter Lombard, who will associate "image" with memory, intelligence, and justice and "likeness" with innocence and justice (*Sententiae in IV libris distinctae* 2.16.3.5, ed. Ignatius Brady, 3rd ed. [Rome: College of St. Bonaventure, 1971], 1:408, trans. Giulio Silano, *Sentences* [Toronto: Pontifical Institute for Mediaeval Studies, 2008], 2:70). The Lombard does not take up the question of whether woman is in God's image, the assumption being that she is.

14. Peter Abelard, *Expositio in Hexameron* cc. 255, 263, ed. Charles Burnett and David Luscombe, Corpus Christianorum Continuatio Mediaevalis 15 (Turnhout: Brepols, 2004), 59, 61.

15. The preferred age was around thirty, which was associated with Christ's age at the time of his resurrection. See Honorius Augustodunensis, *Elucidarium* 3.80, in *L'Elucidarium et les Lucidaires,* ed. Yves Lefèvre (Paris: E. de Boccard, 1954), 463; Peter Lombard, *Sententiae* 2.30.15.1, ed. Brady 1:505, trans. Silano 2:153.

16. Bynum, *Resurrection of the Body,* 164–65.

17. Peter Lombard, *Sententiae* 4.49.4.3, ed. Brady 2:553, trans. Silano 4:270.

18. Honorius, *Elucidarium* 3.9, 31, ed. Lefèvre 446, 452. On the occasion of Christ's postmortem appearance to his apostles, his clothes were likewise fashioned from air (1.69, ed. Lefèvre 391). After the general resurrection, the blessed, now rejoined with their bodies, go around in unashamed nakedness. They are imbued with beautiful colors as are the flowers. Even as various species of flowers have distinct colors, moreover, so too will the resurrected soul be colored according to whether she or he is a martyr, a virgin, etc. (3.8, ed. Lefèvre 464).

19. Ibid. 3.2, 5, ed. Lefèvre 443, 444.

20. Ibid. 3.9, ed. Lefèvre 446.

21. Ibid. 3.6.8, ed. Lefèvre 444–45.

22. Ibid. 3.13–14, 22, 16, ed. Lefèvre 447–48, 450, 449.

23. Ibid. 3.25, 29, 19–21, ed. Lefèvre 450, 451, 449–50.

24. Honorius gives the example of the damned soul of an executed robber, wrongly venerated as a martyr, who appeared after St. Martin prayed to

God to reveal the identity of the person buried at a suspicious shrine (Sulpitius Severus, *Life of St. Martin* c. 11). Pope Benedict appeared in a monastery (or in a monstrous form; the manuscript tradition is conflictive) with the head and tail of an ass and the body of a bear. He asserted that day and night he was dragged up and down through areas of fire that after judgment would be swallowed up in hell (*Elucidarium* 3.30, ed. Lefèvre 452). This vision would seem to concern either Benedict IX (d. ca. 1150) or antipope Benedict X (d. 1161), both of whom were notorious in their day.

25. Peter Lombard, *Sentences* 4.21.2–4, 4.44.5–7, ed. Brady 2:380–81, 519–21, trans. Silano 4:127–28, 241–43.

26. On Erigena and Honorius's indebtedness, see Bynum, *Resurrection of the Body,* 140–50.

27. Bynum notes that Honorius sidesteps the question of individual absorption into the Godhead, however (*Resurrection of the Body,* 147).

28. Honorius Augustodunensis, *Clavis physicae* c. 103, ed. Paolo Lucentini (Rome: Edizione di storia e letteratura, 1974), 75. Cf. cc. 106, 272, ed. Lucentini 76–77, 219–20.

29. Ibid. c. 70, ed. Lucentini 49.

30. Ibid. c. 271, ed. Lucentini 218.

31. Ibid. c. 306, ed. Lucentini 259–60.

32. Ibid. c. 71, ed. Lucentini 50.

33. Ibid. c. 104–5, ed. Lucentini 75–76.

34. Ibid. c. 70, ed. Lucentini 49.

35. Ibid. c. 72, ed. Lucentini 51; cf. c. 308, ed. Lucentini 260.

36. Honorius Augustodunensis, "Drei Fragen aus Cod. Mellic. 850," q. 1, ed. Joseph Endres, in *Honorius Augustodunensis: Beitrag zur Geschichte des geistigen Lebens im 12. Jahrhundert* (Kempten: Jos. Kösel'schen, 1906), 150.

37. Ibid. q. 2, 152. Note, however, that already in the *Elucidarium,* Honorius posits the creation of souls at the beginning of time, which parallels Cathar views (2.34–35, ed. Lefèvre 420–22).

38. Rupert of Deutz, *De trinitate* 2.27, PL 167:314.

39. Whether or not Mark Pegg is correct that orthodoxy more or less invented the Cathars (I think he is incorrect) makes no difference to this discussion, since there is no doubt that religious authorities believed in the menace. Also note that Pegg's conclusions are based exclusively on the examination of one inquisitional register. See *The Corruption of Angels: The Great Inquisition, 1245–1246* (Princeton: Princeton University Press, 2001). For a rebuttal of the view that the heresies of the high Middle Ages were invented, see Peter Biller, "Through a Glass Darkly: Seeing Medieval Heresy," in *The Medieval World,* ed. Peter Linehan and Janet L. Nelson (London: Routledge, 2001), 312 ff.

40. For a discussion of regional groups and differences, see the *Summa* of Rainerius Sacconi (d. after 1262), a former heretic who became a Dominican inquisitor, trans. Walter Wakefield and Austin Evans in their *Heresies of the High Middle Ages* (New York: Columbia University Press, 1969), 330, 336–46.

41. See the Dominican Friar Moneta of Cremona's account (ca. 1241), trans. Wakefield and Evans in *Heresies,* 308–13. Note that the concept of body is not discarded altogether: the Cathars apparently believed that when they finally returned to heaven they would retrieve their original spiritual bodies (310).

42. See the description of this rite in the Franciscan James Capelli's *Summa* (ca. 1240), trans. Wakefield and Evans in *Heresies,* 302–3.

43. See Bynum, *Resurrection of the Body,* 151–55.

44. Hincmar of Reims, *De cavendis vitiis* c. 2, PL 125:874.

45. Robert Pullus, *Sententiae* c. 9, PL 186:733.

46. Honorius, *Elucidarium* 3.19, ed. Lefèvre 446.

47. See Dyan Elliott, *Fallen Bodies: Pollution, Sexuality, and Demonology in the Middle Ages* (Philadelphia: University of Pennsylvania Press, 1999), 146; note the evocative Cathar use of the image "tunics of forgetfulness" for designating the body (145, 256 n. 103). Cf. Rupert of Deutz, who describes angels as putting on clothing of light (*De trinitate* 1.12, PL 167:209).

48. On orthodoxy's efforts to ensure that the two races remained distinct in the thirteenth century, see Elliott, *Fallen Bodies,* 128–50. A parallel concern was expressed as early as Tertullian. See Dyan Elliott, *The Bride of Christ Goes to Hell: Metaphor and Embodiment in the Lives of Pious Women, 200–1500* (Philadelphia: University of Pennsylvania Press, 2012), 19–27.

49. Pullus, *Sententiae* c. 1, PL 186:718.

50. *Summa sententiarum* 2.1, PL 176:79–80. This anonymous treatise circulated under Hugh of St. Victor's name. Cf. Honorius's view in note 37, above.

51. See Johannes Maurini and Petrus Maurini's testimonies in *Le registre d'inquisition de Jacques Fournier, évêque de Pamiers (1318–1325),* ed. Jean Duvernoy (Toulouse: E. Privat, 1965), 2:489, 508; 3:201.

52. Peter Biller, "Cathars and Material Women," in *Medieval Theology and the Natural Body,* ed. Peter Biller and Alastair Minnis (Woodbridge: York Medieval Press, 1997), 61–107. See 61 for the "devil in her belly" image.

53. James of Vitry, *Vita B. Mariae Oigniacensis* (hereafter *VMO*) prol. c. 2, in *Acta Sanctorum,* 68 vols. (Antwerp, also Rome and Paris, 1643–; hereafter *AA SS*), June, 5:547; trans. Margot King as "Life of Marie d'Oignies," in *Mary of Oignies: Mother of Salvation,* ed. Anneke Mulder-Bakker (Turnhout: Brepols, 2006), 16.

54. *VMO,* prol. c. 9, in *AA SS,* June, 5:549, trans. 23–24. Apparently Fulk wanted a record of all of the different wondrous women in the area, but James

said that these women would not be able to stand the attention. He consented to write Mary's life only because she was already deceased.

55. Caroline Walker Bynum, "The Female Body and Religious Practice in the Later Middle Ages," in *Fragmentation and Redemption: Essays on Gender and the Human Body in Medieval Religion* (New York: Zone Books, 1991), 194.

56. See Dyan Elliott, *Proving Woman: Female Spirituality and Inquisitional Culture in the Later Middle Ages* (Princeton: Princeton University Press, 2004), 58–74.

57. See Dyan Elliott, "The Physiology of Rapture and Female Spirituality," in Biller and Minnis, *Medieval Theology*, 141–73, and Barbara Newman, "What Did It Mean to Say 'I Saw'? The Clash between Theory and Practice in Medieval Visionary Culture," *Speculum* 80 (2005): 1–43.

58. *Glossa ordinaria* v. 2, *ad sive in corpore, sive*, PL 114:586.

59. Peter Lombard, *Collectanea in Epistolae D. Pauli*, in Ep. II ad Cor. vv. 1–4, PL 192:79–83.

60. For background on this image, see E. Ann Matter, *The Voice of My Beloved: The Song of Songs in Western Medieval Christianity* (Philadelphia: University of Pennsylvania Press, 1990).

61. On Bernard's bridal imagery, see Jean Leclercq, *Monks and Love in the Twelfth Century: Psycho-Historical Essays* (Oxford: Clarendon Press, 1979), 121–29; Shawn Krahmer, "The Virile Bride of Bernard of Clairvaux," *Church History* 69 (2000): 304–27.

62. *VMO* prol. cc. 6, 7, in *AA SS*, June, 5:548 (bis), trans. King 45, 46. For a more extensive discussion of this imagery among the Beguines and other holy women in the High Middle Ages, see Elliott, *Bride of Christ*, ch. 6.

63. *VMO* prol. c. 8, in *AA SS*, June, 5:548, trans. King 48

64. *VMO* 2.7.81, in *AA SS*, June, 5:565, trans. King 106.

65. *VMO* 2.2.48, in *AA SS*, June, 5:558, trans. King 83–84.

66. *VMO* 2.6.77, in *AA SS*, June, 5:564, trans. King 103.

67. *VMO* 2.8.87, in *AA SS*, June, 5:566, trans. King 110.

68. *VMO* 2.10.95, in *AA SS*, June, 5:568–69, trans. King 117.

69. *VMO* 2.13.107, 2.11.98, in *AA SS*, June, 5:571, 569, trans. King 125, 119. On Mary's song, see Carolyn Muessig, "Prophecy and Song: Teaching and Preaching by Medieval Women," in *Women Preachers and Prophets through Two Millennia of Christianity*, ed. Beverly Kienzle and Pamela Walker (Berkeley: University of California Press, 1998), 146–59; John Coakley, *Women, Men, and Spiritual Power: Female Saints and Their Male Collaborators* (New York: Columbia University Press, 2006), 74–75.

70. See Barbara Newman, "On the Threshold of the Dead: Purgatory, Hell, and Religious Women," in *From Virile Woman to WomanChrist: Studies in*

Medieval Religion and Literature (Philadelphia: University of Pennsylvania Press, 1995), 108–36; Elliott, *Proving Woman,* 74–81.

71. *VMO,* prol. c. 8, in *AA SS,* June, 5:549, trans. King 48–49.

72. She is also divinely informed that she should not bother praying for a certain knight because he died in a tournament and thus was damned to hell (*VMO* 1.9.26, in *AA SS,* June, 5:553, trans. King 63–64).

73. *VMO* 2.6.51, 2.6.52, in *AA SS,* June, 5:559 (bis), trans. King 87, 88.

74. This was not Thomas's first hagiographic venture, however. See his life for the abbot of Thomas's first religious community, before he joined the Dominicans, in "Une oeuvre inédite de Thomas de Cantimpré: La 'Vita Ioannis Cantipratensis,'" *Revue d'histoire ecclesiastique* 76 (1981): 241–316, trans. Barbara Newman in *Thomas of Cantimpré: The Collected Saints' Lives,* ed. Barbara Newman (Turnhout: Brepols, 2008), 57–121.

75. Thomas of Cantimpré, *Supplementum* 15.15, in *AA SS,* June, 5:557–58, trans. Hugh Feiss in *Mary of Oignies: Mother of Salvation,* 153–54. James did mention that Mary had success with the spirit of blasphemy, however (*VMO* 2.6.62, in *AA SS,* June, 5:561, trans. King 94).

76. Thomas of Cantimpré, *Supplementum* 11.12, in *AA SS,* June, 5:576, trans. Feiss 149–50.

77. Ibid. 20.22–21.23, in *AA SS,* June, 5:578–79, trans. Feiss 160–61.

78. Ibid. 18.20, in *AA SS,* June, 5:578–79, trans. Feiss 157–58.

79. See ibid. 4.6, 5.7, 15.15, 2.3, 13.14, in *AA SS,* June, 5:574, 574–75, 577, 573–74, 577, trans. Feiss 144–45, 145–46, 155, 141–42, 152–53.

80. This is partially achieved through continued incursions into James of Vitry's privacy. First it is revealed that James was freed from an unhealthy attachment to a religious protegée by the prayers of Lutgard; then the bishop's ascension into heaven is described, after only two days and three nights in purgatory. James fared much better at Thomas's hands than Innocent III, however, who appears to Lutgard from purgatory engulfed in flames and destined to remain there until the Last Judgment because of three faults (Thomas of Cantimpré, *De S. Lutgarde virgine* 2.1.3, 3.1.5, 2.1.7, in *AA SS,* June, 4:196–97, 205, 197, trans. Margot King and Barbara Newman, in Newman, *Thomas of Cantimpré,* 241, 277, 244).

81. For instance, in the course of an appearance to Lutgard, the Virgin Mary was so despondent over the Cathar threat that the saint determined to fast on bread and beer for seven years (*De S. Lutgarde virgine* 2.1.2, in *AA SS,* June, 4:196, trans. King and Newman, 240).

82. Thomas of Cantimpré, *Vita S. Christinae Mirabilis Virginis* 1.5–6, in *AA SS,* July, 5:651, trans. Margot King and Barbara Newman, in Newman, *Thomas of Cantimpré,* 130–31. See Elliott, *Proving Woman,* 75–76.

83. Thomas of Cantimpré, *Vita S. Christinae Mirabilis Virginis* 2.15, in *AA SS,* July, 5:653, trans. King and Newman 136.

84. Thomas's degree of acquaintance is clear in his prefaces for the respective lives. See Thomas of Cantimpré, *Vita Margarete de Ypris* prol., ed. G. Meersseman, "Les frères prêcheurs et le mouvement dévot en Flandres au XIIIe siècle," *Archivum Fratrum Praedicatorum* 18 (1948): 106–7, trans. Margot King and Barbara Newman, in Newman, *Thomas of Cantimpré,* 163–64; *De S. Lutgarde virgine,* prol., in *AA SS,* June, 4:189, trans. King and Newman 211.

85. Alexandra Barratt, "Undutiful Daughters and Metaphorical Mothers among the Beguines," in *New Trends in Feminine Spirituality: The Holy Women of Liège and Their Impact,* ed. Juliette Dor, Lesley Johnson, and Jocelyn Wogan-Browne (Turnhout: Brepols, 1999), 83–86.

86. Thomas of Cantimpré, *Vita Margarete* c. 6, ed. Meersseman 109, trans. King and Newman 168. For a more detailed examination of these two lives, see Elliott, *Bride of Christ,* 193–203.

87. Thomas of Cantimpré, *Vita Margarete* c. 8, ed. Meersseman 110, trans. King and Newman 170. There were also two crowns for her sisters, contingent on the preservation of their virginity.

88. Thomas of Cantimpré, *De S. Lutgarde virgine* 1.1.2, in *AA SS,* June, 4:192, trans. King and Newman 218.

89. Thomas of Cantimpré, *Vita Margarete* c. 55, ed. Meersseman 129, trans. King and Newman 205. See William Durandus, *De benedictione et consecratione virginum* c. 51, in *Le pontifical de Guillaume Durand,* ed. Michel Andrieu, vol. 3 of *Le pontifical romain au Moyen-Age,* Studi e Testi 88 (Vatican City: Biblioteca Apostolica Vaticana, 1940), 3:421.

90. Thomas of Cantimpré, *De S. Lutgarde virgine* 1.3, 2.2.21, in *AA SS,* June, 4:192, 200, trans. King and Newman 219, 255. The bursting of the vein coincides with Lutgard's early menopause.

91. Ibid. 3.3.21, in *AA SS,* June, 4:209, trans. King and Newman 293–94.

92. Ibid. 2.3.43, in *AA SS,* June, 4:203–4, trans. King and Newman 270–71.

93. Thomas of Cantimpré, *Vita Margarete* c. 34, ed. Meersseman 122–23, trans. King and Newman 193–95.

94. Ibid. c. 35, ed. Meersseman 123, trans. King and Newman 195.

95. See the chronology in *Thomas of Cantimpré,* ed. and introd. Newman, 1–2.

96. Thomas of Cantimpré, *Liber de natura rerum* 1.6, ed. Boese 19.

97. Ibid. 1.72, ed. Boese 73. This method acquitted the pious Ida of Louvain, who was falsely accused. Hugh of Louvain, *Venerabilis Idae Lovaniensis* 2.4.16–17, *AA SS,* April, 2:175.

98. Thomas of Cantimpré, *Liber de natura rerum* 3.55, ed. Boese 99.

99. Ibid. 4.1, ed. Boese 107.

100. Ibid. 1.6, ed. Boese 19. Thomas also uses this lore to critique religious women in his popular *De apibus*. See Elliott, *Bride of Christ,* 208–9.

101. Thomas Aquinas, *Summa theologiae* 1a q. 75, art. 5, resp., ed. Thomas Gilby and T. C. O'Brien (New York: Blackfriars, 1964–73), 11:22. Also see his efforts to separate humans and angels: 1a q. 75, art. 7, ed. Gilby and O'Brien 1:32–36.

102. Claude Carozzi, "Structure et fonction de la vision de Tnugdal," in *Faire croire: Modalités de la diffusion et de la réception des messages religieux du XIIe au XVe siècle: Table Ronde organisée par L'École française de Rome en collaboration avec l'Institut d'histoire médiévale de l'Université de Padoue (Rome, 22–23 juin 1979)* (Rome: Ecole française de Rome, 1981), 223–34. Bynum, in contrast, sees these differences as springing more from personal confusion than from rigid positions, pointing to the contradictions present in the writings of any given author (*Resurrection of the Body,* 138–39).

103. Caroline Walker Bynum, *Christian Materiality: An Essay on Religion in Late Medieval Europe* (New York: Zone Books, 2011).

Kissing the Worm

Sex and Gender in the Afterlife and the Poetic Posthuman
in the Late Middle English "A Disputacion betwyx the
Body and Wormes"

ELIZABETH ROBERTSON

SOUL-BODY DEBATES WERE A MAJOR GENRE OF LITERATURE FROM
the Anglo-Saxon to the Middle English period. These extraordinary
poems, by representing the soul in debate with the body it escapes at
death but hopes to be reunited with at Judgment Day, explore the na-
ture of that thing which is the essence of the human and yet goes be-
yond the human, the soul. The fifteenth-century Middle English poem
"A Disputacion betwyx the Body and Wormes" (A Disputation be-
tween the Body and the Worms) is distinctive in the tradition because in
it the soul that speaks is female. It is also unusual that her soul speaks
through her body and that she speaks not to her body but to a worm.
The late Middle English poem thus represents two if not three non-
human entities—a corpse, a soul that allows the corpse to speak, and a
speaking worm.

Much medieval theology was obscure and contradictory about the
gender of the soul, whether in the body of the animated person on
earth, separated from the body at death and awaiting Judgment Day, or

reunited with the body after Judgment Day. The poet of this thirteenth-century vernacular work, however, uses associations of women with the body, dress, and corporeality to probe the question of the gender of the soul and to comment on its potential salvation poetically rather than theologically. Through the speaker's dialogue with the worms and its associated manuscript illuminations, the poem suggests that the soul retains its gender immediately after death, although it also intimates that the meaning of gender will change when the body is reunited with the soul on Judgment Day. By embracing its shameful sexuality in death, the female soul paradoxically is allowed the possibility of future redemption from purgatory and an identity in heaven marked by gender of a new, celestial kind. Not only does the poem make use of assumptions about gender to consider issues of embodiment, decay, and the nature of the resurrected body, but it also offers, as we shall see, a meta-discourse about the nature of the poem itself as a speaking female corpse, yet another gendered nonhuman entity.

Neoplatonic thinkers such as Augustine understood the soul as an immaterial substance longing to escape "the prison of the body" and ascend to its original home in heaven. Aristotle, however, complicated the idea of the soul's independence from the body by postulating that the "soul is the form of the body" and therefore that the soul and body are always inextricably intertwined with one another, a theory that Aquinas, in his commentary on Aristotle, adopts.[1] By the time the *Disputacion* was written, the predominant view of the soul was that it was an immaterial or incorporeal substance containing both immortal and mortal parts. It was understood to be located throughout the body, although its location in its disembodied phase was not clearly specified. It was assumed, however, to await its reunification with the body on Judgment Day. Following Augustine, theologians agreed that the soul does not exist before the body comes into being, although its immortal aspects will transcend the body after death. It is not meant to be permanently disembodied, however, for that immortal part will be reunited with the body on Judgment Day. The immortal part of the soul consists of will and reason. The remainder of the faculties, the mortal part of the soul, given different names at different times, included the internal (imagination) and external senses and the appetitive aspects of the soul,

that is, the concupiscible and irascible appetites (sometimes also de-
scribed as will).[2] It is the separated soul that plays a part in the popular
genre of soul-body debates to which the *Disputacion* belongs.

Whether or not the soul either in the body or out of it has gender is
obscure in theological discussions. While the Gospels affirm that resur-
rection involves the whole body, including its gender, other commen-
taries suggest that gender is ultimately irrelevant to the essential identity
of the ensouled person. In representations of Judgment Day, souls
often appear as homunculi, that is, as small human figures without sex
characteristics. In his fresco of the Last Judgment in the Scrovegni Cha-
pel, for example, Giotto represents the souls awaiting judgment as small
sexless beings whose gender is indicated only by hair length; the genita-
lia of the naked damned are fully represented; the saved, in contrast, are
fully dressed, and sexual characteristics other than hair are not visible.[3]

Most medieval theologians who discuss the properties of the soul
assume it to be gender free. In a reply to Bishop Vincent Victor con-
cerning whether the soul is a body, Augustine briefly considers if the
soul might have sexual characteristics and concludes that such an entity
would be grotesque. He writes:

> If that form of the male or female soul differentiated by male or
> female members is not a likeness of the body, but a body, whether
> you like it or not, it is male, whether you like it or not it is female,
> depending on whether or not it appears as male or female. But
> suppose, in accord with your opinion, that the soul is a body and
> a living body has large and hanging breasts, but no beard, and has
> a womb and the genital organs that a woman has, but that it is
> not female. Will I not say what is sure and more logical, if I say that
> it also has eyes, a tongue, fingers, and other such bodily members
> but all this is a likeness of a body, but not a body. . . . But you are
> never going to find an example in the whole of nature of this mon-
> ster where you have a true living and female body without the fe-
> male sex.[4]

Augustine here recoils from the idea that what he describes as abject
female genitalia would extend beyond the female body to the soul.

In contrast to the soul itself, the resurrected body, an entity in which soul and body are reunited, is usually assumed to be reconstituted as a whole person with all its identifying characteristics, including gender, restored.[5] Theologians assume that although genitalia will be attributes of the resurrected body, they will no longer function for sexual purposes. These thinkers support their commentaries with reference to Matthew 22:30, "For in the resurrection they shall neither marry, nor be married, but shall be as the angels of God in heaven," but they worry about the sexual characteristics of the resurrected body.[6] Jerome warns that women who might think that the resurrected angel-like body might free them from the "imperfections" of their sex are mistaken, for doctrine asserts that the entire body will be resurrected. As he writes: "Weak women take pleasure in [the heretical teaching that we will rise without sex], seizing their breasts, patting their stomachs, palpitating their loins, thighs, and smooth chins and declaiming, 'What use is it to us if this fragile body shall be resurrected? We shall be like angels and have an angelic nature.' From this one sees that they disdain to be raised in flesh and bones as Christ himself was raised."[7] Although Jerome asserts that when a female body is resurrected it will retain characteristics that will indicate its female gender, his purposes here are not to suggest that women's bodies will be redeemed in heaven but rather, as Elizabeth Clark has argued, to assert that gender inequality and a social hierarchy that depends on recognition of the inferior imperfections of the female body will be retained in heaven.[8]

Augustine concludes with less misogyny that, although women will be resurrected with sex characteristics, their sexual organs will no longer be used for lust:

> Some people suppose that women will not keep their sex at the resurrection; but, they say they will all rise again as men, since God made man out of clay, and woman out of man. For my part, I feel that theirs is the more sensible opinion who have no doubt that there will be both sexes in the resurrection. For in that life there will be no sexual lust, which is the cause of shame. For the first human beings, before their sin, "were naked, the man and the woman, and they were not ashamed."

Thus while all defects will be removed from those bodies, their essential nature will be preserved. Now a woman's sex is not a defect; it is natural. And in the resurrection it will be free of the necessity of intercourse and childbirth. However, the female organs will not subserve their former use; they will be part of a new beauty which will not excite the lust of the beholder—there will be no lust in that life—but will arouse the praises of God for his wisdom and compassion, in that he not only created out of nothing but freed from corruption that which he had created.[9]

Female bodily characteristics clearly troubled theologians in their consideration of the nature of the soul and of the resurrected body. Over time, however, theologians tended simply to restate without question the view that the resurrected body is a gendered one, choosing to focus their attention on other troubling questions about the afterlife, such as the nature of the processes by which fragmented body parts would come together during resurrection. While theologians debated numerous concerns about the precise nature of the resurrected body, most simply accepted an Augustinian position on the gender of the resurrected body and investigated the particular question of the gender of the soul no further.[10]

Middle English poets, however, took up questions about the nature of the soul and its gender and probed such questions as the identity of the person after death, the qualities of the separated soul, and the implications of the doctrine of the resurrection of the body for an understanding of the person both male and female, especially in a genre of poems known as soul-body debate poems. In a tradition that goes back to the Anglo-Saxon period, these poems focus on the person just as he or she has died and represent the soul, newly separated from the body, in dialogue with the body about their fate. Most often, as in the Anglo-Saxon Soul and Body I and II, the person is destined for hell and the exchange focuses on the soul's castigation of the body for its refusal to pay attention to the needs of the soul during its life on earth. Later in the tradition, as in the thirteenth-century poem *Als I Lay on a Winteris Nyt* (As I Lay on a Winter's Night), the poems become more richly dialogic as the body answers back and criticizes the soul for not providing

better guidance. These unusual poems investigate questions most often neglected by philosophy and theology, such as: What role do the senses play in the afterlife? Who is responsible for the fate of the person, the body or the soul? Does the soul feel affection for the body? How deeply intertwined are the soul and the body, not only in theory, but also in practice? And, as Masha Raskolnikov has shown, because these poems make use of personified abstractions of the soul and the body, they necessarily engage questions about the gender of the soul.[11]

The fifteenth-century poem "The Disputacion betwyx the Body and Wormes" emerges from this tradition. Like earlier poems in which the soul castigates the body for its pursuit of material pleasures, the worms remind the speaking corpse of its failure to attend to the care of the soul during its lifetime. The soul that speaks in this poem, however, differs from those that speak in the conventional poems, for here the soul does not emerge from the body as a separated entity but is intertwined with it; the corpse that speaks is animated by a soul, of course, because it is a soul that allows it to speak, and, given that the speaker in the poem comes to an understanding of the need for God's mercy on Judgment Day, the corpse's speech serves the needs of the soul. Nonetheless, there is no separated soul in this poem, and the person who speaks enters into a dialogue, not with a part of itself, but rather with other inhuman but speaking animals, worms. While speaking-corpse poems become prevalent in later centuries beginning in the nineteenth century, as Diana Fuss has discussed, it is rare in the Middle English poetic tradition to find a corpse who speaks for the concerns of the soul.[12] The Middle English tradition provides many examples of a cadaver who speaks, but they most often represent the body alone, separate from the soul with which it debates and which has newly separated from it.

Some have suggested that the poet represents the soul and body together in one entity to avoid the potentially heretical dualism implied by the soul-body debates.[13] Certainly a body inseparable from a soul would reflect Aristotelian ideas, brought forward into medieval thought by Aquinas, of the person as a hylomorphic entity made up of inextricably intertwined soul and body. Poets do not seem to worry very much about dualism, however, since soul-body debates are written and copied throughout the medieval period even before Aristotle's notion of hylo-

morphism became generally known. The inextricably intertwined soul/body entity of this poem seems more likely to be a reflection of the author's interest in representing a specifically gendered dead body.

Because women were understood as always already associated with the body, it is not surprising that in this poem a woman even in death does not escape her bodiliness. Soul-body debates rarely indicate the gender of either entity, though the speakers are often designated as "he." Rosemary Woolf has described several poems in which corpses (as distinct from bodies with newly separated souls) speak, and those that speak are almost always female.[14] The majority of these use gendered assumptions about women's association not only with the body but also with finery and sumptuous clothing to intensify their primary concern to assert the vanity of human wishes.[15] As Woolf writes, "It was evidently thought that the rotting of feminine beauty gave a turn of the screw to the theme of putrefaction."[16] Here, however, gender plays a richer role in conveying a more complex lesson not only about the vanity of human wishes but also about the abject humility the penitent soul needs to exhibit before God on Judgment Day. While the female speaker's growth in spiritual understanding offers a lesson directed to its male Carthusian audience—and even within the poem is one designed for the male dreamer—the corpse's feminine identity plays a much more elaborate role in exploring the nature of the penitent soul in purgatory than do the standard poems in which a female corpse speaks.

Speaking worms are also not common in the soul-body debate tradition, though the view that the body is food for worms is a Christian commonplace. Commenting on Ecclesiasticus 10:9, "Why is earth and ashes proud," St. Bernard condemned the pride of human beings in a phrase repeatedly cited by theologians and preachers from the twelfth century onwards: "Oh food for worms! Oh heap of dust? Oh vanity of dew. Why are you puffed up!"[17] The link between the body's destiny as food for worms and its ultimate disintegration into ashes is made in this poem when the worms summarize the priest's words and actions on Ash Wednesday.

In one of the small number of early poems to represent worms as actors in the drama of the poem, the Anglo-Saxon poem *Soul and Body I* includes among its characters one of the few named worms in literature, Gifer. The poem expresses this commonly received view of the

destiny of the proud as food for worms as the soul castigates the body for disregarding the future state of the soul in its profligate behavior on earth:

. . .	Hwæt, ðu huru wyrma gyfl
lyt geþohtest,	þa ðu lustgryrum eallum
ful geeodest,	hu ðu on eorðan scealt
wyrmum to wiste!	

So, food for worms, you certainly didn't think much, while you were following all your terrible pleasures, about how you will have to be a banquet for the worms, in the earth.[18]

While it does not speak, the worm's name, Gifer, means "greedy," and significantly he becomes the agent by whom the body's ability to speak becomes disabled as he drags away the body's tongue:

Gifer hatte se wyrm,	þe þa eaglas beoð
nædle scearpran.	Se genydde to
ærest eallra	on þam eorðscræfe,
þæt he þa tungan totyhð	ond þa teð þurhsmyhð
ond þa eagan þurheteð	ufan on þæt heafod
ond to ætwelan	oðrum gerymeð,
wyrmum to wiste,	þonne þæt werie
lic acolod bið	þæt he lange ær
werede mid wædum.	Bið þonne wyrma gifel,
æt on eorþan.	þæt mæg æghwylcum
men to gemynde,	modsnotra gehwam!
ðonne bið hyhtlicre	þæt sio halige sawl
færeð to ðam flæsce,	frofre bewunden.
Bið þæt ærende	eadiglicre
funden on ferhðe.	

[Greedy] is the name of the worm whose jaws are sharper than needles, in the grave he was the first of all to make it happen, there he drags off the tongue and bores through the teeth, and eats away

the eyes in the head from on top, he clears a way to the good food
for the others, for the worms' banquet, once the damned body has
grown cold, that the man for so long used to cover and clothe.
Then it is worms' meat, carrion in the ground. This can be a re-
minder to every man, to everyone of sense.[19]

What is unusual in the *Disputacion* is the presence of worms who
not only feed but also speak; indeed, these worms engage in a philo-
sophical "disputation," and oddly, though agents of death, they are also
the agents of Christian education about the potential salvation of the
soul through God's mercy. Like most worms in medieval poetry about
death, the worms in this poem are not given a particular gender. The
poet or scribe designates their identity as worms in the dialogue when
they speak, but they speak as a collective. However, their behavior codes
them as male, for, as we shall see, the worms ultimately force the body
into submission in an act first of rape and then of a willed erotic en-
counter. The poem thus provides us with two major kinds of speaking
subjects who, though humanized, lie beyond the human, both of whom
are gendered: a speaking corpse and speaking worms.

Before turning to a consideration of the various ways gender in-
flects this poem's investigation of the nature of the soul after death, let
me describe the poem as it appears on the manuscript page, since this is
a poem whose meanings are conveyed not only by its words but also by
the visual images that accompany them. "A Disputacion betwyx the
Body and Wormes" survives in British Library MS Additional 30749,
a fifteenth-century manuscript associated with the Carthusians that is
heavily illuminated with crude drawings. A vivid drawing of a transi-
tomb that takes up over half the page precedes the poem (figure 5.1).
Transi-tombs are double-tiered tombs that include an effigy of the fully
dressed deceased in repose in the upper berth and an image of a de-
composing skeleton below. This colored drawing of a transi-tomb in-
cludes a sketch of the woman who has died with her hands clasped in
prayer and who is dressed in a golden crown and elaborate headdress
and a red skirt with pleats and flounces. Her cream-colored bodice
is encrusted with marks not dissimilar to those on the image of the
bleeding pierced body of Christ that appears on the next page, though

they are probably intended to signify either jewels or fur, perhaps, as Marjorie Malvern suggests, ermine.[20] The conventionally grinning skeleton on the lower berth of the double-shelved transi-tomb is crawling with larger than life-sized worms, scorpions, lizards, and toads gnawing at the decomposing body. The left arm of the skeleton is at her side; the right hand holds a winding cloth across the pubic bone.

Below the drawing is an epitaph that announces that the purpose of the tomb and the poem that follows is to educate the viewer/reader about the transitoriness of life and the vanity of human wishes:

> Take hede unto my fygure here abowne
> And se how sumtyme I was fressche and gay
> Now turned to wormes mete and corrupcion
> Bot fowle erth and stynkyng slyme and clay
> Attende therfore to this disputacion written here
> And writte it wysely in thi hert fre
> At ther at sum wisdom thu may here
> To se what thou art and here aftyr sal be
> When thou leste wenes. venit mors te superare
> When thi grafe grenes. bonum est mortis meditari.

———

> Take heed of my figure here above and observe how I once was fresh and gay and now am turned to worms' meat and decay, nothing but foul earth and stinking slime and clay; attend therefore to this disputation written here, and write it wisely in your free heart so that you may acquire some wisdom here by seeing what you are and hereafter shall be; when you least expect it, death will overcome you; when your grave groans, it is good to meditate upon death.[21]

The last two macaronic lines are enclosed in a banderole, perhaps to highlight the Latin in the lines or to suggest a stone carving on the side of the tomb. The epitaph contains a speech quite like those found in the other poems identified by Woolf in which a female corpse speaks. But as this poem unfolds, it goes much further than the epitaph in making use of gender to explore the potentially redemptive qualities of abject penitence even after death.

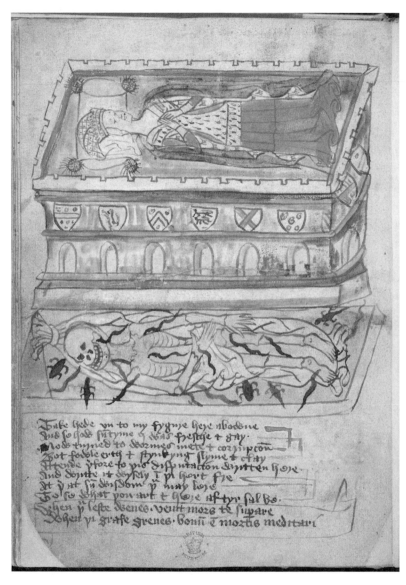

Figure 5.1. Transi-tomb. © British Library Board. British Library Add. 37049, fol. 32v.

On the next folio appears a title, "A Disputacion betwyx the Body and Wormes," followed by 218 continuous lines of poetry with marks at the end of the lines indicating rhyming units. At the top right of folio 33 where the poem begins is an illumination of the narrator of the poem kneeling before a pierced and bleeding affective image of Christ suffering on the cross (figure 5.2). After an introduction, the manuscript indicates the dialogue between the body and worms by announcing each speaker in a different rubrication, for example, "the body spekes to the wormes" (the body speaks to the worms). Although the following lines are in rhyme royal, there is nothing in the manuscript to indicate such a grouping except for markers indicating the closing couplet of each speech. Folio 33v includes a drawing of the skeleton with a raised hand in a flowing headdress and standing on a cloud. Emerging from a cloud over her head are four oversized worms (figure 5.3). On folio 34r, the skeleton appears in the same stance while the four worms appear closer to her body. On folio 34v, the skeleton gestures with a raised right hand, as in the previous two folios, but the worms are now below her body (figure 5.4). On folio 35r there is an illumination of the skeleton, whose right hand is now pointing downwards, while the four oversized worms look up toward her feet (figure 5.5).

The disputation itself is framed, first, by the image of the tomb with its epitaph and, second, by the dream vision frame in which the dreamer describes himself and his circumstances. The narrator recounts how he enters a church seeking to attend mass and prays to an image next to a transi-tomb. The manuscript illumination shows us the dreamer praying before an image of a bleeding Christ on the crucifix. The narrator then falls into a dream state in which he sees the deceased of the tomb in dialogue with worms about her death and the fate of her soul. When he awakes, he seeks advice from a holy man, who urges him to write down the poem as a warning to stir the hearts of men and women to turn away from worldly things and to call to mind the Savior. As in many dream visions, the dream frame allows the dreamer to learn and then explain a lesson, which the reader, too, is meant to learn. That lesson is reinforced by the image of the transi-tomb, the epitaph on it, the poem, and the illuminations of the body and the worm. The combined verbal and visual media create, as Jessica Brantley explains, a text

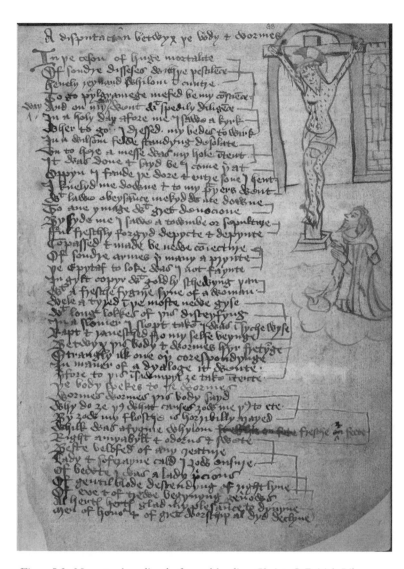

Figure 5.2. Narrator kneeling before a bleeding Christ. © British Library Board. British Library Add. 37049, fol. 33r.

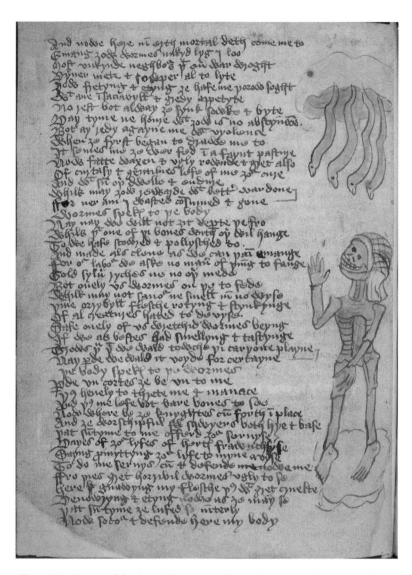

Figure 5.3. Corpse debating with worms above. © British Library Board. British Library Add. 37049, fol. 33v.

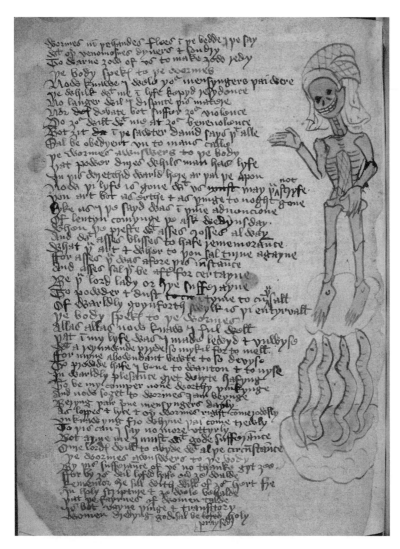

Figure 5.4. Corpse with worms below. © British Library Board. British
Library Add. 37049, fol. 34v.

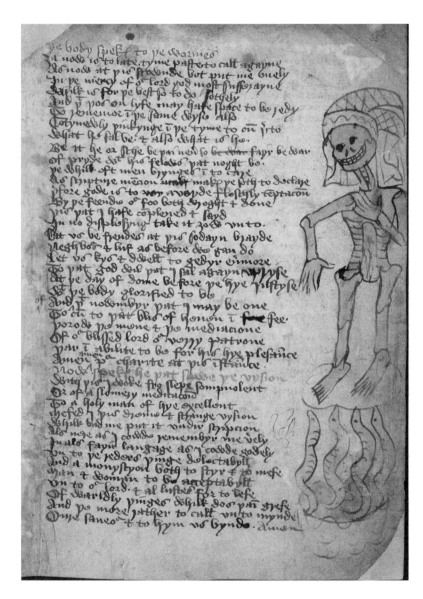

ye body spekes to ye wormes
It nedis to to late tyme passe to call agayne
So nedis at ye presence bot put me euely
In þe mercy of our lord god most souerayne
And it is for þe best so to do forþgely
And if poor on lyfe may haue space to be redy
To remembre þe same blysse also
Comynly puttynge in þe tyme to on þerto
Lyght he sal be & also lyght is he.
Be it he or sche be payned so becom fayr be damn.
of pryde þat his felaws þat noght be.
þe whilk oft men brynges it to care
As scryptur meuon make þe pity to declare
Ifore gode is to avoyde flesshly temptacion
By þe feendis or foo boþ noght & none
In vs þat I haue copnon & sayd
In no displessyng take it god vnto.
Lat vs be frendis at þis sodayn brayde
Neghbors & lufe as before dos gan do
Let vs Lyue & dwell to gedyr eu[er]more
So þat god dud put þat I sal agayne vyse
At þe day of dome before þe hye pystyle
At þe body glorified to be
of þis if nodembyr þat I may be one
To of to þat blis of heuen I for fee.
wordis þis none & þe mediacione
Of our Blissed lord our wery patrone
Prai I able to be for his hye presence
Amen þe charite as þis issuance.

Now spekes þe part þat saw þe vysion
Sorry þis doore fro slepe somnolent
Or of a slomery meditacion
To a holy man of lyfe excellent
Meked & þis slomer & strange vysion
Whilk bad me put it vndir scripcion
Also noþe as I cowde remembyr me vely
In als fayn langage as I cowde godely
On to þe redors þing delectablyt
And a monyfiyod boþ to styr & to meue
Man & Womon to be acceptablyt
Vn to our lord, & al lustes for to leue
Of warldly þynges delyte goo þan streue
And þe more þider to call vnto mynde
Owr sauеos & to hym vs bynde. Amen

designed for performative devotion, most probably originally by the male monastic Carthusian readers with whom the manuscript is associated; nonetheless, the poem states its concern to act as a "monyscyon both to styr and to mefe / Man and woman to be acceptabyll / Unto our Lord" [admonition both to stir and to move man and woman to be acceptable to our Lord] (213–15), and its lessons, as we shall see, are conveyed through the use of gendered diction, images, and motifs.[22]

The opening four rhyme royal stanzas describing the prelude to the dream (the last with an extra line indicating the "ensample" to follow) tell that the dreamer, who is represented in the first illumination as a bearded man in a long monkish cloak with a hood, is moved by the consciousness of mortality that the plague has inspired to seek a church in which he wishes to attend mass.[23] The poem begins, "In the ceson of huge mortalitie, / Of sundry disseses, with the pestilence / Hevely reynand, whilom in cuntre / To go pylgramege mefed be my conscience, / And on my way went with spedily diligence. / In a holy day afore me I sawe a kyrk / Wher to go I dressed, my bedes to wirk" [In the season of huge mortality from sundry diseases, with the pestilence ruling grievously, once, in the country, my conscience moved me to go on pilgrimage and I went on my way with speedy diligence. On a holy day I saw a church before me, where I set myself to go in order to make my prayers] (1–7). The poem immerses us immediately in a realm of death, a time when the plague prevails and when awareness of mortality is at its height.

The urgency of the dreamer's quest is reinforced by the word *disesse,* which not only tells us of the prevalence of disease but also underscores the dis-ease of the narrator, who is in a state of unrest, a destabilized state that encourages his perceptual and emotional vulnerability to the astonishing, transformative disputation he is about to witness. That the narrator is entering a world outside the normal is suggested by the romancelike magical appearance of a church before him just when he needs one. He tells us that his "hole intent" [full intent] (9) upon entering the church is to hear a mass, but by the time he enters the church, mass is over: "It was done and sayd be I come therat" [It was done and said before I came into it] (10); he must let go of his intentions and

allow the will rather than reason to guide him to religious understanding. He submits himself devoutly before an unnamed image beside a tomb. We learn only from the illumination that he prays before an abject image of a profusely bleeding nearly naked Christ on the cross, itself a feminized image of Christ.[24]

The poem begins by describing the narrator's unstable condition in terms of what Patricia Parker might describe as a feminine belatedness.[25] The dreamer's abject submission before the crucifix as well as his belatedness links him to the corpse he encounters in his dream. Just as the corpse within the poem finds that she has come belatedly to consider the state of her soul, this dreamer is too late for mass, that is to say, he arrives too late for conventional ritual and authorized customs that might obscure imaginative openness to the startling events of his dream. Belatedness goes hand in hand with knowledge gained unintentionally and indirectly. The dreamer first finds himself almost accidentally in front of a church and then, once inside, is granted a vision "sideways," not from the crucifix to which he prays, but from the tomb "bysyde" [beside] (15) the one he contemplates. Indirection grants the dreamer access to what becomes an expansive visionary experience. The dreamer's vision is outside the confines of the masculine, authorized church and instead is a queer one: dis-ease opens him to the world of the other, that of the feminine, the vernacular, and the theologically marginal.

That the dreamer is feminized is suggested by the language of rape he uses to describe his vision. Distracted by the epitaph on the tomb, the dreamer falls into a slumber where he is "rapt and ravesched fro my selfe beynge" [rapt and ravished from my self] (25). Anticipating John Donne's later poetic description of an encounter with God as ravishment, the dreamer is raped and ravished by his vision.[26] These gendered verbs suggests the dreamer's relinquishment of his mind's intentions and a submission of his will to his dream, not unlike the submission the corpse herself will come to accept as the dialogue ensues, first to the worms, and second to God.

The dialogue to follow is called in the title of the poem a "disputation," that is, a formal mode of inquiry that took place between university clerics and their masters. It usually involved setting out pros and

cons of an argument followed by a resolution, and this poem follows the outline of the form as we hear the corpse's arguments for the worms' departure, the worms' defense of their presence, and finally the body's acceptance of their presence and prayer for mercy. A woman— or worms for that matter—would not have the training to engage in such a dispute. However, since the poem probes a theological question about the nature of the soul after death and its potential salvation, the appellation "disputation," as a form of dialogue dedicated to inquiry about theological truths, may indeed be apt. Engaged in by a woman and a worm and expressed in the vernacular, the dialogue presents a version of what Nicholas Watson has called "vernacular theology," religious training for the unlearned, here enacted by a female speaker.[27] The poem itself is an instance of vernacular theology addressed to its readers that encloses the dreamer's encounter within a vernacular theological debate.

Images of clothing reinforce the gendered vernacular theology of the poem. The dialogue of twenty-five rhyme royal stanzas takes place between the worms and the body associated with the "fresche fygure fyne of a woman" [a fine, fresh figure of a woman] (20) on the tomb "wele atyred in the moste new gyse" [well attired in the most new guise] (21). The body complains that the worms are eating her and that her attire has changed from the fine clothes depicted on her in the image of the transi-tomb to a new array, not of clothing but of worms: "By 30w my flesche is horribilly arayed / Whilk was a fygure whilom fresche and feete" [By you my flesh is most horribly arrayed, who was a figure once fresh and attractive] (32–33). Sumptuous clothes, especially women's finery, as signs of aristocratic decadence and consumption were the particular target of *memento mori* sermons and poems where the audience was urged to turn away from material pleasures and consider instead the care of the soul.[28] The body here has not yet moved to an understanding that she has a soul to care for but instead laments only a change in clothing from fine attire to a new attire that she contemplates with disgust. Defined by fine clothes that have turned into new garments of worms and of decomposing flesh, the speaker's gendered identity reinforces its lessons about mortal decay. Not only does the speaking corpse lament her new "array," but also the illumination of her

as a corpse presents her as a skeleton with a flowing headdress (figure 5.3). We might describe her then in Jane Burns's terms as a "sartorial body," or more precisely as a "sartorial corpse."[29]

Clothing signifies not only gender but also spiritual states, for in the afterlife souls allowed into heaven change the clothes of mortality for new heavenly raiment. The body will be resurrected in all its particulars, but without imperfections in a new clothing, one that significantly is ungendered in theological descriptions of it. As St. Paul, for example, says in Corinthians 15:51–54: "Behold, I tell you a mystery: We shall all indeed rise again: but we shall not all be changed. In a moment, in the twinkling of an eye, at the last trumpet, for the trumpet shall sound, and the dead shall rise again incorruptible: and we shall be changed. For this corruptible part must put on incorruptible; and this mortal must put on immortality. And when this mortal hath put on immortality, then shall come to pass the saying that is written. *Death is swallowed up in victory*." As Caroline Bynum summarizes St. Bernard in another example of a discussion of the new clothing of the resurrected: "The body that rises is . . . described as a garment, put down at death and taken up again at the Last Judgment, uncorrupted by moth or decay."[30] Skin itself is yet another form of clothing. As St. Bernard writes of resurrection: "I shall be clothed again with my skin, and in my flesh I shall see my God."[31] In the Middle English poem the body is being picked clean of its old skin in order to prepare it for the assumption of a new one: as the worms say, "we will not ȝit departe the fro / While that one of thi bones with other wil hange / To we have scowred and pollysched to / And made als clene as we can thaim emange" [We will not yet depart from you while one of your bones will hang with the other, until we have scoured and polished and made as clean as we can among them] (58–61).

Not only images of clothing but also those of rotting flesh that oozes and smells convey a gendered identity. Describing herself as once "odurus and swete" [odorous and sweet] (34), the body listens to the worms acknowledge her new disgusting odor, which they are incapable of smelling: they "may not savour ne smell in no wyse / Thine orrybyll flesche, rotyng and stynkynge. . . . If we . . . had smellyng and tastynge, / Trows thou that we wald towche thi caryone playne" [may not savor or smell in any way your horrible flesh rotting and stinking; if we had

smell and taste do you believe that we would touch your plain carrion?] (65–70). The worms recoil from the abject feminine body.

While the worms are given no specific gender attribution, their phallic connotations are clearly intended, for the dialogue between the body and the worms describes the female corpse's initial resistance and final acceptance as an encounter with rape. The interaction draws on representations of rape in both courtly romance and the *pastourelle*. The corpse contrasts her aristocratic past as a courtly heroine, "a lady & soferayne" (a lady and a sovereign), with her present condition: "Of bewte I was a lady precious, / Of gentil blode desendyng, of right lyne / Of Eve . . . Men of honour and of gret worschip al dyd declyne; / And nowe here in erth mortal deth come me to— / Emang ʒow wormes nakyd lyg I loo!" [Concerning beauty, I was a lady of worth, descending from gentle blood and of right lineage, from Eve. . . . Men of honor and of great worship all did bow down to me, and now here in earth mortal death comes to me—among you worms I lie naked, behold!] (37–43). The corpse laments the change of her courtiers from "men of honor" to the worms who now uncourteously threaten her (41). Like the courtly romance heroine who calls on knights for protection against rape, this woman calls upon her knights and squires who formerly offered her service to "sucour and defende here my body" [succor and protect here my body], asking the worms to leave her "of curtasy and gentilnes" [out of courtesy and gentility] and to seek another corpse who may "ʒow rewarde with better wardone" [reward you with a better reward] (85, 54, 56), as a lord might a courtier.

The poem not only makes use of courtly gendered vocabulary to convey the abject plight of the female corpse but also uses the more specifically erotic language of rape expressed in the *pastourelle*. The initially thin worms—"whan ʒe first began to drawe me to, / It semes me ʒe wer fed in a faynt pasture" [When you first began to draw to me it seems to me you were fed in a meager pasture] (51–52)—become engorged: "Now fatte waxen and ugly rownde and gret also!" [Now you have grown fat and ugly and round and also great!] (53). Like the knight of the *pastourelle* threatening the maiden with rape as discussed by Kathryn Gravdal, the worms refuse the corpse's entreaties: "Nay, nay, we wil not ʒit departe the fro"[32] [No, no, we will not depart from you] (58). She

objects that they are discourteous to expose her by stripping her of fleshly clothes: "uncortes ʒe be unto me, / thus hevely to threte me and manace / And thus me lefe bot bare bones to see" [Discourteous you are unto me thus grievously to threaten and menace me and thus to leave me nothing but bare bones to see] (72–74). By the end of the poem, however, the corpse, like the maiden in many of the *pastourelle* rape poems, submits to the assault: "What sal I do bot lat thaim hafe thair wyll? /Aventure me must abyde thof thai do me spyll!" [What shall I do but let them have their will? I must abide my fate even though they may destroy me!] (119–20). Stating that she will no longer "dispute" or "debate" "bot suffer ʒour violence" [but endure your violence], she tells them, "Do ʒour will with me" [Have your way with me] (138–39).

The illuminations accompanying the poem reinforce the worms' threatening phallic connotations and the corpse's attempts to resist their assault. The worms depicted on the transi-tomb are much larger and longer in the ensuing drawings and appear in a group of four. So great have they become that in the illuminations they are a third the size of the skeleton. In the first image of the corpse debating with the worms, the skeleton's right arm is raised in a gesture signifying her speech resisting the worms' assault (figure 5.3). The worms are above her, close to her head, that is, the place associated with her mind and reason. In the last illumination, the worms are below her body nibbling her feet and look-ing upwards toward her genitals (figure 5.5). In this image, her resigned submission is suggested by the fact that her right hand is no longer raised but points downwards toward the worms below, a gesture that signifies perhaps her silent acceptance of their assault.

At the end of the poem, however, the corpse performs a remark-able act, one that transforms the previous assault into an actively willed erotic engagement: she seizes the worms and invites them to exchange kisses with her. This willed act recalls some of the *pastourelles* in which the rape victim comes to love her rapist, and it anticipates the more specific actions of Aphra Behn's heroine in *The Disappointment,* who not only submits to rape but also then seeks to caress the penis of her rap-ist, which she, in disappointment, finds to be flaccid. Critics have sug-gested that in greeting the worms the corpse echoes both the kiss of peace of the mass and Job's familial greeting of the worms in Job 17:14,

"I have said to rottenness: Thou art my father; to worms, my mother and my sister." Her welcome to the worms, in addition, is erotically suggestive, especially when placed within the context of the images of oversized worms that accompany her speech, as she says: "Lat us be frendes at this sodayn brayde, / Neghbours, and luf as before we gan do; / Let us kys and dwell to-gedyr evermore, / To that God wil that I sal agayne upryse" [Let us be friends and neighbors at this unexpected moment and love as we before were wont to do, let us kiss and dwell together forever more, until God wills that I shall again rise up] (193–96). By actively inviting the worms to join her in a kiss, the corpse signals her spiritual transformation in her paradoxically active abject submission to God's will. The poet uses the language of rape to convey the radical submission of the will to God necessary for salvation. It is unclear, as Wendy Matlock has argued, whether the corpse can save herself by willingly embracing a desire for God's mercy after death. But her active embrace of the worms followed by her prayer suggests her complete understanding and acceptance of her new state as well as her hope for salvation on Judgment Day.[33]

Not only do the worms teach and enact a gruesome lesson about death, they also serve God's purposes by performing a cleansing action associated with confession. The worms aim to scour and polish until the body is "clene," language that suggests the purification of the soul achieved through the scouring and polishing of confession (61). Medieval theologians, as Matlock points out, attributed such confessional functions to worms. Aquinas, for example, writes, "The worm ascribed to the damned must be understood to be not of a corporeal but of a spiritual nature: and this is the remorse of conscience, which is called a worm because it originates from the corruption of sin, and torments the soul, as a corporeal worm born of corruption torments by gnawing."[34] The worms suggest that God has designed them with the ability to perform this cleansing action. They tell the body that they were designed without smell or taste specifically so that they can relish this unappetizing meal. Like their "mesyngers" (messengers), lice, nits, additional worms, and fleas—they are agents of God who impress upon the body its mortal state and prepare it for its future meeting with God on Judgment Day (121–34).

However, the fact that this poem, unusual in the tradition, represents the dead as speaking in the body rather than as a soul out of the body raises some theological questions about the relationship between soul and body after death and especially about the location and nature of the female soul after death. Given that a woman was described in Middle Ages as a daughter of Eve—a genealogy the speaker here also allies herself with—and as a being inextricably intertwined with her body, one wonders whether it is possible for the female corpse here to have a soul capable of separation from the body. Yet how does the corpse speak if not through animation by a soul? In the end, the intertwined body and soul suggests an Aristotelian notion of the hylomorphic person made up always of body and soul. Furthermore, the emphasis on the dead as an animated corpse rather than as an entity whose body and soul are separated reinforces a fundamental tenet of the Christian faith that is too often minimized: that the body, rather than being despised, is loved and that it will be lovingly resurrected and reunited with the soul on Judgment Day. While the Anglo-Saxon soul-body debate presents the body as a thing to be despised, this poem, in keeping with a number of late Middle English soul-body debates, suggests the soul's need for the body and indeed the soul's affection for the body. While some models of purgatory suggest that the soul goes elsewhere while the body rests in the grave, here both body and soul together await Judgment Day in the same tomb. By representing a soul and body that is specifically gendered female, the poem indirectly suggests answers to questions about the fate of the female soul that theology only touches upon. Given women's assumed corporeality, for example, what happens to the female person's body and soul at death? The answer the poem gives is ambiguous, for the woman here hopes to escape her bodily desires at the same time that she manifests them in her active embrace of the worms. While demonstrating the female corpse's assumed inherent sexuality, her abject embrace also paradoxically signifies the complete subjection of her will to God necessary for her transcendence of the potentially sinful consequences of that sexuality.

But does the poem cast any light on the gender of this body that may be resurrected on Judgment Day? While nothing explicit is stated

in the poem about the gender the body will then display, the poem in its setting, that is, in relationship to the image of the transi-tomb that accompanies it, suggests that sex belongs to death and gender to heaven. Augustine suggests such a division between sex and gender in the discussion cited above, in which he describes the resurrected body as gendered with female organs that are "part of a new beauty." The old sexual organs belong to the realm of death. That the female corpse actively embraces the eroticized worms suggests her understanding that lust belongs to death.

This association of sex with death is reinforced in the elaborate image of the transi-tomb that accompanies the poem. The transi-tomb presents two images of the dead person. On the top of the tomb is an effigy of what we are told is "a fresche fygure fyne of a woman" [a fresh, fine figure of a woman] (21). The epitaph tells us, "sumtyme I was fressche and gay" [once I was fresh and gay]. Below the "fygure fyne," as is common in transi-tombs, is a representation of a partially decomposed corpse crawling with scorpions, worms, and other vermin. Primarily aristocratic given their expense, transi-tombs were fashionable in continental Europe from the late fourteenth century until the seventeenth century. They came into England quite late in the fourteenth century but remained popular well into the eighteenth century.[35] The upper deck of the transi-tomb represents an effigy of the deceased in repose, dressed in fine clothes, and usually with its hands clasped in prayer. As discussed above, the effigy of the female deceased represented here is no exception, and the elaborate design of that effigy, though not especially conveyed by the drawing, is emphasized both by the epitaph and by the depiction of the tomb in the poem itself. The female protagonist of this poem, familiar with the service of courtiers, is undoubtedly meant to be an aristocrat as well.

Also in common with numerous transi-tomb representations of the corpse, the skeleton in the drawing is depicted with her arms no longer in prayer but by her side, one arm in rest and the other pulling a grave cloth across the pelvic bones. This gesture, which occurs in numerous transi-tombs, suggests the corpse's shame of the exposure of her genitals as the worms strip away the body's last clothing, the skin. But when does this shame exhibit itself? This action grants to the

corpse an agency beyond death, for at the moment of death the person is in repose with hands in prayer, but some time later the hands have moved to cover the genitalia. This gesture recalls the origin of genital shame in the Fall: Adam and Eve cover their genitalia in shame at the same moment that they are told they must die in punishment for their original sin. Sexual shame then goes hand in hand with death, and thus it is appropriate for the corpse that manifests death (as opposed to the effigy, who suggests potential resurrection) to display its awareness of the sexual shame that accompanies original sin.

Whether sexuality itself existed before the Fall is a matter of debate in theology from Augustine to Aquinas. Most theologians agree that if there had been sexual intercourse before the Fall it was of a different kind than that experienced by human beings after the Fall, just as Augustine suggests that the resurrected body will manifest sexual organs adapted for a new use. Before resurrection, however, the person must accept death and sexual identity. In this poem, the female protagonist achieves this acceptance by embracing the worms, signs of both death and sexuality. Like the image of the skeleton in the transi-tomb shamefully hiding its genitalia in death, the poem places a sexuality associated with the genitals in the realm of death, but it also suggests that some form of gendered identification carries on beyond death and will go forward into the afterlife after Judgment Day.[36]

At the same time, however, the soul that animates the corpse and gives it voice is an erotic being actively embracing phallic creatures and lovingly defending its former beauty both in person and in clothes. As she embraces the ever-swelling phallic worms, the corpse seems to sustain her sexuality, to enact and prolong it, perhaps as a way to keep the worms from devouring her. On the one hand, she is abject, passive meat to be devoured; on the other she is a kissing woman who enters into a disputation, sexually and humanly assertive. While the poem affirms a lesson about the separation of gender and sexuality at death, the narrative itself remains in the realm of flesh and the sexual and fails to realize imaginatively the newly gendered being Augustine contends will exist in heaven.

Gender thus plays a significant role in the poem's representation of two nonhuman entities, the speaking corpse and the worms. But there

is another entity that goes beyond the limits of the human here and that we have yet to consider: the poem itself. As we shall see, the metadiscourse about poetry uniquely afforded by a speaking-corpse poem also draws on gender, in this instance, as part of its reflections on its own nature as a poem. First, let us consider the ways in which this poem might be considered to be posthuman. As written words on a manuscript page it is in some senses a relic, that is, that which is left over from a once living voice. Diana Fuss, quoting Agamben, notes, "As early as Augustine's *De Trinitate,* . . . to poeticize is to 'experience the death of one's own language and one's own voice.'"[37] Speaking-corpse poems engage the status of poetry at a metalevel, for as Fuss suggests they are peculiar in their ability, to quote Emily Dickinson, "'to die—without the Dying,' engaging what Roland Barthes calls the ontological impossibility of the statement, 'I am Dead.'"[38] But in some sense, all poems speak from the realm of the dead. Fuss writes, "Is not every literary utterance a speaking corpse, a disembodied voice detached from a living, breathing body? Literature that immortalizes voice also entombs it, which is why every poem can be broadly understood as a corpse poem. The speaking corpse names not just a particular kind of literary persona but a general attribute of all lyric poems, verse suspended between the animated voice of the speaker and the frozen form of the poem that preserves it."[39]

But is the form frozen? Is a poem just a dead thing, or are there ways in which it can be said to manifest signs of the living? The poem stresses its desire to create movement rather than stillness in the reader. The narrator describes his poem as "a monyscyon to styr and to mefe" [an admonition to stir and move] (211–12). Though dead words on a page, the poem nonetheless is meant to stir and move. As Brantley has observed, the poem is fundamentally performative. The poem models the ways in which we as readers should be moved by the responses of its characters. At the beginning of the poem the narrator was "mefed" (moved) by his conscience to go on a pilgrimage. The speaking female corpse moves from resistance to active engagement with God. Dead people, especially the pagan dead, do not move; normally corpses do not. This Christian corpse exhibits a capacity for change available to the reader as she moves from resistance to acceptance to an active state of

repentance: "now knaw I ful well / that in my lyfe was I made lewyd and unwise / With a reynawnde pride" [Now I know full well that in my life I was ignorant and unwise with a reigning pride] (156–58). Her dialogue, like the poem itself, ends not in silence but in prayer ("Amen" ([204, 218]), a prayer the reader is invited to emulate.

The fact that the voice of the poem is not only that of a corpse but specifically that of a female corpse intensifies the poem's self-reflexive commentary on the hybrid nature of poetry as both living and dead, first of all by representing the dual helplessness and hopefulness of the human condition through the speaking female corpse's voice. The corpse's paradoxically irrepressible vitality despite her passive embrace of her fate emerges through the poet's use of dialogue, especially in her repeated questions, for example to the worms—"Wormes, wormes, . . . why do 3e thus [Worms, Worms, why do you thus] (30–31)—and in her final lament, "Allas, Allas" (156). Most probably the creation of a male, clerical writer, the poem also recounts the experiences of a male ob-server whose voice is captured in the lines at the beginning and end of the poem. At the heart of the poem, however, is the ventriloquized voice of a vital, desiring woman. The poem records a female voice that the poet constructs from his understanding of women in his own cul-ture as vain, adorned creatures stubbornly obsessed with their own beauty in the face of the devastations of aging and death. Yet the re-peated laments of this character, subjected against her will to the pene-tration of her body, echo the voices of historical women struggling against the passive roles assigned to them, especially those of women in the past subjected to rape.

Furthermore, gender serves this poem's engagement with its fragile status on the border between life and death by linking the poet's artistic endeavor to its meditation on the decomposing female body. In the poem's opening lines, the narrator emphasizes first the beauty of the tomb, "ful freschly forgyd, depycte, and depynte" [fully freshly forged, depicted and painted] (16), and then the beauty of the effigy of the woman who recently died, "a fresche fygure fyne of a woman" [a fresh fine figure of a woman] (21). Both artistic creations remind us, however, of their ultimate decay. The corpse describes herself as like those art objects, once "fresche and feete" [fresh and attractive] (33). That "flesh"

and "fresh" differ by only one letter suggests the close connection be-
tween the decorated body of the newly dead, adorned in clothes, and
then merely in flesh, freshly dead, and yet made newly fresh in the
poem through art. By drawing on the association of female beauty with
inevitable corruption and decay, speaking female corpse poems inten-
sify the metadiscourse about the fragility of all artistic enterprises.

Poetic language, especially rhyme and meter, at once essential and
accidental to the poem (as the body is to the soul), is associated in the
poem with both feminine corruptibility and seductive beauty. The verse
form itself reinforces art's fragility. As Fuss writes, "The broken physi-
cality of verse aligns poetry, more than any other literary genre, with
corporeal disintegration."[40] The poet describes his own verse as femi-
nine in its beauty, for he tells us he was directed by a holy man to write
his vision down "undir scripcion, / Als nere as I cowde remembyr me
verily, / In als fayir langage as I cowde godely" [Under writing as near as
I could remember truly; in as fair a language as I well could] (209–11).
The fair language of the poem reminds us of the "ful freschly forgyd,
depycte, and depynte" [fully freshly forged, depicted and painted] tomb,
"made be newe coniecture" [made by new conjecture] (16–17). This
poem follows the newest fashions in poetic form in its use of the verse
form introduced into English by Chaucer, rhyme royal, and is thus also
freshly forged. But unlike the now decaying, once fresh fine figure of
the body, the poem produces the freshness of a defamiliarized explora-
tion of the understanding of the relationship between the body and the
soul at the point of death. That defamiliarization is achieved through
the poet's engagement with assumptions about the simultaneous appeal
and corruptibility of female beauty and adornment.

Furthermore, like the female body, the poem is destined to be con-
sumed. The poet tells us he has made his poem as a "thinge delectabyll"
[delectable thing] (212)—something to be enjoyed, indeed eaten. The
corpse's gender underscores the delectation the poem invites, for when
alive the woman was herself delectable, a courtly heroine to be con-
sumed by the desires of men who has now become the object of the
worms' delectation. But just as the worms serve a purpose in their eat-
ing, so the reader who consumes the poem can learn from his or her
sensual enjoyment of it (in the manner of one of Horace's requisites for

poetry, *delectare*) the lesson of mortality and the urgent celebration of life that poems about death paradoxically provides. Within a Christian economy, a poem that provides a theological lesson in the vernacular functions then not unlike the Eucharist itself, another thin substance, at once dead and alive, that opens up a pathway to salvation. Perceived feminine corruptibility and seductiveness reinforce the poem's assertion of the vanity of human wishes and the fragility of all human endeavors, including artistic ones and especially those such as poetry marked by its dangerously appealing poetic ornamentation. At the same time, a fragile fifteenth-century manuscript, Additional 37049, preserves the unique copy of a poem, which captures within its form the constructed voice of a desiring, erotic woman longing for and, through her instantiation in the material form of the poem itself, to some extent achieving immortality.

NOTES

I would like to thank Jane Burns, Kristin Morrison, and Jeffrey Robinson for their generous conversations and advice about this essay.

1. For Augustine's discussion of the nature of the soul, see *The Greatness of the Soul and The Teacher,* ed. and trans. Joseph M. Colleran (New York: Newman Press, 1950). For Aristotle's discussion of the soul, see his *De anima* in Aristotle, *The Complete Works of Aristotle: The Revised Oxford Translation,* ed. and trans. J. Barnes (Princeton: Princeton University Press, 1984), especially book 2. For Aquinas's commentary on this work, see his *Commentary on Aristotle's De anima,* trans. Robert C. Pasnau (New Haven: Yale University Press, 1999).

2. This summary is adapted from my discussion of the gender of the soul in "Souls That Matter: Gender and the Soul in *Piers Plowman,*" in *Mindful Spirit: Essays in Honor of Elizabeth Kirk,* ed. Bonnie Wheeler (New York: Palgrave, 2006), 165–86.

3. See Giotto's representation of the souls of the saved and the damned in his treatment of the Last Judgment in the Scrovegni Chapel, reproduced in *Giotto: The Frescoes of the Scrovegni Chapel in Padua,* ed. Giuseppe Basili (Milan: Skira editore, 2002), 428 ff. I am grateful to Diane Wolfthal for pointing out this image to me.

4. Augustine, *The Nature and the Origin of the Soul,* in *Answer to the Pelagians,* trans. Roland J. Teske, S.J., Works of Saint Augustine, pt. 1, vol. 23 (Hyde Park, NY: New City Press, 1997), 555.

5. For a detailed discussion of the nature of the resurrected body from the period of the patristic writers to the fourteenth century, see Caroline Walker Bynum, *The Resurrection of the Body in Western Christianity, 200–1336* (New York: Columbia University Press, 1995).

6. *The Holy Bible: Translated from the Latin Vulgate,* rev. Bishop Richard Challoner [Douay-Rheims Bible] (London: Baronius Press, 2003). All further biblical quotations are taken from this version.

7. Jerome quoted in Bynum, *Resurrection of the Body,* 90–91.

8. As summarized by Bynum, *Resurrection of the Body,* 90.

9. St. Augustine, *De civitate dei* 22.17, trans. as *Concerning the City of God against the Pagans* by Henry Bettenson (1972; repr., London: Penguin, 2003), 1057.

10. See Bynum's general discussion of the resurrected body in *Resurrection of the Body,* especially 77, 82–83, 90, 96–100, 145, 254–55, 265–66.

11. Masha Raskolnikov, *Body against Soul: Gender and Sowehele in Middle English Allegory* (Columbus: Ohio State University Press, 2009).

12. Diana Fuss, "Corpse Poem," *Critical Inquiry* 30 (Autumn 2003): 1–130.

13. See, for example, Robert W. Ackerman, "The Debate of the Body and Soul and Parochial Christianity," *Speculum* 37 (1962): 541–65, especially 551. Marjorie M. Malvern agrees that this poem avoids a potential heretical dualism; see "An Earnest 'Monyscyon' and 'Thinge Delectyball' Realized Verbally and Visually in 'A Disputacion betwyx the Body and Wormes,' A Middle English Poem Inspired by Tomb Art and Northern Spirituality," *Viator* 13 (1982): 425.

14. Rosemary Woolf, *The English Religious Lyric in the Middle Ages* (Oxford: Clarendon Press, 1968), 316–18.

15. See Raskolnikov's discussion in *Body against Soul.*

16. Woolf, *English Religious Lyric,* 318.

17. Kathleen Cohen discusses this commentary in her *Metamorphosis of a Death Symbol: The Transi-Tomb in the Late Middle Ages and the Renaissance* (Berkeley: University of California Press, 1973), 24–25.

18. *Soul and Body I,* ed. and trans. Tom Shippey, www.apocalyptic-theories .com/literature/soul1/soulbody1.html. I am grateful to Johanna Greene of the University of Glasgow for delightful conversations about matters sepulchral and eschatological in the Anglo-Saxon period.

19. Ibid.

20. See Malvern's superb descriptions of the manuscript illuminations in "Earnest 'Monyscyon,'" 415–53, which includes a thorough and persuasive discussion of the poem. She describes the transi-tomb and epitaph on 420–21.

21. I have transcribed this passage from the manuscript, British Library Additional 37049 and have expanded the abbreviations there. All further quotations from the poem are cited parenthetically in the text by line number and are taken from John W. Conlee's edition in *Middle English Debate Poetry: A Critical Anthology* (East Lansing, MI: Colleagues Press, 1991), 50–62. I have chosen to use the title found in the manuscript rather than the translated title Conlee provides. The lines from the epitaph are also provided at 53 n. 19, although Conlee's transcription differs from my own. Thorns have been indicated here as "th" ampersands have been silently expanded, and "v" has been changed to "u" when appropriate. Translations are my own.

22. Jessica Brantley, *Reading in the Wilderness: Private Devotion and Public Performance in Late Medieval England* (Chicago: University of Chicago Press, 2007). This important book provides an in-depth study of the entire manuscript, Additional 37049, and all of its illuminations.

23. The extra line may in fact be the result of scribal error. Malvern suggests that several lines here and elsewhere have been dropped from the poem and offers a suggested expanded version, which follows a regular rhyme royal form. For her reconstruction of the opening lines, see "Earnest 'Monyscyon,'" 424–25 n. 22.

24. See Caroline Walker Bynum's earlier influential discussion of the feminized body of the suffering Christ in *Holy Feast and Holy Fast: The Religious Significance of Food to Medieval Women* (Berkeley: University of California Press, 1989).

25. Patricia Parker discusses at length the ways in which delay and belatedness are coded as feminine in Spenser's *Faerie Queene* in her book *Literary Fat Ladies: Rhetoric, Gender, Property* (London: Methuen, 1987). Although belatedness is more obscurely feminine here, being late for mass is what opens the reader to the possibility of a vision of a speaking feminine corpse.

26. See John Donne's Holy Sonnet 16, "Batter my hart," in *The Holy Sonnets*, ed. Gary A. Stringer, Variorum Edition of the Poetry of John Donne, vol. 7, pt. 1 (Bloomington: Indiana University Press, 2005), 18.

27. Although *vernacular theology* was in use as a critical term before Watson's essay, his work has nonetheless drawn critical attention to its importance; see Nicholas Watson, "Censorship and Cultural Change in Late-Medieval England: Vernacular Theology, the Oxford Translation Debate, and Arundel's Constitutions of 1409," *Speculum* 70, no. 4 (1995): 822–64.

28. For a summary of the tradition, see Woolf's chapter "Lyrics on Death," in *English Religious Lyric*, 309–55.

29. See E. Jane Burns's discussion of clothing and gender in courtly romance in *Courtly Love Undressed: Reading through Clothes in Medieval French Culture*

(Philadelphia: University of Pennsylvania Press, 2002). She introduces the term *sartorial body* on page 12.

30. Bynum, *Resurrection of the Body,* 174.

31. Quoted in ibid., 175.

32. See Kathryn Gravdal, *Ravishing Maidens: Writing Rape in Medieval French Literature and Law* (Philadelphia: University of Pennsylvania Press, 1991).

33. While Malvern argues that the poem offers an example of the efficacy of late contrition, Wendy Matlock, in her essay "Vernacular Theology in the *Disputacione betwyx the Body and the Wormes,*" in *Translatio: or the Transmission of Culture in the Middle Ages and the Renaissance, Modes and Messages,* ed. Laura H. Hollengreen, Arizona Studies in the Middle Ages and Renaissance 13 (Turnhout: Brepols, 2009), 113–27, takes a less optimistic view and suggests that the body persists in its misunderstanding of the necessity to have given up sin in life. I thank Wendy Matlock for sending me a copy of her essay. While I agree with Malvern that the poem charts a moving transformation of the speaker, the efficacy of that transformation in terms of the speaker's potential salvation is theologically obscure. We might have to assume that she has already been granted a position in purgatory that will lead to salvation after penance and that she is here simply becoming aware of that penitential condition. That the speaker here actively embraces the worms and then earnestly prays suggests her complete understanding of her own mortal sinfulness as well as her hope for salvation on Judgment Day, and the poem asserts the emotional power of that understanding and its potential efficacy, if not for her, then most certainly for its readers. For a discussion of medieval attitudes toward purgatory, see Jacques Le Goff, *The Birth of Purgatory,* trans. Arthur Goldhammer (Chicago: University of Chicago Press, 1981), and on the development of those ideas in the late Middle Ages and into the Renaissance, see Stephen Greenblatt, *Hamlet in Purgatory* (Princeton: Princeton University Press, 2001). I would like to thank Desmond O'Brien for discussing the theology of purgatory with me.

34. Thomas Aquinas, *Summa theologiae* 97, art. 2 in the supplement to part 3, quoted in Matlock, "Vernacular Theology," 119. Worms are also associated with rebirth. See, for example, the Anglo-Saxon poem *The Phoenix,* in which the worm signifies not only the abjection of death but also the seed of resurrection.

35. See Cohen, *Metamorphosis,* for a discussion of the tradition as well as her list of surviving transi-tombs in Europe and Great Britain.

36. Bynum suggests that John Erigena Scotus understood there to be such a division in his discussion of what looks like an androgynously sexed soul in which, as Bynum writes, he "hints that something we might think of

today as gender [in contradistinction to sex] survives eternally." See Bynum, *Resurrection of the Body,* 145.

37. Fuss, "Corpse Poem," 1–30, 27.

38. Cited in ibid., 12, and Roland Barthes, "Textual Analysis of Poe's 'Valdemar,'" in *Untying the Text: A Post-Structuralist Reader,* ed. Robert Young (Boston: Routledge and Kegan Paul, 1981), lexia 110, 153–54. I am grateful to John Coyle for directing my attention to this text.

39. Fuss, "Corpse Poem," 30.

40. Ibid., 27.

III

Institutional Effects

Chapter 6

Hybridity, Ethics, and Gender in Two Old French Werewolf Tales

NOAH D. GUYNN

> When I give answers instead of deepening the questions, I take away
> from my text.
>
> —Emmanuel Levinas, *Nine Talmudic Readings*

The fascination that medieval werewolf tales hold for modern readers
undoubtedly stems from their sympathetic, even heroic depictions of
the man-beast hybrid. Unlike the typical Renaissance werewolf ("a
rough, dirty peasant who savagely attacks, kills, and then eats his vic-
tims, who are usually children"), the werewolves of Old French litera-
ture are noblemen who retain their intellectual and moral faculties while
in lupine form.[1] Though initially mistaken for predators, they are even-
tually revealed to be fierce defenders of feudal monarchy. They appear
especially virtuous when contrasted with the women who deceive them
and usurp their power. Indeed, the theme of lycanthropy is seemingly
inseparable from that of female betrayal.

This essay examines two Old French werewolf lays—Marie de France's *Bisclavret* (ca. 1160–78) and the anonymous *Melion* (ca. 1190–1204)—and pays particular attention to gender asymmetry and misogyny as social and ethical problems directly tied to the texts' fascination with hybrid, indeterminate bodies and deceptive, shifting appearances.[2] In both texts, gender hierarchy is inverted when a wife obtains her werewolf-husband's secrets and then betrays him, depriving him of his human body and noble status. Though incapable of speech, the werewolf manages to signify his allegiance to court and king through mute gestures and is assimilated back into society as a beast. When he seeks revenge, his savage conduct ironically reveals his underlying humanity and his wife's secret misdeed. The wife is repudiated by husband and king and is abandoned or chased off like a wolf. In *Bisclavret,* she pays an additional price: the werewolf rips off her nose, and she passes this defect on to some female scions.

At first glance, the message these tales communicate seems rather obvious. The werewolf transcends his bestial nature while trapped in the body of a beast and is restored to human form by wordlessly signifying submission to his king and authority over his wife. By contrast, the wife speaks when she should remain silent and behaves in bestial, antisocial ways; as a result, she is punished by the husband she has betrayed, by the court whose norms she has violated, and (in *Bisclavret*) by the body she has misused. We are apparently meant to conclude that threats to domestic and political unity can be counteracted only through the wise, just, and occasionally violent rule of the *seignor* (lord or husband), who is entitled to protect his rights and dignity even if that entails acts of savagery. *Melion* seems to endorse such a reading by offering a closing aphorism in which the werewolf warns men not to unduly trust their wives, who are capable of destroying them. On the basis of this "explicit moral," Amanda Hopkins concludes that the lay functions as an exemplum of "female treachery."[3] Though *Bisclavret* contains no such aphorism, it, too, has sometimes been read as a misogynistic exemplum, most recently by Paul Creamer, who describes it as "a text in which hatred of the female is, on every level, pungently and efficiently displayed and ratified."[4] Certainly, both werewolf tales suggest an affirmation of male headship and feudal sovereignty through penalties im-

posed upon the wife. They also rather plainly demonstrate how much easier it is to dehumanize a woman than a werewolf.[5]

While *Bisclavret* and *Melion* are unquestionably bound up with patriarchal ideologies, however, I would like to propose that those ideologies are greatly complicated by the indeterminate bodies on which they are enacted and by the literary medium that bodies them forth: the narrative lay. As we shall see, Old French lays use ambiguities of characterization, action, and narration to draw attention to the inadequacy of a strictly deontic, propositional morality. They are, in this respect, more closely tied to casuistry than exemplarity. An ancient and medieval method of case-based reasoning, casuistry serves to moderate the theoretical procedures of a principles-based ethics and to draw attention to the irreducible contingencies at the heart of concrete moral situations. As Albert Jonsen and Stephen Toulmin note, scholastic "natural law doctrine provided room for, and even demanded, a casuistry for its completion," meaning that metaethical theories of right and wrong could be tested only through an inquiry into the unique conditions that surround human actions and alter their meaning.[6] For canonists and confessors, philosophers and poets, the morality of deeds was to be assessed through interlocution. Indeed, they often invoked the mnemonic "quis, quid, ubi, quibus, auxiliis, cur quomodo, quando?" (who, what, where, by what means, why, how, when?) to remind themselves that interrogation and deliberation, accidents and variation are at the very heart of morality.[7] The elementary narrative form that André Jolles calls *casus* is likewise characterized by situational inquiry, though here with an emphasis on the opacity of human events and the incompletion of narrative and interpretive acts: "a weighing occurs but not its result"; questions are posed but "without the possibility of a response."[8] By highlighting irresolvable discrepancies between a particular tale and the universal law it either claims or appears to convey, the casuistic text indicates that its function extends well beyond moral exemplification to encompass narrative and ethical uncertainty and intersubjective dialogue.

Reading werewolf lays as *casus* may help us to perceive the ways in which they not only point to theoretical transcriptions of doers and deeds (e.g., the exemplary force of a wife's betrayal of her husband) but

also undermine those transcriptions through acts of storytelling. Insistently coupling moral judgments with narrative omissions and ambiguities of interpretation and address, *Bisclavret* and *Melion* manifest the characteristic traits of *casus:* boundless interpretive and ethical engagement. Since casuistry proceeds inductively from cases to principles, I will defer my own theorization of narrative ethics until after I have presented readings of my primary texts. Those readings will be linear and plot driven and will focus on gaps in evidence and the ethical questions those gaps seem to raise. In choosing to read *seriatim,* I hope to demonstrate that attention to narrative unfolding is itself a mode of ethical reflection. As Adam Zachary Newton has argued, and as the Old French lay forcefully demonstrates, narrative is a mode of moral instantiation that nonetheless resists totalization and abstraction. It evinces instead the uniqueness of actors, actions, and circumstances and the ethical obligations inherent in communicative exchange: "the exigent conditions and consequences of the narrative act itself," "the costs incurred in fictionalizing oneself or others by exchanging 'person' for 'character,'" and "the ethico-critical accountability which acts of reading hold their readers to."[9]

BISCLAVRET

As many critics have noted, the nameless wife in *Bisclavret* is evocative of two of the most notorious *femmes fatales* in Christian exegesis. Like Delilah (who, for Ambrose, Abelard, and Peter Comestor, embodies female deceit, avarice, and disloyalty), she wheedles her husband until he betrays himself and is incapacitated.[10] Like Eve (for Tertullian, the cause of "human perdition" and paradigm of her sex), her desire for knowledge leads to catastrophe and is punished with exile and traumatic childbirth.[11] At the same time, the wife resembles Delilah and Eve in her inscrutability: her motives are enigmatic, her interiority is heavily obscured, and her story is filled with aporias. The very actions that seem to define her as *mulier perniciosa* are those that, on closer inspection, unsettle attempts to evolve a convincing misogynistic argument. In failing to decipher the motivations for, and meaning of, her actions, Marie

points to blind spots in the narrative and suggests, without fully articulating, alternative interpretations of female infamy.

Marie's interest in narrative and moral ambiguity is obvious from the opening lines of *Bisclavret,* which claim to reveal the tale's origins and werewolf's nature but instead obfuscate the relationship between texts and meanings, species and behaviors:

> Since I've taken it upon myself to make lays, I do not wish to forget Bisclavret; Bisclavret is its/his name in Breton; the Normans call it/him Garwaf. Long ago one could hear tell, and it often used to happen, that some men became garwolves and lived in the woods. The garwolf is a savage beast; as long as this rage is upon him, he devours men and causes great evil, resides in and roams about the great forest. Now I'll put this matter aside: I wish to tell you about the Bisclavret.

Quant de lais faire m'entremet,
Ne voil ublïer Bisclavret;
Bisclavret ad nun en bretan,
Garwaf l'apelent li Norman.
Jadis le poeit hume oïr
E sovent suleit avenir,
Humes plusurs garual devindrent
E es boscages meisun tindrent.
Garualf, c[eo] est beste salvage:
Tant cum il est en cele rage,
Hummes devure, grant mal fait,
Es granz forez converse et vait.
Cest afere les ore ester;
Del Bisclavret [vus] voil cunter.

<div align="center">(1–14)</div>

It is difficult to say here when Garwaf (from Frankish roots meaning "wolf-man") and Bisclavret (etymology disputed) are interchangeable and when they refer to literary titles, fictional characters, or a zoological category. Though the narrator seems to refer to a single tale about a

single werewolf that happens to circulate in two languages, there are stark discrepancies between the description of garwolves as malevolent maneaters and Bisclavret's dutiful, rational conduct in the body of the lay. Indeed, the declaration "les ore ester" (literally, "I now leave this be") announces an interruption and transition, albeit rather ambiguously: it is unclear whether we move from sameness (Garwaf = Bisclavret) to difference (Garwaf vs. Bisclavret), from group (garwolves) to individual (*the* Bisclavret), or from moral description to narrative instance. These attempts to establish Bisclavret's distinctiveness are further confused by the fact that his nature is articulated through a series of discordant pairings and semantic slippages. There is no mention of a *lou* in Marie's lay, only a *beste,* and we therefore know about Bisclavret's lycanthropy primarily through the puzzling association with Garwaf. Moreover, as Matilda Bruckner argues, Bisclavret is "caught in the redundancy of common and proper nouns" and "lacks the distinction conferred by a name which does not simply coincide with a general category; his difference can only be suggested in the subtle play with the definite article."[12] Given these ambiguities, one wonders whether there is a single werewolf lay or several, which lay we will be told, and from what perspective.

A bias in favor of the werewolf and against his wife, known only as "la femme Bisclavret" (193, 227), seems clear in what follows. We learn that Bisclavret is neither beast nor madman but a virtuous knight who is his lord's "privez" [intimate] (19) and beloved of his peers. By contrast, his wife, though initially described as "vailant" (21), soon demonstrates that she may lack the virtues that word signifies: courage, goodness, honesty, and reliability. Even her beauty is suspect in that her demeanor is artfully constructed and associated with pretense: "mut feseit beu semblant" [she made a fair appearance] (22). The wife's guile is increasingly obvious in an ensuing dialogue in which she asks her husband to explain his frequent absences from their home. Though she initially hesitates to speak out of fear "Jeo creim tant vostre curuz, / Que nule rien tant ne redut" [I am so afraid of your anger that there is nothing I dread so much] (35–36), she soon resorts to aggressive strategies of persuasion, disregarding her husband's warnings that the information she seeks will make her stop loving him and lead to his

undoing. She blandishes and flatters him ["blandi e losenga"] (60) until he finally reveals that he is a werewolf. Apparently undeterred, she then torments and tricks him so tenaciously ["tant l'anguissa, tant le suzprist"] (87) that he divulges his secret: should he lose his clothing while in lupine form, he will remain a wolf forever. The wife is again stricken with fear and so enlists the support of a neighboring knight who has long loved her without being loved in return. Revealing her innermost feelings to him ["li descovri sun curage"] (110), she grants him her body and her love and asks him to steal her husband's clothes. When Bisclavret fails to reappear, the wife and neighbor marry.

Though critics are often tempted to ascribe motives to the wife's behavior, it is striking how illegible her actions actually are. Construing the narrative as a particularly hermetic *casus,* we might ask: What is the nature of her "curage," and what part of it are we (and the neighbor) privy to? How genuine are her love and fear, given how quickly and inexplicably they arise and shift? How real is the danger she faces from the werewolf (who, if we are to believe the narrator's initial exposition, may be capable of "grant mal"), and how genuine is the fear that induces her to bind herself to a man she has never loved and conspire against a man she does? If her motive isn't fear, why does she seek to destroy her husband as soon as she has the chance? As is typical of the *casus,* these questions are neither explicitly posed nor satisfyingly answered, though the narrator does indicate that the wife has committed a serious infraction of feudal law: "Issi fu Bisclavret trahiz" [Thus was Bisclavret betrayed] (125). The verb *traïr* likely refers to the crime known in medieval law codes as petty treason, the murder of a husband or master by a wife or servant, a capital offense analogous to high treason, the betrayal of a lord by a vassal.[13] At the same time, some aspect of the wife's (indeed, *any* wife's) vulnerability may be glimpsed in the law's double standard. Though a crime, the murder of a wife by a husband did not rise to the level of treason, nor was it thought to harm sovereignty. Moreover, husbands were entitled to beat their wives to compel obedience without being subject to legal interference, provided the violence wasn't deemed unreasonable or excessive.[14]

The remainder of the lay will to some extent bear out a narrow, legalistic condemnation of the wife's actions in that it is devoted to the

ennoblement of the werewolf (who is faithful to his *seignor*), the penalization of the wife (who is traitorous to hers), and the renewal of feudal, homosocial bonds (an ideological reflex in the lay, though not an unproblematized one). A year after the knight's disappearance, the king's hunting party chases the wolf down in the forest. The dogs are about to tear it to bits when it runs to the king, grabs him by the stirrup (as if with hands), and kisses his leg and foot. The king calls his lords forward to observe this "merveillë" (152): a beast who has "sen de hume" [the mind of a man] (154), "entente e sen" [understanding and intelligence] (157). Ordering his knights to keep the dogs away, the king grants the beast his peace and abandons the hunt. This scene clearly recalls a feudal commendation ceremony: a largely nonverbal ritual in which a vassal pays homage to his lord, offers a "kiss of vassality" (often on the foot or knee), and receives in return a promise of peace.[15] Bisclavret here proves himself to be not simply a tamed animal *(beste privee)* but once again the king's intimate *(privez)*. Put another way, he epitomizes, without at the moment embodying, the fundaments of feudal society: coalition, fellowship, and loyalty.

Paradoxically, the most striking manifestations of Bisclavret's knightly honor are also the most terrifying expressions of his bestial power: brutal assaults on his wife and her new husband when they appear at court. Bisclavret attacks the husband several times, prompting the court-dwellers to conclude that his behavior is not "sanz reisun" (208): the man must have wronged the beast. The werewolf's attack on his wife, though in some ways a more decisive action, is cast in an equally hazy light. When Bisclavret lunges at his wife "cum enragiez" [as one gone mad/wild] (233) and rips off her nose, the narrator explains the assault as a rationally chosen act: "Oiez cum il est bien vengiez!" [Hear how thoroughly/well he is avenged!] (234). Though Bisclavret here resorts to lupine savagery (*enragiez* surely recalls Garwaf's *rage*), the word *vengiez* implies that his actions conform to medieval conceptions of lawful retaliation: revenge was considered a valid response to injury and a legitimate strategy for recovering lost property or safeguarding one's reputation.[16] That said, the text is also deeply ambivalent about the ethical status of vengeance. The *bien* of "bien vengiez" could be taken as a moral endorsement of Bisclavret's attack

or instead as an intensifier that magnifies its violence. Moreover, the narrator immediately raises doubts about Bisclavret's actions with a rhetorical question, one that can be read either as a moral critique or as an amplification of the damage done: "Quei li peüst il faire pis?" [Could he have done anything worse/more wicked to her?] (236). On one hand, the punishment fits the crime, in that the wife's monstrous treachery is now legible on her formerly beautiful, artfully constructed *semblant*. On the other hand, we are left to wonder whether the wife's motives and circumstances, if they were as fully known as her husband's, might transform a barbarous act into one that is itself not lacking in *reisun*.

Indeed, whereas the lay is obviously preoccupied with Bisclavret's interiority and experience, it largely obscures the wife's, rendering her desires and intentions as questions that are neither asked nor answered. The court dwellers fail to express any sort of interest in her motivations. True, they are initially prepared to tear Bisclavret to bits for attacking her; but a "sages hum" [wise man] (239) swiftly intervenes to stop them. Addressing the king and invoking "cele fei ke jeo vus dei" [the faith I owe you] (248), he urges that the wife be tortured until she divulges the reasons for the beast's hatred. At least as it is reported to us, the wife's confession reveals very little about her own experience and is focused almost exclusively on Bisclavret:

> As much from suffering as from fear she told him everything about her lord: how she had betrayed him and stolen his clothes from him, the story he told her, and what he became and where he went.

> Tant par destresce e par poür
> Tut li cunta de sun seignur:
> Coment ele l'aveit trahi
> E sa despoille li toli,
> L'aventure qu'il li cunta,
> E quei devint e u ala.
> (265–70)

The werewolf and king here unmask the "real" monster (could "la femme Bisclavret" suggest both possession and apposition?) through a

legally sanctioned act of violence: a very real experience of fear prompts the wife to reveal the truth. That truth in turn confirms the sagacity of the "sages hum," the sustaining nature of the "fei" uniting king and barons, and the legitimacy of the werewolf's aggression, which was motivated by an act of *traïson*.

And yet Marie is also sensitive to the fuzzy boundary separating the forensic quest for truth from its rhetorical construction. On one hand, the lay seems to depict the wife as obviously culpable and suggests that her actions do not require the kinds of interpretation that awaken sympathy for her husband. On the other hand, her confession invites questions that could lead in a very different direction, suggesting perhaps that the truth she reveals is the product of physical coercion and of an ideological desire to equate justice with feudal alliance. Thus, whereas the wife tells "tut . . . de sun seignur," we may wonder how much of her own story she gets to tell, and how much of it gets remembered in a lay that bears her husband's name and effaces her own. To what extent are remembering and telling shaped by the actions of the werewolf's allies, who inflict pain and fear in the name of truth and justice but also feudal allegiance *(fei)*? Does the wife herself use the word *traïr,* or is this a legal gloss added to a confession as it is reported to us in indirect speech? Does the werewolf's doubly mediated confession ("quei devint") not mitigate the wife's crime, especially given what we have been told of his ilk ("grant mal fait")? Does anyone notice the parallels between werewolf and wife, both of whom have kept their "curages" hidden from their lords?

These questions are never posed, and the wife's behavior elicits few attempts at sustained interpretation. Bisclavret, by contrast, benefits from various sympathetic readings of his predicament and an apparent failure on the part of king, sage, and court to pose moral qualms about his lycanthropy. As if to guarantee the unbreakable solidarity of the baronage, the king restores Bisclavret's lands to him and punishes the wife by driving her off like a wolf: "Chacie [ad] de la cuntree" [He chased her out of the country] (306). No mention is made of a penalty for her new husband, who evidently follows his wife by choice; and oddly, the narrator now links the wife's treachery to her adulterous relationship with the knight she has never loved:

He went away with her, he for whom she betrayed her lord. She had quite a number of children, who were afterward easily recognized by appearance and by face: several women of the lineage—this is the truth—were born without noses and so lived noseless.

Cil s'en alat ensemble od li
Pur ki sun seignur ot trahi.
Enfanz en ad asés eüz,
Puis unt esté bien cuneüz
[E] del semblant e del visage:
Plusurs [des] femmes del lignage,
C'est verité, senz nes sunt nees
E si viveient esnasees.

(307–14)

The passage is famous for its symmetry and obscurity. Human generations repeat the act of defacement; sound *(nees/esnasees, nes/nees)* echoes meaning (reproduction); and for werewolf and wife, outward signs are ostensibly made to conform to inward moral states. Like the feudal justice that banishes her, however, the poetic justice of the wife's punishment is hardly straightforward and does little to resolve the semantic and moral problems attached to gender, childbirth, and memory. Why do women alone bear the imprint of their foremother's transgression, and not men? Why are some female progeny affected but others? Does the lack of a nose make visible an otherwise undetectable flaw transmitted exclusively from mother to daughter? Why is the second husband not remembered as the children's father, almost as if the wife generates them alone? Whether or not we interpret the severing of the nose as symbolic castration, noselessness is tied to sexual difference and childbirth. Indeed, given the importance of agnatic descent in contemporary romances, the emphasis on matrilineage should be understood as highly marked. Its significance, however, is left unresolved and is as marvelous as a beast endowed with "sen d'hume."

Ambiguities aside, it isn't difficult to understand why some critics have interpreted the link between defacement, monstrosity, and matrilineage as an attack on women's moral and sexual weakness. Read

quickly, the passage easily lends itself to an archetypal reading of the one woman in all—precisely the construct some exegetes use to interpret Eve and Delilah as the origin and epitome of female treachery. And yet Marie stops well short of essentialism (only *some* daughters are *nees esnasees*) and crucially fails to decipher anatomical lack: like the werewolf's hirsute body and elongated, phallic snout, the daughters' noselessness does not have any patent moral or characterological significance. More to the point, one could argue, as Bruckner has, that *Bisclavret* demands to be read through the unsystematic model of moral reasoning established in the opening lines—a model that emphasizes "the questionable status of the general category with respect to the individual members of it, questionable at least as a fixed model or predictor for individual behavior."[17] The reader is asked to consider the validity of a category- and rule-bound semiotic and moral system, precisely because the text alternately conflates and differentiates between universals and particulars, seeming and being. Though *Bisclavret* appears in places to allegorize and totalize its characters (none of whom bears a truly proper name), this gesture is counterbalanced by an emphasis on the opacity and particularity of moral situations and the complication of circumstances and motives, especially where the wife is concerned.

Indeed, the wisdom of the "sages hum" lies precisely in his rejection of *semblance* in favor of investigation: he guesses that the werewolf's attack is not savagery but lawful retaliation and urges a formal inquiry. Likewise, moral meaning attached to the wife's behavior (or visibly imprinted on the faces of some female progeny) must be carefully weighed against a multitude of alternative interpretations. This is something the wise man, in using enhanced interrogation techniques to confirm his prejudgment, fails to do. Perhaps his obligation to his king overshadows his commitment to justice, or perhaps, as with Bisclavret, what the wise man is *called* does not fully capture what he *is*. Either way, his concern is exclusively with the werewolf's underlying nature, which he believes he can see underneath the visible exterior. By contrast, he neglects the wife's interiority altogether, judging her purely according to surfaces and using her instrumentally to gain access to her husband's occluded identity. This asymmetry is so conspicuous in its violence that it begs questions about bias and adjudication. Why should a wife accused of

treachery not benefit from the kind of compassionate, inquisitive readings that exculpate and empower her werewolf-husband? And what questions might have been asked in order to provide a firmer grasp on the truth and therefore, perhaps, a more equitable judgment?

Of course the wife remains inscrutable, and any questions about her motives and experience can be posed only retroactively and without hope of finding answers. Still, in emphasizing the inscrutability of the individual and her or his motives, *Bisclavret,* like all *casus,* points to the unbridgeable gap separating narrative witnessing from secure knowledge and the concomitant deficiency of perspectives and judgments. It places particular stress, moreover, on the consequences for a woman of being judged according to assumptions and appearances, of being perceived as a monster and then treated like one. Though the wife remains largely mute, and though questions that might lead to a more sympathetic reading of her actions never get asked, she nonetheless operates, as Marshall Leicester argues, as "a voice for the suppressed of the system."[18] This voice is largely mute and signifies exclusively *sous rature.* However, the casuistic construction of the lay, which refrains from imposing a limiting intention or explanatory moral and repeatedly demonstrates the expressiveness of mute gestures, invites us to interrogate the perspectival, aporetic nature of the evidence we are given and the inadequacy of summary judgments.

MELION

As I have already established, *Melion* does not exhibit comparable interest in female subjectivity, nor is it reticent about allowing its hero to voice his disdain for women. As we shall see, however, the text's misogyny is complicated, if not attenuated, by its fascination with species and gender hybrids, including a humiliated, emasculated, lycanthropic knight and a usurping, mannish, inapprehensible woman. If *Bisclavret* problematizes women's subordination by impeding access to the wife's desires and motives, *Melion* takes this tendency to an extreme, rendering the wife as an unreadable, fairylike cipher whose desires and intentions are never revealed. This flattening out of the wife's identity serves to

highlight disquieting tensions within the social construction of chivalric identity—tensions that, despite Melion's aphorism, could easily be taken as the real subject of the lay.

As the story opens, Melion, a knight bachelor at King Arthur's court, makes a public vow never to love a maiden who has ever loved another man or even spoken of one. All the courtly maidens take offense, presumably because he has impugned female constancy and chastity. They assemble a "parlement" (32) centered on the queen and unanimously agree to shun him. Demoralized by their rebuff, Melion fails to "seek adventure" or "bear arms" (39–40) and swiftly loses his "prestige" and "knightly valour" (47). Arthur grants him a fiefdom to console him, and he retreats there to enjoy the pleasures of the forest. Melion is now enfeoffed but also exiled, and his social standing has been seriously compromised. By casting aspersions on women's rectitude and refusing to love any woman with an existence independent of his own, he has triggered the formation of a shadow political body that repudiates his judgments and leads him to compromise his dignity and betray his obligations. His authority to moralize women's conduct is thus countervailed by his vulnerability to women's moral outrage, sexual choice, and capacity for concerted action. More seriously, if these events are to be generalized (as the lay's exemplary structure suggests they could be), the female *parlement* is threatening not just to Melion but also to *chevalerie* and to the political entities that depend upon it.

To some extent, Melion's subsequent lycanthropic adventures enable him to reclaim moral and political power on behalf of the knightly brotherhood and Arthur's court, though this victory, which involves betrayal, humiliation, and submission, is hard won and remains only partial. While hunting, Melion encounters a maiden wearing an ermine cloak and traversing the forest alone. She reveals that she is of noble lineage (her father, we later learn, is the king of Ireland) and will love him, and him alone, forevermore. They wed and conceive two sons, and Melion again experiences joy. Three years later, while hunting in the forest with a squire, the couple encounters a stag. The wife declares she will never eat again if she cannot have some of its flesh and falls from her horse in a faint. Unable to console her, Melion shows her a ring with two stones—one that will turn him into a wolf, another that will restore

him. He entrusts her with the ring but warns that if he should lose it, he would remain a wolf forever. The wife helps Melion metamorphose, then promptly abandons him, departing for Ireland with the squire in tow. Despondent and later enraged, Melion pursues her in lupine form.

On one hand, the wife's conduct seems to exemplify Melion's earlier doubts about female constancy and submissiveness: not only is she fickle and deceitful, but she also refuses to subordinate her existence to his. On the other hand, Melion has demonstrated that he is incapable of fulfilling his own expectations of male discernment, headship, and choice: he cannot distinguish truths from lies, fails to control his wife's actions, and cannot master his desire to serve her, even at the expense of human dignity. Melion's wife, by contrast, has considerable freedom of movement and choice: she leaves her father and fatherland, wanders alone through a foreign wilderness, condemns her *seignor* to live as a wolf, and claims his squire as her own. Since the squire is an arms bearer, the wife has in effect symbolically castrated her husband and appropriated his knighthood, leaving him to *chacier,* the leisure activity associated with his loss of sexual and chivalric prowess. The wife is indeed so free of external constraints that even her motives go unexplained, leaving us to question the meaning of her behavior. Why has she left Ireland? How has she heard about Melion, and what has she heard? Why does she love him, if she actually does? Why does she abandon him in lupine form, leaving her sons parentless? What is her attachment to the stag, and why does she faint? Is the squire her servant or lover? Should we interpret her near-total lack of interiority as privileging Melion's psychological depth—and therefore his greater claim to the reader's sympathies? Or should we instead read opacity as a determined resistance to capture? Perhaps in leaving the wife's intentions ambiguous, the lay implies that she owes an explanation to no one. Certainly it establishes that she is not her husband's quarry (a creature to be captured and domesticated) but his double and rival: the werewolf-knight and fur-clad princess are both hybrid creatures who wander the forest and abandon their obligations to their *seignors.*

Gendered conflicts continue to dog the narrative of Melion's adventures; indeed, in what follows, it is never entirely clear who is the hunter, who is the prey, and what kind of prey he/she/it is. Melion

follows his wife to Ireland, where he forms a pack with ten real wolves (a likely reference to the Irish *fían,* a band of wolfskin-clad warriors or brigands) and uses them as mercenaries to fight a devastating yearlong war against the Irish.[19] The king responds by organizing a hunting party, which his daughter asks to join. When all the wolves but one are killed, she warns that he is the largest and therefore the most to be feared. Though the remaining wolf is indeed quite dangerous (it is of course Melion), his threat to the Irish is attenuated by the arrival of Arthur, who has traveled to Ireland to broker a peace, reconcile the factions, and forge an alliance against Rome. Having seen Arthur disembark from his ship, Melion approaches his encampment, enters his tent, and lies down at his feet. Arthur and his barons are astonished by what they see: a wolf that is "privés" (411, 426), "tous desnaturés" (430), and even "cortois" (432). Arthur extends his protection to the wolf, which rewards him by prostrating himself at his feet no fewer than five more times over the course of the lay. Melion's restoration to chivalric dignity is thus achieved through behavior that is unnatural for a wolf but is wholly typical of the wolf's domesticated relative, the dog. As Joyce Salisbury observes, dogs were valued in the Middle Ages for their loyalty to their masters; however, their tendency toward servility placed them "in a lower social class than the free predators."[20] Melion's gestures of submission may therefore humble him as both knight *and* wolf, and the interpretation of his behavior as "cortois" may suggest that *courtoisie* is itself debasing or dehumanizing.

The significance of Melion's prostration is further confused by echoes of Norman colonial ideologies throughout the second half of the lay and by associations in contemporary sources between lycanthropy and Irish barbarism.[21] *Melion*'s readers (especially those who knew Geoffrey of Monmouth's *Historia regum Britanniae* or Wace's *Brut*) would likely have understood Arthur's mission as a veiled reference to the Normans' brutal pacification of the Irish and reformation of their church—and therefore as equal parts persuasion and coercion. To some extent, Melion serves as an agent of, and cover for, Arthur's colonial ambitions: his wife's betrayal motivates a ruinous private war that prepares the ground for Arthur to assert sovereignty over the Irish through diplomatic maneuvers. The intensity of Melion's desire for vengeance

and the renewal of his status as Arthur's ally signal a rectification of his earlier failure to fulfill his obligations to king and court: he is now very much a warrior, albeit one who behaves like a vigilante and will require Arthur's moral guidance. At the same time, Melion's restoration also marks him as obedient and domesticated—precisely the traits he sought in a wife but was unable to find. Moreover, like the Irish (as depicted, say, in Gerald of Wales's *Topographia Hibernica*), he is a freakish hybrid: his virile-lupine power to conquer and destroy is conjoined with a form of canine servitude that distinctly "others" him, casting him in a subaltern role that no woman in the lay has been willing to adopt and that mimics the fantasy of the compliant colonial subaltern. Though he devastates the Irish, he also resembles them: the werewolf, like the colonial subject, is simultaneously human and animal, redeemable and perverse. More to the point, the fact that his doggish gestures of obedience lead to his reinstatement as Arthur's *privez* suggests that chivalry itself is a mode of domestication, that knights are made to submit to their lords in much the same way women are made to submit to husbands or Irish barbarians to Norman reformers. In other words, the knight regains his human dignity only by first behaving like a servile dog and willingly subjecting himself to a power that colonizes, feminizes, and tames him.

This focus on the tensions within chivalric masculinity undoubtedly fuels Melion's disparagement of wives in the closing lines. Here, the lay demonstrates how category disruption can stimulate identity panic and outbursts of violent rage. Appearing at court under Arthur's protection, Melion encounters his squire and repeatedly threatens him. When the servants move in to protect the squire and kill the wolf, Arthur intervenes to protect it as his chattel: "Sachiés que li leus est a moi" [Know that this wolf is mine] (502). Arthur and Yder suspect the squire of wrongdoing, and Arthur demands that he confess or die. We are told that the squire recounts "tot" (519), though, like the wife's confession in *Bisclavret,* this one is vague and lacunary:

> At once he told the king
> How the lady had brought him with her,
> How she had touched Melion with the ring,
> And taken him there to Ireland.

———

Maintenant a le roi conté
Comment la dame l'ot mené,
Comment del anel le toucha
Et en Yrlande l'en mena.
 (515–18)

Why does the squire twice indicate that the lady brought him with her, and what does this reveal about their relationship? Why doesn't he mention the wife's theft of the ring or her abandonment of Melion, which are presumably her real crimes? Though the confession reveals precious little about the wife's actual conduct and though she never herself confesses, Arthur decides that "malvaisement engignié l'a" [she has played an evil trick on [Melion]] (526) and demands that the king surrender her along with the ring. After much cajoling, the king manages to convince her to comply with Arthur's demand. Arthur then restores Melion in the privacy of a bedchamber with only Gawain and Yder as witnesses. Melion expresses his gratitude by once again throwing himself at his lord's feet. Weeping for joy, Arthur asks Melion to recount what has befallen him. However, the content of Melion's response, if in fact he does respond, is never revealed to us.

Though neither the werewolf nor his wife has offered testimony, the lay concludes with a judgment scene that initially appears to rehabilitate Melion, condemn his wife, and manifest Arthur's majesty. The Irish king suggests that his daughter be burned to death or torn to pieces, but Melion wishes instead to touch her with his ring—a talionic penalty that would presumably humiliate the wife by trapping her in a wolf's body. However, Arthur calls for clemency in the name of Melion's sons and is supported by his barons. Does Arthur act out of forbearance, a virtue he has exemplified throughout the lay? Or is he instead hoping to safeguard all of England's sons by preventing the princess from acquiring the brute force that brought Ireland to its knees? Either way, Melion relents and returns home with Arthur after the diplomatic mission is complete. He leaves his wife behind, commending her to the devil, declaring (somewhat absurdly) that he will never love her again, and warning husbands to be wary of believing their wives:

Melion said: "It will never fail to happen
That he who believes his wife completely
Will be ruined in the end;
He should not believe all she says."
The Lay of Melion is true,
As all the nobles say.

———

Melïon dist: "Ja ne faldra
Que de tot sa feme kerra,
Qu'en la fin ne soit malbaillis;
Ne doit pas croire tos ses dis."
Vrais est li lais de Melïon,
Ce dïent bien tot li baron.

(587–92)

If the entire baronage agrees on the lay's truth-value (a form of consensus encountered previously only with the female *parlement*), they presumably also endorse Melion's disparagement of women's honor. And yet the narrator tellingly confirms the truth of the tale without endorsing its moral, placing it instead in the mouth of a rather compromised hero. There are indeed many reasons to question the force and validity of Melion's words. To begin with, the aphorism offers a rather incongruous reading of the sequence of events it supposedly encapsulates. Melion was initially ruined not by believing in women's integrity but by denying women interiority on which integrity could be founded. Though his trust in his wife leads to emotional suffering, he is not "ruined in the end" but is instead restored to Arthur's favor. If anything, his rehabilitation was made possible by his wife's betrayal, which spurred him to action, lured him away from leisure, and made him worthy once again of intimacy with a king.

Most crucially, the aphorism fails to distract attention from the tensions inherent in the relationship between lords and vassals, a relationship that is uncomfortably close to that between a master and his mongrel. Even once he has been restored to human form, Melion continues to humble himself, prostrating himself at Arthur's feet like a

dog—or perhaps like a knight receiving investiture. He has in effect re-
placed the wife, whom he was tempted to serve and trust unthinkingly,
by a king, whose commands he obeys without question, even if it means
depriving himself of the revenge he craves. Melion seems to give little
thought to whether unwavering trust in his *seignor* could also diminish
his power, and he is rewarded for his obedience. At the same time, we
are left with the impression that the wife remains more powerful than
her husband and retains self-determination by refusing to be relegated
to a subordinate role. The totalizing gesture of the aphorism ("ja ne
faldra") does not manifest Melion's total authority but on the contrary
his ineffectualness and ready co-optation by power. Indeed, Melion's
restoration to human form is made possible only by the Irish king's
willingness to coax his daughter in what may or may not be a deliberate
repetition of the wife's wheedling in *Bisclavret*: "Tant le blandi e losenga
/ Qu'ele li a l'anel donné" [He cajoled and persuaded his daughter so
much / That she gave him the ring] (530–31).[22] Ultimately, the lay dem-
onstrates the ineffectiveness of male commands, at least when they are
issued to women: to enforce a decree imposed upon him by a foreign
overlord, the king must plead with his own daughter, whose incon-
stancy is punished not with bloody revenge but with a flaccid moral that
does little to vindicate male discernment and power.

In short, *Melion* demonstrates that feudal allegiance confers power
and dignity by requiring a form of submission that is analogous to, and
literalized as, bestial abasement. Melion is his lord's intimate and derives
power from that intimacy, but he also embodies the very qualities (loy-
alty, docility, and dependence) that he sought in a wife and that are
found also in a dog. Just as the lay demonstrates that Melion is dehu-
manized and feminized by alliance, so, too, it foregrounds his resent-
ment at being emasculated and the violence that resentment is capable
of generating. Far from demonstrating the unbreakable unity and moral
consensus to be found among "li baron," *Melion* instead highlights male
resentment and gender panic and suggests that it finds outlets in projec-
tions that miscarry: a defamation of women that fails to vindicate men
and the pacification of an Irish other who proves to be stubbornly un-
manageable. Since defamation and colonization generate a response—
including the formation of a shadow "parlement" that undermines the

court from within—the lay ultimately uses the thwarting of chivalric power to demonstrate how elusive political solidarity and moral consensus are and how masculinity is an intrinsically defensive formation shaped through struggle.

HYBRIDITY, CASUISTRY, AND NARRATIVE ETHICS

In the final analysis, neither *Bisclavret* nor *Melion* demonstrates the kind of moral and ideological rigidity that modern readers have typically associated with misogyny (construed as a cultural process that disparages women by totalizing them) and exempla (construed as a narrative genre that inculcates timeless moral truths in unequivocal ways). Indeed, as many critics have argued, these definitions are themselves oversimplified and do not fully capture the hugely complex aesthetic and ideological phenomena they describe. Recent scholarship has sought to illuminate the complexities of exempla in particular, demonstrating the ways in which they call attention to the contingencies of narrative and moral interpretation even as they make generalizing, prescriptive claims about human behavior.[23] And yet neither *Bisclavret* nor *Melion* really qualifies as an exemplum, since (Melion's dubious aphorism aside) they make little pretense to teaching moral lessons that are directly applicable to lived experience. On the contrary, as casuistic texts, they problematize the moral functioning of narrative cases and emphasize what Mikhail Bakhtin calls the "unfinalizability" of individuals, circumstances, and events.[24]

Among medieval casuistry's distinguishing features are paradigms and circumstances. Unequivocal, paradigmatic cases are used to evaluate more equivocal ones and to determine to what extent adjudication is affected by the status of the individuals involved or by the conditions attached to the case. The further a case moves away from the paradigm, the more uncertain judgment becomes and the greater the need to investigate circumstances in all their uniqueness and contingency. Once the circumstances of a case are more fully known, a standard of probability is used to assess differences between paradigm and case and to arrive at a plausible (rather than apodictic) judgment. Above all, paradigms

are used not as enforcing exemplars but as gauges for evaluating more ambiguous *casus conscientiae:* difficult cases that would elicit perplexity in a person of conscience. According to Jonsen and Toulmin, even the most systematic forms of premodern ethics weren't organized like Spinozan or Cartesian "moral geometry," in which "one could 'prove' that any new case fell unambiguously under some strict universal and invariable definition of, for example, courage or temperance, treachery or murder. Nor were the merits of a case formally entailed by any such definition. Rather, arriving at sound resolutions required one to see how far and in what respects the parallels between problematic cases and more familiar paradigmatic cases could justify *counting them as* cases of 'courage' or 'treachery.'"[25]

Jolles uses the metaphor of the two-pan scale to convey the subtlety of this case-based reasoning: the scale conveys "the swaying and swinging of the mental activity that weighs and ponders"; and just as weight and counterweight move in opposite directions, so laws and paradigms are counterbalanced by the weight of circumstances and are judged by their ability to account for situational contingencies.[26] For Jolles, as we have seen, casuistry is not only a model of moral reasoning but also a narrative form—one that depicts arresting but only partially intelligible moral situations and that poses moral questions without formulating answers. In this regard, casuistry closely resembles Newton's narrative ethics, which is a phenomenology rather than a deontology: a strategy of reading that does not attempt "to evaluate or even solve a text's problems" but rather "engages them in their concrete, formal, narrative particularity." Instead of grounding moral reflection in "universal and self-evident laws of reason" (in the manner of Aristotle, Kant, Hume, and Habermas), narrative ethics emphasizes (along with Bakhtin, Levinas, and Cavell) "the radicality and uniqueness of the moral situation itself, a binding claim exercised upon the self by a concrete and singular other whose moral appeal precedes both decision and understanding."[27]

Initially, it may seem odd to read lays that fail adequately to differentiate characters from categories through the lens of narrative phenomenology and moral uniqueness. And yet Jolles's account of *casus* and Newton's of narrative ethics find a close parallel in Marie de France's well-known claims about obscurity and ethical deferral in her

Prologue to the *Lais*. Marie here asserts a hopeful (though *not* utopian) belief in the advancement of human understanding through the interpretation of ancient authorities:

> It was the custom among the ancients, as Priscian attests, to speak quite obscurely in the books they wrote, such that those who were to come after and study them could gloss the text and add to it the surplus of their understanding.

> Custume fu as ancïens,
> Ceo tes[ti]moine Precïens,
> Es livres ke jadis feseient
> Assez oscurement diseient
> Pur ceus ki a venir esteient
> E ki aprendre les deveient,
> K'i peüssent gloser la lettre
> E de lur sen le surplus mettre.
>
> (9–16)

Acknowledging that interpretation is an arduous task ["grevos' ovre"] (25), Marie insists that it also offers rich rewards: improving readers' minds, keeping them from vice, and freeing them from suffering. This is why she has decided to compose lays, even though it has kept her awake at night. The difficulty of obscure texts, whether Roman or Breton, lies in their unfinalizability: they continually return readers to the difference between *lettre* and *surplus* and therefore to the limits of interpretation and understanding. The opacity of the text and the futurity of the gloss (which is always "a venir") neatly capture casuistry's unfulfillable ethical imperative: the obligation to seek out wisdom by deliberating over perplexing cases, all the while understanding wisdom as deficient, provisional, and consigned to the past. *Lettre* and *surplus,* narrative and gloss, case and verdict can only momentarily coincide; and the discrepancies between them belie the illusion of insight. The text's problems are so irresolvable that we are left to ask questions about gaps in narrative and the contingency of knowledge. Put somewhat differently, the lay, like the werewolf himself, is a hybrid, in the sense Jeffrey Cohen assigns to that term: not a synthetic whole but a monstrous

convergence, "a conjoining of differences that cannot simply harmo-
nize" and that reflect the heterogeneity of, and irresolvable tensions
within, medieval literary cultures and audiences.[28] Though fictions of
shared origins, pure identities, and unbreakable bonds are ubiquitous in
medieval literature, they are often predicated upon the artificial merging
of disparate elements rather than true synthesis; and unresolved differ-
ences within hybrid structures regularly threaten to destabilize unity by
exposing its fictitiousness.

In her *Lais,* Marie exploits hybridity to its fullest, drawing attention
to hybrid creatures, failed equivalences, defective references, and dubi-
ous translations. The letter of the text is incomplete until it merges with
its gloss, while the gloss is, by dint of the passage of time, an always al-
ready insufficient response to the text's demands and cannot therefore
fuse with it. Similarly, *Bisclavret* is a Breton tale translated into Anglo-
Norman but featuring a Breton title and *matière* that are only superfi-
cially analogous to their Norman counterparts. Just as Garwaf, Bis-
clavret, and "la femme Bisclavret" are never fully revealed or unmasked,
so, too, the signifiers *Garwaf* and *Bisclavret* (whether as name, thing, cate-
gory, or tale) are not coextensive with the meanings assigned to them—
meanings that, like the daughters' missing noses, are lacking at the text's
inception. The lay itself is a composite of many different sources—oral
and written, Breton and Norman, texts and intertexts—none of which
contains the truth of the werewolf, only the marvelous obscurity of the
letter. As a written work, the lay's dissemination also entails hybridity:
the fusion of human letters and animal skin that constitutes a medieval
manuscript. As for "la femme Bisclavret," her hybridity (wife-monster)
and intertextuality (Eve, Delilah) suggest that she is not an archetype
but a monstrous crossbreed who gestures insistently—but, like her hus-
band, often mutely—toward the gaps, silences, and omissions in folk-
tales, coerced confessions, judicial verdicts, and collective memory.

Marie de France is especially probing in her efforts to cultivate the
ambiguities of lycanthropy and to tie narrative opacity to an unspoken
but nonetheless palpable feminine discontent. It is clear, however, that
the *Melion*-author also uses lycanthropy as a lens through which to ob-
serve the evasiveness of moral, ontological, or epistemological certainty.
As prominent as it is, Melion's aphorism can only go so far toward re-

solving the problems of gender and power raised within the narrative itself. Indeed, in some sense it exaggerates these problems by condemning *all* wives and imbuing marriage itself (and the feudal alliances that depend upon it) with permanent suspicions and antagonisms. What kind of power do men have if their wives are relentlessly pursuing their destruction, and if survival depends upon knowing what aspects of women's speech can actually be trusted? How much moral authority should be given to a man who claims to have been overly trusting with a woman he made little effort to understand—a woman, moreover, whom he seems to have assumed would submit willingly to his stifling vision of love and marriage? For that matter, who should be considered a "real" man or woman in a werewolf tale, and how seriously can we take an aphorism uttered by a hero who is simultaneously man and wolf, knight and dog, leader and idler, warrior and outlaw? Acclaimed as true by "tot li baron," the lay simultaneously reaffirms and erodes the "natural law" of male headship, along with stable identities and moral truths. Though we cannot simply ironize away Melion's disparagement of women, we should understand it as only partially distracting attention from cultural anxieties regarding the real power and discernment of men. Indeed, misogynistic topoi in *Melion* must be read through and against the lay's tendency to associate moralization and authority with ambiguity and resistance.

Of course, it isn't terribly surprising that texts devoted to lycanthropy should associate ethics and narrative with alterity and hybridity—with other cases and meanings and with incongruous, compound forms of being. Though these moral subtleties may have been lost on many medieval readers, who no doubt saw in *Bisclavret* and *Melion* confirmation of their cynical attitudes about women's probity, it is difficult to deny that both lays are sensitive to, and seek to amplify, the ambiguities and tensions inherent in narrative reception. Through storytelling, they draw attention to the polymorphic, unfinalizable nature of individuals, circumstances, and events and to the inadequacies of a systematic, deontic morality. At the same time, they leave ample room for the reader to interrogate the moral transparency of human actions and the reliability of acknowledged, naturalized forms of wisdom and authority. The defacement of the wife and her female offspring in *Bisclavret,* an act

that perpetuates monstrosity even as it attempts to rob it of its power, is particularly telling in this regard. It brings our attention to bear on the inexhaustibility of moral debate and on the violent effects of exercising moral authority. We might even see in the wife's defaced countenance (which is both "vis" and "semblant," exposure and resistance) an anticipation of Levinas's ethical reading of the face as vulnerability and obligation. "The face is a living presence," he asserts, one that "resists possession, resists my powers" but also "speaks to me and thereby invites me to a relation."[29] Whether human or lupine, beguiling or disfigured, the face inexorably signifies even as it thwarts attempts to complete its meaning.[30] By shifting shape or having new shape foisted upon it, it points to the vulnerability and resilience of lived existence: even after being mutilated and torn by a brutal act of revenge, "the face presents itself, and demands justice," if, in the case of "la femme Bisclavret," only mutely.[31]

NOTES

I am grateful to Gina Bloom, Matilda Bruckner, Fran Dolan, and Margie Ferguson for offering feedback on this essay, and especially to Seeta Chaganti, Claire Waters, and the editors of this volume for reading several drafts and making invaluable suggestions for improvements.

The epigraph is from Emmanuel Levinas, *Nine Talmudic Readings,* trans. Annette Aronowicz (Bloomington: Indiana University Press, 1994), 62.

1. Leslie Sconduto, *Metamorphoses of the Werewolf: A Literary Study from Antiquity through the Renaissance* (Jefferson, NC: McFarland, 2008), 127.

2. Citations to *Bisclavret* and *Melion* are to line numbers and are given parenthetically in the text. Those to *Bisclavret* are taken from Marie de France, *Lais,* ed. Alfred Ewert (Oxford: Blackwell, 1944); translations are mine. Those to *Melion* are taken from *French Arthurian Literature IV: Eleven Old French Narrative Lays,* ed. and trans. Glyn S. Burgess and Leslie C. Brook, with Amanda Hopkins (Cambridge: D. S. Brewer, 2007); translations are Hopkins's.

3. Amanda Hopkins, "*Bisclavret* to *Biclarel* via *Melion* and *Bisclaret:* The Development of a Misogynous *Lai*," in *The Court Reconvenes: Courtly Literature across the Disciplines,* ed. Barbara K. Altmann and Carleton W. Carroll (Cambridge: D. S. Brewer, 2002), 321.

4. Paul Creamer, "Woman-Hating in Marie de France's *Bisclavret,*" *Romanic Review* 93, no. 3 (2002): 272.

5. Giorgio Agamben reads the werewolf in *Bisclavret* as the embodiment of "bare life," that is, life that can be exterminated without violating the law and that, by its inherent vulnerability, confirms the sovereign authority of the law. He further reads the werewolf's metamorphosis as a "state of exception," a suspension of citizenship that affirms and extends state power. See *Homo Sacer: Sovereign Power and Bare Life,* trans. Daniel Heller-Roazen (Stanford: Stanford University Press, 1998), 104–8. Though this reading is a suggestive one, it blithely disregards the fact that werewolf and wife are each in turn constituted as bare life and that feudal sovereignty is ultimately restored through the brutal imposition of the state of exception on the wife: she is mutilated, tortured, and forced into exile. On Agamben, bare life, and *Bisclavret,* see Erin Labbie, *Lacan's Medievalism* (Minneapolis: University of Minnesota Press, 2006), 66–106; Miranda Griffin, "The Beastly and the Courtly in Medieval Tales of Transformation: *Bisclavret, Melion,* and *Mélusine,*" in *The Beautiful and the Monstrous: Essays in French Literature, Thought, and Culture,* ed. Amaleena Damlé and Aurélie L'Hostis (Bern: Peter Lang, 2010), 139–50; and Emma Campbell, "Political Animals: Human/Animal Life in *Bisclavret* and *Yonec,*" *Exemplaria* 25, no. 2 (forthcoming).

6. Albert R. Jonsen and Stephen Toulmin, *The Abuse of Casuistry: A History of Moral Reasoning* (Berkeley: University of California Press, 1988), 127.

7. See ibid., 132.

8. André Jolles, *Formes simples,* trans. Antoine Marie Buguet (Paris: Seuil, 1973), 151. Jolles's text originally appeared in German: *Einfache Formen: Legende, Sage, Mythe, Rätsel, Spruch, Kasus, Memorabile, Märchen, Witz* (Halle: Max Niemeyer, 1930).

9. Adam Zachary Newton, *Narrative Ethics* (Cambridge, MA: Harvard University Press, 1995), 18.

10. Ambrose, *Apologia altera prophetae David,* 3, PL 14:892; Peter Abelard, *Planctus Israel super Samson,* PL 178:1820–21; and Peter Comestor, *Historia libri Judicum,* 19, PL 198:1289–90.

11. Tertullian, *De cultu foeminarum,* 1.1, PL 1:1304–5.

12. Matilda Tomaryn Bruckner, "Of Men and Beasts in *Bisclavret,*" *Romanic Review* 81, no. 3 (1991): 255.

13. On feudal law in Marie's *Lais,* see Judith Rice Rothschild, "A *Rapprochement* between *Bisclavret* and *Lanval,*" *Speculum* 48, no. 1 (1973): 78–88.

14. See Emma Hawkes, "The 'Reasonable' Laws of Domestic Violence in Late Medieval England," in *Domestic Violence in Medieval Texts,* ed. Eve Salisbury (Gainesville: University Press of Florida, 2002), 57–70.

15. See Sconduto, *Metamorphoses of the Werewolf,* 45.

16. See Ann Park Lanpher, "The Problem of Revenge in Medieval Literature: *Beowulf, The Canterbury Tales,* and *Ljósvetninga saga*" (PhD diss., University of Toronto, 2010).

17. Bruckner, "Of Men and Beasts," 266.

18. H. Marshall Leicester Jr., "The Voice of the Hind: The Emergence of Feminine Discontent in the *Lais* of Marie de France," in *Reading Medieval Culture: Essays in Honor of Robert W. Hanning,* ed. Robert M. Stein and Sandra Pierson Prior (Notre Dame: University of Notre Dame Press, 2005), 132–69.

19. See Matthieu Boyd, "Melion and the Wolves of Ireland," *Neophilologus* 93 (2009): 555–70.

20. Joyce E. Salisbury, *The Beast Within: Animals in the Middle Ages* (New York: Routledge, 1994), 133.

21. Lisa Lampert-Weissig argues that the renewal of interest in lycanthropy in the twelfth century is at least in part a reaction to Norman expansionism. See *Medieval Literature and Postcolonial Studies* (Edinburgh: Edinburgh University Press, 2010), 41–56.

22. As Amanda Hopkins observes, there is no solid evidence proving the *Melion*-author knew Bisclavret. She believes the two texts derive from separate sources but hypothesizes that all medieval werewolf narratives descend from "a single ultimate source." See Burgess and Brooke, *French Arthurian Literature IV,* 418–21, quotation at 418.

23. See especially Elizabeth Allen, *False Fables and Exemplary Truth in Later Middle English Literature* (New York: Palgrave Macmillan, 2005).

24. Mikhail Bakhtin, *Problems in Dostoevsky's Poetics,* trans. Caryl Emerson (Minneapolis: University of Minnesota Press, 1984), passim.

25. Jonsen and Toulmin, *Abuse of Casuistry,* 108.

26. Jolles, *Formes simples,* 151.

27. Newton, *Narrative Ethics,* 11, 12.

28. Jeffrey Jerome Cohen, *Hybridity, Identity, and Monstrosity in Medieval Britain: On Difficult Middles* (New York: Palgrave Macmillan, 2006), 2.

29. Emmanuel Levinas, *Totality and Infinity: An Essay on Exteriority,* trans. Alphonso Lingis (Pittsburgh: Duquesne University Press, 1969), 66, 197, 198.

30. Levinas famously equivocated when asked whether animals had faces. On his anthropocentric ethics and Jacques Derrida's critiques thereof, see David Clark, "On Being 'the Last Kantian in Nazi Germany': Dwelling with Animals after Levinas," in *Animal Acts: Configuring the Human in Western History,* ed. Jennifer Ham and Matthew Senior (New York: Routledge, 1997), 165–98.

31. Levinas, *Totality and Infinity,* 294.

Chapter 7

A Snake-Tailed Woman

Hybridity and Dynasty in the *Roman de Mélusine*

E. JANE BURNS

THE FOURTEENTH-CENTURY PROSE NARRATIVE *LE ROMAN DE MÉLUSINE* stages the marriage of a mortal man, Raymond, nephew of Count Aymeri of Poitiers, to a fairy-woman: Mélusine. The romance charts the complex entanglements of dynastic succession, crusading, and colonization that result from this unconventional marriage as the worlds of these two protagonists, one highly political and the other heavily mythic, collide on the geographic terrain of the Hundred Years' War and exotic lands far beyond.[1]

Crucial from beginning to end, however, is the puzzling question of Mélusine's identity. "Who is she, really?" the text seems to ask. Although Mélusine, who gives her name to the Lusignan family line, claims to be a princess from Albania ["Melusigne d'Albanie"] (38/196), her future husband worries before the wedding that his bride might in fact be only an apparition, or what he later calls a *fantosme* (255/692).[2] Indeed, the wedding chapel seems to appear out of nowhere, suspiciously adjacent to a marvelous fountain, and its decorations, while bearing the requisite

marks of nobility, wealth, and status, are eerily otherworldly.[3] Thus does Raymond's brother, the comte de Forez, press him repeatedly to learn something of Mélusine's family lineage.[4]

The terms Mélusine uses to reassure her prospective husband are telling: "I know you think that my words and I are an illusion and the work of the devil. But I certify that I am a creature of God's world" [Je scay bien que tu quides que ce soit fantosme ou euvre dyabolique de mon fait et de mes paroles, mais je te certiffie que je suiz de par Dieu] (25/164). She repeats the claim shortly thereafter, insisting: "Have no fear, I am definitely from God's world" [Et ne vous doubtez car seurement, je suiz de par Dieu] (26/166). Mélusine then describes the couple's future marriage, not as a highly vexed joining of a fairy and a mortal but as the more straightforward union of a man and a woman, two earth-bound humans. It is a union not unlike that of the first couple Adam and Eve, as we shall see.

Despite her assertion that she is from God's world, Mélusine makes Raymond promise that, once they are married, he will not seek her out or look at her on Saturdays, that is, when she bathes.[5] Yet when the curious and anxious Raymond eventually breaks his solemn oath and spies on his wife, surveying her enormous marble bathing pool through a tiny hole in the gate, he discovers that Mélusine, the courtly beauty, the noble and elegant princess of Albania, is in fact much more than a simple woman:

> She had the appearance of a woman down to the navel, a woman combing her hair. Below the navel, she had an enormous serpent's tail, thick as a barrel of herring and horribly long, which she used to slap the water that sprayed as high as the vaulted ceiling.

> ───────

> [Mélusine] . . . estoit jusques au nombril en figure de femme et pignoit ses cheveulx, et du nombril en aval estoit en forme de la queue d'un serpent, aussi grosse comme une tonne ou on met harenc, et longue durement, et debatoit de sa coue l'eaue tellement qu'elle la faisoit saillir jusques a la voulte de la chambre. (242/660)

The scene is represented in a number of manuscripts that feature the heroine's snake tail. We might consider, for example, Paris, Bibliothèque

de l'Arsenal Ms. 3353, which shows Mélusine alone in the bath (figure 7.1), although the small tub represented here differs significantly from the enormous rectangular pool described in the text.

At the end of Jean d'Arras's romance, after many narrative threads involving political intrigue across far-flung countries have been spun out, the betrayed Mélusine, the faithful wife and mother of ten sons, bounteous courtly lady, and capable administrator of estates, bids farewell to her husband and undergoes the most complete transformation yet, temporarily losing all human features. As the narrator explains, "She changes into a large, thick, long serpent, fifteen feet in length" [Et lors se mue en une serpente grant et grosse et longue de la longueur de xv. piez] (260/704). Appearing now as a kind of winged dragon or wiveryn, this "lady in the form of a serpent" [dame, en guise de serpent] (260/704) takes flight from the castle window, circles the building several times, and flies off toward Lusignan (260/704). We see her later in Ms. 3353 with wings and a snake's tail (figure 7.2).

In one sense, the romance seems to stage the question of Mélusine's identity in stark either/or terms: Is she a supernatural fairylike being who can magically shape and reshape her body into semianimal form as circumstances dictate? Or is Mélusine, as she contends, a fully human woman formed by God?[6] Is she in fact the dangerous "faulse serpente" that Raymond calls her in one particularly angry outburst?[7] Or is she, as Raymond also asserts, somewhat curiously, at the very moment he first views his wife's serpent tail, "the best and most loyal lady ever born since 'she who carried our Creator'" [La meilleur et la plus loyal dame qui oncques nasquist après "celle qui porta Nostre Createur"] (242/662)? The latter remark displaces the putative fairy/woman/monster figure into a clearly Christian context, aligning this half-woman half-serpent with the Virgin Mary. At this moment, the romance seems to indicate that Mélusine might in fact be both: a powerful snake-tailed creature and an elegant, civilizing, courtly lady as beneficent as the Virgin. In its complex staging of this woman with a tail, then, the *Roman de Mélusine* encourages us to ask at every turn, "What happens to gender when we move beyond human bodies?"

At the same time, the thoroughly hybrid Mélusine is firmly grounded in local politics. According to legends of the region of Poitou, the lands of the Lusignan family and more specifically "the noble and

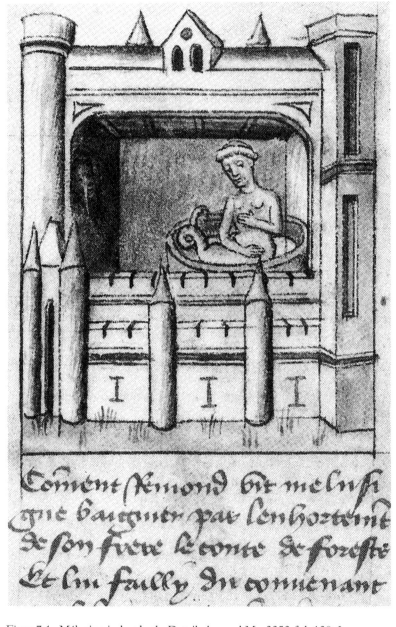

Figure 7.1. Mélusine in her bath. Detail, Arsenal Ms. 3353 fol. 130, Jean d'Arras, *Le Roman de Mélusine,* Bibliothèque nationale de France.

Figure 7.2. Mélusine flying toward Lusignan. Detail, Arsenal Ms. 3353, fol. 155v, Jean d'Arras, *Le Roman de Mélusine,* Bibliothèque nationale de France.

powerful fortress of Lusignan in Poitou were founded by a fairy" [La noble et puissant forteresse de Lisignen en Poictou fu fondee par une faee] (5/118), or so Jean d'Arras claims.[8] We learn from the outset of the tale that Jean de Berry, son of the king of France, duc de Berry and Auvergne, and Count of Poitou, commissioned Jean d'Arras to write

what he later calls *La noble histoire de Lusegnen* to secure Jean de Berry's claim to Lusignan lands (1, 312/109, 818). To this end, the romance author boasts of marshaling sources that range from "true chronicles," which he obtained ostensibly from Jean de Berry and the Count of "Salbery en Angleterre," to "several books" that were discovered somewhat mysteriously along with eyewitness testimony.[9] The story opens and closes in the local, family terrain amid the captivating swirl of inexplicable and marvelous events we have noted. Jean d'Arras insists throughout the tale that "wondrous things throughout the world, like those associated with fairies, are in fact the most true" [les merveilles qui sont par universel terre et monde sont les plus vrayes, comme les choses dictes faees] (2/112), using this logic to explain how a fairy-woman might found a political dynasty and how a supernatural past might secure a powerful and "noble lignie" that will "reign until the end of time" [La noble lignie . . . qui regnera jusques en la fin du monde] (5/118). Rarely does the fairy world represented in medieval literature carry such strong sociopolitical implications.

A number of years ago Jacques Le Goff and Emmanuel Leroy Ladurie demonstrated the central importance of geography to the Mélusine legend, charting her domain of influence within a substantial scope of Celtic myth stretching from Normandy to Provence.[10] But the Lusignans' territorial fortunes, defined as they are in the fourteenth century by battles against the English during the Hundred Years' War, also derive from a much earlier trans-Mediterranean historical past that this romance replays at length.[11] Here the long arms of Mélusine stretch from Poitou to Cyprus and extend as far as the eastern Mediterranean kingdom of Armenia.[12] As early as the twelfth century, the Lusignans claimed an influential presence in the Middle East, perhaps most notably through Guy de Lusignan, who was king of Jerusalem from 1186 to 1192 and then king of Cyprus, a domain held by the Lusignans until 1489. The family gained control of Cilician Armenia in 1342.[13]

In the end, the fundamental question of Mélusine's identity that is posed with many variations throughout the prolonged romance narrative, making us wonder at every turn whether she is a human or a fairy, a woman or a dragon, a good Christian or an incarnation of the devil, a woman-serpent or some kind of shape-shifter, must be read, I think, in

relation to a heritage of vast land holdings and colonizing dynastic expansion. Indeed, as we struggle to understand the ever-changing form of this heroine's body, we are also faced with the ever-expansive parameters of the Lusignan lands she governs and oversees. Both landscapes, carnal and geographic, shift constantly before our eyes, asking us to expand our conceptions of the human body as we rethink standard romance configurations of medieval women in relation to land and lineage.

Since the scope of this essay does not allow for equal development of both aspects of the Mélusine story, I will focus here on the function of hybridity, alluding, in the closing section, to its broader political implications.

BEYOND THE HUMAN BODY

All three medieval Latin texts considered as ancestors to the Mélusine narrative, accounts penned by Walter Map, Geoffroy d'Auxerre, and Gervais of Tilbury between 1180 and 1220, align the fairy figures they depict with Eve: a seductress in league with the Eden serpent, as Laurence Harf-Lancner and Anita Guerreau-Jalabert have shown.[14] Eve emerges in this paradigm not as the first woman and mother of humankind but as the dangerous temptress who caused the Fall. Yet in many ways Eve does not seem the most apt model for the differently bodied Mélusine.

To be sure, a number of thirteenth-century French romances warn of female beauty being used as a deceptive cover for snakelike seduction. In Jean de Meun's *Roman de la rose,* for example, deceitful courtly ladies are figured literally as snakes in the grass when the character Genius, quoting Virgil, admonishes lovers to flee from such serpent-women:

> Good sirs, protect yourselves against women. Flee, flee, flee, flee, flee, children, flee from such a beast, I advise and warn you, without wishing to deceive or mislead you. Consider these lines of Virgil: . . . "Children who pick small flowers and fresh strawberries: a

cold serpent lies in the grass. Flee, children, because it poisons and envenoms anyone who comes near."

Biau seigneurs, gardez vos de fames/, . . . Fuiez, fuiez, fuiez, fuiez / fuiez enfant, fuiez tel beste, / jou vos conseill et amoneste / san decepcion et san guile; / et notez ces vers de Virgile. . . anfanz qui cueilliez les floretes, / et les freses fesches et netes / ci gist li froiz sarpanz en l'erbe; / fuiez, anfant, car il anherbe / et anpoisone et anvenime / tout home qui de lui s'aprime. (16547, 16552–56, 16559–64)[15]

In Jean's text, the woman as "the cold, evil serpent" becomes transposed into a wholly feminine "malicious snake who dissembles, covers, and hides its venom in the tender grass until the moment when it can spew it out to take you by surprise and harm you" [la malicieuse couleuvre / qui son venim repont et queuvre / et le muce souz l'erbe tandre / jusqu'a tant que le puisse espandre / por vos decevoir et grever] (16569–73). The narrator specifies further that such a snake is venomous throughout, "in body, tail, and head" [car tant est venimeuse beste, / par cors et par queue et par teste] (16577–78).

The *Queste del Saint Graal* reiterates the theme of woman's dangerous seduction by tying it specifically to Eve's deception of Adam. A hermit tells Lancelot that he will fail to complete the Grail quest because he has fallen away from God into love and lust for Guenevere, much as Adam fell for Eve:

But when the enemy, who first made man sin and led him to damnation, saw you so protected and well-armed and was afraid he would not be able to take you by surprise . . . he thought about how to deceive you. At last he realized that he could lead you into mortal sin more easily through a woman than anything else, considering that the first man had been deceived by a woman.

Mes quant li anemis, qui primes fist hom pechier et le mena a dampnacion, te vit si garniz et si coverz de toutes parz, si ot poor qu'il ne te poïst sorprendre en nule maniere. . . . Lors se pensa en mainte maniere coment il te porroit decevoir. Et tant qu'au darrein li fu

avis qu'il te porroit plus tost mener par fame que par autre chose a pechier mortelement, et dist que li premiers peres avoist esté par fame deceuz. (125)[16]

Perceval's temptation in the *Queste del Saint Graal* follows a similar pattern: a ravishing courtly beauty magically appears before the knight and so "heats him up" that he proposes a love match, asking that she be his and he hers. "The young woman who seems so beautiful to him that he thought he had never seen anyone as lovely" is, the hermit later explains, the Eden serpent: "The woman you spoke to is the devil" [La damoisele qui li est si bele, ce li est avis, que onques n'ot veue sa pareille de biauté. . . . La damoisele a qui tu as parlé si est li anemis] (109, 113). However, this serpent appears interestingly to be of mixed gender: "the devil, master of hell, *he* who has power over everyone. It is true that *she* was formerly in heaven in the company of angels, so beautiful and fair" [li mestres d'enfer, cil qui a poesté sor toz les autres. Et si est voirs que ele fu jadis ou ciel de la compaignie des anges, et si biaux et si clers] (113).[17] Shifting pronouns, attested in the majority of manuscripts of this text, allow this *anemis* to become a "she" who then returns to the masculine with the adjectives "biaux et clers."[18] If Perceval has been seduced by a version of the Eden serpent, that creature seems, not unlike Mélusine, to be in fact some sort of hybrid: in this instance a cross-gendered devil in a woman's body. In Mélusine's case, we confront a creature who most often looks like a woman but is perhaps, actually, something else. What would that be?

Since Mélusine's serpentine nature becomes apparent, initially at least, only when she is in the bath where her tail is said to splash water up to the ceiling, we might imagine a fishlike appendage, giving the sense that Mélusine could be some sort of siren or mermaid. Emphasis on her haunting voice later in the narrative further reinforces the resonance with mythic sirens (260/704), as does the detail of Mélusine as a woman "combing her hair." One thinks, for example, of any number of images of mermaids performing that familiar gesture. We might consider the fifteenth-century breviary of Charles of Neufchatel in figure 7.3.

The gesture is, of course, not limited to sirens but also often characterizes clerical depictions of courtly ladies, perhaps most notably

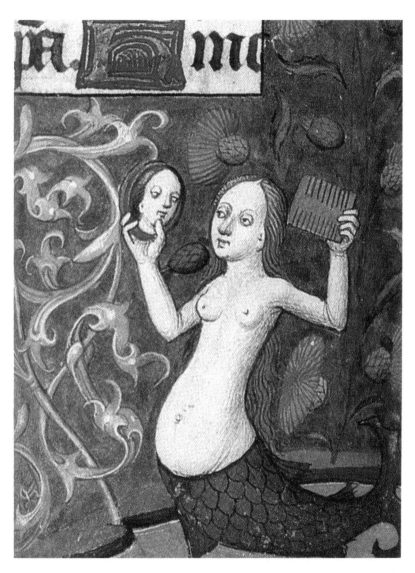

Figure 7.3. Siren holding a comb and mirror. Detail, Ms. 69, fol. 458, *Bréviaire à l'usage de Besançon,* © Bibliothèque municipale de Besançon.

Oiseuse in Guillaume de Lorris's *Roman de la rose,* the courtly beauty who looks into a mirror while combing her hair.[19] To be sure, there is no tail in this depiction of seduction, or in other similar images used to represent the noblewoman's reputed association with Luxuria, often claimed to result from idleness.[20] Etienne de Fougères, for example, cautions in his *Livre des manières* (written in 1174–78) against the dangers of noblewomen who, rather than spin or weave, do nothing but make themselves seductively attractive.[21] Yet it is also possible to read Oiseuse, the iconic figure of idleness who welcomes the Lover into the garden of delights in Guillaume de Lorris's *Roman de la rose,* as an independent woman who threatens courtly conventions less through sexual seduction than by other means. I have argued elsewhere that through her facile creation and re-creation of a sartorial body forged from luxury cloth and costly accoutrements, the figure of Oiseuse in the *Roman de la rose* displays considerable powers of self-fashioning that extend far beyond the pat temptations of "idleness."[22] So too do Mélusine's abilities as a courtly lady far surpass her apparently idle and playful gestures of tail slapping in the bath.

To be sure, in the minds of clerical writers from Augustine on, the danger posed by the truly hybrid versions of seductive women, whether sirens or others, as Jacques Voisenet has shown, is the danger of all half-humans: that they might shift and move between the component parts of their unsettled identities, sliding unpredictably and uncontrollably from the human into the nonhuman. Indeed, the central question that hybrid creatures raise for many patristic writers is whether they form part of God's world or the devil's.[23] Mélusine herself invokes this paradigm, as we have seen, when she claims that she is not an illusion of the devil but a creature of God's world (25–26/164–66).

THE WOMAN-HEADED SERPENT

Yet I would like to suggest that, rather than choose between these limited options in our effort to understand such a complex heroine, we consider a rich pictorial tradition that flourishes in the thirteenth and fourteenth centuries. Joseph Bonnell, Henry Ansgar Kelly, and Nona

Flores have documented the appearance of a woman-headed serpent in Catalonian, English, French, and Jewish manuscripts depicting the temptation scene from Genesis.[24] Take, for example, the image of the Eden serpent bearing a woman's head in Oxford's Bodleian Library, Douce Ms. 381, fol. 123 (figure 7.4). Especially striking is the progression depicted in a moralized Bible from Vienna that first shows Adam and Eve standing on either side of God, who has created them, and then shifts to a second trio of Adam and Eve separated by a woman-headed Eden serpent of indeterminate gender and uncertain species (figure 7.5). In the second panel, instead of the all-knowing and all-powerful God joining the first couple visually, we see an image of intense diversity. The creature seems at one and the same time human and animal (bearing hooves), animal and vegetal, human and avian (bearing wings), and male and female. Other images provide variations on this pattern. A thirteenth-century Parisian psalter shows a woman-headed serpent with her head seemingly crowned by the foliage behind her (figure 7.6).

If we invoke the terms laid out initially in the Mélusine narrative and ask, "Are the woman-serpents figured in these images human or nonhuman?" the question seems thoroughly beside the point. Rather, the multiply hybrid figures represented here issue a serious challenge to those very categories, calling into question the boundaries assumed to distinguish components of the godly and diabolical worlds.

Kelly explains that the tradition of representing the maiden-faced serpent in the Garden of Eden originates with Peter Comestor's interpretation of Genesis 3:1. His twelfth-century paraphrase of the Bible (*Historia scolastica,* ca. 1170) describes the Eden serpent as "erect like a man *[ut homo]*," since it was only laid prostrate later, when it was cursed. In planning Adam's transgression, Lucifer "chose a certain kind of serpent . . . which had the countenance of a virgin *[virgineum vultum habens]* because like favors like *[quia similia similibus applaudunt]*."[25] Yet if we refer to the pictorial tradition that develops from Comestor's commentary, it seems that Eve's likeness to the serpent (or the serpent's likeness to Eve—for resemblance must go both ways) is qualified considerably. Whereas the two figures often share remarkably similar heads, they differ obviously in body. The distinction is crucial.

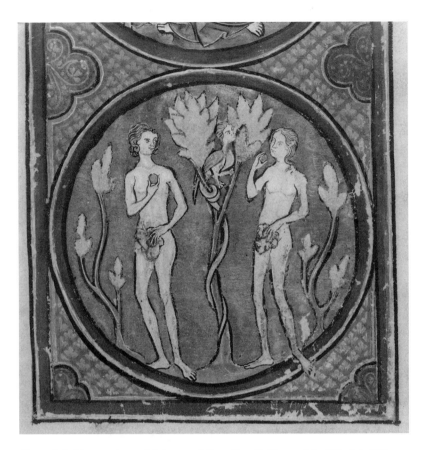

Figure 7.4. Temptation of Adam and Eve. Detail, Douce Ms. 381, fol. 123, Bodleian Library, University of Oxford.

Indeed, the serpent-woman who bears a female head lacks the problematic woman's lower body that traditionally plagues Eve: the reproductive body that comes to define the first woman through the punishment of laboring in childbirth, the utterly fallen female body that Dyan Elliott has analyzed so compellingly.[26] Rather, the emphasis in these images rests on the woman's head, significantly overturning the standard clerical depiction of women modeled on the fallen Eve as a body needing to be governed by the head of a husband, which is exemplified in Augustine's commentary in Genesis.[27] In terms of visual

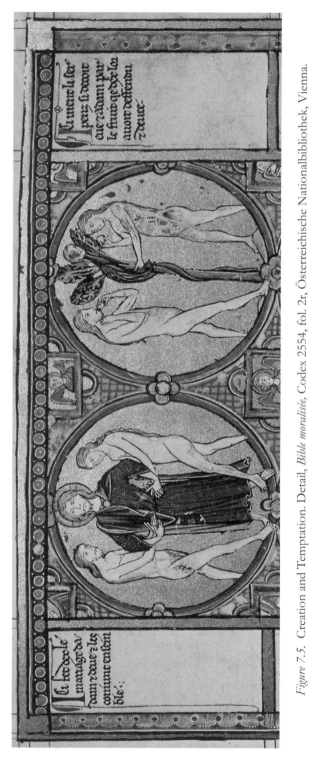

Figure 7.5. Creation and Temptation. Detail, *Bible moralisée*, Codex 2554, fol. 2r, Österreichische Nationalbibliothek, Vienna.

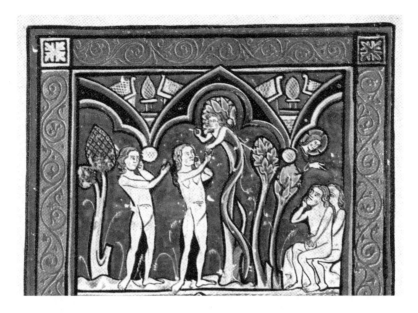

Figure 7.6. Temptation. Detail, Latin Ms. 10434, fol. 10, *Psautier latin aux armes de France et de Castille,* Bibliothèque nationale de France.

composition alone, in these images of Creation, the significance of the woman's head is underscored through its repetition. In a number of the temptation scenes there are in fact two female heads to Adam's one, as in figures 7.5 (second panel) and 7.6.[28] In others, such as the fourteenth-century Peterborough Psalter / Brussels Psalter (figure 7.7), Adam's head does not appear at all. Eve's head is emphasized in yet another way in temptation scenes that differentiate it clearly from the serpent's head. In these instances, the woman-headed serpent appears as a well-coiffed snake adorned with a wimple or other courtly headdress, whereas Eve's head is bare. Consider, for example, the thirteenth-century Cambridge Psalter (figure 7.8).[29] In these varied depictions of the temptation scene from Genesis, Eve and the woman-headed serpent bear not only distinct bodies but also heads that, despite Peter Comestor's assertion, are not in fact "alike."

More to the point, however, in all of the foregoing visual examples, the female-headed serpent is neither purely female nor wholly animal.

Figure 7.7. Temptation. Detail, Cod. 9961-2, fol. 25, Peterborough Psalter, Bibliothèque royale de Belgique.

Figure 7.8. Temptation. Detail, MS K.26, fol. 4r, Cambridge Psalter, St. John's College, Cambridge. By permission of the Master and Fellows of St. John's College, Cambridge.

Nor is it male, although it suggests all these possibilities and more, the vegetal and avian among them. The hybrid image of the woman/not-woman standing next to the heterosexual pair of Adam and Eve offers a significant visual alternative to the binary terms of sexual difference that the Genesis narrative otherwise underwrites. Indeed, the very terms of what might constitute sameness and difference in the founding narrative of heterosexual coupling are richly complicated in these thirteenth- and fourteenth-century pictorial representations of the Fall. At the same time that viewers are encouraged to consider what differentiates Adam from Eve, they are led to consider a potentially more disruptive question about the crucial and defining differences between Eve and the woman serpent standing next to her. In terms of our reading of the Mélusine narrative, these temptation scenes encourage us to ask yet again, "What happens to gender when we venture beyond Eve and other human bodies? Where does one stop being a woman and begin to be something else? Where does the border lie?"

To be sure, one could read the images of the woman-headed serpent we have surveyed here as Raymond eventually reads Mélusine: as a "faulse serpente" (255/692) lurking beneath a deceptive female veneer, much like the temptress encountered by Perceval in the *Queste,* a phantom created to deceive. Yet at other moments in Jean d'Arras's narrative, specifically when Raymond spies Mélusine in the bath, he speaks longingly of his "doulce amour" (243/662), his "chiere amie" (257/696), describing Mélusine as a flawlessly perfect human "woman," a paragon of "beauty, goodness, sweetness, friendship, and courtliness."[30] Raymond's remarks at this juncture remind us that despite medieval clerical fears of seductive Eve-like women that color some of the pages of this fourteenth-century narrative, the *Roman de Mélusine* is also relentlessly secular and courtly.[31] Indeed, when Raymond views the supposedly monstrous and hideous tail of Mélusine in the bathing pool, he laments not her deception but his own betrayal of a steadfast and faithful wife (242/662). Confessing that he did "not see clearly"—"J'ay fait le borgne" [I was blinded / I saw with only one eye] (243/662)—Raymond suggests that in suspecting his wife of adultery at his brother's insistence he was blind to her unflinching devotion to him and was thus unable to see her fully.[32]

More literally, however, we know that Raymond was also blind to the existence of Mélusine's tail, to her serpentine "self," the nonhuman nature that makes possible her extraordinary abilities. Indeed, Raymond's remarks in this scene, the crucial moment when the serpent-woman is revealed to him and to us, suggest something very different from Jean de Meun's warning against women as snakes in the grass, the anonymous *Queste* author's admonitions to Perceval and Lancelot about sexualized women's bodies that conceal the devil, or earlier Latin writers' condemnations of diabolical Eve-like fairy-women. Rather than underscore the danger of monstrosity, Raymond's remarks seem to suggest the potential if perplexing value of hybridity, even for one partner of a married couple. He should have *seen* the value in Mélusine, not only as a woman without a tail during six days of the week (the part of her he did in fact see), but also as a woman with a tail on Saturday (the part he did not see). From this perspective, Mélusine emerges not as a deceptive force, a delusion, or a transitory, devilish apparition, but rather as a body in process: a "woman" who can move between the states of human and animal, land and water, and later, when she flies away, between land and air.

She would occupy, then, the transformative position of the hybrid in Robert Young's definition of the term: a cultural formation exhibiting a seemingly impossible simultaneity of sameness and difference.[33] Indeed, when Mélusine, transformed once again, this time into a winged dragon, takes off from the window ledge and heads toward Lusignan, stupefied onlookers witness a concise version of her relentless hybridity. This "dame en guise de serpente" (260/704):

> let out such a wondrous and mournful cry . . . and was lamenting in the voice of a woman that the inhabitants of the fortress and the city were utterly amazed and didn't know what to think because they saw *the form of a serpent* and heard *the voice of a woman* issuing from it.

———

> gettoit un cry si merveilleux et si dou[le]reux . . . et se lamentoit de voix femminine, dont ceulx de la forteresse et de la ville furent tous esbahiz et ne scorent que penser, car ilz voient la *figure d'une serpente* et oyent *la voix d'une dame* qui yssoit de lui. (260/704–6)

Not unlike the manuscript images of woman-headed serpents we have considered, this female figure is a woman *and* a serpent *and* a bird and perhaps more. We might compare "her" specifically to the human/animal/avian serpent creature from Douce Ms. 381 that we discussed earlier (figure 7.4). But a fifteenth-century temptation scene in the *Speculum humanae salvationis* provides an even closer match (figure 7.9). In this instance, the wholly human Eve stands in sharp contrast to the winged, long-tailed serpent wearing the crown and dress of a courtly lady. It is this hybrid image of the Eden serpent, not the figure of Eve standing beside it, that most closely resembles the romance heroine Mélusine.

READING AGAINST EVE

Perhaps even more to the point, Jean d'Arras's portrait of the courtly Mélusine differs significantly from early clerical writings that cast Eve as the root cause of sexuality, sin, and misery, claiming that the first woman and all women after her would not only suffer in childbirth and pregnancy but also, as the twelfth-century Robert of Liège advised, become subjected to the dominion of their husbands.[34] In stark contrast to this interpretation of the Eden narrative, one that views Eve as prolonging human life sadly by giving birth, the *Roman de Mélusine* shows that the birth of its heroine's ten sons secures unprecedented political advantage and vast territorial holdings for the Lusignan family. Raymond is indebted to Mélusine for his very survival, his wealth, and his social standing. If anything, it is she who holds dominion over him.

By the same token, Mélusine, although she inhabits at times a body that is literally part animal, exhibits none of the vices alleged to characterize the putatively bestial descendants of Eve. Twelfth-century thinkers who follow Augustine's interpretation of the Genesis narrative in his *De Genesi ad litteram,* for example, understand concupiscence as a kind of "animality," a bestial force introduced into the body of man by woman, who is, by nature, Augustine contends, more animalistic than man, more subject to animal appetites of pride, covetousness, and desire.[35] The danger posed by such Eve-like women for many twelfth-century thinkers is that when the serpent advises pleasure, the sensu-

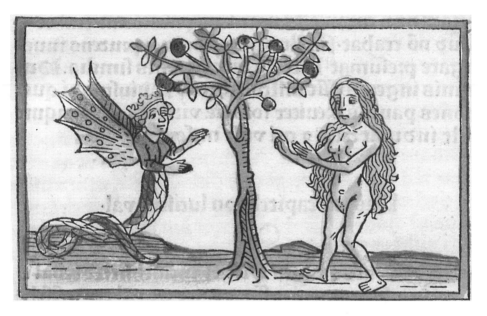

Figure 7.9. Temptation. Detail, 2 Inc.s.a. 1087, fol. 21, *Speculum humanae salvationis,* Bayerische Staatsbibliothek München.

ality of the animal body obeys and reason is overcome.[36] Thus does Etienne de Fougères decry vice-ridden noblewomen in the late twelfth century as sorceresses who deceive and rebel against their husbands by taking lovers, so overcome are they by the force of *luxuria,* which leads to adultery.[37] In stark contrast, when Raymond suspects his serpent-wife of adultery in the *Roman de Mélusine,* he is proven categorically wrong. Mélusine, despite her tail, emerges in this narrative as an exceedingly capable and highly rational manager of estates, convents, long-range expeditions, and battles. All of these tasks require the expert use of her head and appear wholly unimpeded by her partly (and intermittently) animal body.

Finally, in the *Roman de Mélusine,* it is not the heroine who transgresses but her husband, Raymond, who defies a key prohibition. Having been seduced into believing the false allegations concerning Mélusine's alleged adultery whispered by his brother, Raymond emerges

repeatedly in this narrative as the consummate transgressor: an oath breaker, traitor, and betrayer. He alone is said to be at fault in this marital scenario: first, by his own admission immediately upon seeing Mélusine in the bath, as we have seen—"'Alas!' he said, 'my love, I have betrayed you . . . and I have forsaken my promise to you'" [Hay, dist il, m'amour, or vous ay je trahie. . . et me sui parjurez envers vous]—and later by Mélusine's own calculation: "You so falsely betrayed me" [Tu m'as si faussement trahie] (256/694). Indeed, she will suffer until Judgment Day, she contends, because of his *"faulseté"* (256/696).

The source of the ethical infraction here is not Mélusine's seductive body or even her animalistic body. In fact, the problem it is not with her body at all (even though she has a tail). To be sure, the bath functions in many medieval narratives as a locus of sensuality, especially for fourteenth-century preachers, whose advice to virgins concerning ways to control corporeal urges includes, according to Duby, "point de bain surtout" (definitely no baths).[38] However, Mélusine's bath is presented as a private locus of a hybrid woman's playful enjoyment, not sexualized indulgence or adulterous deception, as Raymond feared. The problem articulated in the *Roman de Mélusine* lies more squarely with Raymond's transgression: his breaking an oath and looking at the forbidden image in defiance of Mélusine's warning: "You will never attempt to see me or inquire where I might be" [Vous ne mettrez jamais peine a moy veoir ne enquerre ou je seray] (26/166). In this instance, it is the wife who forbids the husband to seek knowledge. Whereas God issues the fateful prohibition in the Adam and Eve story, here it comes from the lavishly clad and capable courtly heroine herself.[39]

Thus does the *Roman de Mélusine* offer a significant alternative to the binary structuring of the Adam and Eve story that allows only for wifely obedience or dangerous seduction. In the romance's rewriting of the Genesis narrative, we see a woman who embraces the pleasure of the mythical siren playing in the bath, but in a context that reinforces the marriage bond. Posing no lascivious threat to the institution of marriage, Mélusine procreates abundantly. Rather than cause men to fall, this woman with a hybrid body props up the faltering Raymond, ensuring that he will become "the most powerful and the greatest lord and landholder" of all those in his lineage [le plus seignoury et le plus grant

qui oncques feust en ton lignaige et le plus puissant terrien] (26/164). Rather than the bestial body of Augustine's Eve or the female "forbidden fruit" of the monastic tradition, Mélusine's body, paradoxically both snakelike and reproductive, ensures vast political gain and territorial expansion that remaps a Mediterranean under Lusignan control. The woman with the half-serpent body produces sons who become kings of Cyprus and Armenia, Luxembourg, and Bohemia and lords of La Marche, Parthenay, and Lusignan. The romance builds to a conclusion that records genealogical and territorial expansion in tandem. It says that Mélusine's son,

> King Urien, reigned forcefully in Cyprus and his heirs after him; Guy in Armenia, Regnault in Bohemia and his heirs after him, Anthoine in Luxembourg and his heirs after him, Eudes in La Marche, Raymond in Forest, Geoffrey in Lusignan, and Thierry in Parthenay.

> Le roy Uriien regna moult puissaument en Chipre, et ses hoirs après lui; et Guion en Armenie; et Regnault en Bahaigne, et ses hoirs ont regné puissaument après lui; et Anthoine en Lussembourc, et ses hoirs aprez lui; et Oeudes en la Marche; et Remond en Forests; et Gieffroy a Lusegnen; et Thierry a Parthenay. (294/780)

Then we are told: "Here ends the true story of the noble line of the Lusignans in Poitou. And still others descended from them . . . as one finds in the 'old chronicles'" [Et cy fine la vraye histoire de la noble lignie de Lusegnen en Poictou, et avez ouy ceulx qui en sont yssuz. Et encores en sont yssus ceulx de . . . si comme on le treuve es anciennes croniques"] (294/780). Additional names prolong the list.

DYNASTIC AND TERRITORIAL EXPANSION

In Jean d'Arras's version of the Mélusine story, the narrative segments describing Mélusine's various magical or mythical transformations are relatively brief. The bulk of the narrative is taken up with epiclike

adventures of travel and conquest through which Mélusine builds an empire stretching from Poitou in western France to the eastern Mediterranean, stationing her many heirs as rulers on foreign shores and neighboring lands. Indeed, Mélusine's substantial accomplishments at building castles, founding towns, running estates, and directing invasions overseas rewrite the familiar romance narrative of the helpless *orpheline* in desperate need of a male protector because she is considered incapable of governing her land alone. As the roy d'Ausay says during his attempt to persuade the barons of Luxembourg that their deceased lord's daughter must marry, "Land governed by a woman is of little consequence" [Terre qui est gouvernement de femme, c'est petit de chose] (188/534). In a fictionalized feudal world where women and land are regularly gifted together as conjoined properties (170/492–94), orphaned women are often told, "You need to marry a man noble enough to govern you—you and your country" [Il vous fault marier un homme tel qui soit digne de vous gouverner, vous, et vostre pays] (188/536). These potential young brides, dressed up in "the most costly attire" [les plus riches garnemens] (190/540), are encouraged, like the "noble pucelle" Esglentine in the kingdom of Behaigne, to give "the gift of your noble body and the inheritance of your noble realm" [le dons de vostre noble corps et herite de vostre noble royaume] (192/544). Their bodies and lands are one.[40]

In stark contrast, Mélusine is represented as the definitively capable, skilled, and knowledgeable "governor" of Lusignan, La Rochelle, Poitou, and lands far beyond. She selects the sites her sons will acquire and issues extended directives detailing how they should proceed. The question in Mélusine's case is not so much who will help this woman "govern" her land but who should be counted among those she herself governs. One indication of this difference is that the mark of Lusignan, which derives from Mélusine's name and not her husband's, is repeated incessantly in battle cries for conquest of foreign lands and even invades the lineage of those distant rulers. The narration of events in Armenia concludes, for example, with a comment that these ancient and geographically remote kings descend directly from the Lusignan line. The narrator states: "I leave the story of the Armenian kings here. It is obvious that they were extracted from the noble lineage of King

Elinas of Albania and the lineage of Lusignan" [Cy me tairay des roys d'Armenie, et en ay conclut l'hystoire pour ce qu'il est tout evident qu'ilz sont extraiz de la noble lignie du roy Elinas d'Albanie et de Lusegnen] (307/808), that is, from Mélusine's father and the heroine Mélusine herself. To be sure, the *Roman de Mélusine* is penned by Jean d'Arras in 1393, the same year that Leon VI (Leon de Lusignan), the last ruling king of Armenia, died in Paris, having taken refuge there from Mameluk invaders. That is not Jean's point, however. His claim on behalf of the duc de Berry is that the Lusignan family line has a trans-Mediterranean reach, that it has been as entrenched in the East as in the West, as firmly rooted in Armenia (along with Cyprus, Bohemia, and Luxembourg) as in Poitou: that its body politic respects no set limits.

What I wish to suggest, then, is that the fourteenth-century *Roman de Mélusine* stages a revaluation and rewriting of the story of the Eden serpent for an expansionist political purpose. Seduction has little to do with this tale of a hybrid serpent-woman, which focuses instead on the facticity of unknown, differently bodied creatures and the lands they might govern.

In the opening pages of his romance, Jean d'Arras quotes Gervais of Tilbury's *Otia imperialia* (ca. 1214–15) to justify the fantastic elements of his tale that will explain "how the noble and powerful fortress of Lusignan in Poitou was founded by a fairy" [comment la noble et puissant forteresse de Lisignen en Poictou fu fondee par une faee] (5/118). Gervais provides an example of the Mélusine story in a nutshell but without the heroine's name. In his version, Jean explains, Rogier du Chastel de Rousset marries a fairy creature, and when, defying her prohibition, he dares to look at her in the bath, he sees her become a serpent, dive into the water, and disappear (4/118). In a sense, then, Jean d'Arras tells us the story of his heroine Mélusine before narrating it.

Yet what Jean does not tell us is perhaps equally important. Gervais of Tilbury, a former protégé of Henry II in England, who later served under William II in Sicily and eventually became marshal to the Emperor Otto IV of Brunswick in Arles, wrote the *Otia imperialia* as a kind of mirror of princes for the young Otto.[41] The text is a literary compilation designed to provide encyclopedic knowledge of the frontiers of human understanding, including but not limited to accounts of inexplicable marvels and fairies found in book 3. Book 2 of the *Otia* provides

extensive *mappa mundi* and descriptions of peoples around the world. Most significantly for our purposes, however, book 1 offers a detailed cosmography and early history of the world, beginning with an account of Genesis.[42] That account reiterates Peter Comestor's description of the Eden serpent as having a woman's head.

Gervais uses this preamble to set up his account of the fairy woman and Rogier du Chastel de Rousset, a story he offers to nonbelievers as a "reliable account."[43] The passage, highly charged on many levels, is of interest to us here not only because it grounds the Mélusine story firmly within the tale of the woman-headed serpent but also because of its insistence, consistent with the larger purpose of the *Otia*, on setting both the Eden myth and the serpent-woman tale within an expansive geography: a terrain that stretches in this instance from Aix en Provence (where Gervais locates the story of the castle of Rousset) to England, Greece, and Jerusalem. Gervais insists that readers take the woman-headed serpent in the temptation story seriously because "in England we have often seen men change into wolves according to the phases of the moon. . . . It has also, so they say, been a regular practice of the women of Greece and Jerusalem to turn men who spurn their desire into asses."[44]

Gervais offers these tales as part of his larger effort to extend the frontiers of human understanding and to expand the young emperor's knowledge of world geography. It is significant that he launches that project with an icon of bodily expansion: the hybrid body of the woman-serpent that he insists is historical rather than mythic or illusionary. This author's compendium of knowledge then frames the Mélusine material within a doubly expansive biblical and geographic context that Jean d'Arras chooses not to mention. And yet we can see that Jean adopts a similar strategy himself by staging the Lusignan takeover of extensive and distant lands in terms of a corporeal body that also pushes expected limits.

This, I think, is where the tale of Mélusine leads us ultimately: to a fully secularized version of that ambiguous configuration represented in the thirteenth- and fourteenth-century images of the woman-headed Eden serpent: a creature in motion, between categories, with a flavor of worlds unknown and unaccounted for in orthodox versions of the

Genesis narrative, which is itself so crucially structured by division into binary categories that neatly isolate God from humans while also distinguishing humans from animals, darkness from light, and land from water.

By contrast, the story of Mélusine gives us a model of a tantalizing hybrid in which political boundaries are as expansive as the female body that here redefines them so productively. If this newly constituted corporeality lacks the fixity and certainty of the sexual difference posited by Adam and Eve, it is not to be taken, according to Jean d'Arras, as something "unnatural," despite the prevailing view of church authorities against half-humans. Rather, we are to understand Mélusine's hybrid body in light of Gervais of Tilbury's insistence that marvels are in fact part of the "natural world" although they are often beyond our comprehension, something that we, like Raymond, cannot yet see or fully grasp.[45] Mélusine's hybrid body is as unexpected as a bird/woman/winged snake standing between Adam and Eve. Indeed, what could be more unexpected than a courtly lady with a tail?

In Mélusine's case, that tail has a long reach. As we think about the parameters of Mélusine's body—where the woman ends and the animal begins—we are encouraged to contemplate any number of unexpected border crossings: the territorial relation between the seeming fairy world of the Fontaine de Soif and the human world of Raymond's vassals in Brittany; between France and England during the Hundred Years' War, and between France and the eastern Mediterranean during the Crusades in which previous members of the historical Lusignan family participated and whose military conquests are replayed in this protracted narrative in surprising and imaginative ways.[46]

We should perhaps then not be surprised to find at least one medieval Armenian manuscript with the image shown in figure 7.10. This miniature from the Gospels of Jerusalem fittingly celebrates a marriage: the marriage of King Leo II of Armenia and Queen Keran in 1262.[47] They appear on the frontispiece, as patrons offering the Gospel in honor of their marital union. The two figures are posed, not unlike Adam and Eve in the moralized Bible from Vienna discussed above (figure 7.5), standing and facing each other: a man and a woman joined

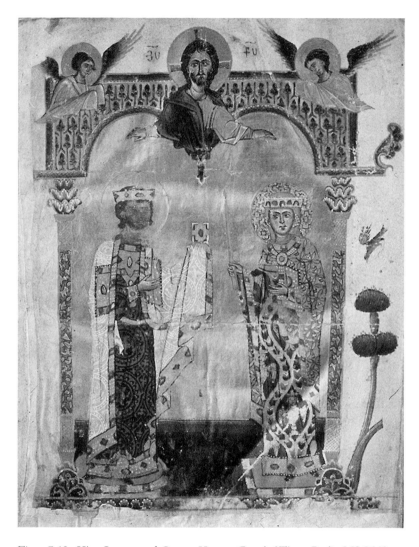

Figure 7.10. King Levon and Queen Keran. *Gospel of T'oros Roslin.* MS 2660, fol. 288, Armenian Patriarchate of Jerusalem. Courtesy Dickran Kouymjian, *The Arts of Armenia,* Lisbon: Calouste Gulbenkian Foundation, 1992, #87.

Figure 7.11. Detail, Ms. 2660, fol. 228, Armenian Patriarchate.

in marriage. Yet also like the couple in the Vienna manuscript who are joined visually by the third figure of the woman-headed serpent, this couple is not entirely alone. If we look carefully at the pattern on Queen Keran's gown, we find that it offers yet another thirteenth-century depiction of the woman-headed serpent (figure 7.11). Here the hybrid snake-woman is patterned into the royal silk of Armenian kings in the eastern Mediterranean, rulers who, across the generations, intermarried with members of the Lusignan family to secure their dynastic interests abroad.[48]

NOTES

1. Jean d'Arras, *Mélusine: Roman du XIVe siècle,* ed. Louis Stouff (Dijon: Imprimerie Bernigaud et Privat, 1932), 38; and *Mélusine ou La noble histoire de Lusignan,* ed. Jean-Jacques Vincensini (Paris: Livre de poche, 2003), 196. All subsequent page citations to the *Roman de Mélusine* are given parenthetically in the text and refer first to Stouff's edition and then (separated by a slash) the corresponding page(s) in Vincensini's edition. Translations from the Old French are my own. Jean d'Arras's prose version of the story, dated to 1393, is followed in 1401 by a verse rendition written by Coudrette and aimed perhaps more specifically at an audience in English-occupied Aquitaine and England itself. Although Coudrette never cites the earlier text directly, the prologue and epilogue to his version of *Mélusine* refer implicitly to Jean d'Arras's text. See Louis Stouff, *Essai sur Mélusine, roman du XIV siècle par Jean d'Arras* (Paris: Éditions Picard, 1930), 7–8; and Catherine Gaullier-Bougassas in *La tentation de l'Orient dans le roman médiéval: Sur l'imaginaire médiéval de l'autre* (Paris: Champion, 2003), 303–7.

2. The reference to Albanie (Albania) suggests a number of possible geographic coordinates. Although the medieval kingdom of Albania was located on the Adriatic, in the Roman period and far beyond, a kingdom of Albania existed in the Caucasus, on the west coast of the Caspian Sea, just northeast of Armenia. Both of these Albanian sites contribute to the thickly layered geography of this romance, which, as we shall see, names its key protagonist in terms of the Greek language. The scholarly consensus that the term *Albania* is used by Jean d'Arras to refer to Scotland has underestimated the larger and often illogical geographical reach of a romance, which tends to condense space as readily as it collapses time. See Robert H. Hewison, *Armenia: A Historical Atlas* (Chicago: University of Chicago Press, 2001), 49; Richard J. A. Talbert, ed., *Barrington Atlas of the Greek and Roman World: Map by Map Directory* (Princeton: Princeton University Press, 2000).

3. "La chappelle, qui estoit tant noblement aournee que nulz ne sauroit esprisier la richesse tant des paremens qui y estoient le plus estrangement ouvrez et si richement, d'or, de brouderie, de perles, que on n'avoit oncques mais veu les paraulx" [The chapel, which was so nobly decorated that no one could assign a value to its wealth; the wall hangings were worked so richly and wondrously with gold, embroidery, and pearls that no one had ever seen their equal] (39/198).

4. "Dictes moy de quel lignie vostre femme est" [Tell me about your wife's lineage] (43/208).

5. "Vous me jurerez sur tous les sermens que preudoms doit faire, que le samedi vous ne mettrez jamais peine a moy veoir ne enquerre ou je seray" [You will swear to me on all the oaths of an honorable man that on Saturdays you will never attempt to see me or inquire where I am] (26/166).

6. On Mélusine's hybridity, see Kevin Brownlee, "Mélusine's Hybrid Body and the Poetics of Metamorphosis," in *Mélusine of Lusignan: Founding Fiction in Late Medieval France,* ed. Donald Maddox and Sara Sturm-Maddox (Athens: University of Georgia Press, 1996), 76–99; and Gabrielle Spiegel, "Maternity and Monstrosity: Reproductive Biology in the *Roman de Mélusine,*" in Maddox and Sturm-Maddox, *Mélusine of Lusignan,* 100–124.

7. "Hee, tres faulse serpente, par Dieu, ne toy ne tes fais ne sont que fantosme, ne ja hoir que tu ayes porté ne vendra a bon chief en la fin" [Ah! By God, false serpent, you and your deeds are nothing but illusions; no offspring you have carried will ever come to a good end] (255/692).

8. Stouff explains the sleight of hand involved in Jean's fictive creation of this politicized fairy, noting that Jean d'Arras combined a local legend of the "fee de Lusignan" with others, drawing most notably on Gervais of Tilbury's account of a legend from Arles that Jean transposes into the region of Poitou. Stouff, *Essai sur Mélusine,* 48, 54.

9. "Laquelle histoire j'ay commencé selon les vrayes coroniques que j'ai euez tant de lui [Jean de Berry] comme du comte de Salbery en Angleterre et plusieurs livres qui ont esté trouvez" [I undertook this history according to true chronicles that I had received from him [Jean de Berry] and the Count of Salisbury in England and several books that had been recovered] (1/110). Eyewitness testimonies are given on 309–10/812–14.

10. Jacques Le Goff and Emmanuel Leroy Ladurie, "Mélusine maternelle et déchiffreuse," *Annales: Economies, sociétés, civilisations* 26 (1971): 589–622.

11. Gaullier-Bougassas explains that Jean d'Arras's fictive narrative plays off a number of political conflicts, drawing on events from twelfth-century Jerusalem and the Third Crusade in particular to reflect a crusading spirit in fourteenth- and fifteenth-century France (*Tentation de l'Orient,* 287–88 and ff.). See also Emmanuèle Baumgartner, "La Dame du Lac et la Mélusine de Jean d'Arras," in *Mélusines continentales et insulaires,* ed. Jeanne-Marie Boivin and Proinsias MacCana (Paris: Champion, 1999), 181–92. On *Mélusine* and the Hundred Years' War, see Ana Pairet, "Mélusine's Double Binds: Foundation, Transgression, and the Genealogical Romance," in *Reassessing the Heroine in Medieval French Literature,* ed. Kathy Krause (Gainesville: University Press of Florida, 2001), 71–86; On Mélusine's complex genealogical trees, see Jane Taylor, "Mélusine's Progeny: Patterns and Perplexities," in Maddox and Sturm-Maddox, *Mélusine of Lusignan,* 165–84.

12. Although the boundaries of medieval Armenia shifted over the years, in the thirteenth and fourteenth centuries the kingdom occupied a segment of the Mediterranean coast of Turkey with its eastern boundary falling just north of Antioch. See Claude Mutafian and Eric van Lauwe, eds., *Altas historique de l'Arménie: Proche-Orient et sud-Caucase du VIIIe siècle av. J-C. au XXI siècle* (Paris: Éditions Autrement, 2001), 54–57.

13. The history of the Lusignan family in Cyprus and the Holy Land was recorded in a number of chronicles that circulated widely in the Middle Ages. For the Holy Land, see the *Historia* of William of Tyre and its French translation and continuations in *L'estoire d'Eracles, La chronique d'Ernoul,* and *L'estoire de la guerre sainte,* by Ambroise. For Cyprus, see Joinville's *La vie de St. Louis,* Philippe de Novarre's *Mémoires,* and Guillaume de Machaut's *Prise de l'Alexandrie,* among others (Gaullier-Bougassas, *Tentation de l'Orient,* 313).

14. Laurence Harf-Lancner, *Les fées au Moyen Age: Morgane et Mélusine, La naissance des fées* (Geneva: Slatkine, 1984); Anita Guerreau-Jalabert, "Des fées et des diables: Observations sur le sens des récits mélusiniens au Moyen Age," in Boivin and MacCana, *Mélusines continentales,* 105–37; Walter Map, *De nugis curialium,* ed. and trans. M. R. James, rev. C. N. L. Brooke and R. A. B. Mynors (Oxford: Clarendon Press, 1983); Geoffrey of Auxerre, *On the Apocalypse,* trans. Joseph Gibbons (Kalamazoo, MI: Cistercian Publications, 2000); Gervais of Tilbury, *Otia imperialia: Recreation for an Emperor,* ed. and trans. S. E. Banks and J. W. Binns (Oxford: Clarendon Press, 2002).

15. Jean de Meun, *Le roman de la rose,* ed. Félix Lecoy, vol. 3 (Paris: Champion, 1966). Here and subsequently, citations are to line numbers and are given parenthetically in the text.

16. *La queste del Saint Graal,* ed. Albert Pauphilet (Paris: Champion, 1980). Here and subsequently, citations are to page numbers and are given parenthetically in the text.

17. The scene builds on the hermit's earlier interpretation of Perceval's dream in which a seductive woman rides a serpent: "Et li serpenz qui la porte, . . . ce est li anemis meisme; . . . ce est li serpenz qui dist a Adam et a sa moillier: 'Se vos mengiez de cest fruit vos seroiz ausi come Dieu" [And the serpent she is riding . . . is the devil itself. . . . This is the serpent that said to Adam and his wife, "If you eat of this fruit, you will be like God"] (103).

18. See E. Jane Burns, "Devilish Ways: Sexing the Subject in the *Queste del Saint Graal*," *Arthuriana* 2, no. 2 (Summer 1998): 11–32.

19. See, for example, Chantilly, Musée Condé, Ms. 665, Guillaume de Lorris, *Le Roman de la rose,* ca. 1370.

20. For summary accounts of these readings of Oiseuse, see Carlos Alvar, "Oiseuse, Venus, Luxure: Trois dames et un miroir," *Romania* 106 (1985): 108–

17; and Gregory M. Sadlek, "Interpreting Guillaume de Lorris's Oiseuse: Geoffrey Chaucer as Witness," *South Central Review* 10 (1993): 21–37.

21. Etienne de Fougères, *Le livre des manières,* ed. R. Anthony Lodge (Geneva: Droz, 1979), lines 1053–60.

22. E. Jane Burns, *Courtly Love Undressed: Reading through Clothes in Medieval French Culture* (Philadelphia: University of Pennsylvania Press, 2002), 77–80.

23. Jacques Voisenet, *Bêtes et hommes dans le monde médiéval: Le bestiaire des clercs du Ve au XIIe siècle* (Turnhout: Brepols, 2000). Medieval clerical writers discuss animals most often with the aim of emphasizing their essential difference from humans, who are created by God. See Gaston Duchet-Suchaux and Michel Pastoureau, *Le bestiaire médiéval: Dictionnaire historique et bibliographique* (Paris: Le Léopard d'or, 2002), 6.

24. Joseph K. Bonnell, "The Serpent with a Human Head in Art and Mystery Play," *Journal of the Archaeological Institute of America* 21 (1917): 255–91; Henry Ansgar Kelly, "The Metamorphosis of the Eden Serpent during the Middle Ages and Renaissance," *Viator* 2 (1971): 301–27; Nona Flores, "'Effigies amicitiae . . . veritas inimicitiae': Anti-Feminism in the Iconography of the Woman-Headed Serpent in Medieval and Renaissance Art and Literature," in *Animals in the Middle Ages: A Book of Essays,* ed. Nona C. Flores (New York: Garland, 1996), 167–95. Flores traces in particular the patristic tradition of commentaries on the woman-headed serpent that assert that the woman's face is used as a trick to conceal the serpent's body. It should be noted that the sculpture on the west facade of Notre Dame cathedral in Paris mentioned by Flores, while offering a compelling image of the woman-headed serpent, is a nineteenth-century reconstruction by Viollet-le-Duc. The original sculpture features a statue of the Virgin with a snake-tailed, winged harpy beneath her feet. See Alain Erlande-Brandenburg and Dieter Kimpel, "La statuaire de Notre Dame de Paris avant les destructions révolutionnaires," *Bulletin monumental* 136 (1978): 226.

25. Petri Comestoris, *Scolastica historia: Liber genesis,* ed. Agneta Sylwan (Turnhout: Brepols, 2005), 40. The formulation comes originally from Bede.

26. Dyan Elliott, *Fallen Bodies: Pollution, Sexuality, and Demonology in the Middle Ages.* (Philadelphia: University of Pennsylvania Press, 1999).

27. "Was it because the man would not have been able to believe this, that the woman was employed on the supposition that she had limited understanding, and also perhaps that she was living according to the spirit of the flesh and not according to the spirit of the mind?" Augustine, *De Genesi ad litteram* 2.42, trans. as *The Literal Meaning of Genesis* by John H. Taylor (New York: Newman Press, 1982), 58.

28. See also the fourteenth-century Ramsey Psalter at the Pierpont Morgan Library, Ms. 302 fol. 1r.

29. Other examples include the temptation scene in the thirteenth-century Carrow Psalter from East Anglia, Baltimore, Walters Art Gallery, Ms. W34. Perhaps the most striking image of two women face to face but bearing distinctively different heads because of their differing hairstyles occurs in the British Library Harley Ms. 4996 (fol. 4v) of the *Speculum humanae salvationis*.

30. "Beauté, bonté, doulcour, amistié, sens, courtoisie, charité, humilité, toute ma joye, tout mon confort, toute m'esperance, tou mon eur, mon bien, mon pris, ma vaillance [Beauty, goodness, sweetness, friendship, good sense, courtliness, charity, humility, all my joy, all my comfort, all my hope, all my happiness, my well-being, my status, my valor] (243/662). Denyse Delcourt argues that the fairy narrative in the *Roman de Mélusine* records the ambivalence of medieval heterosexual male desire, at once attracted to and repelled by women; Denyse Delcourt, "Métamorphose, mystère, fémininité: Lecture du *Roman de Mélusine* par Jean d'Arras," *Le moyen français* 33 (1993): 85–107.

31. Passages that evince an especially strong clerical voice condemning Mélusine occur in the section devoted to the destruction of the monastery at Maillezais by her son Geoffroi a la Grant Dent.

32. Hay, dist il, m'amour, or vous ay je trahie, par le faulx enortement de mon frère, et me sui parjurez envers vous ["Alas," he said, "my love, I have betrayed you because of the false prodding of my brother and I have broken my oath to you"] (242/660).

33. Robert Young, *Colonial Desire: Hybridity in Theory, Culture, and Race* (London: Routledge, 1995), 85.

34. See Georges Duby, *Dames du XIIe siècle: Eve et les prêtres* (Paris: Gallimard, 1996), 77.

35. Ibid., 82, 62–67.

36. Ibid., 70.

37. Etienne de Fougères, *Livre des manières,* lines 993–1052.

38. Duby, *Dames du XIIe siècle,* 104.

39. Christopher Lucken cogently makes this point only to undercut its significance later in his essay, where he argues for Mélusine's equivalence to Eve or Lilith: "Roman de Mélusine ou histoire de Lusignan: La fable de l'histoire," in Boivin and MacCana, *Mélusines continentales,* 139–67. His larger argument, that the narrative uses the mythic Mélusine to distract us from Raymond's initial murderous act, remains compelling. But I think there is even more to the story.

40. This is, in fact, the dominant model governing this narrative's accounts of both domestic and foreign expansion: reputedly valiant armed men

seek to marry helpless young women with substantial territorial holdings, which the newly arrived husbands then take over. The model holds not only for Melusine's many sons who conquer distant sites in Luxembourg, Bohemia, Cyprus, and the Holy Land but even for their enemy, the sultan of Damascus, who threatens to invade Cyprus not out of religious fervor but to marry the king's daughter, as Gaullier-Bougassas explains (*Tentation de l'Orient,* 348). The pattern extends even further to the scene of the Espervier, where the successful knight Antoine asks, surprisingly, not to regain control of the Holy Land for the Lusignan family but to marry the resident lady, Melior.

41. See Banks and Binns's introduction to their edition of Gervais of Tilbury's *Otia imperialia,* xxix–xxxii. Two French translations of the *Otia* existed at the time Jean d'Arras was writing: one, by Jean d'Antoiche, appeared at the end of the thirteenth century, the other, by Jean de Vignay, was produced in the early years of the fourteenth century. See Cinzia Pignatelli and Dominique Gerner, *Les traductions françaises des* Otia imperialia *de Gervais de Tilbury par Jean d'Antioche et Jean de Vignay: Éditions de la troisième partie* (Geneva: Droz, 2006).

42. Gervais of Tilbury, *Otia imperialia,* 87.

43. Ibid., 89. Notably, Gervais's narrative is one of the few pre-Mélusine tales that does not condemn the serpent woman, blaming the husband instead (Gaullier-Bougassas, *Tentation de l'Orient,* 300).

44. Gervais of Tilbury, *Otia imperialia,* 87.

45. Gervais of Tilbury, *Le livre des merveilles,* trans A. Duchesne (Paris: Les Belles Lettres, 1992): "Par merveilles, nous entendons, ce qui echappe a notre comprehension, bien que naturel" [By marvels we mean things that surpass our understanding, even though they may be natural] (20).

46. For an extended analysis of the *Roman de Mélusine* as a narrative that both replays and undercuts earlier crusading accounts, see the chapter "Mélusine et les rêves de croisade," in Gaullier-Bougassas, *Tentation de l'Orient,* 289–354.

47. See Sirarpie der Nersessian, *Miniature Painting in the Armenian Kingdom of Cilicia from the Twelfth to the Fourteenth Century* (Washington, DC: Dumbarton Oaks, 1993), 154–55.

48. The kingdom of Cilician Armenia on the Mediterranean coast reached its political apogee under King Leon II, who supported Richard the Lionheart in his conquest of Cyprus and then married the daughter of Aimery of Lusignan, king of Cyprus and Jerusalem. Soon thereafter the Armenian court began to adopt Western feudal legal structures and cultural patterns of Frankish courts. See Sirarpie der Nersessian, "The Kingdom of Cilician Armenia," in *Études byzantines et arméniennes,* ed. Sirarpie der Nersessian (Louvain: Imprimerie Orientaliste, 1973), 341–45. On Armenian princesses marrying Lusignan sons,

see Michèle Perret, "Attribution et utilisation du nom propre dans *Mélusine*," in Boivin and MacCana, *Mélusines continentales,* 169–79. On the Lusignans in Armenia, Cyprus, and the Holy Land, see David Jacoby, "The Frankish States of the Levant and Cyprus under the Lusignans: A Century of Relations (1192–1291)," in *From Aphrodite to Mélusine: Reflections on the Archaeology and the History of Cyprus,* ed. Matteo Campagnolo and Marielle Martiniani-Reber, trans. Erika Milburn (Geneva: La Pomme d'or, 2007), 63–89.

Moving beyond Sexuality in Medieval Sexual Badges

ANN MARIE RASMUSSEN

HERE STANDS A HAIRY CREATURE WHOSE BODY IS A VULVA (FIGURE 8.1). Its torso and head are unified, and its vaginal opening seems to fuse all body openings—nose, ears, mouth, vagina, urethra, anus—as well as genital and cranial hair. The features of this image shown on a medieval sexual badge mingle the senses, with the exception of touch, into one. Although the creature represented here lacks eyes, ears, and nose, it is instantly and recognizably human because it features fully articulated human limbs: arms with shoulders, elbows, wrists and hands that grasp; legs with knees and feet that are shod. It is mobile. The creature also features attributes belonging to the social sphere of human activities. On the top of its body it sports a crown, a symbol of lordship; on its feet, high-heeled clogs or sandals elevating it off the ground. Further, it is engaged in a recognizable human activity. Hands grasping poles, it balances adroitly on stilts. This acute, physical awareness of grounding the body through contact with the earth is a form of touch, and together with the hairiness the gesture amplifies the creature's connection to that single sense.

Figure 8.1. Vulva on stilts. Inventory number 2592. Image courtesy of the Van Beuningen Family Collection, Langbroek, the Netherlands.

The "vulva on stilts" participates in the attributes of humanness beyond the sexual and the genital. It has recognizable human body parts, as we have said: legs, feet, arms, and hands. Its stilts and crown allude to specific medieval professional and social identities: stilts to the artisan acrobats who were ubiquitous in the medieval world and belonged to the group of wandering artisans who made their living by trading their skills for food, shelter, and other goods; the crown to political elites. The creature's legs and feet show that it is mobile. It can move independently through the world, an attribute of agency and will. Nevertheless, its hairiness links it to the animal world. Like beasts of field and forest, it is covered in fur. This body part is a human, social body, mobile and humanlike in its limbs and in the identity-making ob-

jects it uses and wears, yet able to cross over into the animal realm in its display of fur.

In this image distinct and separate realms coexist. Part human, part beast, part elite, part commoner, royalty and acrobat, human and animal in one, the vulva on stilts is a composite, female creature, resembling in its symbolic mixing of disparate attributes the mythological and exotic human creatures populating medieval art and literature: satyrs, mermaids, mermen, and the dog-headed or umbrella-footed peoples of faraway realms. Like all the imaginary creatures of the sexual badges, the vulva on stilts is not a hybrid in the modern, scientific sense of the word, in which *hybrid* means either the offspring of the interbreeding of two different taxa (the mule, for example, as a cross between a donkey and a horse), or the crossing of populations or breeds within a single species (hybrid roses, for example). The vulva on stilts references human and animal spheres in decidedly complex and heterogeneous ways. Indeed, some medieval sexual badges use attributes from the vegetal world as well. Neither can these images be understood using the important insights of cultural studies thinkers such as Homi Bhaba and others, who view hybridity as a political term to challenge simplified understandings of the multidimensioned political, social, and cultural encounters between colonizers and colonized in the modern world.[1] More useful are Caroline Walker Bynum's thoughts on hybridity as one of two important and contrasting ways (the other being metamorphosis) to think about change that emerged in the twelfth century. According to Bynum, "The hybrid expresses a world of natures, essences, or substances (often diverse or contradictory to each other), encountered through paradox; it resists change. . . . A hybrid is a double being, an entity of parts, two or more. It is an inherently visual form. We *see* what a hybrid is; it is a way of making two-ness, and the simultaneity of two-ness, visible."[2]

Bynum's definition resonates with the vulva on stilts, which borrows its parts from different entities and thus exceeds simple binaries. The image takes advantage of the visibility inherent in this medieval notion of hybridity, which it bodies forth. Further, the multiple parts in the vulva on stilts do not merge or meld but rather jostle against one another. Their very visibility as separate entities joined together creates

a situation of assertive, almost aggressive, paradox and reciprocal appraisal. As Bynum puts it, the "hybrid forces contradictory or incompatible categories to coexist and serve as commentary each on the other."[3]

The line between hybrid and metamorphosis in the medieval sexual badges can be indistinct. Both concepts, as Bynum notes, can be revelatory and destabilizing at the same time. "On the one hand, they can be ways of suggesting that the reality they image is what the world really is; in this sense they are revelations. On the other hand, both hybrid and metamorphosis can be destabilizing of expectation. Both can suggest that the world, either in process or in the instant, is disordered and fluid, with the horror and wonder of uncontrolled potency or violated boundaries."[4] The vulva on stilts partakes in this twin action of revelation and destabilization. It undertakes a destabilizing act of metonymy that condenses and fuses all senses into the single mode of touch. This insistence on touch reorients the perceptual coordinates of this composite, female creature and refigures its connections to the wider world as balancing, pressing, stroking, brushing, petting, tangling. Its revelatory message of wonder is that through the sense of touch two or more can become, for the moment, one.

The vulva on stilts is more than a visual image. It is also a material object from the late Middle Ages, a small pin (about 3 centimeters high and 2.5 centimeters wide) made of lead or lead alloy and found in Holland. The majority of the surviving badges (and there are thousands) have religious themes, usually related to the cult sites that proliferated in the High Middle Ages. Mass-produced and inexpensive, roughly 60 percent of the surviving badges can be connected to pilgrimage sites or religious cults. The other roughly 40 percent represent secular themes, usually of a more delicate nature than the vulva on stilts badge: a loyal dog, a heart with flowers, a swan, for example.[5]

Still, the vulva on stilts badge is not unique. It belongs to a larger category of badges or pins known as the sexual badges.[6] These badges employ a diverse, entertaining, and historically specific array of images including visual references to linguistic puns, visual allusions to aspects of religious life such as pilgrimage, and persistent images of mobility.[7] Above all, the sexual badges delight in hybrid creations. The most

popular image, the walking or wandering penis, always has legs and feet, and at least two of the following attributes as well: wings, furry breeches, a bell around its "neck," and a crown (figure 8.2). Other penis creatures are mounted on horseback like knights or perched in trees like birds or gathered in a purse or basket like bread rolls or fish. The vulva badges, which make up a smaller but still significant number of the sexual badges, are often depicted as pilgrims, or mounted on horseback, or crowned, or on stilts, as we have seen. The sexual badges usually feature either a penis or a vulva, but in a few badges penis and vulva creatures appear together. In what might be the most famous example of this assemblage, three penis creatures balance on their shoulders a litter, upon which is throned a vulva, crowned like the Blessed Virgin Mary. In some badges, penis and vulva sprout from or land in trees, assimilated to the animal, the vegetal, and the cultural world.

To return to our initial example, the vulva on stilts, through its citation and display of component parts, asserts multiple, yet separate, sites of belonging, each of which comments on the others. The composite image contrasts social worlds and identities, the mobility of humankind, the furriness of beasts, and the sex of the female. It calls out for interpretation and comment; indeed, like all the sexual badges, it is designed to do so.

Figure 8.2. Crowned, belled, bewinged walking penis. Inventory number 1856. Image courtesy of the Van Beuningen Family Collection, Langbroek, the Netherlands.

GENDER IN THE SEXUAL BADGES

Let me state what is blindingly obvious: these small, mass-produced, inexpensive pins of wandering penises and vulvas are about sex, about the meaning, power, and place of sex in the human, social world. I say sex, not gender, advisedly. The badges display sexual organs, making the single most significant anatomical difference between male and female of the species visible for all to see. This display is blatant, focusing on the two, contrasting features of human, mammalian, anatomy that universally show the greatest difference between male and female and are necessary for sexual reproduction.

Yet the sexual badges are not about sexuality in the modern sense of a belief that sexual desire is an attraction called into being by the sex of the desired object. They are about neither hetero- nor homosexuality in the modern senses of the words. Few sexual badges make reference to whom the object of desire might be, or what kinds of sexual practices might be performed, or with whom, or what kind of pleasure, if any, might result from those acts.[8] These questions, so central to the modern imagination, often go unanswered in the sexual badges. What sex, gender, and sexuality might mean in the medieval sexual badges is better explored as being based in a "much more diffused and complex interaction of categories than we are used to," categories that also included, alongside the sexualities of the sexual badges, for example, chaste marriage, clerical masculinity, virginity, willful virginity, and Amazons.[9]

The sexual badges also present us with categories of gender that differ from those of modernity. The selection and combination of motifs and images in the sexual badges show patterns of symbolic ordering and signification that create "perceived differences between the sexes" and that produce a system of gender concepts, which is, to continue with Joan Wallach Scott's formulation, "established as an objective set of references [that] . . . structure perception and the concrete and symbolic organization of all social life."[10] In the case of the sexual badges, produced and used in the late Middle Ages in northwestern Europe, what concepts of gender might these be? Doubtless, many gendered sexualities are suggested by this material. Of these, we will explore what

modern scholars have called female masculinity, that is to say, a gendered identity in which women wield symbolic, agentive, and dominant power using the phallus.[11] We will then turn to a discussion of the assimilation of the male sex into a worldview in which nature is always already culture.[12] The hybrid nature of the badges allows us to see the ways in which these forms of sexuality establish, to again speak with Scott, "distributions of power" or "differentiated control over or across material and symbolic resources" that underwrite gender.

FEMALE MASCULINITY

The sexual badges cobble their hybrid images together from an entertaining, diverse, yet limited and often repeated set of symbols and representations. One set of sexual badges distributes power around the control of reproduction, understood in both material and symbolic terms. It reorganizes the social world to proclaim domestication as the dominant mode for organizing knowledge. This is, in other words, a form of authority or power (that is to say, masculinity) that is sexual (there do not appear to be any images of virginity in the sexual badges) and that belongs to women.

I approach the topic of female masculinity by first surveying features shared by penis and vulva badges. Both create hybrid creatures by drawing insistently on images of mobility. Sometimes an autonomous vulva or penis uses an agent of mobility, usually sailing in a ship or riding a horse, but most commonly it incorporates features that foster mobility, for example, having legs and feet, wearing shoes or sandals, and being bewinged. Further, in the sexual badges, both penis and vulva often wear crowns, which, as we have said with the vulva on stilts, connotes elite power. Also, both display hairiness and animal fur. Usually a badge features a single creature, whether a penis or a vulva, but occasionally they appear together. And finally, the sexual body part badges are not interested in the so-called secondary sex characteristics. There are almost no breasts in the badges at all.[13]

How, then, do the male and female sexual badges differ? Most crucially, there are more penis badges than vulva badges. The most common sexual badge of all is the penis creature, whose iconography

includes wearing a bell around the neck and having an animal tail, both features not found on the vulva badges.[14] Comparing the hybrid penis creatures' tails with those of other, nonsexual animal badges shows that the sexual badges always refer to specific animals, especially roosters, horses, and dogs, which opens up the possibility, not pursued in this essay, that jokes are being made here by alluding to specific discourses about the sexual natures, appetites, or acts of these specific animals. In any case, there is no such thing in the world of the sexual badges as a generic "animal" tail.[15]

A number of features are associated more often, and sometimes almost exclusively, with the vulva badges. These hybrid creatures often have arms and hands, which is rare in the penis badges. The imagery of pilgrimage and of stilts is overwhelmingly associated with the vulva badges. A number of the vulva creatures wear ornaments, either crowns with penises or objects that might be construed as penis badges, but I have not yet seen any penis creatures wearing penis or vulva badges or penis crowns.

Alongside the badges discussed above depicting detached or autonomous male or female genitalia, there is a second group of badges showing ordinary human bodies engaged in sex (figure 8.3). These badges tend to focus on representations of recognizably human male figures engaged in some kind of sexual activity, copulation with a woman, for example, or watching others having sex, or displaying their genitals to someone else, male or female.[16] In these badges, the penis, if visible, is clearly anatomically a part of a recognizably human, male body.

Finally, there is a third group of hybrid badges that mix depictions of human figures and autonomous sexual organs. Closer attention to this third group yields insight into the creation of the category of female masculinity in the medieval sexual badges.

The badges mixing depictions of human figures and ordinary sexual organs overwhelmingly depict a woman doing something ordinary, something not overtly sexual, with a detached, autonomous penis. A woman holding a harp rides a penis creature like a horse; a woman pushing a handcart walks atop a penis creature; a woman wearing a wimple and holding a spade kneels on the ground and touches a penis

Figure 8.3. Couple copulating in brothel or inn. Inventory number 1842. Image courtesy of the Van Beuningen Family Collection, Langbroek, the Netherlands.

that is buried beneath her (figure 8.4); three women of different ages roast a penis-sausage over a fire (in some of these images, its fat drips down into a waiting vulva-grate) (figure 8.5); and a naked woman working at a forge wears a penis crown. These descriptions comprise images that survive in a single badge, the woman carrying a basket of penises, or the woman at the forge, for instance. The descriptions also comprise images shared by multiple badges, the most common of which are the woman (sometimes women) planting or stroking a buried penis and the women roasting a penis. The quantity of surviving badges that juxtapose an ordinary female figure with an autonomous penis, therefore, exceeds the number of images mentioned above.

Figure 8.4. Woman planting or digging up a phallus. Image courtesy of the Stedelijke Musea Ieper, Ypres, Belgium.

Thinking structurally, four combinatorial configurations would be theoretically possible in this group of complexly hybrid badges: female figure and autonomous penis; female figure and autonomous vulva; male figure and autonomous penis; and male figure and autonomous vulva. However, only the first grouping, female figure and autonomous penis, is common in the medieval badge corpus. Sexual badges showing recognizably human males with a detached, autonomous penis are very rare. I have not yet seen a badge of a recognizably male figure doing something with an autonomous, detached vulva. A single cast (for a badge?) survives of a woman holding a vulvalike object in her hand.[17] In other words, there are virtually no badges of men doing things with autonomous, detached penises or vulvas. There are no surviving badges of women doing things with autonomous, detached vulvas. This is not to say that such images do not exist in the medieval world, only that

Figure 8.5. Three figures roasting a penis. Inventory number 2985. Image courtesy of the Van Beuningen Family Collection, Langbroek, the Netherlands.

there is a signifying system in the imaginary of the sexual badges, doubtless linked to the now difficult to reconstruct cultural coordinates of their time and place, in which such images are marginal. The badges are selective in their hybridity, showing in this case only recognizably human, female figures doing ordinary, nonsexual things with autonomous, detached penises. This finding indicates that we have reached a threshold of representation regarding differences, not of sex, but of gender.

Let me summarize this threshold. Penises and vulvas alike can wander the world as autonomous, though different, beings. But when combined in hybrid badges with female figures, the autonomous penises lose their autonomy or their mobility. One wandering penis is ridden, that is to say, ruled or governed, by the woman who sits atop it. Another has become the ground plowed by a woman above it. Other women do things with penises: plant them, harvest them, collect them, or cook them. And it is overwhelmingly women who carry out these activities. (There are two or three badges where a man might be present, looking on, in the group of women as well. It is hard to be exact in these cases because it is difficult to discern the difference between man and crone.) These activities transform the penises, from meat to fat, from seed to plant, from wild to tame. The images integrate penises into the cycle of preparing food, quintessential woman's work, suggesting that they, like the plants women tend and the food they prepare, are passive. They are raw material, transformed by the actions and agency of women into something else. These badges represent a way of thinking in which sex and food belong to the same sphere of life, to the same processes and forces of life, which are actively managed and controlled by women.

The sexual badges being discussed in this section are, in short, about sex as reproduction, that is to say, they are about women's fertility, that precarious and tenuous human resource. Historian Lyndal Roper's remarks on the connections between gender and fertility in sixteenth-century Europe are equally applicable to the fourteenth and fifteenth centuries: "Fecundity and fertility were blessings in early modern Europe; barrenness a curse. Women, rich and poor alike, sought cures for sterility at shrines. If the man was not impotent, a fruitless marriage, it was believed, was caused by the woman's infertility. Peasants had their fields and animals blessed to ensure their fruitfulness—and to protect crops and beasts against witchcraft and the Devil. The same magical thinking was applied analogously to human, beasts and the soil—all could be blessed to protect their fertility from harmful attack."[18] The other insight afforded by Roper's remarks is that human beings could and did intervene to the best of their abilities in the mysterious and necessary process of fertility, whether by blessing or by cursing. These sexual badges, I contend, imagine such interventions. Concerned with women's fertility, they do not stage the penis as being

about sexual pleasure. I do not even think that they are about female sexuality in the modern sense of the term. As I have stated earlier, they say nothing about sexual desire as attraction called into being by the sex of the desired object. These badges do, however, stake out a position, a "distinctive way of understanding the female body," that distributes power and control of material and symbolic resources, that is, masculinity, to women.[19]

Women are agents in these images. They exercise power and control over the penises, and they transform them. In this imaginary discourse, actual, individual human men are superfluous, replaced by a penis that has become material, instrument, matter. To hazard an analogy from the modern world, there is a remote resemblance to sperm donation, in which the individual man simply provides the seed (of course, it isn't quite as simple as that in the modern world). The autonomous vulva badges, which belong to a different category than the ones being discussed here, participate in or allude to this discourse of female masculinity when they are shown wearing crowns made up of penises or phalluses, the sign of masculinity.

The badges of female masculinity being discussed here blur the boundary between hybridity and metamorphosis. Bynum defines metamorphosis as process and narrative:

> Metamorphosis goes from an entity that is one thing to an entity that is another. . . . There is, to be sure, a certain two-ness in metamorphosis; the transformation goes from one being to another, and the relative weight or presence of the two entities suggests where we are in the story. At the beginning and end, where there is no trace of the otherness from which and to which the process is going, there is no metamorphosis; there is metamorphosis only in between. Nonetheless metamorphosis is about process, *mutatio*, story—a constant series of replacement-changes, or, as Bernard of Clairvaux puts it, little deaths. It is about a one-ness left behind or approached.[20]

The "labile world of flux and transformation, encountered through story" summoned in these badges of female masculinity is the process

of transformation unique to women's bodies, that of conception, pregnancy, and birth.[21] The badges position us at the beginning of that story, when the "one-ness" that precedes pregnancy is about to be left behind. Yet in this story of human reproduction, women are not passive vessels of male seed. Rather, the female agent is seeking, or already has power over and control of the material, the seed (after all, the penises are already in the basket or grilling over the fire), that will permit her to overcome oneness on her own terms and to become two, become pregnant. We might call this moment, which is fundamental to the notion of female masculinity in the sexual badges, the female will to conception. It is noteworthy that while the story of conception, pregnancy, and birth is filled with potential for memorable images (as the religious imagery around the birth of Christ makes clear), the badges show only this aspect. This suggests that the female will to conception is understood to be a highly significant part of the cycle of reproduction, and one in which women control the initiative. Surely the vulva on stilts participates in this imagery of female masculinity as well, such that it, like the other images featuring wandering vulvas and ordinary women doing nonsexual things with penises, is linked in culturally weighty ways to a variety of rituals and rites, communal and individual, secular and religious, licit and illicit, that belonged to the season of sex, fertility, and reproduction. And what of the penis badges?

THE BIRDS AND THE BEES AND THE FLOWERS AND THE TREES

The belled and bewinged wandering penis sexual badge, the most common image in the corpus of sexual badges, shares salient features with a pan-European group of images associating penises with trees and depicting them as fruit or birds.[22] These include manuscript illuminations from the Old French *Roman de la rose,* showing nuns plucking penises from trees; the frescos adorning the fountain, Fonte Nuova, in the Italian city of Massa Marittima (after 1265), depicting a tree bearing penis-fruit that are being pecked by birds and plucked by women; and a wall painting in the southern Tyrolean castle Castel/Schloss Moos-

Schulthaus in Appiano/Eppen, again depicting a tree bearing penis-fruit that are being harvested by women.[23] These images share the most salient feature of the badges of female masculinity discussed above: they juxtapose ordinary women with autonomous penises, and they show these women collecting and harvesting the penis-fruit. Two sexual badges that take up and vary this imagery will help us further explore the masculinity of the penis-fruit and the notions of nature and culture it suggests.

In the first of these badges, whose Kunera database number is 623, a winged penis creature perches at the very top of the tree, wings outstretched, pointed straight upwards, ready to fly (figure 8.6). The penis is anatomically detailed: the foreskin, rolled back, is clearly delineated, and the testicles, often not depicted in the wandering penis creatures, rest on the treetop. The penis looks, to the modern eye, like a rocket ready to launch. The tree trunk, which arises from a grassy bed, sways slightly under its weight. On the ground at the right, a smaller, immature stalk bends so far that its top nearly touches the ground. Symmetrically on the left, a single, giant leaf-shaped vulva emerges budding from the tree. It, too, has clear anatomical attributes; the clitoris is clearly visible. If we look very closely, we see that the stalk bending on the right does not actually touch the ground. Its leafy crown actually rests on three small balls. It is impossible to tell whether an equivalent element supports the flowering vulva on the left-hand side of the badge, because the lower left-hand corner of the badge is damaged.

In this badge, the penis and the vulva belong to different realms of the natural world: the penis is a birdlike creature, endowed with mobility. It has alighted and is now ready to take flight again. The vulva, on the other hand, is part of a plant. Not an autonomous creature, capable neither of movement nor of self-propelled, self-willed action, it has unfolded itself like a leaf in springtime, a natural step in a natural process. It is connected to and part of larger systems—the tree, its roots, its crown—and the unfolding of nature itself. The leaf-vulva's state of budding is only one sign on the badge that the season of fair weather, of plenty, is here. With its multiple references—to generation both sexual and vegetal, to the natural world, to the season of spring—the badge implies a natural process that encompasses planting, ripening, and birth.

Figure 8.6. Winged penis in tree. Inventory number 2026. Image courtesy of the Van Beuningen Family Collection, Langbroek, the Netherlands.

For a modern, English-speaking viewer, the image suggests the modern circumlocution for sex, "the birds and the bees," which also gestures toward the processes of fertilization and reproduction in the natural world.

The symbolism of this badge appears to substantiate modern truisms about gender. The bewinged penis would represent masculinity, characterized by free movement from place to place. This mobility would symbolize autonomy and the capacity for individual agency and would contrast with the rootedness, the bound-in-placeness of the vulva. Passive and dependent, the vulva would seem to represent a notion of femininity that lacks agency and individuality. It would symbolize femininity as bound up in, defined by, and integral to a larger system of reproduction and complex relationships to which it is indispensible and upon which it depends for life. But before deciding that we have hit on the semiotics of gender undergirding the entire symbolic system of signification of the sexual badges, let us look at another badge.

In badge 624, a bewinged vulva perches obliquely at the crown of tree, ready to fly away to the right (figure 8.7). The tree trunk stands stout and tall. Near its top, directly under the crown, appendages sprout symmetrically from each side. They droop in an odd manner, much like the droopy sprout on the left in badge 623. Are these branches intended to remind us of flaccid penises? Perhaps. The tree trunk itself is a fantastical creation, a composite of male and female bodies, and of animal and vegetal life. Two small balls midway up resemble breasts (which are otherwise quite unusual in the badges), although they might also be testicles; a wing sprouts behind them on the right-hand side (most likely the left wing is missing because of damage); the tree has a series of odd curling lines about its base that suggest, again, a penis.

This badge undoes and inverts the gender ideology of the previous badge. Badge 624 overturns the gendered opposition that male equals active and female equals passive, suggested in the symbolism of badge 623. The vulva is autonomous, an agent free to wing its way about the world. The tree trunk evokes a penis that is rooted in the earth, stationary and firmly planted in the ground, part of a larger system of generation and ripening, passively waiting for the vulva to visit it and leave again, dependent on the rhythms of the seasons and the desires of the vulva for its fulfillment. The vulva is self-sufficient; the penis but one link in a larger system of relationships. Looking at both badges together, a feature emerges that is salient for the entire corpus of sexual badges, as we have already seen with the vulva on stilts: mobility and stasis are not gendered attributes or distinctive features marking a gender difference in this corpus of images. Rather they are available, or not, to either sex. Both penis and vulva can be mobile or bound in place.

And what of the opposition between nature and culture? Let us examine the trees in these two badges. In badge 624, the tree's branches closely resemble the stumped branches typical of pollarded trees, a method of pruning common in medieval and early modern Europe (and indeed still practiced, especially in urban centers where it is desirable to maintain trees at a specific height).[24] Far from being wild or natural, the tree in badge 624 is represented as a natural artifact or object created by human beings and used for human purposes. Something similar is happening in badge 623. The budding vulva sprouts from the base of its tree like a shoot. This evokes another common method of

Figure 8.7. Winged vulva in tree. Inventory number 1850. Image courtesy of the Van Beuningen Family Collection, Langbroek, the Netherlands.

pruning used for woodland management in the Middle Ages, coppicing, in which a tree trunk is cut back to encourage the growth of new shoots. Both kinds of trees, pollarded and coppiced, can be found in manuscript illuminations and in other badges, but more germane to the argument here is that coppiced woodlands and pollarded trees would have been ubiquitous, defining features of the medieval agricultural landscape. The trees bearing penis-fruit (or vulva-fruit, for that matter, as in badge 623), both in these badges and in the images mentioned earlier, have their site of belonging in a vegetal world that is an agricultural world, a domesticated landscape created by human culture and for human purposes. This evidence suggests that we should be very cautious in applying modern gendered binaries that equate masculinity with culture and femininity with nature to these late medieval materials. There is no opposition between nature and culture here; rather, nature is already culture.[25]

CUT MASCULINITY

A final thought on gender. The sexual badge imagery and agricultural practices discussed here diverge in countless ways, but they do converge around another issue, namely the problem of cutting and castration. The pollarded tree is pruned and trained for human use. The coppiced tree, cut and cut again, provides fodder, bedding, and other necessary materials over generations. Ceaselessly renewed, these trees can be extremely long-lived. The processes of coppicing and pollarding retard the process of aging, so that the tree remains, to speak in human terms, an adolescent.

The autonomous penis badges and the penis-fruit imply (or perhaps I should say insinuate) cutting and castration as well, for the sexual badge creatures are on their own in the world, without a human body to which they presumably should belong, while the fruit must be severed from its source in order to be consumed. Two medieval German fabliaux dealing with wandering, autonomous penises comically stage the issue of castration as well.[26] Perhaps the penis creature and the penis-fruit represent a gender identity that I will, for the sake of discussion, call cut masculinity, a masculinity that is young and sexually potent (in the terms of the female masculinity badges, nutritious), yet compliant, passive, and useful. The penises would then represent paradoxical agents that are in fact merely objects to be acted with and upon. The so-called planting badges, in which a woman kneels on the ground holding a spadelike cutting implement over a penis lying just beneath the earth's surface, support this insight.

The penis-fruit and disembodied penis creatures summon to the modern mind the idea of human male castration as punishment and disfigurement and Freud's theory of castration anxiety as a foundational stage in the development of sexual and social identity. Terrible anxieties about castration appear to have plagued the Dominican writers of the *Malleus maleficarum,* Henricus Institoris and Jacobus Sprenger, to judge by the apprehensions characterizing their work. The now well-known *Malleus* passage about witches who steal penises and hide them in nests in trees provides, in our terms, another example of the nexus of female masculinity and cut masculinity:

As for what pronouncement should be made about those sor-
ceresses who sometimes keep large numbers of these members
(twenty or thirty at once) in a bird's nest or in some cabinet, where
the members move as if alive or eat a stalk or fodder, as many have
seen and the general report relates, it should be said that these
things are all carried out through the Devil's working and illu-
sion. . . . A certain man reported when he had lost his member and
gone to a certain sorceress to regain his well-being, she told the sick
man that he should climb a certain tree and granted that he could
take whichever one he wanted from the nest, in which there were
very many members. When he tried to take a particular large one,
the sorceress said, "You shouldn't take that one," adding that it be-
longed to one of the parish priests.[27]

Institoris and Sprenger show us that Freud's notion of castration an-
xiety may well have medieval antecedents, at least among these clerics,
at any rate, whose fear of castration and of witches who steal penises
was bound up in complex, indeed contorted, theological anxieties about
demonic influences in the failure of human reproduction. Clerical
thinkers such as Institoris and Sprenger may well have found the ico-
nography of the penis- and vulva-trees, or what I have called the gender
identities of female masculinity and cut masculinity, transgressive and
demonic. When Institoris and Sprenger stridently and (from the mod-
ern perspective at any rate) tediously disavow that women can have
nondemonic access to and control of reproductive power, they are not
making something up but rather, as the badges (and other evidence)
would suggest, responding to a shared cultural imaginary that they re-
frame and reinterpret according to the specific theological and natural-
philosophical dilemmas that pressed upon them. In historian Hans
Peter Broedel's words, "Most of the notions about witchcraft in the
Malleus can be understood as products of minds which—although
theologically learned and aware—have a view of the world that in many
respects comes extremely close to that of their informants."[28]

 The badges share Institoris's and Sprenger's preoccupation with
human fertility and reproduction, but do they share their fears? I think

not. Here the sexual badges are incontrovertible witnesses to a mode of thought that speaks back to or does not conform to contemporaneous clerical thought. Taken together, the *Malleus* and the badges show us, in Broedel's words, a contested reality.[29] The badges allow us to discern a different medieval perspective on fertility and reproduction and a different set of gender identities. The badges show a way of understanding the female body that is not hostile or eroticized, that may even be humorous and positive. They represent a gendered mode of asserting power and control over the inscrutable, vital, yet precarious forces of sex, fertility, and reproduction.

FOOD, SEX, AND POWER

In *Holy Feast and Holy Fast,* Caroline Bynum explains:

> In Western Europe in the Middle Ages, as in many cultures today, women cooked and men ate. One of the strongest social links between male and female lay in the fact that wife or servant cooked what husband and lord provided and in the even more consequential fact that mother's womb and mother's milk guaranteed survival for the next generation. As Elias Canetti says: "A mother is one who gives her own body to be eaten." This is not, of course, to say that women never ate or that only male children were nourished from the female body. It is, rather, to say that social arrangements and cultural symbols stereotyped reception of nurture as a male activity, provision of nurture as a female one.[30]

The conclusions this essay has reached regarding the gendered symbolism of the sexual badges and related imagery resonate in odd, not fully contiguous ways with Bynum's pioneering study of (to quote the subtitle of her book) the religious significance of food to women. In *Holy Feast and Holy Fast,* Bynum compellingly and lucidly demonstrated the extraordinary creativity with which medieval religious women manipulated, for the purpose of claiming religious vocation and authority, the social expectations and cultural symbols that inexorably linked women

and food. The sexual badges and sexual imagery discussed here also link women and food, but they claim no religious authority. Perhaps, however, they afford us a glimpse into a now largely lost world of heterodox and perhaps even magical practices that sought to influence divine and demonic forces. These cultural practices differ from late medieval religious practice insofar as they were not institutionally or doctrinally sanctioned. However, perhaps we can say that both of these shifting worlds of belief seek influence over the powers that be, whether human, divine, or demonic.

Women cooked. And what do they cook in the sexual badges? Penises. The image of women grilling penises over the fire that appears in sexual badges from the Low Countries in the fifteenth century appears again at the beginning of the sixteenth century in a drawing by Hans Baldung Grien, which Urs Graf copied (figure 8.8). While the Baldung and Graf drawings clearly draw on iconographic traditions shared with those of the sexual badges (note that the crossed legs of the woman lounging in front of the fire even recall the vulva "fat catchers" in the some of the badges), they have also altered that imagery in ways that, to us, suggest what will become a profound remaking of gender ideologies. The sticklike female figures of the badges, recognizable as women by their clothing and hair, standing and working, cooking, at the fireplace, have changed. In the engraving, the women are naked, lasciviously lounging about the fire, eroticized and made available to a male gaze in a manner that is utterly absent in the sexual badges. The penises, too, have changed. Whereas the badges clearly show penises, the engraving employs a subtle metaphorical shift, depicting not penises but sausages grilling over the fire. There is much that could be analyzed profitably here, but for the purposes of this essay we can say that the female masculinity represented in the sexual badges has been ideologically transformed, in the engraving, into witchcraft.[31]

The sexual badges and the penis-tree imagery show us the instability of categories of gender. They reveal gender as a cultural construction and as a contested reality, and they confound the notion that gender is a stable, universal binary based on biological sex. Gender in the badges is a contested field of meaning, and it requires us to reassess the limits of our conceptual assumptions about embodied creatures and to reconfigure the limits of gender in the late medieval world.

Figure 8.8. Four Witches and Cat, 1514. Drawing by Hans Baldung Grien, copied by Urs Graf.

NOTES

1. For a useful introduction to the complexities of the term *hybrid* as it is used in contemporary anthropology, cultural studies, and folklore, see Deborah A. Kapchan and Pauline Turner Strong's introduction to their special issue, "Theorizing the Hybrid," *Journal of American Folklore* 112, no. 445 (Summer 1999): 239–53, www.jstor.org/stable/541360.

2. Caroline Walker Bynum, *Metamorphosis and Identity* (New York: Zone Books, 2001), 29–30.

3. Ibid., 31.

4. Ibid.

5. Scholars wishing to learn about the astonishing array of badges, both religious and secular, surviving from the Middle Ages are directed to the following reference works and to the following searchable databases of badges on the Web: H. J. E. van Beuningen and A. M. Koldeweij, eds., *Heilig en Profaan: 1000 Laat-Middeleeuwse Insignes Uit de Collectie H. J. E. Van Beuningen,* 3 vols. (Cothen: Stichting Middeleeuwse Religieuze en Profane Insignes, 1993, 2001, and

2012); Stichting Middeleeuwse Religieuze en Profane Insignes, www.medieval badges.org/; Pilgerzeichendatenbank, www.pilgerzeichen.de/; and Kunera database, Radboud Universiteit Nijmegen, www.kunera.nl/. I refer to the badges by the numbers assigned them in the Kunera database. For examples of dog badges, see the Kunera database, objects 00678 and 00680; for hearts, see objects 00884, 00108, and 00902, the last of which is a crowned heart with scroll pierced by an arrow; for swans, see objects 00704, 00705, 00706, and 00707.

6. Among the growing number of interesting and useful scholarly articles on the badges, see especially A. M. Koldeweij, "A Barefaced *Romance de la Rose* (Paris, B.N.ms. fr. 25526) and Some Late Medieval Mass-Produced Badges of a Sexual Nature," in *Flanders in a European Perspective: Manuscript Illumination around 1400 in Flanders and Abroad,* ed. Maurits Smeyers and Bert Cardon (Leuven: Peeters, 1993), 499–516; and Ann Marie Rasmussen, *Wandering Genitalia: Sexuality and the Body in German Culture between the Late Middle Ages and Early Modernity,* King's College London Medieval Studies, Occasional Series 2 (London: Centre for Late Antique and Medieval Studies, King's College London, 2009), which contains references to other key studies. I am extremely grateful to Christoph Retsch for sharing with me his voluminously documented senior thesis, "Obszön-erotische Tragezeichen des Spätmittelalters," 2 vols. (BA thesis, University of Bamberg, Germany, 2009).

7. See Ann Marie Rasmussen, "Wanderlust: Gift Exchange, Sex, and the Meanings of Mobility," in *"Liebe schenken": Liebesgaben in der Literatur des Mittelalters und der frühen Neuzeit,* ed. Margreth Egidi, Ludger Lieb, and Marielle Schnyder (Berlin: Erich Schmidt, 2012), 219–29.

8. Though few, some badges also show what we would call male voyeurism, exhibitionism, and anal penetration.

9. Karma Lochrie, *Heterosyncrasies: Female Sexuality When Normal Wasn't* (Minneapolis: University of Minnesota Press, 2005), xv.

10. Joan Wallach Scott, "Gender: A Useful Category of Historical Analysis," *American Historical Review* 91, no. 5 (1986): 1067.

11. This term was coined by Judith Halberstam in her influential book *Female Masculinity* (Durham: Duke University Press, 1998). By using the term I am not arguing for continuity between the past and present; nor am I trying to construct a medieval prehistory, as it were, of this concept. However, Halberstam's term seems, superficially at least, to describe the medieval images discussed here very well and can so serve to provide the reader with a conceptual bridge between past and present. See also *The Lesbian Premodern,* ed. Noreen Giffney, Michelle M. Sauer, and Diane Watt (New York: Routledge, 2011).

12. For recent work in medieval sexuality studies, see Sahar Amer, *Crossing Borders: Love between Women in Medieval French and Arabic Literature* (Philadel-

phia: University of Pennsylvania Press, 2008); William Burgwinkle and Cary Howie, *Sanctity and Pornography in Medieval Culture: On the Verge* (Manchester: Manchester University Press, 2011).

13. There is a group of religious badges showing the Virgin Mary holding the Christ child and baring a single, naked, tiny breast that looks rather like a toggle button or a circular doorbell. See, for example, object number 00530.

14. The belled penis is an example of the kind of linguistic material that suffuses the entire badge corpus, in this case, via references to commonplaces and proverbs. Even in modern English, we still have the idiom "to bell the cat," as in "Who will bell the cat?" It means to undertake, or to agree to perform, an impossibly difficult task. As David Kunzle points out, "To bell the cat is a general warning to be well prepared or figuratively well-armed when undertaking anything risky, and not to underestimate your enemy." Here the "cat" has already been belled, which implies a degree of domestication already achieved and gestures suggestively toward the implicit presence of storytelling narration: Who belled the cat? How did they accomplish this difficult feat? David Kunzle, "'Belling the Cat'—'Butting the Wall': Military Elements in Bruegel's Netherlandish Proverbs," in *The Netherlandish Proverbs: An International Symposium on the Pieter Brueg(h)els,* ed. Wolfgang Mieder (Burlington: University of Vermont, 2004), 145.

15. Laurie Shannon, "The Eight Animals in Shakespeare: Or, Before the Human," *PMLA* 124, no. 2 (2009): 472–76. "To put it in the broadest terms: before the cogito, there was no such thing as 'the animal.' There were creatures. There were brutes, and there were beasts. There were fish and fowl. There were living things. There were humans, who participated in animal nature and who shared the same bodily materials with animals (Paster). These humans were measured as much in contradistinction to angels as to animals, taking their place in a larger cosmography, constitution, or even 'world picture' than the more contracted post-Cartesian human/animal divide with which we customarily wrangle. None of these classifications line up with the fundamentally modern sense of the animal or animals as humanity's persistent, solitary opposite" (474).

16. These last badges bear a fleeting resemblance to the Sheela-na-Gig figures in medieval sculpture, in which a recognizably human female, often positioned over a threshold of some kind, assertively displays her vulva, or to the "bare bottom" sculptures of human buttocks. See Michael Camille, "Dr. Witkowski's Anus: French Doctors, German Homosexuals and the Obscene in Medieval Church Art," in *Medieval Obscenities,* ed. Nicola McDonald (Woodbridge: York Medieval Publications, 2004), 17–38; and Ruth Mellinkoff, *Averting Demons,* 2 vols. (Los Angeles: Ruth Mellinkoff Publications, 2004).

17. There is something like this in a medieval manuscript illumination, however, illustrating the story, *Das Almosen* (Alms). The wife of a miser has sex with a beggar who has asked her for alms because she has no other goods to share with him. The image shows a woman handing a man an object that looks like an oblong doughnut, but which, when compared with the sexual badges, is clearly a vulva. I want to thank Dr. Nicola Zotz warmly for sharing this image with me.

18. Lyndal Roper, *Witch Craze: Terror and Fantasy in Baroque Germany* (New Haven: Yale University Press, 2004), 148.

19. Ibid., 154. Another sexual badge (07554)—that I discovered, alas, too late to be included in this chapter—shows a vulva resembling figure 8.1 but with a penis and testicles between its legs. Female masculinity, indeed!

20. Bynum, *Metamorphosis and Identity,* 30.

21. Ibid.

22. I am quoting in this section's title the first line of the popular song, written ca. 1965, by Herb Newman (1892–1984): "Let me tell you 'bout the birds and the bees and the flowers and the trees and the moon up above, and a thing called love."

23. See discussion and photographs in George Ferzoco, *Il murale di Massa Marittima / The Massa Marittima Mural* (University of Leicester: Center for Tuscan Studies, 2004); for a critical discussion of Ferzoco's thesis, see Matthew Ryan Smith, "Reconsidering the 'Obscene': The Massa Marittima Mural," *Shift: Queen's Journal of Visual and Material Culture* 2 (2009): 1–27, www.shiftjournal .org/articles/2009/smith.htm.

24. Oliver Rackham, *Woodlands* (London: Collins, 2006). The following blog post is easily accessible, readable, and reliable: Deirdre Larkin, "Woodswoman, Pollard That Tree," *The Medieval Garden Enclosed,* February 25, 2011, http://blog.metmuseum.org/cloistersgardens/2011/02/25/woodswoman -pollard-that-tree/.

25. Karma Lochrie's summary of the learned, or theologically based, medieval concepts of nature is excellent: "Nature does not signify 'majority practice or system of belief,' as norm does. . . . It defines what is consistent with reason and that means, for sexual practices, what is consistent with the purpose of reproduction. The only natural and desirable sexual act, therefore, is narrowly defined to exclude most heterosexual sex acts: sex in the appropriate vessels, with the appropriate instruments, in the appropriate position, without inordinate desire. Natural sex acts could still be sinful because nature had not yet become normative" (*Heterosyncrasies,* xxiii).

26. These fifteenth-century, anonymous, rhymed couplet texts are known as *Das Nonnenturnier* and *Gold und Zers.* Both are discussed in Rasmussen, *Wandering Genitalia.*

27. Henricus Institoris and Jacobus Sprenger, *Malleus maleficarum,* English and Latin, ed. and trans. Christopher S. Mackay, 2 vols. (Cambridge: Cambridge University Press, 2006), 2:280. On this motif, see Walter Stephens, "Witches Who Steal Penises: Impotence and Illusion in *Malleus maleficarum,*" *Journal of Medieval and Early Modern Studies* 28 (1998): 495–529; also Walter Stephens, *Demon Lovers: Witchcraft, Sex, and the Crisis of Belief* (Chicago: University of Chicago Press, 2002).

28. Hans Peter Broedel, *The Malleus Maleficarum and the Construction of Witchcraft: Theology and Popular Belief* (Manchester: Manchester University Press, 2003), 58. On other evidence, see, for example, Charles Zika, *Exorcising Our Demons: Magic, Witchcraft, and Visual Culture in Early Modern Europe* (Leiden: Brill, 2003). Discussing an engraving by Hans Baldung Grien, Zika notes that "Baldung seems to be presenting witchcraft as female power, specifically female sexual power, by refashioning traditional representations of male power and spectacle. . . . The extent of this transformation can be appreciated if we compare the scene to representations of witchcraft and sorcery from the later fifteenth century. The bulk of these are concerned to illustrate the harm of malefice carried out by sorcerers. They do not restrict these activities to women, nor do they focus on women's bodies and their sexuality as the source of their malefic power. The woodcuts accompanying the text of Johannes Vintler's *Buch der Tugend,* a book of virtues and vices published by Johannes Blaubirer in Augsburg in 1486, illustrate this well" (244).

29. Broedel, *Malleus maleficarum,* 158.

30. Caroline Walker Bynum, *Holy Feast and Holy Fast: The Religious Significance of Food to Medieval Women* (Berkeley: University of California Press, 1987), 277.

31. For excellent discussions of this image and of related, early sixteenth-century images of witchcraft, see Zika, *Exorcising Our Demons,* 253–57 and 270–73; and Roper, *Witch Craze,* 150–54. It is useful to repeat Roper's cautionary words here: "It is tempting to interpret such images as the visual counterpart of the early modern European witch hunt. But this would be misleading. After all, the images date from the first two decades of the sixteenth century, a period before the real beginnings of the witch craze" (153).

Selected Bibliography

Primary Texts

Augustine. *Concerning the City of God against the Pagans.* Trans. Henry Bettenson. 1972. Reprint, London: Penguin, 2003.

———. *The Greatness of the Soul and The Teacher.* Ed. and trans. Joseph M. Colleran. New York: Newman Press, 1950.

———. *The Literal Meaning of Genesis.* Trans. John H. Taylor. New York: Newman Press, 1982.

———. *The Nature and the Origin of the Soul.* In *Answer to the Pelagians,* trans. Roland J. Teske, S.J. Works of St. Augustine, pt. 1, vol. 23. Hyde Park, NY: New City Press, 1997.

Boccaccio, Giovanni. *Decameron.* Ed. Vittore Branca. 2 vols. Florence: Le Monnier, 1951.

———. *The Decameron.* Trans. Mark Musa and Peter Bondanella. New York: Norton, 1977.

Book of Minerals. Trans. Dorothy Wyckoff. Oxford: Clarendon Press, 1967.

Caesarius of Heisterbach. *The Dialogue on Miracles.* Trans. H. Von E. Scott and C. C. Swinton Bland. London: Routledge, 1929.

———. *Dialogus miraculorum.* Ed. Joseph Strange. Cologne: J. M. Heberle, 1851.

Le Chevalier au cygne and La fin d'Elias. Ed. Jan A. Nelson. Vol. 2 of *The Old French Crusade Cycle,* gen. ed. Jan A. Nelson and E. J. Mickel. Tuscaloosa: University of Alabama Press, 1985.

Chrétien de Troyes. *Le Chevalier au lion.* In *Romans,* ed. David F. Hult. Paris: Livre de poche, 1994.

———. *Yvain, ou Le Chevalier au lion.* Ed. Mario Roques. Classiques Français du Moyen Âge 89. Paris: Champion, 1970.

De lapidibus. Ed. and trans. D. E. Eichholz. Oxford: Clarendon Press, 1965.

Donne, John. *The Holy Sonnets.* Ed. Gary A. Stringer. Variorum Edition of the Poetry of John Donne, vol. 7, pt. 1. Bloomington: Indiana University Press, 2005.

Les enfances Godefroi. Ed. Emanuel J. Mickel. Vol. 3 of *The Old French Crusade Cycle,* gen. ed. Jan A. Nelson and E. J. Mickel. Tuscaloosa: University of Alabama Press, 1999.

Etienne de Fougères. *Le livre des manières.* Ed. R. Anthony Lodge. Geneva: Droz, 1979.

Geoffrey of Auxerre. *On the Apocalypse.* Trans. Joseph Gibbons. Kalamazoo, MI: Cistercian Publications, 2000.

Gerald of Wales. *The History and Topography of Ireland.* Trans. John J. O'Meara. London: Penguin Books, 1982.

Gervais of Tilbury. *Le livre des merveilles.* Trans. A. Duchesne. Paris: Les Belles Lettres, 1992.

———. *Otia imperialia: Recreation for an Emperor.* Ed. and trans. S. E. Banks and J. W. Binns. Oxford: Clarendon Press, 2002.

Giotto: The Frescoes of the Scrovegni Chapel in Padua. Ed. Giuseppe Basili. Milan: Skira Editore, 2002.

Guibert of Nogent. *Self and Society in Medieval France: The Memoirs of Abbot Guibert of Nogent.* Trans. John Benton. Toronto: University of Toronto Press, 1984.

Heilig en Profaan: 1000 Laat-Middeleeuwse Insignes Uit de Collectie H. J. E. Van Beuningen. Ed. H. J. E. van Beuningen and A. M. Koldeweij. 2 vols. Cothen: Stichting Middeleeuwse Religieuze en Profane Insignes, 1993 and 2001.

Heresies of the High Middle Ages. Trans. Walter Wakefield and Austin Evans. New York: Columbia University Press, 1969.

The Holy Bible: Translated from the Latin Vulgate [Douay-Rheims Bible]. Annotated by Rev. Bishop Richard Challoner. London: Baronius Press, 2003.

Huon de Bordeaux. Ed. William Kibler and François Suard. Paris: Champion, 2003.

Ibn Tufayl. *Ibn Tufayl's Hayy Ibn Yaqzan: A Philosophical Tale.* Trans. Lenn Evan Goodman. Chicago: University of Chicago Press, 2009.

Istitoris, Henricus, and Jacobus Sprenger. *Malleus maleficarum.* Ed. and trans. Christopher S. Mackay. 2 vols. Cambridge: Cambridge University Press, 2006.

Jacques Fournier. *Le registre d'inquisition de Jacques Fournier, évêque de Pamiers (1318–1325).* Ed. Jean Duvernoy. Toulouse: E. Privat, 1965.

James of Vitry. "Life of Marie d'Oignies." Trans. Margot King. In *Mary of Oignies: Mother of Salvation,* ed. Anneke Mulder-Bakker. Turnhout: Brepols, 2006.

Jean d'Arras. *Mélusine: Roman du XIVe siècle.* Ed. Louis Stouff. Dijon: Imprimerie Bernigaud et Privat, 1932.

———. *Mélusine ou La noble histoire de Lusignan.* Ed. Jean-Jacques Vincensini. Paris: Livre de poche, 2003.

Jean de Meun. *Le roman de la rose.* Ed. Félix Lecoy. 3 vols. Paris: Champion, 1966.

Kunera database. Radboud Universiteit Nijmegen. www.kun.nl//kunerapage .aspx?From=Default.

Mandeville, John. *The Book of John Mandeville.* Ed. Tamarah Kohanski and C. David Benson. Kalamazoo, MI: Medieval Institute Publications, 2007.

———. *The Defective Version of Mandeville's Travels.* Ed. M. C. Seymour. EETS. Oxford: Oxford University Press, 2002.

———. *Le livre des merveilles du monde.* Ed. Christiane Deluz. Paris: CNRS Editions, 2000.

Marie de France. *Lais.* Ed. Alfred Ewert. Oxford: Blackwell, 1944.

Mary of Oignies: Mother of Salvation. Ed. Anneke B. Mulder-Bakker. Turnhout: Brepols, 2006.

Melion. Trans. Amanda Hopkins. In *French Arthurian Literature IV: Eleven Old French Narrative Lays,* ed. and trans. Glyn S. Burgess and Leslie C. Brook, with Amanda Hopkins. Cambridge: D. S. Brewer, 2007.

La naissance du Chevalier au cygne. Ed. Emanuel J. Mickel and Jean A. Nelson. Vol. 1 of *The Old French Crusade Cycle,* gen. ed. Jan A. Nelson and E. J. Mickel. Tuscaloosa: University of Alabama Press, 1977.

Peter Lombard. *Sentences.* Trans. Giulio Silano. Toronto: Pontifical Institute for Mediaeval Studies, 2008.

Petri Comestoris. *Scolastica historia: Liber genesis.* Ed. Agneta Sylwan. Turnhout: Brepols, 2005.

Pilgerzeichendatenbank of the Staatliche Museen zu Berlin. Database. www .pilgerzeichen.de/.

La queste del Saint Graal. Ed. Albert Pauphilet. Paris: Champion, 1980.

Soul and Body I. Ed. and trans. Tom Shippey. Apocalyptic Ideas in Old English Literature. www.apocalyptic-theories.com/literature/soul1/soulbody1 .html.

Stichting Middeleeuwse Religieuze en Profane Insignes. Database. www .medievalbadges.org/.

Thomas of Cantimpré. *Liber de natura rerum.* Ed. Helmut Boese. Berlin: Walter de Gruyter, 1973.

———. "Une oeuvre inédite de Thomas de Cantimpré: La 'Vita Ioannis Cantipratensis.'" *Revue d'histoire ecclésiastique* 76 (1981): 241–316.

————. *Thomas of Cantimpré: The Collected Saints' Lives.* Ed. Barbara Newman. Trans. Margot H. King and Barbara Newman. Turnhout: Brepols, 2008.

————. *Vita Margarete de Ypris.* Ed. G. Meersseman. In G. Meersseman, "Les frères prêcheurs et le mouvement dévot en Flandres au XIIIe siècle," *Archivum Fratrum Praedicatorum* 18 (1948): 106–30.

Valentin et Orson: An Edition and Translation of the Fifteenth-Century Romance Epic. Ed. and trans. Shira Schwam-Baird. Tempe: Arizona Center for Medieval and Renaissance Studies, 2011.

Walter Map. *De nugis Curialium.* Ed. and trans. M. R. James. Rev. C. N. L. Brooke and R. A. B. Mynors. Oxford: Clarendon Press, 1983.

William Durandus. *Le pontifical de Guillaume Durand.* Ed. Michel Andrieu. Vol. 3 of *Le pontifical romain au Moyen-Age.* Studi e Testi 88. Vatican City: Biblioteca Apostolica Vaticana, 1940.

Secondary Sources

Ackerman, Robert W. "The Debate of the Body and Soul and Parochial Christianity." *Speculum* 37 (1962): 541–65.

Adams, Carol J., and Josephine Donovan. *Animals and Women: Feminist Theoretical Explorations.* Durham: Duke University Press, 1995.

Agamben, Giorgio. *The Open: Man and Animal.* Trans. Kevin Attell. Stanford: Stanford University Press, 2004.

Alexandre, Jérome. *Une chair pour la gloire: L'anthropologie réaliste et mystique de Tertullien.* Paris: Beauchesne, 2001.

Allen, Elizabeth. *False Fables and Exemplary Truth in Later Middle English Literature.* New York: Palgrave Macmillan, 2005.

Alvar, Carlos. "Oiseuse, Venus, Luxure: Trois dames et un miroir." *Romania* 106 (1985): 108–17.

Amer, Sahar. *Crossing Borders: Love between Women in Medieval French and Arabic Literature.* Philadelphia: University of Pennsylvania Press, 2008.

Atkinson, Clarissa. *The Oldest Vocation: Christian Motherhood in the Middle Ages.* Ithaca: Cornell University Press, 1991.

Bakhtin, Mikhail. *Problems in Dostoevsky's Poetics.* Trans. Caryl Emerson. Minneapolis: University of Minnesota Press, 1984.

Barnes, Jonathan. "*Anima Christiana.*" In *Body and Soul in Ancient Philosophy,* ed. Dorothea Frede and Burkhard Reis, 447–64. Berlin: Walter de Gruyter, 2009.

Barratt, Alexandra. "Undutiful Daughters and Metaphorical Mothers among the Beguines." In *New Trends in Feminine Spirituality: The Holy Women of Liège*

and Their Impact, ed. Juliette Dor, Lesley Johnson, and Jocelyn Wogan-Browne, 81–102. Turnhout: Brepols, 1999.

Barthes, Roland. "Textual Analysis of Poe's 'Valdemar.'" In *Untying the Text: A Post-Structuralist Reader,* ed. Robert Young, 133–61. Boston: Routledge and Kegan Paul, 1981.

Bartlett, Robert. *The Natural and the Supernatural in the Middle Ages.* Cambridge: Cambridge University Press, 2008.

Baumgartner, Emmanuèle. "La Dame du Lac et la Mélusine de Jean d'Arras." In *Mélusines continentales et insulaires,* ed. Jeanne-Marie Boivin and Proinsias MacCana, 181–92. Paris: Champion, 1999.

Beauvoir, Simone de. *The Second Sex.* Trans. H. M. Parshley. New York: Knopf, 1952.

Bennett, Jane. *Vibrant Matter: A Political Ecology of Things.* Durham: Duke University Press, 2010.

Bennett, Judith M. *History Matters: Patriarchy and the Challenge of Feminism.* Philadelphia: University of Pennsylvania Press, 2006.

Berlioz, Jacques, and Marie Anne Polo de Beaulieu. *L'animal exemplaire au Moyen Age (Ve–XVe siècle).* Rennes: Presses Universitaires de Rennes, 1999.

Biller, Peter. "Cathars and Material Women." In *Medieval Theology and the Natural Body,* ed. Peter Biller and Alastair Minnis. Woodbridge: York Medieval Press, 1997.

Blanshard, Alastair J. L. *Sex: Vice and Love from Antiquity to Modernity.* Chichester: Wiley-Blackwell, 2010.

Blumreich, Kathleen M. "Lesbian Desire in the Old French *Roman de Silence.*" *Arthuriana* 7, no. 2 (1997): 47–62.

Bonnell, Joseph K. "The Serpent with a Human Head in Art and Mystery Play." *Journal of the Archaeological Institute of America* 21 (1917): 255–91.

Boyd, Matthieu. "Melion and the Wolves of Ireland." *Neophilologus* 93 (2009): 555–70.

Braidotti, Rosi. "Animals, Anomalies, and Inorganic Others." *PMLA* 124, no. 2 (2009): 526–32.

Brakke, David. *The Gnostics: Myth, Ritual, and Diversity in Early Christianity.* Cambridge, MA: Harvard University Press, 2011.

Brantley, Jessica. *Reading in the Wilderness: Private Devotion and Public Performance in Late Medieval England.* Chicago: University of Chicago Press, 2007.

Broedel, Hans Peter. *The Malleus Maleficarum and the Construction of Witchcraft: Theology and Popular Belief.* Manchester: Manchester University Press, 2003.

Brown, Peter. *Augustine of Hippo: A Biography.* Rev. ed. Berkeley: University of California Press, 2000. Brownlee, Kevin. "Mélusine's Hybrid Body and the Poetics of Metamorphosis." In *Mélusine of Lusignan: Founding Fiction in*

Late Medieval France, ed. Donald Maddox and Sara Sturm-Maddox, 76–99. Athens: University of Georgia Press, 1996.

Bruckner, Matilda Tomaryn. "Of Men and Beasts in *Bisclavret.*" *Romanic Review* 81, no. 3 (1991): 251–69.

Bullough, Vern L. "Medieval Medical and Scientific Views of Women." *Viator* 4 (1973): 485–501.

Burgwinkle, William. *Sodomy, Masculinity and Law in Medieval Literature: France and England, 1050–1230.* Cambridge: Cambridge University Press, 2004.

Burgwinkle, William, and Cary Howie. *Sanctity and Pornography in Medieval Culture: On the Verge.* Manchester: Manchester University Press, 2011.

Burns, E. Jane. *Bodytalk: When Women Speak in Old French Literature.* Philadelphia: University of Pennsylvania Press, 1993.

———. *Courtly Love Undressed: Reading through Clothes in Medieval French Culture.* Philadelphia: University of Pennsylvania Press, 2002.

———. "Devilish Ways: Sexing the Subject in the *Queste del Saint Graal.*" *Arthuriana* 2, no. 2 (1998): 11–32.

———. "The Man behind the Lady in Troubadour Lyric." *Romance Notes* 25 (1985): 254–70.

———. "Refashioning Courtly Love: Lancelot as Ladies' Man or Lady/Man?" In *Constructing Medieval Sexuality,* ed. Karma Lochrie, Peggy McCracken, and James A. Schultz, 111–34. Minneapolis: University of Minnesota Press, 1997.

Busby, Keith, Terry Nixon, Alison Stones, and Lori Walters, eds. *The Manuscripts of Chrétien de Troyes.* 2 vols. Amsterdam: Rodopi, 1993.

Butler, Judith. *Bodies That Matter: On the Discursive Limits of Sex.* New York: Routledge, 1993.

Bynum, Caroline Walker. *Christian Materiality: An Essay on Religion in Late Medieval Europe.* New York: Zone Books, 2011.

———. *Fragmentation and Redemption: Essays on Gender and the Human Body in Medieval Religion.* New York: Zone Books, 1991.

———. *Holy Feast and Holy Fast: The Religious Significance of Food to Medieval Women.* Berkeley: University of California Press, 1987.

———. *Metamorphosis and Identity.* New York: Zone Books, 2001.

———. *The Resurrection of the Body in Western Christianity, 200–1336.* New York: Columbia University Press, 1995.

Byrne, Aisling. "The Archipelagic Otherworld: Geography and Identity in Medieval Ireland and Britain." Paper presented at the New Chaucer Society Congress, Siena, 2010.

Cadden, Joan. *The Meanings of Sex Difference in the Middle Ages: Medicine, Science, and Culture.* Cambridge: Cambridge University Press, 1993.

Caillois, Roger. *The Writing of Stones.* Trans. Barbara Bray. Intro. Marguerite Yourcenar. Charlottesville: University Press of Virginia, 1985.

Camille, Michael. "Dr. Witkowski's Anus: French Doctors, German Homosexuals and the Obscene in Medieval Church Art." In *Medieval Obscenities,* ed. Nicola McDonald, 17–38. Woodbridge: York Medieval Publications, 2004.

———. *Image on the Edge: The Margins of Medieval Art.* Cambridge, MA: Harvard University Press, 1992.

Camus, Marie-Thérèse. *La sculpture romane du Poitou: Les grands chantiers du XIe siècle.* Paris: Picard, 1992.

Carozzi, Claude. "Structure et fonction de la vision de Tnugdal." In *Faire croire: Modalités de la diffusion et de la réception des messages religieux du XIIe au XVe siècle: Table Ronde organisée par L'École française de Rome en collaboration avec l'Institut d'histoire médiévale de l'Université de Padoue (Rome, 22–23 juin 1979),* 223–34. Rome: École française de Rome, 1981.

Cheyette, Frederic L., and Howell Chickering. "Love, Anger, and Peace: Social Practice and Poetic Play in the Ending of *Yvain.*" *Speculum* 80 (2005): 75–117.

Clark, David. "On Being 'the Last Kantian in Nazi Germany': Dwelling with Animals after Levinas." In *Animal Acts: Configuring the Human in Western History,* ed. Jennifer Ham and Matthew Senior, 165–98. New York: Routledge, 1997.

Clark, Robert L. A. "Queering Gender and Naturalizing Class in the *Roman de Silence.*" *Arthuriana* 12, no. 1 (2002): 50–63.

Coakley, John. *Women, Men, and Spiritual Power: Female Saints and Their Male Collaborators.* New York: Columbia University Press, 2006.

Cohen, Jeffrey Jerome. *Hybridity, Identity, and Monstrosity in Medieval Britain: On Difficult Middles.* New York: Palgrave Macmillan, 2006.

———. *Medieval Identity Machines.* Minneapolis: University of Minnesota Press, 2003.

———. *Of Giants: Sex, Monsters, and the Middle Ages.* Minneapolis: University of Minnesota Press, 1999.

———. "Stories of Stone." *postmedieval: a journal of medieval cultural studies* 1 (2010): 56–63.

———. "Time Out of Memory." In *The Post-Historical Middle Ages,* ed. Sylvia Federico and Elizabeth Scala, 37–61. New York: Palgrave Macmillan, 2009.

Cohen, Kathleen. *Metamorphosis of a Death Symbol: The Transi-Tomb in the Late Middle Ages and the Renaissance.* Berkeley: University of California Press, 1973.

Conlee, John W. *Middle English Debate Poetry: A Critical Anthology.* East Lansing, MI: Colleagues Press, 1991.

Crane, Susan. "Chivalry and the Pre/Postmodern." *postmedieval: a journal of medieval cultural studies* 2, no. 1 (2011): 69–87.

———. "For the Birds." *Studies in the Age of Chaucer* 29 (2007): 23–41.

Creamer, Paul. "Woman-Hating in Marie de France's *Bisclavret.*" *Romanic Review* 93, no. 3 (2002): 259–74.

De Landa, Manuel. *A Thousand Years of Nonlinear History.* New York: Serve Editions, 2000.

Delcourt, Denyse. "Métamorphose, mystère, fémininité: Lecture du *Roman de Mélusine* par Jean d'Arras." *Le moyen français* 33 (1993): 85–107.

Deleuze, Gilles. "Immanence: A Life . . ." *Theory, Culture and Society* 14, no. 2 (1997): 3–7.

Deleuze, Gilles, and Felix Guattari. *A Thousand Plateaus: Capitalism and Schizophrenia.* Trans. Brian Massumi. Minneapolis: University of Minnesota Press, 1987.

Derrida, Jacques. *L'animal que donc je suis.* Ed. Marie-Louise Mallet. Paris: Galilée, 2006.

———. *The Beast and the Sovereign.* Trans. Geoffrey Bennington. Chicago: University of Chicago Press, 2009.

Dinshaw, Carolyn. *Getting Medieval: Sexualities and Communities, Pre- and Post-Modern.* Durham: Duke University Press, 1999.

Duby, Georges. *Dames du XIIe siècle: Eve et les prêtres.* Paris: Gallimard, 1996.

Duchet-Suchaux, Gaston, and Michel Pastoureau. *Le bestiaire médiéval: Dictionnaire historique et bibliographique.* Paris: Le Léopard d'or, 2002.

Elliott, Dyan. *The Bride of Christ Goes to Hell: Metaphor and Embodiment in the Lives of Pious Women, 200–1500.* Philadelphia: University of Pennsylvania Press, 2012.

———. *Fallen Bodies: Pollution, Sexuality, and Demonology in the Middle Ages.* Philadelphia: University of Pennsylvania Press, 1999.

———. "The Physiology of Rapture and Female Spirituality." In *Medieval Theology and the Natural Body,* ed. Peter Biller and Alastair Minnis, 141–73. Woodbridge: York Medieval Press / Boydell and Brewer, 1997.

———. *Proving Woman: Female Spirituality and Inquisitional Culture in the Later Middle Ages.* Princeton: Princeton University Press, 2004.

Fausto-Sterling, Anne. *Sexing the Body: Gender Politics and the Construction of Sexuality.* New York: Basic Books, 2000.

Ferzoco, George. *Il murale di Massa Marittima / The Massa Marittima Mural.* University of Leicester: Center for Tuscan Studies, 2004.

Flores, Nona. "'Effigies amicitiae . . . veritas inimicitiae': Anti-Feminism in the Iconography of the Woman-Headed Serpent in Medieval and Renaissance Art and Literature." In *Animals in the Middle Ages: A Book of Essays,* ed. Nona C. Flores, 167–95. New York: Garland, 1996.

Fronty, Jerome. *L'étrange bestiaire médiéval du Musée de Metz.* Metz: Éditions Serpentoise, 2007.

Fuss, Diana. "Corpse Poem." *Critical Inquiry* 30 (Autumn 2003): 1–30.

Gallop, Jane. *Thinking through the Body.* New York: Columbia University Press, 1988.

Garber, Marjorie. *Vested Interests: Cross-Dressing and Cultural Anxiety.* New York: Routledge, 1992.

Gaullier-Bougassas, Catherine. *La tentation de l'Orient dans le roman médiéval: Sur l'imaginaire médiéval de l'autre.* Paris: Champion, 2003.

Giffney, Noreen, and Myra J. Hird, eds. *Queering the Non/Human.* Aldershot: Ashgate, 2008.

Giffney, Noreen, Michelle M. Sauer, and Diane Watt, eds. *The Lesbian Premodern.* New York: Routledge, 2011.

Gilbert, Jane. "'Boyz Will Be . . . What? Gender, Sexuality, and Childhood in *Floire et Blancheflor* and *Floris et Lyriope.*" *Exemplaria* 9, no. 1 (1997): 39–61.

Girard, René. "Love and Hate in *Yvain.*" In *Modernité au Moyen Âge: Le défi du passé,* ed. Brigitte Cazelles and Charles Méla, 249–62. Geneva: Droz, 1990.

Gravdal, Kathryn. *Ravishing Maidens: Writing Rape in Medieval French Literature and Law.* Philadelphia: University of Pennsylvania Press, 1991.

Grosz, Elizabeth. *Chaos, Territory, Art: Deleuze and the Framing of the Earth.* New York: Columbia University Press, 2008.

———. *Volatile Bodies: Toward a Corporeal Feminism.* Bloomington: Indiana University Press, 1994.

Guerreau-Jalabert, Anita. "Des fées et des diables: Observations sur le sens des récits mélusiniens au Moyen Age." In *Mélusines continentales et insulaires,* ed. Jeanne-Marie Boivin and Proinsias MacCana, 105–37. Paris: Champion, 1999.

Haidu, Peter. *Lion-Queue-Coupée: L'écart symbolique chez Chrétien de Troyes.* Geneva: Droz, 1972.

Halberstam, Judith Jack. *Female Masculinity.* Durham: Duke University Press, 1998.

Haraway, Donna. *Simians, Cyborgs and Women: The Reinvention of Nature.* New York: Routledge, 1991.

Harf-Lancner, Laurence. *Les fées au Moyen Âge: Morgane et Mélusine, La naissance des fées.* Geneva: Slatkine, 1984.

Harlow, George E., ed. *The Nature of Diamonds.* Cambridge: Cambridge University Press, 1998.

Hassig, Debra. *Medieval Bestiaries: Text, Image, Ideology.* Cambridge: Cambridge University Press, 1995.

Higgins, Iain. "Defining the Earth's Center in a Medieval 'Multi-Text': Jerusalem in the *Book of John Mandeville.*" In *Text and Territory: Geographical Imagination in the European Middle Ages,* ed. Sylvia Tomasch and Sealy Gilles, 29–53. Philadelphia: University of Pennsylvania Press, 1998.

Holsinger, Bruce. "Of Pigs and Parchment: Medieval Studies and the Coming of the Animal." *PMLA* 124, no. 2 (2009): 616–23.

Hopkins, Amanda. "*Bisclavret* to *Biclarel* via *Melion* and *Bisclaret:* The Development of a Misogynous *Lai.*" In *The Court Reconvenes: Courtly Literature across the Disciplines,* ed. Barbara K. Altmann and Carleton W. Carroll, 317–23. Cambridge: D. S. Brewer, 2002.

Hotchkiss, Valerie R. *Clothes Make the Man: Female Cross Dressing in Medieval Europe.* New York: Garland, 2003.

Jacoby, David. "The Frankish States of the Levant and Cyprus under the Lusignans: A Century of Relations (1192–1291)." In *From Aphrodite to Mélusine: Reflections on the Archaeology and the History of Cyprus,* ed. Matteo Campagnolo and Marielle Martiniani-Reber, trans. Erika Milburn, 63–89. Geneva: La Pomme d'or, 2007.

Jolles, André. *Formes simples.* Trans. Antoine Marie Buguet. Paris: Seuil, 1972.

Jonsen, Albert R., and Stephen Toulmin. *The Abuse of Casuistry: A History of Moral Reasoning.* Berkeley: University of California Press, 1988.

Kapchan, Deborah A., and Pauline Turner Strong. "Theorizing the Hybrid." *Journal of American Folklore* 112, no. 445 (Summer 1999): 239–53.

Kardulias, Nick, and Richard W. Yerkes, eds. *Written in Stone: The Multiple Dimensions of Lithic Analysis.* Lanham, MD: Lexington Books, 2003.

Karras, Ruth Mazo. *Sexuality in Medieval Europe: Doing unto Others.* New York: Routledge, 2005.

Kay, Sarah. "Legible Skins: Animals and the Ethics of Medieval Reading." *postmedieval: a journal of medieval cultural studies* 2, no. 1 (2011): 13–32.

Kay, Sarah, and Miri Rubin, eds. *Framing Medieval Bodies.* Manchester: Manchester University Press, 1994.

Kelly, Henry Ansgar. "The Metamorphosis of the Eden Serpent during the Middle Ages and Renaissance." *Viator* 2 (1971): 301–27.

Klapish-Zuber, Christiane. *Women, Family and Ritual in Renaissance Italy.* Trans. Lydia Cochrane. Chicago: University of Chicago Press, 1985.

Koldeweij, A. M. "A Barefaced *Roman de la Rose* (Paris, B.N.ms. fr. 25526) and Some Late Medieval Mass-Produced Badges of a Sexual Nature." In *Flanders in a European Perspective: Manuscript Illumination around 1400 in Flanders and Abroad,* ed. Maurits Smeyers and Bert Cardon, 499–516. Leuven: Peeters, 1995.

Krafft-Ebbing, Richard von. *Psychopathia Sexualis, with Especial Reference to the Antipathic Sexual Instinct: A Medico-Forensic Study*. 12th German ed. Trans. F. J. Rebman. New York: Medical Art Agency, 1922.

Krahmer, Shawn. "The Virile Bride of Bernard of Clairvaux." *Church History* 69 (2000): 304–27.

Krueger, Roberta L. *Women Readers and the Ideology of Gender in Old French Verse Romance*. Cambridge: Cambridge University Press, 1993.

Kunzle, David. "'Belling the Cat'—'Butting the Wall': Military Elements in Bruegel's Netherlandish Proverbs." In *The Netherlandish Proverbs: An International Symposium on the Pieter Brueg(h)els*, ed. Wolfgang Mieder, 129–62. Burlington: University of Vermont, 2004.

Larkin, Deirdre. "Woodswoman, Pollard That Tree." *The Medieval Garden Enclosed*, February 25, 2011, http://blog.metmuseum.org/cloistersgardens/2011/02/25/woodswoman-pollard-that-tree/.

Latour, Bruno. *Reassembling the Social*. Oxford: Oxford University Press, 2005.

Leclercq, Jean. *Monks and Love in the Twelfth Century: Psycho-Historical Essays*. Oxford: Clarendon Press, 1979.

Lefay-Toury, Marie-Noëlle. "Roman breton et mythes courtois: L'évolution du personnage féminin dans les romans de Chrétien de Troyes." *Cahiers de civilisation médiévale* 15 (1972): 193–204, 283–93.

Le Goff, Jacques. *The Birth of Purgatory*. Trans. Arthur Goldhammer. Chicago: University of Chicago Press, 1981.

———. "Culture ecclésiastique et culture folklorique au Moyen Âge: Saint Marcel de Paris et le dragon." In *Un autre Moyen Âge*, 256–65. Paris: Gallimard, 1999.

Le Goff, Jacques, and Emmanuel Leroy Ladurie. "Mélusine maternelle et déchifreuse." *Annales: Economies, sociétés, civilisations* 26 (1971): 587–622.

Le Goff, Jacques, and Pierre Vidal-Naquet. "Lévi-Strauss en Brocéliande." In *Claude Lévi-Strauss: Textes de et sur Claude Lévi-Strauss*, ed. Raymond Bellour and Catherine Clément, 265–319. Paris: Gallimard, 1979.

Leicester, H. Marshall Jr. "The Voice of the Hind: The Emergence of Feminine Discontent in the *Lais* of Marie de France." In *Reading Medieval Culture: Essays in Honor of Robert W. Hanning*, ed. Robert M. Stein and Sandra Pierson Prior, 132–69. Notre Dame: University of Notre Dame Press, 2005.

Levinas, Emmanuel. *Totality and Infinity: An Essay on Exteriority*. Trans. Alphonso Lingis. Pittsburgh: Duquesne University Press, 1969.

Lochrie, Karma. *Heterosyncrasies: Female Sexuality When Normal Wasn't*. Minneapolis: University of Minnesota Press, 2005.

Lomperis, Linda, and Sarah Stanbury. *Feminist Approaches to the Body in Medieval Literature.* Philadelphia: University of Pennsylvania Press, 1993.

Lucken, Christopher. "Roman de Melusine ou histoire de Lusignan: La fable de l'histoire." In *Mélusines continentales et insulaires,* ed. Jeanne-Marie Boivin and Proinsias MacCana, 139–67. Paris: Champion, 1999.

Malvern, Marjorie M. "An Earnest 'Monyscyn' and 'Thinge Delectyball' Realized Verbally and Visually in 'A Disputacion betwyx the Body and Wormes,' A Middle English Poem Inspired by Tomb Art and Northern Spirituality." *Viator* 13 (1982): 415–43.

Matlock, Wendy A. "Vernacular Theology in the *Disputacione betwyx the Body and Wormes.*" In *Translatio: or the Transmission of Culture in the Middle Ages and The Renaissance, Modes and Messages,* ed. Laura H. Hollengreen, Arizona Studies in the Middle Ages and the Renaissance 13, 113–27. Turnhout: Brepols, 2009.

Matter, E. Ann. *The Voice of My Beloved: The Song of Songs in Western Medieval Christianity.* Philadelphia: University of Pennsylvania Press, 1990.

McGowan, Richard. "Augustine's Spiritual Equality: The Allegory of Man and Woman with Regard to the Imago Dei." *Revue des études augustiniennes* 33 (1987): 255–64.

Mellinkoff, Ruth. *Averting Demons.* 2 vols. Los Angeles: Ruth Mellinkoff Publications, 2004.

Moi, Toril. *Sexual/Textual Politics: Feminist Literary Theory.* London: Routledge, 2002.

Morton, Timothy. *The Ecological Thought.* Cambridge, MA: Harvard University Press, 2010.

———. *Ecology without Nature: Rethinking Environmental Aesthetics.* Cambridge, MA: Harvard University Press, 2007.

———. "Guest Column: Queer Ecology." *PMLA* 125, no. 2 (2010): 273–82.

Muessig, Carolyn. "Prophecy and Song: Teaching and Preaching by Medieval Women." In *Women Preachers and Prophets through Two Millennia of Christianity,* ed. Beverly Kienzle and Pamela Walker, 146–59. Berkeley: University of California Press, 1998.

Nadeau, Carolyn A. "Blood Mother/Milk Mother: Breastfeeding, the Family, and the State in Antonio de Guevara's *Relox de Príncipes (Dial of Princes).*" *Hispanic Review* 69, no. 2 (2001): 153–74.

Nersessian, Sirarpie der. "The Kingdom of Cilician Armenia." In *Études byzantines et armeniennes,* ed. Sirarpie der Nersessian, 341–45. Louvain: Imprimerie Orientaliste, 1973.

———. *Miniature Painting in the Armenian Kingdom of Cilicia from the Twelfth to the Fourteenth Century.* Washington, DC: Dumbarton Oaks, 1993.

Newman, Barbara. *From Virile Woman to WomanChrist: Studies in Medieval Religion and Literature.* Philadelphia: University of Pennsylvania Press, 1995.

―――. "What Did It Mean to Say 'I Saw'? The Clash between Theory and Practice in Medieval Visionary Culture." *Speculum* 80 (2005): 1–43.

Newton, Adam Zachary. *Narrative Ethics.* Cambridge, MA: Harvard University Press, 1995.

Orchard, Andy. *Pride and Prodigies: Studies in the Monsters of the Beowulf Manuscript.* Cambridge: Brewer, 1995.

Oswald, Dana M. *Monsters, Gender and Sexuality in Medieval English Literature.* Rochester, NY: D. S. Brewer, 2010.

Pairet, Ana. "Mélusine's Double Binds: Foundation, Transgression, and the Genealogical Romance." In *Reassessing the Heroine in Medieval French Literature,* ed. Kathy Krause, 71–86. Gainesville: University Press of Florida, 2001.

Parker, Patricia. *Literary Fat Ladies: Rhetoric, Gender, Property.* London: Methuen, 1987.

Pegg, Mark. *The Corruption of Angels: The Great Inquisition, 1245–1246.* Princeton: Princeton University Press, 2001.

Perret, Michèle. "Attribution et utilisation du nom propre dans *Mélusine.*" In *Mélusines continentales et insulaires,* ed. Jeanne-Marie Boivin and Proinsias MacCana, 169–79. Paris: Champion, 1999.

Pignatelli, Cinzia, and Dominique Gerner. *Les traductions françaises des* Otia imperialia *de Gervais de Tilbury par Jean d'Antioche et Jean de Vignay: Éditions de la troisième partie.* Geneva: Droz, 2006.

Rackham, Oliver. *Woodlands.* London: Collins, 2006.

Raskolnikov, Masha. *Body against Soul: Gender and Sowehele in Middle English Allegory.* Columbus: Ohio State University Press, 2009.

Rasmussen, Ann Marie. *Wandering Genitalia: Sexuality and the Body in German Culture between the Late Middle Ages and Early Modernity.* King's College London Medieval Studies, Occasional Series 2. London: Centre for Late Antique and Medieval Studies, King's College London, 2009.

―――. "Wanderlust: Gift Exchange, Sex, and the Meanings of Mobility." In *"Liebe schenken": Liebesgaben in der Literatur des Mittelalters und der frühen Neuzeit,* ed. Margreth Egidi, Ludger Lieb, and Marielle Schnyder. Berlin: Erich Schmidt, forthcoming.

Retsch, Christoph. "Obszön-erotische Tragezeichen des Spätmittelalters." 2 vols. BA thesis, University of Bamberg, Germany, 2009.

Reynolds, Lyndon. "Bonaventure on Gender and Godlikeness." *Downside Review* 106/107 (1988–89): 171–94.

Ripert, Pierre. *Le bestiaire des cathédrales: Imagerie de la statuaire médiéval symbolique des monstres, gargouilles et autres chimères.* Paris: Editions De Vecchi, 2010.

Robertson, Elizabeth. "Souls That Matter: Gender and the Soul in Piers Plowman." In *Mindful Spirit: Essays in Honor of Elizabeth Kirk,* ed. Bonnie Wheeler, 165–86. New York: Palgrave, 2006.

Roper, Lyndal. *Witch Craze: Terror and Fantasy in Baroque Germany.* New Haven: Yale University Press, 2004.

Rothschild, Judith Rice. "A *Rapprochement* between *Bisclavret* and *Lanval.*" *Speculum* 48, no. 1 (1973): 78–88.

Sadlek, Gregory M. "Interpreting Guillaume de Lorris's Oiseuse: Geoffrey Chaucer as Witness." *South Central Review* 10 (1993): 21–37.

Salisbury, Joyce E. *The Beast Within: Animals in the Middle Ages.* New York: Routledge, 1994.

Salmón, Fernando. "A Medieval Territory for Touch." *Studies in Medieval and Renaissance History,* ser. 3, 2 (2005): 59–81.

Sautman, Francesca Canadé. "What Can They Possibly Do Together? Queer Epic Performances in *Tristan de Nanteuil.*" In *Same Sex Love and Desire among Women in the Middle Ages,* ed. Francesca Canadé Sautman and Pamela Sheingorn, 199–232. New York: Palgrave, 2001.

Scobie, A., and A. J. W. Taylor. "I. Agalmatophilia, the Statue Syndrome." *Journal of the History of the Behavioral Sciences* 11 (1975): 49–54.

Scott, Joan Wallach. "Gender: A Useful Category of Historical Analysis." *American Historical Review* 91, no. 5 (1986): 1053–75.

Schiebinger, Londa. *Nature's Body: Gender in the Making of Modern Science.* Boston: Beacon Press, 1993.

Schultz, James A. *Courtly Love, the Love of Courtliness, and the History of Sexuality.* Chicago: University of Chicago Press, 2006.

Sconduto, Leslie. *Metamorphoses of the Werewolf: A Literary Study from Antiquity through the Renaissance.* Jefferson, NC: McFarland, 2008.

Shannon, Laurie. "The Eight Animals in Shakespeare: Or, Before the Human." *PMLA* 124, no. 2 (2009): 472–79.

Sinclair, Finn E. *Blood and Milk: Gender and Genealogy in the "Chanson de Geste."* Bern: Peter Lang, 2003.

Smith, Matthew Ryan. "Reconsidering the 'Obscene': The Massa Marittima Mural." *Shift: Queen's Journal of Visual and Material Culture* 2 (2009): 1–27.

Sobin, Gustaf. *Luminous Debris: Reflecting on Vestige in Provence and Languedoc.* Berkeley: University of California Press, 1999.

Spiegel, Gabrielle. "Maternity and Monstrosity: Reproductive Biology in the *Roman de Mélusine.*" In *Mélusine of Lusignan: Founding Fiction in Late Medieval France,* ed. Donald Maddox and Sara Sturm-Maddox, 100–124. Athens: University of Georgia Press, 1996.

Stanesco, Michel. *"D'armes et d'amours": Études de littérature arthurienne.* Orléans: Paradigme, 2002.

Steel, Karl. "Briefly, on the Animal Sacer." *In the Middle,* July 29, 2010. www
.inthemedievalmiddle.com/2010/07/briefly-on-animal-sacer-curse
-anyone.html.

———. *How to Make a Human: Animals and Violence in the Middle Ages.* Colum-
bus: Ohio State University Press, 2011.

Steel, Karl, and Peggy McCracken, eds. "The Animal Turn." Special issue. *post-
medieval: a journal of medieval cultural studies* 2, no. 1 (2011).

———. "Into the Sea with the Fish-Knights of *Perceforest.*" *postmedieval: a
journal of medieval cultural studies* 2, no. 1 (2011): 88–100.

Stephens, Walter. *Demon Lovers: Witchcraft, Sex, and the Crisis of Belief.* Chicago:
University of Chicago Press, 2002.

———. "Witches Who Steal Penises: Impotence and Illusion in *Malleus malefi-
carum.*" *Journal of Medieval and Early Modern Studies* 28 (1998): 495–529.

Stoppino, Eleanora. "Animality and Prophylaxis in Medieval Italian Litera-
ture." Paper presented at "Geographies of Risk" conference, University
of Illinois, Urbana-Champaign, September 23–25, 2010.

Stouff, Louis. *Essai sur Mélusine, roman du XIV siècle par Jean d'Arras.* Paris: Édi-
tions Picard, 1930.

Taylor, Chloë. "The Precarious Lives of Animals: Butler, Coetzee, and Animal
Ethics." *Philosophy Today* 52 (2008): 60–72.

Taylor, Jane. "Melusine's Progeny: Patterns and Perplexities." In *Melusine of Lu-
signan: Founding Fiction in Late Medieval France,* ed. Donald Maddox and Sara
Sturm-Maddox, 165–84. Athens: University of Georgia Press, 1996.

Tesnière, Marie-Hélène. *Bestiaire médiéval: Enlumineures.* Paris: BNF, 2005.

Thomassen, Einar. "Valentinian Ideas about Salvation as Transformation." In
*Metamorphoses: Resurrection, Body and Transformative Practices in Early Chris-
tianity,* ed. Turid Karlsen Seim and Jorunn Økland, 169–86. Berlin: Walter
de Gruyter, 2009.

Tilley, Christopher. *The Materiality of Stone: Explorations in Landscape Phenome-
nology.* Oxford: Berg, 2004.

Voisenet, Jacques. *Bestiaire chrétien: L'imagerie animale des auteurs du Haut Moyen
Age (Ve–XIe s.).* Toulouse: Presses Universitaires du Mirail, 1994.

———. *Bêtes et hommes dans le monde médiéval: Le bestiaire des clercs du Ve au XIIe
siècle.* Turnhout: Brepols, 2000.

Watson, Nicholas. "Censorship and Cultural Change in Late-Medieval En-
gland: Vernacular Theology, the Oxford Translation Debate, and Arun-
del's Constitutions of 1409." *Speculum* 70, no. 4 (1995): 822–64.

White, Murray J. "The Statue Syndrome: Perversion? Fantasy? Anecdote?"
Journal of Sex Research 14, no. 4 (1978): 246–49.

Williams, Norman Powell. *The Ideas of the Fall and of Original Sin.* London: Long-
mans, 1927.

Williamson, Joan B. "Elias as a 'Wild-Man' in *Li estoire de Chevalier au cisne*." In *Essays in Honor of Louis Francis Solano,* ed. Raymond J. Cormier and Urban T. Holmes, 193–202. Chapel Hill: University of North Carolina Press, 1970.

Wolfe, Cary. *Animal Rites: American Culture, the Discourse of Species, and Posthumanist Theory.* Chicago: University of Chicago Press, 2003.

Wolfthal, Diane. *In and Out of the Marital Bed: Seeing Sex in Renaissance Europe.* New Haven: Yale University Press, 2010.

Woolf, Rosemary. *The English Religious Lyric in the Middle Ages.* Oxford: Clarendon Press, 1968.

Yamamoto, Dorothy. *The Boundaries of the Human in Medieval English Literature.* Oxford: Oxford University Press, 2000.

Young, Robert. *Colonial Desire: Hybridity in Theory, Culture, and Race.* London: Routledge, 1995.

Zika, Charles. *Exorcising Our Demons: Magic, Witchcraft, and Visual Culture in Early Modern Europe.* Leiden: Brill, 2003.

Contributors

MATILDA TOMARYN BRUCKNER, Professor of French at Boston College, has published widely on twelfth- and thirteenth-century French romance. Her most recent book, *Chrétien Continued: A Study of the "Conte du Graal" and Its Verse Continuations*, explores the dialectical movement of the cycle as well as the "and/both" logic of its paradoxical structure.

E. JANE BURNS, Druscilla French Distinguished Professor of Women's and Gender Studies at the University of North Carolina, Chapel Hill, has published a series of books that offer feminist readings of medieval French texts, most recently *Sea of Silk: A Textile Geography of Women's Work in Medieval French Literature*.

JEFFREY J. COHEN is Professor of English and Director of the Medieval and Early Modern Studies Institute at the George Washington University. He is currently writing a book on stone as a lively material and editing a collection for the University of Minnesota Press entitled *Prismatic Ecologies: Ecotheory beyond Green*.

DYAN ELLIOTT is the Peter B. Ritzma Professor of the Humanities in Department of History at Northwestern University. Her research focuses on the intersection of gender, religion, and sexuality. Elliott's most recent book is *The Bride of Christ Goes to Hell: Metaphor and Embodiment in the Lives of Pious Women, 200–1500*.

NOAH D. GUYNN is Associate Professor of French at the University of California, Davis. He is the author of *Allegory and Sexual Ethics in the High Middle Ages* and is currently completing a book on the ethics and politics of medieval farce.

PEGGY MCCRACKEN is Professor of French, Women's Studies, and Comparative Literature at the University of Michigan. Her latest book is *Marie de France: A Critical Companion,* coauthored with Sharon Kinoshita, and she is completing another coauthored book, with Donald S. Lopez Jr., called *The Christian Buddha.*

ANN MARIE RASMUSSEN is Professor of German at Duke University. She is the author *of Mothers and Daughter in Medieval German Literature* and, most recently, coeditor of *Visuality and Materiality in the Story of Tristan and Isolde* (with Jutta Eming and Kathryn Starkey). She is currently completing a book on medieval sexual badges.

ELIZABETH ROBERTSON is Professor and Chair of English Language at the University of Glasgow. Co-founder with Jane Burns and Roberta Krueger of the Society for Medieval Feminist Scholarship, she publishes on gender and religion in Middle English literature. Her most recent project is a book, *Chaucerian Consent, Women, Religion and Subjection in Late Medieval England.*

Index